Stanley Spencer RA

ROYAL ACADEMY OF ARTS LONDON 1980

Catalogue published in association with

WEIDENFELD AND NICOLSON LONDON

General Information

DATES OF EXHIBITION
20 September–14 December 1980

HOURS OF OPENING
10 am–6 pm daily

PRICE OF ADMISSION
£1.80
Half price for students, pensioners and children,
and until 1.45 pm on Sundays.
School parties and other groups of over 10 will be admitted
at 90p a head.
Admission at the officially reduced rate of 90p for students,
teachers accompanying parties, Members of Staff Associations,
Working Men's or Girl's Clubs or similar organisations, and
for Pensioners, can be obtained at the entrance of the
Exhibition on production of the appropriate card.

BUFFET RESTAURANT WITH LICENSED BAR
Open daily.
Access to the Restaurant is from the Ground Floor, Entrance Hall.

Invalids may use their own wheeled chairs or obtain the use of
one without charge by previous arrangement.
Application should be made to the Registry
for the necessary authority.

Visitors are required to deposit all miscellaneous items other
than ladies' handbags with the attendants at the Cloakroom in
the Entrance Hall. The other attendants are strictly forbidden
to take charge of anything.

House Editor Anne Dobell
House Art Editor Martin Richards
Designed by Trevor Vincent
for George Weidenfeld and Nicolson Ltd
91 Clapham High Street, London SW4

ISBN 0 297 77832 3

Set in Monophoto Apollo and printed by
BAS Printers Limited, Over Wallop, Hampshire

Colour separations by Newsele Litho Ltd, Italy

Contents

Foreword

It has long been the intention of the Royal Academy to do honour to Stanley Spencer, one of its most outstanding members. He is indeed one of the greatest English artists to have worked in this century, his art marking a high point in that strongly personal tradition of English painting which extends back to William Blake.

At times his relationship with the Academy was stormy. He joined in 1932 but resigned a few years later in 1935, when the hanging committee for the Summer Exhibition decided against hanging certain of his canvases. He rejoined in 1950, and even now his spirit happily continues to make itself felt within the Academy. There is no surprise in this, for the Royal Academy has always functioned as a genuine home and as a link with the world outside for those artists who, like Spencer, appear to operate outside the mainstream of their time.

Once again the Royal Academy must say thank you to those many people who have made this exhibition possible: to Carel Weight, whose passionate interest in Spencer's work is so evident in his own painting; to Spencer's brother-in-law, Richard Carline, who has been generous in his support throughout; to three younger scholars, Duncan Robinson of the Fitzwilliam Museum, Dr Andrew Causey of Manchester University, and Keith Bell, who, together with Richard Carline, have by their knowledge and enthusiasm ensured that this exhibition is unchallengeably authoritative and its catalogue the most comprehensively documented as yet in existence. We are very happy indeed to acknowledge the association of *The Observer* with the exhibition and believe it will do much to stimulate the widest interest in Stanley Spencer's work. We thank too all the fortunate owners of Spencer's works both here and abroad for so generously lending their treasures, in particular perhaps the Stanley Spencer Gallery at Cookham, the National Trust, who have permitted all the moveable pictures from the Oratory of All Souls at Burghclere to be seen in London for the first time, and finally, and above all, the Trustees of the Tate Gallery, who have placed their entire Spencer collection at the disposal of this exhibition. This magnificent gesture sets the seal upon what we believe will be recognised as the definitive exhibition of the works of one of the most remarkable artists of our time, Stanley Spencer.

Hugh Casson President

Notes to Users

The catalogue is divided up into sections, each dealing with a stage in the artist's career. All the pictures are listed in chronological order.

Where possible, pictures are given the title by which they were originally exhibited, and otherwise that by which they are best known. In certain cases, where the original meaning has been obscured by a later title, the name has been changed to accord with Spencer's own lists of works.

A simple date, after the title, indicates that the picture was definitely executed, or, if painted over a span of years, completed during this year. A date preceded by 'c.' indicates that the picture was executed at around this date, thus: c. 1925. Two dates separated by a hyphen indicate that the picture was definitely executed at some point during this span of years, thus: 1924–5.

Inscriptions on the picture are transcribed in full, where possible, with their nature and placing indicated by the following abbreviations:

s	signed	t	top	r	right
d	dated	l	left	insc	inscribed
b	bottom	c	centre	rev	reverse

Sizes are given to the nearest 0.5 cm, and to the nearest $\frac{1}{4}$ inch; height precedes width.

Under EXHIBITIONS, the number of the picture in an exhibition, where known, appears in brackets, thus: (130).

Under REFERENCES are listed only significant discursions of the picture in question, and also references to reproductions.

Documentary references are given within the text of the catalogue entry.

Number references within the text refer to pictures which appear in the present exhibition, thus: no. 247.

Archive references

Tate Gallery archives Most references included in the exhibition entries are taken from the extensive collection of Spencer material in the Tate Gallery archives. Each reference is identified by its catalogue number and is accompanied, where possible, by the date, thus: Tate 733.3.1, *c.* 1926. *Arthur Tooth and Sons* References drawn from the correspondence between Spencer and his dealer Arthur Tooth are referred to as Tooth archive and are accompanied by the date.

Abbreviations

Abbreviations are used only where a particular source or exhibition is cited frequently.

EXHIBITIONS

Goupil Gallery, 1927: *The Resurrection and other works by Stanley Spencer*, 1927.

Tooth, 1932 (and subsequently): London, Messrs Arthur Tooth and Sons, who were Spencer's sole agent from 1932.

Leicester Galleries, 1942: London, Leicester Galleries, *Stanley Spencer Exhibition of Paintings and Drawings*, arranged by Ernest Brown and Philips Ltd, in conjunction with Arthur Tooth and Sons Ltd, November 1942.

Leeds, 1947: Temple Newsam House, Leeds, *Paintings and Drawings by Stanley Spencer*, 25 July–7 September 1947.

Arts Council, 1954: The Arts Council of Great Britain, *Drawings by Stanley Spencer*, 1954. Introduction by David Sylvester.

Tate Gallery, 1955: London, Tate Gallery, *Stanley Spencer, A Retrospective Exhibition*, November–December 1955. Introduction by the artist.

Arts Council, 1961: The Arts Council of Great Britain, *Three Masters of Modern British Painting*, Second Series, touring exhibition, 1961.

Worthing, 1961: Worthing Art Gallery, *Sir Stanley Spencer RA*, 1961.

Cookham, 1962 (and subsequently): Cookham on Thames, Kings Hall, *Stanley Spencer Gallery*, opened 7 April 1962, with an exhibition of works from the permanent collection, augmented by loans.

Plymouth, 1963: Plymouth, City Museum and Art Gallery, *Sir Stanley Spencer CBE RA*, 1963. Introduction by Richard Carline.

Brighton, 1965: *The Wilfrid Evill Collection*, Brighton Art Gallery.

Glasgow, 1975: Glasgow, Scottish Arts Council, Third Eye Centre, *Stanley Spencer, War Artist on Clydeside, 1940–45*, 1975. Introduction by Joan Hughson.

Arts Council, 1976–7: Arts Council Touring Exhibition, *Stanley Spencer*.

Piccadilly Gallery, 1978: Piccadilly Gallery, London, *Sir Stanley Spencer RA, A Collection of Paintings and Drawings*.

d'Offay Gallery, 1978: *Stanley and Hilda Spencer*, Anthony d'Offay Gallery, London, 1978. Introduction by Richard Carline.

BOOKS

Wilenski, 1924: R. H. W. (Wilenski), *Stanley Spencer*, Ernest Benn, London, 1924.

E. Rothenstein, 1945: Elizabeth Rothenstein, *Stanley Spencer*, Phaidon Press, Oxford and London, 1945.

Newton, 1947: Eric Newton, *Stanley Spencer*, The Penguin Modern Painters, Harmondsworth, 1947.

Wilenski, 1951: R. H. Wilenski (introduction), *Stanley Spencer: Resurrection Pictures 1945–50*, with notes by the artist, Faber and Faber, London, 1951

J. Rothenstein: John Rothenstein, *Modern English Painters, Lewis to Moore*, London, 1956.

G. Spencer, 1961: Gilbert Spencer, *Stanley Spencer*, Gollancz, London, 1961.

E. Rothenstein, 1962: Elizabeth Rothenstein, *Stanley Spencer*, Beaverbrook Newspapers, 1962.

M. Collis, 1962: Maurice Collis, *Stanley Spencer*, Harvill Press, London, 1962.

L. Collis, 1972: Louise Collis, *A Private view of Stanley Spencer*, Heinemann, London, 1972.

Carline: Richard Carline, *Stanley Spencer at War*, Faber and Faber, 1978.

Robinson, 1979: Duncan Robinson, *Stanley Spencer: Visions from a Berkshire Village*, Phaidon Press, Oxford, 1979.

J. Rothenstein, 1979: Sir John Rothenstein, ed., *Stanley Spencer the Man: Correspondence and Reminiscences*, Paul Elek, London, 1979.

Additional abbreviations

NEAC	New English Art Club
RA	Royal Academy of Arts
CAS	Contemporary Art Society
RSA	Royal Scottish Academy
MOMA	Museum of Modern Art, New York

Stanley Spencer: his personality and mode of life

Richard Carline (Stanley Spencer's brother-in-law)

Childhood and youth

'The intention in all my work is towards happiness and peace,' wrote Stanley Spencer, thinking back on his life's work and motives. But did he achieve this happiness and peace? Was this possible for someone as complex in character and unpredictable in behaviour as he was during his sixty-nine years? It was his complete absorption in his painting that brought him the happiness that eluded him in daily life.

He always retained a loyalty to his family, often recalling his upbringing and home life, despite their total lack of encouragement when he chose an artist's career. In early childhood he had revealed very little inclination to draw or paint, but when he was fourteen he was prompted to do so by reading fairy stories that awakened his visual imagination. In his favourite 'Books for the Bairns' series, each priced one penny, he especially enjoyed *Brer Rabbit* and *Snow White*, much of which he knew by heart. His earliest wish was to be a 'frog artist' because, as he wrote later, 'I had found a fossilised one and could draw it'.

The predominant influence at home was musical, his father, William Spencer, being organist at Hedsor Church and a teacher of music. Stanley constantly listened to the piano and violin played by his two eldest brothers, Will and Harold, who from being musical prodigies had become professionals, but others among his five older brothers and two sisters also played. Thus he soon acquired a familiarity with the work of the great composers, whereas visual art was never considered nor discussed in the Spencer household.

Close after music came literary influences, inspired by his father, who had established a lending library at their home, 'Fernlea', in Cookham-upon-Thames, where Stanley was born. William Spencer read the Bible aloud, and Stanley soon knew many passages by heart. His absorption in whatever he read – besides the Old Testament, there was *The Faerie Queene* and *Paradise Lost* – was related to his much-loved Cookham environment. Years later, as I recall him, his conversation would be punctuated with quotations from the poets or with humming bars of music.

Of the prevailing tendencies in art, however, he was entirely ignorant in his early years, and it is also questionable whether he could name any of the old masters until he had attended art school. It was the artists of Victorian England that he was familiar with, such as Fred Walker, reproductions of whose *Harbour of Refuge* and *Geese in Cookham Village* hung on the dining-room wall, with Sir John Millais' *Ophelia* and *Una and the Lion*. Shortly before his death, Stanley wrote: 'I love Frederick Walker dearly and his wit. I have always thought and said that he is one of England's greatest artists.'

He was never sent away to school, nor did he ever sleep away from home during childhood, his education being conducted by his two sisters Annie and Florence in the school-room behind the house; but it never went beyond the elementary stage. To meet him in later years one would consider him well read, with his intimate knowledge of classical and English literature, but this was self-taught. One can recognise his intellectual development by comparing his youthful letters, so awkward in writing, elementary in grammar, curious in spelling, with their fluency in later years.

When Stanley Spencer first disclosed a wish to be an artist his father was dismayed, having assumed that he would take up a musical career, and he consulted the only artist he knew, A.J. Sullivan, who was not encouraging. But, acceding to his son's wishes, he allowed him to take watercolour lessons with Miss Dorothy Bailey, a flower painter, whose father's watercolour views were locally admired.

In 1907 Stanley's father enrolled him at Maidenhead Technical Institute, where he spent a year. Teaching was based on drawing from the casts of antique sculpture; there was no living model. 'Each statue and easel or chair or person had a meaning for me,' he wrote in retrospect; 'I could worship every hard-edged shadow the gas-light made on the casts'. Years later he drew from memory the big Roman statue of the 'Gladiator', with the Mayor of Maidenhead resting his hand on it before beginning his tour of inspection.

In May 1908, on Lady Boston's recommendation, father and son had an interview with Professor Brown and his assistant, Henry Tonks, at the Slade School, University College, London. Stanley was accepted, but was so nervous in filling up the application form that his father wrote his signature together with other particulars for him.

Mr Spencer had to take Stanley to the School until he

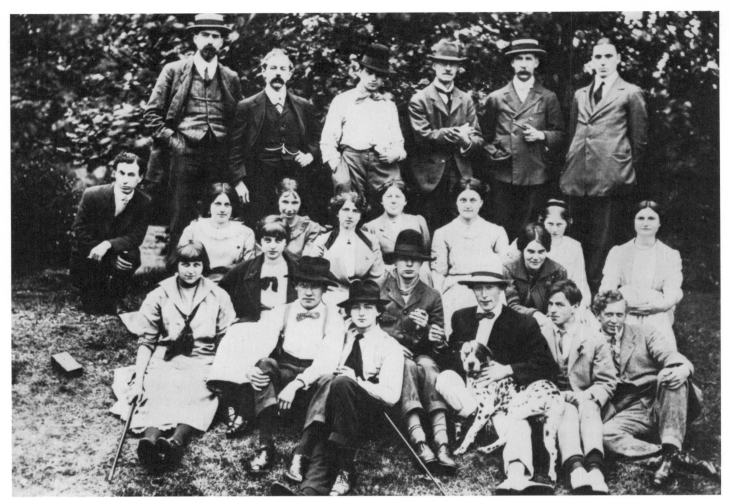

A Slade picnic party, c. 1912. Spencer is second from the right in the front row, next to Adrian Allinson (with the dog). Mark Gertler is in the centre front, with outstretched legs, and Nevinson is on the left of him. Dora Carrington is on the extreme left, front row.

had acquired the confidence to make the journey alone, walking the two miles to Maidenhead for the 8.50 train to Paddington, and returning by the 5.08 in time for tea. During his first year he drew from the 'antique' under Walter Russell, but won no prizes and was not awarded a scholarship until 1910, when he shared it with Adrian Allinson. He was then drawing in the 'life-room', where the nude model retained the same pose during the morning and afternoon sessions throughout the week. He missed the final sessions in the late afternoons, when the model took short poses, in order to catch his train home, and this may have led to his life-long reluctance to sketch or draw quickly.

Stanley did not leave the school premises for his midday meal, but ate his sandwiches in the 'life-room' or the corridor. Darsie Japp did likewise and a lasting friendship was thereby created. Stanley's limited experience and confined upbringing kept him apart from most of the other students with their public school backgrounds and well-to-do homes, but his outward-going disposition, interest in

whatever was told him and anxiety to learn soon made him acceptable; he had a musical voice, slightly high-pitched, with no trace of a Berkshire accent. He was soon nicknamed 'Cookham', since he mentioned it so constantly, and his fellow students, led by Nevinson, often teased him unmercifully.

Some students like Lightfoot, who committed suicide in 1911, and Rudolph Ihlee became Stanley's close friends, and they may have introduced him to the work of the old masters. Gowans and Gray's pocket editions, price sixpence each, which covered fifty of them prior to the nineteenth century, became as familiar to him as his favourite works of literature. The first master to be mentioned in his letters was Pietro Lorenzetti. Among his Gowans and Gray reproductions he especially admired the fresco in the Campo Santo, Pisa, of knights on horseback drawing back with horror as the horses approach the open graves with the uncovered corpses. This fresco was ascribed at the time to Lorenzetti; he could not know that subsequently it was to be ascribed to Traini. Moreover the

subject of graves was to be, for him, a life-long pre-occupation. In 1914, he was writing to his artist friend and patron Henry Lamb: 'Do not forget the Lorenzettis', adding 'I am getting a very good collection of post-cards. . . . I put (one) somewhere in the room. It sort of keeps me company and makes me work.' His admiration was mainly for the early Italians – Giotto, Mantegna, Masaccio, Uccello, especially – but he was also devoted to Claude Lorraine.

Although eighteen, Stanley looked boyish, being little more than five feet tall, wearing a norfolk jacket, eton collar, jersey, breeches and long stockings. His youthful image was emphasised by his tousled black hair, fresh, rosy complexion and general untidyness. He liked to recount incidents against himself, as for example the occasion when he was on his way to receive the Nettleship Award. A voice called 'Here, boy, carry this bag'. On reaching the college, he was offered a tip, and there was evident embarrassment on finding that he and the owner of the bag had the same destination. In a letter to his brother Sydney he wrote: 'I was a horrid swank yesterday at the College Assembly. It was very pretty to see the whole of the professional board troop in in their lovely robes; the Provost wore a flowing red one.'

The only letters Stanley had occasion to write during his student days were to Sydney, who was away from home, studying for the Church. Stanley was devoted to him, addressing him by curious nicknames, ranging from 'Dear Syd' to 'Hingy' and 'Higgy', and signing himself 'Brer Stan'.

At the Slade he confined himself to drawing, and was never taught painting. 'Tonks taught me drawing and was very critical of it', Stanley wrote some years later. In a letter to Sydney in 1911, he described a lesson: 'This is what Tonks says: "Don't copy, but try and express the shape you draw; don't think about the paper and the flatness of it; think of the form and the roundness of form. . . . Think of those bones, those beautiful sweeps and curves they have. . . . Expression, not style; don't think about style. If you express the form, the 'style', as some people call it, is there. . . . Photos don't express anything and your drawing is too much of a photograph." ' Stanley absorbed these precepts, and in due course Tonks acknowledged him as 'having the most original mind of anyone we have had here at the Slade'.

Stanley was always modest, even after gaining prizes or receiving awards; his work absorbed all his attention. Several fellow students during this later period at the Slade became friendly, such as Wilcox, who invited him to draw in his studio. But social functions organised at the College did not distract him. 'I used never to go to the dance,' he wrote later, 'didn't know there was one . . . did not feel I could bear to rejoice one little bit until I could draw.'

Tonks thought in 1911 that Stanley's development might be furthered by his going to stay at the home of an older student, Harrison, a wealthy landowner, at Clayhidon in Somerset. Robert Bevan and Spencer Gore were frequent guests. Stanley's letters home indicated that he was enjoying being there, but subsequently he repudiated this: 'I felt when I got back that I had lost caste; my work was never the same.'

There are some surviving watercolours, scarcely finished, which he may have made in Somerset, but once back in Cookham he was again immersed in drawing compositions. He wrote to Sydney in 1911: 'At the present moment, I am so excited about my composition for *Leisure* – the subject set by the Slade for the summer holiday picture – that I can scarcely tell "tother" from which. I have done a "gooden", as Lightfoot would say, of *Maternity*, also set by the School.'

Stanley's earliest oils were done on paper. It was probably Ihlee who had stimulated his use of oil paint, judging by a letter to Sydney in July, 1911: 'I was up at Ihlee's the other day and he gave me about thirty half-used tubes of oil paint. After that, he asked me to let him have that drawing of Dot Bailey for 2s/6d, which I did. After that, he said: "If you give me the half-crown back, I will let you have the box as well as the paints." I walked away with about fifteen shillings' worth of colours and a lovely oak box.'

Of his first important painting, *Two Girls and a Beehive* (no. 3), he commented a year later: 'My feeling for things being holy was very strong at this time. . . . It marks my becoming conscious of the rich religious significance of the place I lived in.' This feeling was equally applicable to his *John Donne Arriving in Heaven* (no. 8) of 1912. He had puzzled over Donne's sermon mentioning 'going to Heaven by Heaven', and he concluded: 'Donne went past Heaven, alongside it. Heaven was Heaven everywhere, so of course they prayed in all directions.'

This small painting led to Stanley's involvement, probably unknown to himself, in 'Post-Impressionism'. He had shown it to Tonks, who commented, so Stanley records: ' "I don't like it. . . . It has no colour, and is influenced by a certain party exhibiting at the Grafton Gallery" – 'post-imps' – the damned liar.' He had sold the picture to Jacques Raverat, who had married Gwen Darwin, both Slade School friends. Roger Fry saw it, presumably through them, and included it in his Second Post-Impressionist Exhibition at the Grafton Galleries in Bond Street in 1912. Stanley has left no record to suggest that he knew of this or ever visited either of these exhibitions. It is most unlikely that he saw the Gauguins and Cézannes shown in Fry's first exhibition in 1911, nor Matisse and Picasso, and he may well not have seen the exhibits by the English pioneers – Spencer Gore,

Wyndham Lewis, Henry Lamb, Duncan Grant and others – shown in 1912.

After Spencer had left the Slade, reproductions of Cézanne may have come his way and he agreed with Tonks's aversion for him. This led to his alienation from contemporaries such as Mark Gertler, although he was the proud possessor of a Gertler drawing in blue chalk. His letters or other writings throughout this time never mentioned the other giants of the French school such as Renoir, Gauguin or Van Gogh, and it is doubtful whether he knew their work until much later, as when he wrote to my sister, Hilda, in 1923: 'I do not like the Renoir atmosphere.' He found in French painting, he added, 'an utter lack of spiritual grace'; Delacroix might be acceptable but, he added, 'I would not be certain'.

His work was never merely illustrative. He denounced critics who suggested it was. Nor was distortion intended. In the early 1920s he wrote: 'The more real and natural I made a drawing or composition, the more intense and beautiful it was. . . . In destroying the physical realness, you destroy the spiritual. . . . Its essential beauty is its realness.' For him, he continued, painting was 'solemnising and celebrating . . . by taking solid chunks of my own life and putting it on canvas. I like my life so much, that I would like to cover every empty space on a wall with it.'

Stanley's first large canvas was for *The Nativity* (no. 10), submitted for the Slade summer prize in 1912, to a prescribed size. He found space at home too cramped, and was allowed to use Ovey's barn across the road. After making a 'grill' on his preliminary drawing, he would similarly 'square-up' the canvas, in order to transfer it accurately. He relied completely on this careful and detailed drawing. Painting was begun on the top left-hand corner, working steadily downwards and completing it as he went. He scarcely ever altered what he had painted or worked over it. This was his method all his life.

Not concerned with exhibiting, he had sufficient patrons who visited him in Cookham after he had left the Slade School. But he did, perhaps reluctantly, allow himself to be elected to the New English Art Club in the 1920s. Nor did he seek praise or publicity, but when a critic commented on his work he felt a sense of pride, whether it was complimentary or critical. It was characteristic of him to repudiate progress: 'I never want', he wrote in 1924, 'any subsequent work I mean to do shall be better than the one I am engaged on. I only mean it to be different.' He wished to create visually as freely as Bach or Beethoven.

His religious views have been often questioned. Brought up from childhood to respect religion, his loyalty was divided between the orthodox church attended by his father, whom he sometimes accompanied, and chapel, which he attended with his mother. Subsequently, during the war, he made friends with an ardent Roman Catholic;

the language and ritual of the Catholic service appealed to him, and for a while he disowned his Protestant allegiance. Persuaded, later, by Eric Gill, the sculptor, to accompany him to the priory at Hawkesyard, he disclaimed any conversion, and in a fit of anger wrote to Hilda: 'I doubt very much if God is as vital to me as Shakespeare or Beethoven', and in 1923 he told her 'I hope I am not Judas, but it looks very much as if I am'.

A more balanced view emerged when he wrote much later: 'If one is sincerely trying to be a Christian, his work will be alright . . . but if he is like me, he will know of difficulties, real difficulties.' In 1944 he wrote more positively: 'Somehow religion was something to do with me, and I was to do with religion. It came into my vision quite naturally, like the sky and rain. . . . I am still faithfully trying to turn and keep in the Christian direction.'

War Years

Although having no special interest in politics or current affairs and seldom looking at a newspaper, Stanley Spencer had a strong sense of patriotism and was proud of being English. With the outbreak of war in August 1914 he felt an immediate wish to take part. Despite his physical inadequacy to compete with others on equal terms, his first impulse was to enlist in the infantry, but he was persuaded to hold back by his mother, who thought ambulance work was safer and more appropriate for one of his small stature.

He joined in first-aid and drill in Kidwell Park, Maidenhead, and awaited 'call-up'. 'If I go to war,' he wrote to Henry Lamb, now serving as a medical officer, 'I go on condition I can have Giotto, the Basilica of Assisi book, Fra Angelico in one pocket, and Masaccio, Masolino and Giorgione in the other.' Meanwhile he painted with a renewed sense of urgency, completing four large compositions as well as his large over-size *Self-Portrait* (no. 23), with its questioning gaze, some of them indicative of the influence of war, and he had begun a fifth when he was ordered to report for service in July 1915 as an orderly in the RAMC at Beaufort Hospital, Bristol. He left home secretly, joining other recruits on the train from Maidenhead. This was only his second stay away from home in Cookham, and three and a half years were to elapse before he would be living there again.

Stanley had no aversion to the menial tasks assigned to him – scrubbing floors and baths. 'I was always prepared to do anything I was ordered to do,' he wrote. What he read in St Augustine's *Confessions* – 'glorifying God in all His different performances . . . bearing, filling, guarding' – inspired him. He never sought any higher responsibility nor, strange to say, any promotion throughout his career in the army. He willingly obeyed orders, though he was wary of victimisation.

Many years later, in writing his reminiscences, he recalled the Sergeant-Major at Beaufort Hospital: 'I know that man could pick a quarrel with a stripe on his shirt and that stripe would be me. . . . I am working in a Hospital that is his and therefore, in a sort of way, I am part of him myself.' Stanley's recollections continued: 'There was a lavatory seat which proved to be the Sergeant-Major's special. I don't know if kings on their thrones are apt to be more terrifying than when they are not – I imagine this is so – but the SM on his lavatory seat was . . . quite the contrary . . . the only time that he became friendly.'

Distrust of those above him could alternate with devotion, as when he volunteered to accompany his captain to a hill-top exposed to enemy fire on the Macedonian front, and helped the captain when he was wounded. Stanley could call forth unwonted strains of courage. In volunteering for transfer to the infantry in 1917, it seemed that he wished to prove his equality with others. Nevertheless, his failure to keep up in the final offensive resulted in his ending active service in the base hospital in Salonika.

Throughout his war service he had to be content with a supply of pencils and paper sent from home, which enabled him to draw portraits of his fellow soldiers or nurses, a branch of work that he continued to the end of his life. While he was in Macedonia a letter from the Ministry of Information told him that the War Office has been asked to release him from active service in order to paint a subject of his own choice. Overjoyed, he wrote to his friend James Wood on 3 June 1918, listing subjects he had in mind – a bivouac, two mule-line pictures, a travoy, a lecture on germs, two drinking-water pictures, a stretcher-bearer, a limber wagon, inside a tent, and a donkey picture, and he added: 'The most moving things about these pictures will be that wonderful, remote feeling that this particular sector gives me. If I had the chance, I would not leave this place just now.' For a long time he retained a grievance against his superior officers for failing to release him as requested. It was not until after his demobilisation that he carried out the Ministry's commission by painting *Travoys with Wounded Soldiers Arriving at a Dressing Station* (no. 34).

When service duties permitted he could resume his education by further reading. But he never read the comic magazines favoured by many of his fellow soldiers, especially in hospital. He wrote home for the work of the poets – Milton, Marlowe, Crashaw and, of course, Shakespeare, as well as Dostoievsky and Dickens. His growing literary appreciation emerges in a letter to James Wood at this time about Dante: 'I think when he is speaking about hemispheres and cones and light and things like that, he gives one a feeling of the spiritual geometry of things.' Such treasured possessions as these books, together with the few sketches that he had not parted with, were, alas,

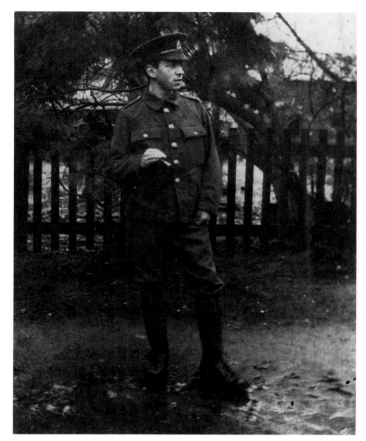

Spencer in the RAMC, 1916.

destroyed by order of those in command before the final offensive, and when ultimately he returned home he was empty-handed. He travelled through Italy, arriving in time for Christmas.

Stanley Spencer's long absence had not only developed his character and education. Association with fellow soldiers and listening to their frequent exchange of views must inevitably have led to discussions about sex, though this was never mentioned in his letters. I wrote to him after returning with my brother Sydney from the Middle East, where we had made sketches of the war in the air for pictures commissioned by the Imperial War Museum, and Stanley came promptly to visit us in December 1919. Besides our parents and Hilda at dinner there was our mutual friend, James (Jas) Wood. Stanley subsequently described the visit: 'As she [Hilda] came round to me and Jas and the rest of us with the soup, I thought how extraordinary she looked. I felt sure she had the same mental attitude towards things as I had. I could feel my true self in that extraordinary person.'

Post-war activity and marriage

Hilda, studying at the Slade, was courted by Stanley's younger brother, Gilbert, and Stanley respected his prior claim. Five years were to elapse before Stanley's admi-

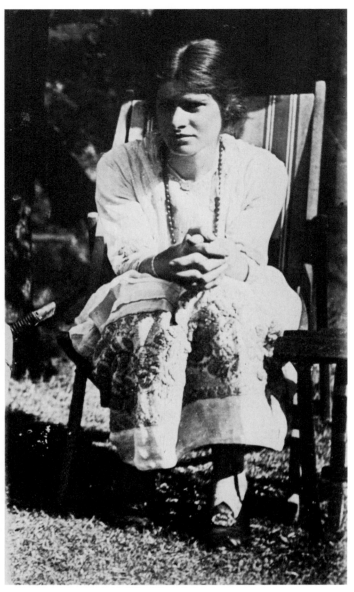

One of Spencer's favourite photographs of Hilda.

ration for Hilda could be consolidated in marriage. Meanwhile, he came with us to the Balkans in the summer of 1922. The prospect of replenishing his concern with Islamic culture, of which he had read so much, and of hearing the Mullahs' call to prayer 'from the minarets appealed to him, as well as the expectation of spending some months with Hilda. We painted regularly together, and there is a watercolour sketch on which Hilda wrote: 'Done on occasion of Stanley's proposing to me.'

The engagement took a devious course and was frequently broken off. Stanley was reluctant to commit himself in anything, and marriage, especially, would be a tremendous commitment. For him, as for Hilda, marriage was indissoluble. Once committed, would he subsequently regret it? Doubts assailed him. On one occasion, he arrived unexpectedly to find Hilda standing on the kitchen table

while her mother measured her for the wedding dress; he was dismayed; the engagement was again broken off.

He was thirty-three when the wedding took place in 1925 at Wangford, Suffolk, and their honeymoon was spent there. Gilbert joined them, and Stanley affirmed afterwards that it was not he but Hilda who had invited him. She may have felt nervous about her ability to cope alone with Stanley's overpowering personality. Hilda asserted later that Stanley had no previous sex experience; moreover he had told her that he had never kissed a girl before their courtship.

Marriage to Stanley was necessarily hazardous. Though they possessed many interests in common, their habits were very different. His were derived from a childhood spent exclusively at home in Cookham, whereas Hilda's had been spent at boarding schools, staying with relatives or living in various places. She had been strictly educated. He could readily become self-assertive and was easily irritated; neither of them would willingly concede an argument. He was not at all fastidious; I remember when we were crossing Germany in 1922, travelling in a third-class coach, that my mother gently rebuked him for laying our sandwiches on the grubby seat.

Their main divergence arose from Stanley's overwhelming vitality, whereas Hilda could be lethargic and easily tired. He would talk until the early hours and then be ready, after a few hours' sleep, to cook his breakfast and begin his day's work. I remember occasions, when sleeping in an adjoining bedroom, hearing Stanley's insistent voice until long after midnight. Worn out by the long discussion, Hilda would be unable to rise early. She might fall asleep when Stanley was expounding his views in our family circle, and she would be reproved accordingly. Stanley had a supreme confidence; he knew best how to nurse the baby, wash the nappies and cook; he would find fault with Hilda's methods, though she was not incapable, if allowed to do things in her own way. In contrast to his frequent fault-finding was his enthusiasm for her painting, as was his generous interest in any form of self-expression in others.

They had much in common. Stanley was entranced with her dark reddish hair, her general appearance, her intensity of feeling, her strong convictions. But she could be stubborn and immovable when challenged, and had an inbuilt incapacity to meet others half way. During their regular walks on Hampstead Heath, they would thrash out their ideas and exchange views on art. Both were utterly sincere and fearful of boredom.

For periods of some months, Stanley stayed with us in Downshire Hill, Hampstead, and he joined me in the spring of 1923 in drawing at the Slade. 'I am having a grand time at the Slade,' he wrote to Henry Lamb. 'It's like being set on a cloud and floated through the sky twice a week.' After

Stanley and Hilda at Chapel View, Burghclere, 1928.

Spencer painting in the High Street, Cookham, 1929, with Shirin and Hilda in the background.

their marriage he and Hilda moved into Lamb's studio in the Vale of Health, frequently walking over to Downshire Hill for meals or to join our studio gatherings, where he always took a leading part in the discussions. Among the artists often present were Lamb, Charles Ginner, Ethelbert and Betty White, Mark Gertler, Kathleen Hale, sometimes Dorothy Brett; David and Edwin John and the younger generation of Stracheys also joined us and became Stanley's friends. He was gay, sociable and very entertaining; when we had charades or fancy-dress dances, he took part, though he did not dance.

During these post-war years, Stanley painted large compositions, as he had done earlier. It seemed extraordinary that, such was his visual memory, he could retrieve his *Swan Upping* (no. 33), left unfinished in 1915, and continue painting it in the same style and mood as if four years had not intervened.

He was forgetful, however, when he chose. His attitude towards landscape provides an example. Having accepted Lamb's invitation to join him and Gilbert at Durweston, Dorset, he followed their example in painting several landscapes. Years later, he told Hilda that he 'hated doing landscapes', and did so 'solely for money'. For him, landscape was not to be confused with his 'place-feeling', of which he wrote to Hilda: 'The only really significant love affairs I have ever had have been with places, rather than with human beings', and he told an audience in 1922: 'The instinct of Moses to cast his shoes off when he saw the burning bush was very similar to my feelings. I saw many burning bushes in Cookham. . . . I could see the richness that underlies the Bible in Cookham in the hedges, in the yew-trees.'

He could similarly forget his war-time passion for the sea. He had written to his sister Florence after seeing the sea for the first time on the way to Salonika in 1916: 'I do not want to talk about anything else. . . . I think, after the war, I shall be a sailor', and he joined our family on a visit to the seaside in 1920. Completely reversing such notions, he subsequently repudiated any wish for sea or travel, claiming he knew more of the world by staying in Cookham. When he did, very rarely, paint sea or shore, it was only because other motives took him to the coast.

He had visualised, during war service, painting his experiences in Beaufort Hospital and in Macedonia as a series of wall decorations. For some curious reason, he allowed several years to elapse, and not until the summer of 1923, when staying with Lamb at Poole, did he work on drawings for a project of this kind. Perhaps, with the war over, memories of it were distasteful. He wrote 'of the absence of love of war', explaining his attitude thus: 'Because it is not with us a real passion, as it is in Germany, most of it is what the English call a "duty".' But he must often have turned the war paintings project over in his

mind, as he had done during the war, since, within months in Poole, he had drawn complete sketches of the eighteen pictures he had in mind and a sketch of the three walls, showing their relative positions. He wrote to his brother Will: 'I am rather pleased to note that without any conscious imposition of my moral outlook on the war, nevertheless the pictures are free from any bellicose tendencies.' Although he had not at first envisaged them in an almshouse, he was delighted, having always admired Fred Walker's *Harbour of Refuge* depicting the Maidenhead Almshouses.

The scheme for a series of war paintings aroused the enthusiasm of visitors, including Augustus John and Colonel Lawrence, and soon Louis and Mary Behrend decided to build an Oratory for it. Meanwhile, awaiting its fruition, Stanley turned to another ambitious project, the Resurrection visualised in Cookham Churchyard, explaining his ideas very fully in letters to Hilda. With its completion in 1926 and inclusion in his retrospective exhibition at the Goupil Gallery in February 1927, he and Hilda with their daughter Shirin left Hampstead in May of that year to stay at Palmer's Hill Farm, near Burghclere, whence he cycled to the nearly finished Chapel.

Stanley and Hilda's marriage had its ups and downs. He painted all day in the Chapel, apart from his brief afternoon rest, which he never missed, and the evening would be occupied in discussion. Despite his seemingly inexhaustible resources, the strain brought several bouts of illness, increasing his proneness to irritability, argument and even bursts of anger, which, once aroused, proved difficult to suppress. Their friends would blame Hilda for deserting him on occasion, but Stanley understood her need for quiet periods on her own. There was usually a justifiable excuse, such as the death of her brother Sydney in 1929 or, in 1930, the birth in Hampstead of their second daughter, Unity, or, finally, the fatal illness of her eldest brother, George. The idea of permanent separation never crossed their minds. He stressed this in writing to her in 1930: 'I can't understand or believe to be true that kind of attitude towards married love, as though it were some sort of physical phase, which passes off at about forty', adding 'You still are to me the most revealing person of true essential joy I know.'

During Hilda's absences, he was putting his thoughts in letters, sometimes expressing extreme devotion and sometimes explaining sources of irritation. Letters were

Left to right: Shirin, Mrs Carline, Hilda, Stanley and Richard Carline.

becoming increasingly long. Returning from work in the Chapel for tea, he would begin writing to her, sometimes a single letter lasting several days. He referred to one of them proudly as his 'hundred page letter'. Feeling that no one really understood his painting so well as Hilda, he could expound his 'notions', as he called them, to her, more clearly than to anyone else. He had married her, he claimed, from respect for her as an artist and for her powers of criticism. He often taxed her with neglect of her painting since their marriage, but she found it difficult to paint under his powerful sway.

Separation and re-marriage

Stanley and Hilda left Burghclere in 1931, having together acquired 'Lindworth', a large house with a garden off Cookham High Street, and all seemed well. When Hilda was in Hampstead in 1932, however, Stanley renewed his acquaintance with Patricia Preece, whom we had met in 1929, when she joined our family picnics on Odney Common. A letter to Hilda contained hints of his growing infatuation with her. He had no wish to lose Hilda, but wanted Patricia, not merely as a visitor but to reside with them, as he hoped.

It was characteristic of him to presume that his desires, whatever they might be, must be acceptable. He could not tolerate being thwarted. In a letter to Wood at this time, he revealed his attitude: 'I have just been reading the story of the man who wanted something for nothing, and never ceased to make supplication to God for it. Isn't it a magnificent idea? Makes earning one's living look such a brainless silly affair.' Stanley's trusting, affectionate, outward-looking nature endeared him to a host of admirers, but when opposed he would retort with sarcasm, even anger.

Hilda returned to 'Lindworth' early in 1933 to hear Stanley announce, somewhat brutally, that he hoped to become Patricia's lover, though he had no evidence that she would reciprocate. Hoping that Stanley's intentions were not serious, Hilda tried to be on good terms with Patricia, and both painted portraits of her. Since Patricia had a home of her own in Cookham, shared with her devoted woman friend, her immediate intentions probably went no further than flirtation.

Feeling increasingly superfluous, Hilda again left 'Lindworth'. She did not then contemplate divorce, which conflicted with her principles, while Stanley

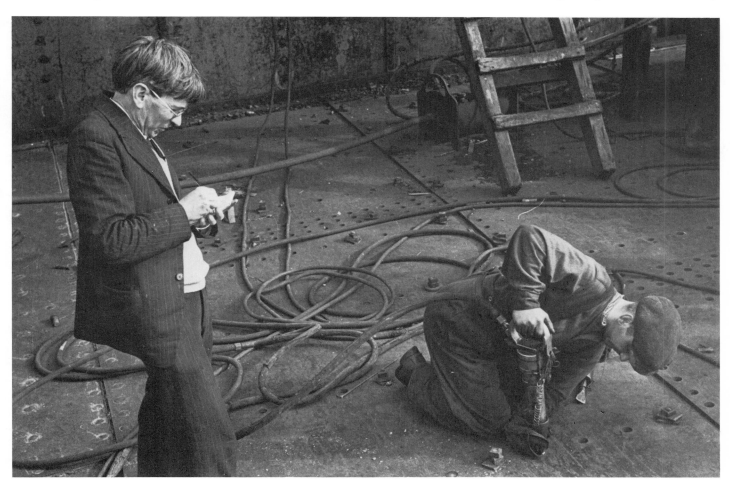

Spencer sketching a shipyard worker on Clydeside in 1943.

wished to possess both of them; but in 1937, Hilda felt that divorce and re-marriage offered the only solution for Stanley, whose slender income was being frittered away. He recorded years later that he had spent £2500 on dresses and jewellery for Patricia, as well as consigning to her the freehold of 'Lindworth', on condition that she married him.

The wedding of Stanley and Patricia took place in May 1937, at Maidenhead Registry Office. It must have seemed improbable that she would behave as a wife to him, and it is hard to understand how Stanley could have expected otherwise. For the honeymoon, Patricia went with her friend to a rented cottage in Cornwall; Stanley was to follow them soon afterwards. Patricia wrote to Hilda inviting her to join Stanley at 'Lindworth', and then accompany him to Cornwall if she liked. This struck Hilda as a very odd proposal from a bride. But with Stanley adding his entreaty, she spent the week-end with him, rashly as it turned out.

Arriving at Cornwall by himself, Stanley was dismayed to be assigned a separate lodging, and when, with his usual frankness, unable to hold anything back, he recounted Hilda's visit, he was amazed at Patricia's expressing abhorrence. She could not possibly live with him after such inconstancy, she declared. On their return to Cookham, Stanley went alone to 'Lindworth', and the other two to their own house.

The marriage proved to be a mockery, but Stanley believed himself irresistible. What could be Patricia's motives? She now owned 'Lindworth', henceforth would receive alimony, and could sell his work as she wished. The value of money meant little to Stanley, and his own needs were very modest. He could be generous, almost prodigal, with what little he had.

It was during the middle and late 1930s, with Hilda absent, that Stanley began painting what have been designated his 'sex pictures'. Looking back, one feels they were clearly the effect of frustration. But every aspect of life, whether pleasing or distasteful, was acceptable to him. As he explained in a note: 'I am on the side of the angels and dirt.' Deformity had its appeal, as had refuse and the content of dustbins. In one of his numerous notebooks, he frankly admitted in 1938: 'The erotic side I

Spencer in 1956.

am so drawn to really belongs to the very essence of religion.' In Stanley's daily life, nothing was private.

Obliged to leave his home, 'Lindworth', which was to be sold, and deprived of his studio in the garden, Stanley came to Hampstead, where he acquired lodgings. Thence he could frequently visit Hilda, who was living at home with my mother and myself. She declined his repeated proposals of re-marriage, nor would she accompany him to Wangford, where they had spent their honeymoon, as he urged, but she saw him frequently; his visits continued during her years in hospital in the 1940s. He was the last to sit by her bedside during her final illness, such was his never-ending devotion, and he continued addressing letters to her, even after her death in 1950.

March 1980

Stanley Spencer and the art of his time

Andrew Causey

Stanley Spencer did not start out by wanting to become an artist, but by wanting to communicate something about his native village, Cookham. Later on he recalled how when he was young he had spent a lot of time drawing in different parts of the village, at first with no particular sense of purpose or even satisfaction. 'The moment when I realised there might be a next step was when one day I was drawing old Sarah Sandall's cottage from her garden. I felt there was something there that was very much my business. But . . . I noticed that the feelings I had were . . . not to be found in any real way in the drawings I made. . . . I was before an instrument I could not play.'[1]

Spencer felt an urgency about the problem because he began to see all sorts of subjects around Cookham that answered to him, and realised that other people did not see anything special in them. He gave as a reason for wanting to be an artist the need to retain his vision. 'Unless I did something to conserve these things and make it clear that they were not "child" things, I would have them snatched from me.'[2] He increasingly enjoyed drawing people, especially the children at Ovey's farm opposite his home in the High Street. More than topography, it was people and places in conjunction that gave him a clue to his mystery. 'I need people in my pictures as I need them in my life. A place is incomplete without a person. A person is a place's fulfilment, as a place is a person's.'[3]

It was probably around 1906, when Spencer was fifteen, that these ideas were passing through his mind. He was the ninth child of William and Annie Spencer, and lived at 'Fernlea', a semi-detached house in Cookham High Street built by his grandfather, a master builder, for his father when he married in 1865. William Spencer was also a master builder by training, but a church organist and piano teacher by preference. He was an amateur astronomer with more of a feeling for the mystery of the universe than for systematic knowledge. He was a firm paterfamilias with an abhorrence of laziness that helped to push his eldest son William, who was an unusually talented pianist and later taught at the Cologne Conservatoire, into a severe nervous breakdown. After that his wife, Annie, who had a more liberal attitude to the upbringing of children, played a larger part. Music was supervised by their father; reading was largely stimulated by Sydney, the most intellectual of the three (he would

have entered the priesthood if he had not been killed in France in 1918); and long rambles round the village led to the discovery of the places that were to be important for Stanley's painting.

Cookham lies next to the Thames some thirty miles from London, a kind of island, in effect, surrounded by low-lying common lands: Widbrook and Odney Commons, Bellrope and Marsh Meadows. Well before 1900 the attractions of the river and the coming of the railway had led to the construction of substantial houses for the well-to-do, with gardens hidden behind enclosing walls. Spencer 'used to peep through chinks and cracks in fences and catch glimpses of these gardens of Eden'.[4] His getting to know Cookham through drawing it, and recognising the way people seemed to emanate from and belong to particular places, was connected with his marking out his own territory, taking possession of his imagined heritage through art. 'There are two parts of myself, one is me, and the other is the life around me that is me also. . . . I am aware that all sorts of parts of me are lying about waiting to join me. It is the way I complete and fulfil myself.'[5]

Spencer was accepted at the Slade in 1908 and spent four years there, almost exclusively occupied in drawing. Under the rigorous tuition of Henry Tonks he quickly became a capable draughtsman, and at the end of his second year he was awarded a scholarship.

Spencer's knowledge of art had been confined to book illustration and a few reproductions, so his taste was for the Pre-Raphaelite tradition which still dominated the graphic arts. In his drawings he liked to pull one or more of his figures right up close to the picture plane and to include a landscape beyond, often with a second, less prominent figure to reinforce the complement of place and person he liked. His early drawings recall especially Millais's engravings for *The Parables of Our Lord* (published in 1864). In Millais's *The Prodigal Son* the main figures are brought to the front as in Spencer's *Jacob and Esau* (no. 4), and both artists portray a local, unidealised landscape; Spencer's cloaked figure in *Man Goeth to his Long Home* (no. 7) recalls the passer-by in Millais's *The Good Samaritan*. Spencer was also attempting more complicated designs, such as *Paradise* (no. 5), with a Pre-Raphaelite mixture of close-up figures and glimpses of deep space reminiscent of Holman Hunt's composition for *A Converted British Family*

Sheltering a British Missionary from the Persecution of the Druids. The overwhelming importance of the revolution in taste that Roger Fry and others were beginning to stimulate may conceal in retrospect the fact that when Spencer first went to the Slade Pre-Raphaelitism, as conceived in such contemporary writings as Percy Bate's *The English Pre-Raphaelite Painters* (1910), was regarded as a movement extending unbroken to the present. Interest was still abundant, the Tate Gallery had Pre-Raphaelite exhibitions in the winter of 1911–12 and again in 1913, Rossetti was still at the height of his fame as painter and poet, and the literature on the movement was growing fast.

Spencer's early paintings were inspired by places in Cookham; all were in some way religious, and almost all have some kind of love theme. *Two Girls and a Beehive* (no. 3) marked Spencer's 'becoming conscious of the rich, religious significance of the place I lived in'.[6] He envisaged himself in the role of the Good Shepherd passing along behind his Cookham friends Dot and Emmie Wooster.[7] The complicated system of railings that are a recurrent feature of his paintings are like territorial markers distancing Spencer from the world of the Wooster sisters. The beehive, which Spencer saw at the bottom of Mill Lane, is mysterious because it is not clear why it was included here in preference to other things he must have seen; it is as if this closed-box shape somehow contained the answer to the riddle of human relationships. Though Stanley and Gilbert were fond of the Wooster sisters, with whom they spent a good deal of time, the kind of possessive emotion that is projected here seems pre-sexual and innocent.

The Visitation (no. 16), in which friends also acted as models, relates to fifteenth-century Italian Annunciations, in which either the Archangel or Mary is seen against a garden background while the other is in an architectural setting. Spencer shows unerring pictorial judgement in the way he has recreated the subject in Cookham and given it a certain everyday reality, without losing the tenderness of a Fra Angelico. Both pictures have an immediacy and complete lack of sentimentality typical of Spencer when he felt confident of his subject. He found in a quiet, unassuming realism an answer to the artifice he feared had insinuated itself into certain of his early drawings; more than once in his writings he expressed surprise that 'people cannot see the wonder that is in the barest reality'.[8]

Two Girls and a Beehive was followed by three other paintings which represent his total achievement in oils while he was at the Slade: *John Donne Arriving in Heaven* (no. 8), *Apple Gatherers* (no. 15) and *The Nativity* (no. 10). The first was inspired by a passage in one of Donne's sermons, the others were Slade set subjects. *John Donne*, Spencer said, 'came more from my imagination than any I have done. . . . I seemed to see four people praying in different directions. I saw all their exact relative positions all in a moment. Heaven was heaven everywhere, so of course they prayed in all directions'.[9] He told his brother Gilbert that the scene was Widbrook Common, but in another place he described *John Donne* as one of his 'nowhere' pictures,[10] those few designs that did not relate to specific places; the landscape's almost lunar barrenness is unusual and lends weight to this suggestion. *John Donne* is akin in feeling, and even subject, to Symbolist paintings in which figures on paths amid fields and trees become metaphorical expressions of stages in life. There is a Frenchness in the handling of the simplified planes of muted colour which earned a rebuke from Tonks[11] and the inclusion of the picture by Clive Bell in the Second Post-Impressionist Exhibition. But it is not really a programmatic picture. Spencer admitted that, though he loved reading Donne, he understood very little of it, as Richard Carline writes, and there seems no reason to expect more explanation than Spencer offers of this small, rather private painting.

Apple Gatherers and *The Nativity*, which followed, were obviously attempts on Spencer's part to claim a distinct place among his contemporaries. He was quite clear about the importance of *Apple Gatherers*: 'This picture was my first ambitious work and I have in it wished to say what life was.'[12] It is an expression of that essential relationship between people and places that Spencer believed in. 'The apples and the laurel and the grass can fulfil themselves through the presence in their midst: the husband and wife of all places and elements in the picture. The central two figures are still related in this universal sense, not this time so much through any specified religion but through a consciousness of all religions. . . . The couple in the centre here seem not to need each other in any personal way or even be aware of each other. They seem only co-existent with each other like earth and water, and yet it seems a vital relationship.'[13]

Spencer's Christian home background and the titles of some of his early pictures can create the misleading impression that he was seeking religious orthodoxy in his art. Actually he shared the feeling of many European artists of that period and a little earlier for religious inspiration that cut across accepted denominational boundaries and looked beyond Christianity altogether. With Spencer this was beginning to take the form of a pantheism in which people were particular emanations of the creative power of nature as a whole, manifested in specific places.

The rigorous formality of *Apple Gatherers*, from which it draws its emotional intensity, is hieratic, and comparable with the work of certain of Spencer's Jewish contemporaries at the Slade. Ottoline Morrell pointed out with reference to the paintings of Mark Gertler that 'there was still the Jewish tradition, the Jewish mark, which gave them the fine, intense, almost archaic quality'.[14] The pose

STANLEY SPENCER AND THE ART OF HIS TIME

and expression of the figures in *Apple Gatherers* bears comparison with the abstracted gaze and similarly linked arms in Gertler's *Rabbi and Rabbitzin* of 1914. Spencer later recalled a meeting with David Bomberg and Gaudier-Brzeska at which they discussed an aspect of this archaic tendency and the pull it exerted in the direction of abstraction, in the relationship of an outstretched arm in one of Bomberg's paintings and a straight line conceived as an abstraction.[15] When Spencer was painting *Apple Gatherers*, Bomberg and a few others were embarking on the road that was to lead them close to abstraction by 1914. Spencer's search by means of forceful patterns and symmetries for a kind of pictorial seriousness equivalent to the pre-humanist religious authority of his subject suggests that he was momentarily attracted in that direction. But there are other things about *Apple Gatherers*, the Pre-Raphaelite draughtsmanship and bright colouring in the grass and bushes in particular, that leave no room for surprise that Spencer moved no further towards abstraction.

The Nativity, Spencer's largest pre-war painting, was done for the summer vacation competition of 1912, in which it was awarded joint first prize. It marks the end of his four years at the Slade, and if it has some sense of aspiring to be (and almost succeeding in being) a masterpiece, this is surely connected with the way Spencer wanted to crown his already successful Slade career. His idea was not to repeat or extend any traditional treatment of the Nativity; he just 'thought and felt what all that is associated with hearing that title means to me',[16] and the only deliberately illustrational part of it, the baby in the manger, he later found the least convincing. 'The Couple occupy the centre of the picture, Joseph who is to the extreme right doing something to the chestnut tree and Mary who stands by the manger; they appear in their relationship with the elements generally, so that Mary to the couple in contact with one another seems like some preponderating element of life, just another big fact of nature such as a tree or a waterfall or a field or a river. Joseph is only related to Mary in this picture by some sacramental ordinance. . . . This relationship has always interested me and in those early works I contemplated a lot of those unbearable relationships between men and women.'[17] As with the man and woman in *Apple Gatherers*, the nature of the relationship between Mary and Joseph does not require them to pay particular regard to one another, since they are both wedded to the whole of nature. Instead of shepherds and kings Spencer includes lovers embracing, as if outside the sacramental love of the Holy Family, which relies on no physical proximity, a commoner love needs direct expression.

Despite its pantheist character, *The Nativity* could be a Quattrocento Nativity recreated on a Cookham common;

the costumes and some of the poses are traditional, and Spencer's eccentric fences are distant reminders of the classical architectural fragments which the Italian painters liked to use for stables. The figure of Joseph is close to being a reverse image of Botticelli's Mercury in *Primavera*. Although a few men of advanced taste like Fry were reacting against the Victorian feeling for the decorative and linear in Italian art, which Botticelli epitomised, in favour of the more austerely formal art of Piero della Francesca and others, Botticelli was still the canonical Quattrocento painter for English taste.[18]

No Italian painting, however, has quite the air of heavy solemnity that Spencer achieves; this is an aspect of his relationship with Symbolism. There is a feeling of the Renaissance seen in terms of the pictures of Maurice Denis, with their processional figures in gardens, and there is a reminiscence of Gauguin's gods presiding over Polynesian landscapes from beneath the shadow of trees, expressing that mysterious connection between men and women, godhead and nature, that Spencer also was seeking. Gauguin's paintings had been shown at the Stafford Gallery in 1911, and no less than forty had been hung at 'Manet and the Post-Impressionists' in the winter of 1910–11 (including an *Adam and Eve* which – without tying Spencer's picture to a specific interpretation – seems a possible subject of *Apple Gatherers*). Gauguin appealed to English taste in a way no other French Post-Impressionist did. 'The most prized qualities in modern art', Frank Rutter wrote later, looking back on 1909, 'were simplicity, sincerity, expression. . . . Gauguin was the Master of the Moment. . . . We respected him because he was a neo-primitive and a savage',[19] and Sickert declared in 1910 that Gauguin's pictures were 'National Gallery quality at its highest level'.[20]

Pre-Raphaelitism and early Italian painting were part of the fabric of English taste, but French Symbolist painting was not, and assimilating it would not have been easy for an artist with so narrow a background as Spencer. The dream-world unreality of *The Nativity*, which seems to challenge the existence of time, though Symbolist in the widest sense, is more English than French, and Spencer's tall, dark-cloaked Mary is nearer to Leighton's *Captive Andromache* than any figure in Gauguin. In so far as the recovery of a more primitive religion such as Spencer wanted meant overthrowing the Victorian orthodoxies and the preciosity of the Decadence, Spencer, like many English artists, accepted the leadership of that 'most notorious nonconformist of his age',[21] Augustus John. John was the admired painter of near life-size groups of figures in landscapes, and he was the artist who expressed an essential correspondence between women and nature as creative forces.

The commonly told tale of the innocent and unworldly

Spencer being mercilessly teased at the Slade, described by Paul Nash as 'the typical English Public School seen in a nightmare',[22] is not untrue, but it is not the whole story. Spencer was formidably successful in terms of awards and prizes, though the religious and Symbolist subjects that were commonly set for the vacation prizes certainly aroused him to compete more than they did many other talented students. Spencer also sold his work. Besides *John Donne*, which went to Jacques Raverat, who had given him Donne's *Sermons*, Sidney Schiff bought *Two Girls and a Beehive*, Edward Marsh bought *Apple Gatherers* in 1913 against the competition of others, and *The Nativity* won a London University purchase prize. Spencer's fellow-Cookhamite student Ruth Lowy (later Mrs Victor Gollancz) bought *Jacob and Esau*, two other students, Darsie Japp and Adela Bluett, bought drawings, and Tonks himself bought a drawing of *The Deposition*.[23]

Spencer could probably have built rapidly on this success if he had been more concerned to pursue his art world contacts and less shy of exhibiting. He may have exaggerated in claiming that when he left the Slade he 'had for a long time been receiving invitations from dealers',[24] but there was certainly interest in his work. He was one of twelve British artists selected by Clive Bell to exhibit in the Second Post-Impressionist Exhibition in 1912, but he did not show at the New English Art Club till 1913, though his friends Gertler, John Currie and Maxwell Lightfoot had done so since 1910.

Spencer was too committed to Cookham to devote energy to London art society. Though Bell remained interested in his work for a time,[25] Spencer did not fit into the Bloomsbury circle, in which personal friendship and conversational exchange were basic. Spencer had no educational background to compare with the Cambridge experience of many Bloomsbury adherents, he was not patient in conversation, which he inclined to monopolise, and he may have been put off in his relations with Bloomsbury, as John was, by what he saw as the rationalists' lack of feeling for the intense and elemental.[26]

Spencer first met Marsh in November 1913, and was more at ease in Marsh's group of painters, which included Gertler, Currie, Lightfoot, Isaac Rosenberg, William Roberts and Paul and John Nash, than he ever could have been in the Bloomsbury circle. The majority of the artists came from unprivileged backgrounds, the *raison d'être* of the circle was as much Marsh's patronage and practical assistance as intellectual exchange, and it was here that Spencer found the most convinced support for his work. Paul Nash recalled later that Spencer's early works were 'the real thing with all the right inheritance of the fine qualities of the mighty . . . which caught one by a strange enchantment'.[27] Marsh told Rupert Brooke, his closest poet friend, that Currie and Gertler 'both admire Cookham

[Spencer's nickname] more than anyone else',[28] and Rosenberg described Spencer as 'the finest of all. . . . His pictures have the sense of everlastingness, of no beginning and no end, that we get in all masterpieces.'[29] Brooke was Spencer's first critical champion in print, describing *John Donne* as 'a most remarkable picture . . . with a passion of design and form and . . . a crude and moving nobility'.[30]

Characteristic of Brooke's support for Spencer was a recommendation to Middleton Murry, editor of the *Blue Review*, who reproduced *Joachim among the Shepherds* (no. 24) in his issue of June 1913. The magazine was the successor of *Rhythm*, founded by Michael Sadler, the leading English buyer of Gauguin's work. Sadler had written in the opening editorial: 'Aestheticism has had its day and done its work. . . . We need a new art that strikes a deeper, profounder reality.'[31] It was for this profounder reality that Brooke looked to Spencer, believing that the magazine's art coverage had become 'too New English and dreary'[32] (which meant committed to a kind of watered-down Impressionism).

Of the work by the others in the Marsh circle Spencer himself was most immediately attracted to a very early drawing of Roberts's,[33] but his greatest admiration was for Gertler. 'I have always been a tremendous admirer of Gertler's work and we were good friends [from] before the war to the end', he later told Marsh's biographer, Christopher Hassall,[34] and said also, 'I always feel proud that I knew John Currie'.[35] Though Marsh's artists can scarcely be considered to have had a common artistic approach, several had started from a Pre-Raphaelite drawing style and several could be counted as disciples of Augustus John. Mystery and intensity of expression in figure compositions was a general aim, and the majority (Roberts and Gaudier-Brzeska being exceptions) were not closely involved with the advanced movements of Cubism and Futurism.

By the middle of 1914 critics were seeing a group identity in the work of John and Henry Lamb, together with certain painters from the Marsh circle, including Spencer, Currie and Lightfoot. The trend was defined as 'Neo-Primitive' in the *Observer* review of the New English Art Club in 1914,[36] and in the catalogue of the Whitechapel Art Gallery's exhibition in the same month called 'Twentieth-Century Art: A Review of the Modern Movements' the figure work of Gertler and Duncan Grant was also added to form a category that the writer defined as 'imposing decorative designs by means of commanding human types'; at the same time Sickert referred to the work of Lamb and Spencer, not altogether enthusiastically, as marked by 'a certain professional solemnity'.[37] The *Observer* critic's term was apt enough, especially as all these painters were interested in different degrees in the Italian Primitive painters as well as in primitivism in

modern expression; if it can be said that 'Neo-Primitive' equally described the more advanced movements, particularly Vorticism, this only emphasises that the differences between these various artistic currents were more to do with style and method of expression than with the artists' basic preoccupations.

The final eighteen months before Spencer enlisted in July 1915 were a period of great achievement in English art: in Vorticism, Nevinson's Futurism and the non-figurative art of Grant and Vanessa Bell in particular. For Spencer, too, it was marked by successes, and the extension of his work in new directions: *Mending Cowls* (no. 30) is a new kind of landscape of buildings with figures in a lesser role, *The Centurion's Servant* (no. 25) is his first interior, and *Swan Upping* (no. 33) prefigures Surrealism in the daring with which imagination and reality are fused. It is doubtful whether, even in this fertile period, any other English painter achieved more.

Spencer spent most of his time in Cookham, visiting London rarely, staying occasionally overnight with Marsh or the Morrells. He borrowed postcards and reproductions of paintings from the Raverats and Lamb through the post and bought inexpensive books of reproductions.[38] His tastes now were for the Italian Primitives and certain Quattrocento painters, like Masaccio and Piero. But Spencer was surely not unaware of what was happening in London. *Mending Cowls* and *The Centurion's Servant*, with their large areas of plain grey and brown paint, are more abstract than anything he had done before, and the jagged diagonal line of the river's edge in *Swan Upping* is characteristic of many Vorticist designs.

In one sense *Mending Cowls* needs no explanation, as the moving cowls on the malthouses were visible from the back of 'Fernlea'. But Spencer believed that this was a religious painting, indeed that none of his paintings was 'a more sincere and *direct* expression of my belief. . . . It is for me to go where the spirit moves me and not to attempt to ally it to some known and specified religion'.[39] The attraction of the cowls was their mobility: Stanley remembered Gilbert saying that he always felt they were looking at 'Fernlea', as if they were animate.[40] To Stanley the maltings were a rare, unexplored part of Cookham because, though they were always visible, he never went inside them before the war; this added to the interest of the cowls' shape. The sense of mystery that architectural curiosities can create in a painting had been discovered by the early Italians. Giotto, for instance, uses a device comparable to the cowls, of a wooden crucifix and its rope support seen from the back, in the *Crib at Greccio* in San Francesco, Assisi; Piero della Francesca's odd wooden framework in the *Torture of Judas* at Arezzo is another such example.

The title *The Centurion's Servant* refers to the miracle by

which Jesus healed a sick man who was far away. Spencer recalled that the bedroom in the painting was suggested to him by the servant's bedroom at 'Fernlea' (Carline, p. 41); he was not normally allowed in but occasionally heard mysterious voices coming from it (which turned out to be the maid conversing through the party wall with next door). This connected in his mind with his mother's telling him how Cookham people gathered to pray round the beds of the sick.[41] There are several ideas fusing here, connected with servants, sickness and healing, words heard from afar, and rooms unknown except in the imagination. But, strangely, no explanation accounts for the child on the bed whose terror is the real subject of the picture. When Frank Rutter later assumed it to be connected with the war Spencer was dismissive[42] and, even without the clues Spencer did give to its inspiration, the picture seems too complex and personal to be explained in so objective a way. It has a strong autobiographical element and, like many of the early paintings, it stands on the borders of innocence and experience. It is here that sexuality seems for the first time to play an important part, as a force that is felt but only slightly understood.

Swan Upping started with Spencer seeing some swans being wheeled down Cookham High Street in a barrow.[43] It was part of the annual wing-clipping procedure, but strange enough even to someone who knew what it meant. Later he saw a local girl, Miss Griffiths, carrying decorated punt cushions down to the river, and was struck by the incongruity of things that belonged indoors being seen in the open air.[44] Then Spencer was sitting in the eleven o'clock Sunday service in Cookham Church listening to the launching of punts on the river from Turk's boatyard nearby. 'The village seemed as much a part of the atmosphere prevalent in the church as the most holy part of the church such as the altar. . . . And so when I thought of the people going to the river at that moment my mind's imagination of it seemed . . . to be an extension of the church atmosphere.'[45]

Spencer did not rush to the boatyard to draw it. He went home and drew it in his bedroom and then, taking the drawing to the boatyard, was pleased to find that 'there was indeed a signification in the place which was exactly the place in my mind. This meant that the place itself immediately became the special part of my mind which was to be the abode for all I wished to put in it.'[46] When drawing Sarah Sandall's cottage he had been frustrated at his inability to find himself in his subjects; now, by allowing the images to enter freely into his imagination, and checking them afterwards with the place, he was able to achieve the holy atmosphere that gave him his sense of joy.

Swan Upping remains an 'indoor' or 'church' picture in the sense that its intense colours belong as much to

heraldry, banners or ceremonial objects that might be found in church as they do to nature. There are conscious references to early Italian painting. A glamorous Florentine exists on comfortable terms with the Cookham boatmen emptying water from a punt, and the device of a swan concealing the head of the man carrying it creates a strangely alarming shape, which is like the mysterious way Giotto hides the head of a man carrying a basket in *The Presentation of the Virgin* at Padua. These references, by alluding to a prestigious art of the past, which was largely spiritual in inspiration and purpose, further enhance the otherworldly 'church' atmosphere.

The skill with which Spencer was managing in his new pictures to weave the different strands of his inspiration into a single design is connected with his readier command of style. He was now a very stylish painter, not in the sense that he adopted manners in an arbitrary way, but because his knowledge and experience of past and contemporary art increased the variety of ideas on which he could draw. The Douanier Rousseau, for instance, seems to have influenced *Swan Upping*; the patterning on the water is like that in Rousseau's *The Snake Charmer*, while the colours and shapes of clouds and sky relate to those in Rousseau's *Self-Portrait* of 1890. The point is not that Rousseau was a casual discovery of Spencer's, but that there are elements in Rousseau's painting – the paradox of its highly polished naïvety, its rich colouring and clarity of image, and the convergence in it of memory and observation – that made him the most apposite painter to help Spencer add mystery and richness to the ideas he had got from the early Italians.

Spencer was enormously stimulated by his war experiences at the Beaufort Hospital, Bristol and subsequently in Macedonia. He liked to distinguish between places where he had had happy feelings and those where he had not; Bristol and Macedonia were among the former.[47] It is surprising how easily Spencer, inexperienced as he was at living outside the family circle, adjusted to his new life. He had a naïve confidence and was extremely good at his work as an orderly. Though resentful of officious authority, he felt that if caring for the wounded was a necessary part of the war effort, then any domestic chore connected with it was an honourable occupation. This attitude filtered through bit by bit into his painting; by the 1930s no subject was too menial for him.

In April 1918 Spencer was approached by the Ministry of Information with a suggestion by Muirhead Bone that he should paint 'a religious service at the front' for the nation's war records.[48] Spencer agreed to do 'a Balkan subject'[49] and in February 1919 started on *Travoys with Wounded Soldiers Arriving at a Dressing Station at Smol, Macedonia* (no. 34). The picture shows wounded being brought on travoys, which are a kind of mountain sledge, to a dressing station in a ruined Greek church. It was based on memories of two or three nights of heavy fighting in September 1916 when the wounded were brought in in a steady stream.

Travoys was 'intended to convey peace in the middle of confusion'.[50] The men on the stretchers were 'so many crucified Jesus Christs, not as conveying suffering, but as conveying a happy atmosphere of peace'.[51] Spencer stressed calmness and peace because he wanted 'not a scene of horror but a scene of redemption'; his art was to offer not just a record but an atonement, although his refusal to show suffering isolates Spencer from traditional conceptions of atonement as inspired by the centrality of Christ's suffering. The shape of *Travoys* is interesting in this respect, because while it does follow traditional Renaissance compositional forms, they are not those of any subject as obviously connected with redemption as a Crucifixion would have been. In replying to Bone's suggestion of 'a religious service at the front' by agreeing to a Balkan subject, Spencer was not tactfully by-passing the suggestion, because what he has done is something between a traditional Adoration – with the wounded in the role of the shepherds and kings facing the ruined church in place of the stables – and a depiction of an ordinary religious service at which the surgeon's table has replaced the altar in an actual, if ruined, church. Spencer often repeated that his paintings were about love and fraternity, not hatred or suffering. The skill with which he shifted the emphasis from suffering and death to an Adoration theme, with its implications of love and birth, is certainly striking.

The war was over and Spencer was free; but Cookham was changing, its spell was broken. 'The old island feeling was going', Gilbert Spencer recalled,[52] and after three and a half years away, Stanley, now twenty-seven, could not simply pick up the threads of his old life, even if one of his first actions was to complete the unfinished bottom half of *Swan Upping*. He was restless and impatient, longing to be independent without knowing how, and unwilling to follow Gertler and his brother Gilbert under the wing of Ottoline Morrell at Garsington, even though he had responded positively to her patronage before the war. He resented what he perceptively diagnosed as 'the intellectual's love of an illiterate. . . . The nobleman's appreciation of a workman.'[53] Even the support of the patient and accommodating Henry Lamb came to irritate him: 'I felt too much in Henry's world not mine. . . . I have been whirled and whisked through place, circumstance and experience. . . . My life was in a sort of abeyance. I was tired of not being me, of being a corpse watching other people be alive.'[54] He was 'longing to step on a stage before a highly appreciative audience. That audience I deserved and should have had.'[55]

Spencer's problems were personal, but his disorien-

tation was far from unique. The pre-war atmosphere of experiment had fallen victim to a post-war urge for retrenchment, and the abstract artists had to adjust more radically than Spencer; on top of the war itself the Ministry of Information's wartime commissions for documentary works were less relevant to their ambitions. Despite Spencer's mood he was the artist, together with Paul Nash and Nevinson, who had made something most personal out of his war commission, and, with Roberts, Wadsworth and Gertler, adjusted most readily to the new conditions of the twenties.

Though the realism of the Cookham ambience in *Christ's Entry into Jerusalem* (no. 57) and *Christ Carrying the Cross* (no. 45) is momentarily disconcerting, these are orthodox pictures when compared with the 1912 *Nativity*, with its great marriage of man and nature. Their Cookham detail is not essentially different from the contemporary surroundings a Florentine painter would have included, and the more urban kind of realism that Spencer was evolving is parallel with the development of Roberts's painting. In *Christ Carrying the Cross* the terrace of foreground figures, the buildings behind with people leaning from the windows, and the fancy hats of the local brewer's draymen all correspond closely to similar ideas in, for instance, the *Christ on the Way to Calvary* of the fourteenth-century painter Andrea da Firenze in Santa Maria Novella; while the figures leaning from the windows, with blowing curtains to add the effect of wings, are like the angels who attend the Crucifixions in works of Giotto or the Lorenzetti.

Spencer's design for *The Last Supper* (no. 41), with its severe brick walls stressing the solemnity of the moment, the changing of bread into flesh, was based on the interior of the Cookham malthouses. The design recalls Donatello's *Feast of Herod* on the font of Siena Cathedral; the space, the table arrangement, and the way each artist in his own medium has picked out the pattern of the brick walls are similar. In Spencer's drawing for the painting the figures, instead of being solemn and still, are relaxing – one of the disciples is fetching a decanter from the sideboard, and the feeling is more that of a feast than of a Last Supper. Just before he went to the war Spencer had been considering making low reliefs in plaster, and eventually in stone, of two pictures, *Zacharias and Elizabeth* (no. 21) and *The Centurion's Servant*.[56] He never carried out these or any other three-dimensional works (Carline, p. 38), but his ambition is interesting because the only sculptor whose name crops up among the many painters he refers to in letters at that time is Donatello, and he had a copy of Hope Rea's book on Donatello (1900) with him in Macedonia.[57]

The persistence of Spencer's interest in the early Italians coincides with a modest increase in his concern for recent French art. He was never an avant-garde painter, and was not interested in stylistic innovation for its own sake, but he was certainly not unaware of what was going on around him. A single apparent reference to the Negro period of Picasso in the right-hand figure on the 'Good' side of the 1915 *The Resurrection of the Good and the Bad* (no. 28) may be a coincidence, but in many of Spencer's post-war pictures there is a new rhythmic quality and interest in surface patterns that are certainly a legacy of Cézanne. The change is most marked in his drawings. Spencer's later pre-war drawings, such as *Joachim among the Shepherds*, were still essentially Pre-Raphaelite, with an arrangement of figures and space recalling, in that instance, Samuel Palmer too. After the war Spencer began to use ink and wash rather than pen alone, which diminished his dependence on outline, and produced some of the best – and most abstract – of his drawings.

Anxious, wandering years for Spencer, when he moved about from Cookham to Bourne End, Steep, Petersfield, Poole and Hampstead, unable to settle anywhere, ended with his marriage to Hilda Carline in 1925. The second half of the twenties was a happy time, not only on account of his marriage, but also because he was working on two projects in which he had complete confidence: *The Resurrection, Cookham* (no. 89) and the paintings for the Sandham Memorial Chapel at Burghclere near Newbury. Both were drawn out in detail in 1923; the first was painted between 1924 and 1926, and the second between 1926 and 1932. The focal subject of both is the Resurrection.

Spencer's first Resurrection was painted under what is now *Apple Gatherers*. Gilbert Spencer recalled that 'it was very dark in colour and tone, and simply handled, showing the central path leading up to the porch at Cookham Church. A number of naked figures had risen from their graves, and were in the air diagonally to and going in between the cypress trees each side of the path.'[58] Spencer's second attempt was the 1915 painting *The Resurrection of the Good and the Bad*, which shares with the 1927 picture the sense that nobody is condemned; both good and bad are called up by angels, although the good come out of grassy tombs amid flowers and seem to enjoy the sunlight, while the bad struggle free with more difficulty, to emerge as regenerated Jonahs from great jaw-like turves.

In 1922 Spencer showed the design for the 1915 picture to friends, including the poet Gordon Bottomley, who greatly admired it.[59] Perhaps encouraged by this, Spencer immediately started planning *The Resurrection, Cookham*. In May 1923 he told Marsh that he had the idea but wanted a literary peg to hang it on, a Dante to illustrate, and was thinking of writing something himself.[60] By November the composition was clear in his mind and even the lighting, a key element in the picture, had been considered.

The scene was Cookham churchyard at 2.45 in the afternoon of a Tuesday in May.[61] In design the only picture

of Spencer's that it looks back to is *Travoys*, with which it shares a kind of outward-pointing fan-shaped design which leads, in the earlier picture, from the encircling travoys in to focus on the operating table, and, here, from the arc-shaped row of tombs round the front of the picture to the figure of Christ, with God the Father behind him, in the porch of the church. As in *Travoys*, the focal point is in the background, and the eye is encouraged to explore a variety of spaces before it rests on the master figures. A similar idea is pursued in the Burghclere *Resurrection*, where Christ is even further in the distance, his presence drawn attention to only by the emptiness of the space surrounding him. Spencer wanted to repeat the sense of peacefulness he had aimed at in *Travoys*, of the dead awakening to freedom from the turmoils of life and standing or lying around enjoying themselves.

The Resurrection, Cookham is Spencer's first painting with nude figures, and this drew him again to the Italian Renaissance. The pose of the kneeling nude of Richard Carline recalls the main figure in Bronzino's *Allegory* in the National Gallery, and a number of figures, not only nude ones, are reminiscent of Michelangelo: indeed Spencer's saints ranged along the church wall remind one as a group of the prophets and sibyls on the Sistine Chapel ceiling. Spencer wanted the painting to have the substantial quality he associated with *Apple Gatherers*, and the figures are certainly different, heavier, more static and less elegant than in the earlier post-war religious pictures. There is an earthy quality to the forms, and especially the colours, that recalls early Gainsborough. *The Resurrection, Cookham* is a very English picture, with almost no concession to the Cézannesque leanings Spencer had been showing.

Spencer does not seem to have written the text he spoke of to Marsh, but he did give the picture a subtitle, with a very nineteenth-century ring to it: 'An Allegory of the Saving of the Black and White Races: the Instinctive and the Intellectual'. This does not appear in the catalogue of the picture's first exhibition, which was at the Goupil Gallery in 1927, and seems to have been first referred to in an interview the director of the Tate, Charles Aitken, gave in 1929:[62] even if Spencer did not intend the subtitle to offer an exclusive interpretation of the picture, it was certainly a part of his plan. His concept of the intellectual is of interest because there is a sub-theme in the picture connected with reading. Spencer set great store by his own very varied reading, and he said that a particular book, Donne's *Sermons*, was an inspiration for this picture. The historical reference to Michelangelo's prophets is an association with figures who are reading; throughout the picture the resurrected are reading their own epitaphs, and in the bottom right-hand corner, where a signature might be expected, Spencer himself is seen lying on a tombstone drawn like an open book. Any reclining figure on top of a

tomb is likely to recall sculptured funerary effigies which, in the eighteenth century – the century to which the design of the two tombs on the left belongs – commonly showed the deceased reading or holding a book; this is of interest because a sculptural idiom, evident largely on account of their pale stone colouring, is common to the holiest of the figures who are grouped round the church at the back.

The Resurrection, Cookham had started to build a reputation for itself before it was finished. The Claridge Gallery offered to pay for the huge frame if it was allowed to exhibit it, and R.H. Wilenski, one of Spencer's main critical supporters, wanted it for the 'Young Artists' exhibition he organised on behalf of the *Daily Express* in June 1927.[63] But Spencer decided to make it the centrepiece of his first one-man exhibition at the Goupil Gallery in February 1927. He liked to stress the continuity of his work and its meaning as a whole, and he therefore preferred his exhibitions to have a retrospective element, as this one did. *The Resurrection, Cookham* was bought soon after the opening by the Joseph Duveen Trustees and presented to the Tate.

The Goupil exhibition gave Spencer his first big press coverage in art magazines. The first articles devoted entirely to his work were by William Gaunt in *Drawing and Design* in March and by John Rothenstein in *Apollo* in April. Charles Marriott of *The Times*, whose comment that *The Centurion's Servant* was the most interesting picture in the November 1915 New English Art Club show had sustained Spencer all through the war,[64] now called *The Resurrection* 'in all probability . . . the most important picture painted by an English artist in the present century'.[65] The *Morning Post*'s critic called it 'one of the most extraordinary paintings of our era';[66] Wilenski, in the *Evening Standard*, described it as 'the most original and important picture painted in England since the war';[67] and Roger Fry, writing in *The Nation* and *Athenaeum*, referred to it as 'a stupendous invention. . . . One cannot restrain one's admiration for the force of conviction. . . .'[68] Fry welcomed the picture as an 'arresting' and 'intriguing' manifestation of a sophisticated taste that was not his own: he called Spencer's literary inspiration an 'alternative art' rather than a 'plastic' one. He did not like the picture, but he recognised its importance and wrote about it generously and at length.

Within a few years an avant-garde mindful of abstraction and other recent developments in Paris was going to need different critical standards. Even now it is not altogether easy to look back across the thirties and appreciate how precisely this strange picture satisfied the taste of its time: it credited the traditions of the Renaissance, it had links with the eighteenth century, which was important in that essentially conservative decade, and

it had a quirkish individuality which has often found favour with English taste.

The Sandham Memorial Chapel at Burghclere (nos. 96–119) was commissioned by Louis and Mary Behrend as a memorial to Mary Behrend's brother, Lieutenant H. W. Sandham, who had died in 1919 from wounds received while he was serving in Macedonia. Spencer had been introduced to the Behrends at the Morrells' in 1914, and now met them again at Henry Lamb's house in Poole. 'I have done a whole architectural scheme of pictures',[69] Spencer wrote to Hilda Carline on 31 May 1923, and on 6 June Lamb wrote to Richard Carline: 'Stanley sits at table all day evolving Salonika and Bristol war compositions.'[70] The Chapel is decorated on the side walls with paintings of Spencer's wartime experiences at the Beaufort Hospital in Bristol, at Tweseldown camp near Aldershot, and in Macedonia. On the east wall is a Resurrection in a Balkan setting, with soldiers rising from the dead and handing to Christ the white crosses that mark their graves.

In rather the same way that Spencer may have gained confidence to paint The Resurrection, Cookham from approval given to a previous version of the subject, so here he had a measure of critical support in advance. In January 1925 Arthur Hind, who must have seen the designs when they were exhibited at the New English in June 1924, wrote that he 'could think of no artistic project of the last few years which shows more promise than this of repaying a patron a hundredfold',[71] and P. G. Konody, reviewing in the Observer the Goupil exhibition, where the designs were also shown, said that 'it promises to be the most remarkable achievement in pictorial decoration ever undertaken by a British artist'.[72] Even when Spencer was in a confident mood, as with The Resurrection, Cookham and Burghclere, he was nevertheless nervous of outside opinion; comments like these must have been heartening.

Burghclere shows Spencer as the most skilled designer of figure compositions among English artists of the period. On the left wall, for instance, the main scenes have identifying shapes that imprint them individually on the memory: the great gates, the pattern of ground sheets, the dugouts. Spencer's concern with ordinary human emotion is very direct: the nervousness of the wounded arriving as the gates are drawn back, the jostling of the crowd in the washroom, the more formal arrangement of the kit inspection where each man makes his personal territorial claim with his possessions laid out on a ground sheet. The predella paintings along the bottom of the side walls are interiors with men engaged in domestic duties, carrying kitbags, sorting washing, shifting tea urns. Soap bubbles, heaped laundry, piles of cut bread and the looming curved ends of two baths bring home the reality of life as it was and not according to any preconception. 'I wish I could do a picture of each different thing I did in hospital, so

wonderful in their difference', Spencer had written to Lamb before he left for the Balkans.[73] Realism in his painting is experience preserved and intensified without thought of conformity to any accepted way of seeing. Mary Chamot has pointed out that one of the reasons so many people find it hard to accept Spencer's paintings is that they magnify reality rather than accommodating themselves to conventions.[74]

Burghclere is a record of youthful, fraternal relationships, of men working together without the supervision of authority (there is only one officer in the Chapel, in Map Reading (no. 116). 'I have avoided any too unpleasant scene . . . because in this scheme, as in all my paintings, I wish to stress my own redemption from all that I have been made to suffer.'[75] The redemptive process is inherent in the fraternal love expressed by the businesslike devotion to a common task, and is further developed on the east wall, where the sacrifice of each soldier, commemorated in his resurrection and the return of his cross to Christ, is emphasised by reference to Christ's sacrifice for the world. The scene remains essentially one of human activity, and, as in The Resurrection, Cookham, the figure of Christ is far from prominent; but his example, nevertheless, is the essential point of reference. Burghclere represents Spencer's self-education in compositions – like Ablutions (no. 106) and Making a Firebelt (no. 118) – that are more complex than anything he had tried before, and provide a basis for his development in the thirties and after.

Burghclere was as great a critical success as The Resurrection, Cookham. Charles Marriott said that 'the century has produced nothing so truly original'.[76] William Rothenstein later wrote: 'To my mind it stands alone as a great imaginative conception. . . a whole which has both the directness and complexity of great art.'[77]

Like The Resurrection, Cookham, Burghclere raises the question of the exact nature of Spencer's Christianity. 'The trouble with us', he had told Bottomley, 'is that we haven't a religion to paint.'[78] People, their mutual love and loyalty, and the special qualities of places were the material out of which Spencer had built a religious art, but at the same time there was a part of him that was searching for orthodoxy. 'My first outdoor anchorage seemed to be the Church. Somehow religion was something to do with me, and I was to do with religion. . . . My early work was, as far as specified religion is concerned, non-denominational, but whatever was the direction, it was utterly believed in.'[79] When working at the Beaufort Hospital he was stimulated by the friendship of Desmond Chute, a Roman Catholic later to become a priest, and in 1918 Stanley wrote to his sister Florence: 'I cannot get rid of the feeling that the Church of Rome is the only Church.'[80] In the thirties he was still holding to the view that 'since the Reformation the loss

of Catholicism meant the loss of knowledge, of perception, of vision, of direction'.[81]

In 1919 the Catholic artist Eric Gill, whom Spencer had met through the Raverats before the war, invited him, encouraged by Chute, to the Dominican priory at Hawkesyard in Staffordshire. The chances of pinning him down to any single religious practice were always slim, and following Gill's initiative Spencer's attitude remained, in the words of his brother Gilbert, 'one of tolerance and respect for all creeds and independence from any denomination'.[82] Spencer acknowledged that he was drawn towards marriage by the break-up of family life in Cookham after the war, but he later found it impossible to submit to the framework of marriage for fear of losing part of his identity; in a similar way he was attracted to the idea of Christianity as an external moral authority, but when faced with actually submitting to it, as he was in 1919, he drew back.

Spencer's preoccupations as a painter were not closely linked with the Catholic tradition. His favourite subject was the Resurrection, not the Resurrection of Christ, but the Resurrection of the body. Spencer's Resurrections are really Last Judgements, but differing essentially from the Catholic tradition in that they have little or no recognition of sin, suffering or damnation. This certainly explains Spencer's mistrust of the title Last Judgement and preference for the term Last Day, which has less connotation of good and evil. Spencer's social background may also have drawn him in a non-Catholic direction: the Spencers as children had been chapel-goers until the chapel in Cookham closed (it is now the Stanley Spencer Gallery), when they joined the higher social stratum of Cookhamites at church. Much of Spencer's work is concerned with the socially unprivileged and, as Wyndham Lewis observed, his Resurrections often 'take place at the lower middle class end of the churchyard'.[83] To describe Spencer as a Protestant painter, however, would be to oversimplify his complex personality and ambitions. His ebullient optimism about man's natural goodness appears shaken in his anxiety-ridden paintings of the late thirties, and if he never completely regained his certainty as an artist after that, it was surely connected with some loss of that faith in his own and other people's capacity to love which was the foundation of his belief.

In December 1931 Spencer moved back to Cookham which he had left despondently in 1921. Burghclere was finished in the summer of 1932 and the opening in December coincided with his election to the Royal Academy. His homecoming must have seemed like a triumph, but it began a period of terrible personal problems, with the break-up of his first marriage and the immediate failure of his second.

Spencer doubted the wisdom of joining the Academy within days of his election,[84] as if once again submission to a framework of rules diminished his individuality. But his decision was surely a right one: Sickert was a member and so was John, whom Spencer particularly admired. Though Spencer was unrivalled there as a composer of imaginative figure compositions, other capable figure painters, Bernard Fleetwood-Walker, L. M. Glasson and J. W. Tucker, were regular exhibitors. Gerald Brockhurst, who like Spencer was interested in early Italian painting, was a member, and the realist Meredith Frampton was shortly to become one; Mark Symons, whose work, though edging towards Surrealism, was related to Spencer's in its association of Christianity with contemporary realism, regularly caught the critics' and the public's attention at the summer exhibitions. Spencer did not show at the Academy in 1933 because he had already promised his new paintings to Dudley Tooth of Arthur Tooth & Sons, who had become his sole agents the previous year. But he took his membership seriously, and in 1934 sent his best new work and gained more press coverage than any other artist including John, Sickert or even Epstein, who was also showing for the first time. Statements such as 'Stanley Spencer's year'[85] and 'Stanley Spencer's Academy'[86] appeared in reviews. This success may have engendered some ill feeling, since when he offered his best pictures again the next year, two of the five were rejected by the hanging committee, and Spencer resigned. There had been crises over the hanging of exhibitions since 1784 when Gainsborough ceased exhibiting there on failing to influence the hanging of his pictures, but the Academy was within its rights, as Spencer knew. The secretary, Walter Lamb, tactfully pointed out that a picture by another academician – in fact it was Sickert's portrait of Beaverbrook – had been rejected that year, but Spencer was not mollified, and vented his anger in the correspondence columns of The Times.[87]

John and Sickert, who were both to resign before long over separate issues, defended Spencer in the press,[88] but his fiercest defender was D. S. MacColl, an early member and champion of the New English Art Club, and a scourge in earlier days of the Academy for its handling of the Chantrey Bequest. 'At a time when any tincture of genius is rare', MacColl wrote, 'he has been admitted for what he was, and had given to last year's exhibition its chief, if disputed, distinction. This year two pictures, no more Spencerian than those accepted, have been thrown out.'[89] Spencer's champions were by no means protagonists of advanced art, MacColl's position in this respect being particularly interesting, since he had recently launched a swingeing attack on Paul Nash's arguments in favour of abstraction.[90]

Spencer's resignation from the Academy was part of a crisis of confidence in himself which public success, far

from alleviating, seemed actually to augment. His marriage had failed and he feared the loss of his artistic vision. Early in 1933 he wrote to Lady Boston, the patron who had paid his fees when he first went to the Slade: 'I think the war did for me all right. . . . As far as there was any possibility of my doing any good as an artist I think the event and all my experience from that time and weakness of character in myself have been fatal in preventing this desirable result.'[91] The point in time to which Spencer attributed this fateful loss of vision varied: sometimes he felt that going to the Slade in the first place had deprived him of the constant contact with Cookham which alone could sustain his vision, and that 'when I left the Slade I entered a kind of Earthly Paradise'.[92] But in April 1915 he had written to Marsh – in what seems to be the earliest contemporary record of his fear – 'something has gone out of me, something I had two years ago that I shall never have again'.[93] More commonly he attributed the loss of vision to war service, as in the letter to Lady Boston, sometimes associating this with the notion that travel of any kind destroyed his concentration. 'I paint what I know, I don't want to run about the world getting impressions of things', he told a reporter in 1932.[94] He commonly fixed in his mind on 1922–3 as the turning point: 'All the painting I was to do from 1922 to 1932 was settled in nearly every detail; ten years of solid bliss was ahead of me. But I knew in 1922–3 that I was changing or losing grip or something.'[95] So that his final view was that in 1932, when the inspiration of ten years earlier had been used up in *The Resurrection, Cookham* and at Burghclere, his loss of vision became apparent.

Spencer had originally turned to art to perpetuate a childhood vision of people and places, an ambition which he never wholly outgrew. He was nervous of adult life and was reluctant to commit himself to permanent relationships. He liked youthfulness in his paintings – most of the soldiers at Burghclere have boyish faces – and he cultivated a boyish appearance in himself (in the way he had his hair cut in a fringe, for instance). It has been argued that the paintings he did up to 1915 are his best, and they do indeed have a compulsive quality, a kind of inevitability. But childhood visions can only thrive by expansion through experience in the way that Spencer's war experience provided the material for Burghclere.

Spencer was over-sensitive to his own moods and too inclined to judge his paintings by his feelings when he painted them. He stood by the belief that the early Italian painters were confident of their vision and therefore did not need to be concerned with technique, and used this conviction to justify the centrality of vision in his own work.[96] In the long run, though, visions can only be the raw material for art, and if after the First World War Spencer did lose something of that absolute certainty

which was a relic of youthful innocence, experience and new technical skills introduced other qualities.

The domestic chores depicted at Burghclere opened up for Spencer the possibility of a more secular type of painting. By 1930 he was married with two children and found that domesticity had acquired a new reality. Sexuality was also becoming, gradually, a governing force in his art, directing it into more secular channels. Burghclere had confirmed Spencer's inclination to work on a big scale. In the second and third editions of *Who's Who in Art* (1929 and 1934) Spencer described himself simply as a mural painter, and the way his election to the Royal Academy in 1932 was reported in the press shows that this is the way he must have been described in the Academy's announcement. Spencer's interest in mural painting was more deeply psychological than can be accounted for in any obvious way, by stressing the links, for instance, between his painting and the traditions of narrative art or the Italian Renaissance in particular. At root it was part of his concern for the coincidence of event and place; just as people fulfilled themselves by association with particular places, so his paintings belonged to special places. In the many lists of his pictures he made in notebooks he usually marked against the title the room of the house, and sometimes even the part of the room, in which the picture was made.[97] He was excited by rooms and the architectural settings of pictures. One notebook has a diagram of all the rooms in the houses in which he lived and stayed;[98] another records a pipe-dream he had just after the First World War of finding a patron who would pay for the construction of individual brick studios in Cookham.[99] The idea of a private enclosed space which he could call his own, in which he could be himself, was very dear to him, and Burghclere was an extension of this on a public scale; it was not a space for him to live in but one for him to exhibit his life in. His intention in the thirties was to extend the potential of Burghclere on a much grander scale.

There can be no question that ten years of work on *The Resurrection, Cookham* and Burghclere exhausted Spencer's imagination. When he was at the Slade Tonks had diagnosed his problem as an overcrowding of ideas,[100] and this was still true. Before finishing Burghclere Spencer was already turning over in his mind ideas for a much bigger project, the Church House (see p. 122). The more secular direction his work had been taking at Burghclere led him to feel that 'there are a vast series of spiritual qualities of feeling that can only be found in a house and not in a church',[101] but he still believed that all his paintings except portraits and landscapes were forms of religious expression, so the ideal architectural setting for it must have a 'church' element. 'I began to feel an analogy between the form of the place in which I wished to express most of what I felt and the form of a church.'[102]

The Church House never became a defined and limited concept even in Spencer's mind, but it was clearly intended to be church-shaped to the extent of having a nave and side aisles, and to have included a series of probably twelve passages leading off the aisles into small rooms that Spencer called cubicles, which broadly correspond in church terms to side chapels. The subject of the painting cycles was to be Cookham and its inhabitants, and the unifying theme was to be God in the world and the propagation of his message of love.[103]

The focus of the main building was to have been a painting of the Pentecost over the chancel arch, painted in such a way that the steps which the apostles would take down from the upper room to spread the word of God through the world would lead them – in architectural terms – to the spaces over the arches of the nave, and – in terms of subject matter – into Cookham High Street; the High Street was conceived as being the nave and each side of the street was represented in the decorations on either side of the nave. The Cookham street scenes, which were started in 1933, and include *Sarah Tubb and the Heavenly Visitors* (no. 142), *St Francis and the Birds* (no. 149) and *The Dustman* (no. 150), did not in fact show the apostles, but other saints and angels performing miracles or simply Cookhamites in a state of grace. The Pentecost, which was a logical way of linking the New Testament and Cookham together, as it represented Christ's authority devolved upon the apostles and the birth of the Church worldwide, was never painted.

With the experience of Burghclere behind him, Spencer was master of complex figure compositions, like *The Dustman*, which he realised in a crisp, draughtsmanlike way. The jug, teapot and cabbage are no more true refuse than the objects that can be deciphered in the dustbins, while the bins themselves, with their precise circular tops, have the same integrity and value as the cylindrical tea urns in one of the Burghclere predellas. The clarity of Spencer's sharply realised vision relates to some of Paul Nash's paintings of the same period, and some of the colours, browns, greys and off-whites, are common to both.

Spencer's human figures in the Church House paintings have assumed an uninhibited bulkiness which has parallels with certain earlier paintings of Gertler and the contemporary work of Roberts. Roberts's urban realist paintings of the twenties, showing figures in bars and cinemas, in bus queues and on park benches, were the closest precedent for Spencer's present realism, and Roberts had also been an occasional religious painter (Augustus John had bought a *Crucifixion* painted in 1919). Though Roberts, like Spencer, had been interested in early Italian painting – and this was one reason for the appeal of fully rounded volumes to both artists in the thirties – elements of caricature are apparent in his work, as they are

not in Spencer's at this point.

Spencer had always been intrigued by the relationship of figures to drapery and all kinds of fabric. He remembered his curiosity as a child at the way blankets affected the shapes of people lying in bed, he enjoyed painting the blankets covering the wounded in *Travoys*, and at Burghclere he obviously liked painting people in bed, in bandages, under a mosquito net and against a mountain of dirty laundry. The soft volumes of his figures in the thirties have parallels in Giotto and the Trecento, but they also represent a curious assumption of a person's immediate surroundings into their figure. The clearest example of this is *St Francis and the Birds*: the saint's squat shape was derived from the whole of an earlier drawing of Spencer's showing Hilda resting against a haystack – figure and ambience together.[104]

Like Roberts, who was shortly to be elected to the Academy also, Spencer was an outsider in an avant-garde art world that was rapidly expanding its links with Paris. Clive Bell, a former supporter of Spencer, wrote in 1935: 'Only with French physic has it been possible to expel the virus of Pre-Raffaelism: painters as able as the Spencer brothers, having failed to shake off the disease, succeed for all their talent in producing nothing of permanent value.'[105] It was a partial judgement, but points rightly to Spencer's withdrawal from his already tenuous links with France. There are closer parallels between Spencer's new work and developments in America and Germany than those in France: in America large-scale mural projects, in which the working man was sometimes a kind of hero, were highly regarded, and the work of some of the artists, notably Thomas Hart Benton and the Mexican Diego Rivera, were illustrated in *The Studio* through the thirties. Spencer's portraits, which reached a high level of accomplishment at that time, and his erotic nudes of 1936–7 have parallels with the German artists of the Neue Sachlichkeit movement.

The second part of the Church House scheme, begun in 1935, was a *Marriage at Cana*, commemorating an imaginary wedding in Cookham and symbolising the physical and spiritual aspects of marriage as the central sacrament of life. The plan was to show domestic preparations for the wedding, progress to the wedding through Cookham, the ceremony itself, and the wedding guests' return home, now all with children, since the scheme was a metaphor in which one day stood for the span of life.

The coincidence of Spencer's painting the *Marriage at Cana* sequence at the time of his separation from Hilda late in 1933 and the subsequent divorce proceedings leading to his second marriage, to Patricia Preece, in 1937, seems ironical. But Spencer was reluctantly persuaded that divorce was a practical solution to an impossible day-to-day situation, and a means of marrying Patricia, which he did

not intend should represent a final break with Hilda. 'All things for me to love them seemed to have to be memorials',[106] Spencer said in a different context; but it was true of his relationship with Hilda, and his being relieved of the pressure of living all the time with her (or any other woman, as it turned out) gave their relationship a new life: he wrote to her, visited her, planned to remarry her, cared for her when she was dying, and continued to write to her after her death. He told Dudley Tooth in 1942 that Hilda would be the only person other than himself to feature in his autobiography, because she was the only other person in his life.[107] He needed Patricia because he envied her social standing and her contacts with Bloomsbury. They had met in Cookham in 1929; it may have been she who arranged for Duncan Grant and Vanessa Bell to visit Burghclere to see the murals in 1930, and as late as 1942 she was exhibiting with them and other Bloomsbury artists in an exhibition organised by the Council for the Encouragement of Music and the Arts. Spencer hoped that divorce would allow him to be married in effect to two women; in this he was wrong, not because he altogether lost Hilda, but because his marriage to Patricia was based on a shallow relationship.

The third main section of the Church House scheme, begun in 1936, were *Adorations* and paintings of couples which he called *The Beatitudes of Love* (see p. 166). The *Marriage at Cana* had been intended for the side aisles; these, which represented the most secular part of the scheme, were presumably destined for the cubicles. They mark a striking change in Spencer's art in 1936–8. *Love Among the Nations* (no. 155) of 1935–6, a sensual painting from an earlier part of the scheme, had been a happy extrovert painting with a distinctive Brueghel-like rhythm and references in the figure designs to other artists in whom Spencer was interested – Dali, Lewis, Cézanne – which affirm the outward-looking character of the painting. The ironically titled *Beatitudes*, on the other hand, are introverted; they are partly self-portraits, and the misery they express is apparent. Uncharacteristically devoid of location with their plain dark backgrounds, they represent not only Spencer's sense of himself as a victim of women, but his homelessness; the essential reciprocity of person and place has disappeared, leaving Spencer in limbo. Eric Newton, reviewing two of Spencer's *Adorations*, spoke for the *Beatitudes* as well when he discerned a 'profound unhappiness behind them. . . . A few years ago Spencer painted like some bucolic saint. But these recent paintings are disillusioned. Spencer has turned his mind earthwards, and though it is still child-like it is no longer tranquil. He sees man no longer made in God's image. The village of Cookham is no longer his earthly paradise.'[108]

Individual paintings for the Church House scheme are among Spencer's best, but as a project it was a failure.

Spencer lamented the absence of a patron like the Behrends; he realised that the whole project was 'far too big unless I could devote the whole of my time to it';[109] and, because he was under great financial pressure, he not only had to paint landscapes and portraits, but had to let Tooth have Church House compositions as well for exhibition and sale. 'My difficulty in the thirties', he said later, 'was not that I had no more to say, but that I was not ready to say it.'[110] Spencer worked best at his own pace and was incapable of juggling with the different pressures that bore in on him – artistic, marital and financial.

But the other difference from the twenties was that the Church House scheme was never fully prefigured in his mind as Burghclere had been. The project was much bigger than Burghclere, and there was no unifying experience to support it in the way that the war had provided all the material for Burghclere. Spencer suffered from the lack of self-discipline he mentioned in his letter to Lady Boston and he seems to have found it curiously difficult from now on, not only to finish a project, but even to complete its keystone; *Pentecost* was never even started; in the war-time shipbuilders series the centrepiece, *Furnaces* (no. 224), was rushed through at the end of the project under pressure from the War Artists' Advisory Committee, and was smaller than had been anticipated; the two focal designs of the revived Church House project in the fifties, *The Apotheosis of Hilda* and *Christ Preaching at Cookham Regatta* (no. 279), were both left unfinished. But despite his problems in the thirties Spencer had daemonic energy, and it should not be assumed that he could not have completed the Church House if he had had time and the stimulus of a commission.

Spencer's commonest lament in the thirties was that he was forced by financial pressures to paint landscapes which were saleable, and that the public was insensitive in wanting them in preference to his figure compositions. In the twenties and early thirties he was averaging around six landscapes a year; suddenly the figure rocketed in the late thirties, when financial pressures on him were at their height, and after 1939, when he was working on commissions from the War Artists' Advisory Committee, the number fell to its earlier level.[111] In a list made in 1942 – which may not be completely accurate – he recorded that of the twenty-five public galleries at home and abroad that owned thirty-three of his works, only the Tate and the municipal galleries at Leeds, Manchester and Belfast owned figure paintings; three of the other paintings were portraits and the remainder landscapes.[112] Spencer painted his landscapes in front of the subject with a painstaking care which, though the paint is generally only one layer deep in the mature works, must have taken a considerable time. He easily got bored: 'When for one or two or five or seven weeks I stand on one patch of ground I begin to feel

something of what a post in the ground just by me feels.'[113] But his grumbles about landscape painting belong to the thirties, when he was overwhelmed by financial need. His friend and fellow painter, the Slade School teacher George Charlton, with whom he stayed in Gloucestershire for long periods in 1939–41, has affirmed that Spencer enjoyed doing landscapes,[114] and Spencer himself recognised that it kept him in touch with reality: 'My landscape painting has enabled me to keep my bearings. It has been my contact with the world, my soundings taken, my plumb line dropped.'[115] As with his figure designs, Spencer felt with his landscapes that his mood at the time contributed to the character of the painting. He thought *Tree and Chicken Coops, Wangford*, belonging to Marsh, successful because 'I was reading old English ballads at the time and feeling a new and personal value in the Englishness of England';[116] and he felt that the success of a landscape William Rothenstein owned related to his having 'just been looking at the big Rubens in the National Gallery [the *Château de Steen*?] and thinking how blissfully happy it was, and came away feeling inspired'.[117]

Spencer left Cookham in October 1938, as he had left in 1921, in a mood of depression. He spent the winter living alone in London, where he began the *Christ in the Wilderness* series (nos. 194–201). Though he conceived them as potentially fitting into the covings of a church roof, they are the first figure paintings since Burghclere that were not part of the Church House project. The figures of Christ are at ease, absorbing their natural environment in the leisurely way the resurrected in the 1927 painting had gazed about the churchyard. The images of Christ watching and touching each animal speak for Spencer's belief in the sanctity of all life. These pictures, for which Spencer claimed the inspiration of Thoreau's *Walden*,[118] obviously refer to Spencer's own life at the time, and though a barely furnished room near Swiss Cottage bore no obvious resemblance to an isolated shack by a lake in Massachusetts the idea of recovering emotional vitality through a retreat into introversion is a link between Spencer and Thoreau and the subject of these pictures.

The second stage of Spencer's recovery was the series of commissions he was given by the War Artists' Advisory Committee of the Ministry of Information. Dudley Tooth, who was often the only person to exhibit practical sense in the management of Spencer's affairs, approached the chairman of the committee, Kenneth Clark: 'I am sure he will prove amenable to work with as he is terribly in debt all round.'[119] Spencer's imagination ran to a confusion of religion and current events, a huge crucifixion with scenes such as the Nazis overrunning Poland. It was impressed upon him that the committee's brief was documentary, as the equivalent body's in the First World War had been,

and Spencer was pleased with the idea of painting shipbuilders. Indeed when he reached Lithgow's yard at Port Glasgow in May 1940 he became very excited ('I hardly know how to tear myself away', he wrote to the secretary of the committee),[120] because he found in the shipyards the same camaraderie, confidence in common purpose and human warmth that he had felt at the Beaufort Hospital and in Macedonia. War again provided him with a structure and meaning to daily life that he found it difficult to build for himself. 'People generally make a home for themselves wherever they are and whatever their work, which enables the important human element to reach into and pervade in the form of mysterious atmospheres of a personal kind the most ordinary procedures of work and place. Many of the places and corners of Lithgow's yard moved me in much the same way as I was by the rooms of my childhood.'[121] Being at ease seems to have been associated with childhood and youth and, as with the soldiers depicted at Burghclere, the youthfulness of the shipyard workers was one of the things that impressed him. He spoke of 'the riveters with their extremely youthful and never to be forgotten assistants', and the burners, 'youths about sixteen to twenty years of age who can draw chalk lines in sheets of steel with an assurance that tells me what artists they could be'.[122]

In the first pictures that Spencer delivered in 1940–1, *Burners* (no. 216), *Riveters* (no. 219) and *Welders* (no. 218), a feeling of busy preoccupation, characteristic of the Burghclere designs, emerges from the figures of the working men. They sprawl around like some of the contemporary *Christ in the Wilderness* portraits, in whatever position is most comfortable for their occupation. Following his scheme at Burghclere Spencer related adjacent compositions in terms of composition: *Burners* is like the earlier *Kit Inspection* (no. 108), with figures seen from a high viewpoint against flat, rather abstract shapes, in this case the sheets of metal they are cutting, while in *Riveters*, beside it, a theme of flatness is exchanged for preoccupation with the volume of the great iron cylinders, and there is greater depth of space.

Though the shipbuilding series was not finished till 1946, by 1943–4 Spencer's mind had begun to wander back towards his favourite subject of the twenties, the Resurrection. Between 1945 and 1950 he painted nine big paintings on the Resurrection theme, of which the centrepiece is *The Resurrection, Port Glasgow* (no. 242). The idea of a return to the subject had been in his mind at least since 1936, when he had written that his 'next Resurrection would not simply occur in a graveyard as it would be natural to suppose, just anywhere in the street, out of the gutters. A lady magnificently altered would push the lid off a manhole and step out, some would come up from under the drawing room carpet or the floorboards of the

kitchen.'[123] When staying in Gloucestershire in 1940 Spencer made two drawings which became designs of the side panels of one of the Resurrection triptychs, *The Resurrection with the Raising of Jairus's Daughter* (no. 241). The left side was inspired by a street in Stonehouse, the raised paving stones – bearing a strong resemblance to the lifted tomblids in *The Resurrection* attributed to Fra Angelico in San Marco at Florence – pushed aside in very much the way he had predicted in 1936.

Spencer recalled how he was inspired to take up the theme and make the centrepiece a Scottish subject: 'One evening in Port Glasgow, when unable to write due to a jazz band playing in the drawing room below me, I walked up the road past the gas works to where I saw a cemetery on a gently rising slope. . . . I seemed then to see that it rose in the midst of a great plain and that all in the plain were resurrecting and moving towards it. . . . I knew then that the Resurrection would be directed from this hill.'[124] Spencer's moving description calls to mind a crowded hillside outside a city as in Van Eyck's *Adoration of the Lamb* in the Ghent Altarpiece, and there are features of Spencer's *Resurrection* that were probably inspired by the Van Eyck painting.

When Spencer's new set of Resurrections was exhibited in 1950, partly at the Royal Academy and partly at Tooth's, there was more adverse criticism than usual, aimed mainly at technical weaknesses of colour, texture and drawing. Wyndham Lewis, who had spoken appreciatively of Spencer before,[125] asserted now that Spencer 'inhabits a different world from the potboiler; he has a visionary gift after all'. But Lewis was critical, and identified a basic fault of the series when he said: 'His painting is endlessly repetitive. One feels he could turn out a thousand figures as easily as a hundred, it would take him ten times as long, that is all.'[126] There is something mechanical about the series, a feeling that each picture is merely a variant of the others. The Church House pictures had given the opposite impression: each seems such an individual creation obedient both as subject and composition to its own laws that it is not easy to conceive of the whole working as a set. The Resurrections are nothing if not a set – the only set, in fact, that Spencer completed after Burghclere – but, with the exception of *The Raising of Jairus's Daughter*, they seem to lack individuality.

In 1942 Spencer returned to Cookham after an absence of four years, living at first in lodgings and spending much of his time in Glasgow, and then in 1945 moving to a house at Cookham Rise about a mile from the old village centre, where he lived until he returned finally to 'Fernlea', his childhood home in the High Street. Hilda died in 1950, and his separation from Patricia was formalised in the same year. Spencer rebuffed an attempt at reconciliation on the part of the Royal Academy, probably in 1942,[127] but was re-elected in 1950 as a result of what seems to have been his own initiative, and was generously allowed the seniority that he would have had if he had not resigned. In the post-war years he had, as always, a secure relationship with Tooth's and, though not wealthy, was free from money worries.

In 1943 the critic Jan Gordon wrote: 'Fifteen years ago Stanley Spencer was still being lauded by the highest brows in London; today much of that approval has been withdrawn.'[128] With abstraction out of favour in the forties, and religion in its widest sense again becoming an inspiration for art, Spencer might be expected to have regained some of his lost prestige. His early pictures, especially, with their pantheist impulse, were in accord with the spiritual values of the forties, but, with the exception of *The Nativity* at the Slade, these were all hidden from view in private collections until the Tate bought the 1911 drawing *Man Goeth to his Long Home* (no. 7) in 1945 and was given *Apple Gatherers* by Marsh in 1946 (the Tate had been given *Christ Carrying the Cross* (no. 45) and *The Resurrection, Cookham* in the twenties, and had since bought Spencer's work dutifully but with caution). Attention was drawn to his almost forgotten early works by two new monographs, Elizabeth Rothenstein's in 1945 and Eric Newton's in 1947, the first since Wilenski's of 1924. Robin Ironside, a leader of the Pre-Raphaelite revival in the forties and therefore naturally interested in Spencer, was the first person to put in print what the artist had been saying for some time, that his best work was done before 1921.[129] It is not surprising that this, the hardiest myth about Spencer, which elevates vision above skill, should have been established in the period of Neo-Romanticism. It was in his chapter on this movement that Ironside placed Spencer, but, apart from noting the quality of his early work, he had curiously little to say about him. Though there were certain painters, Francis Bacon, Lucian Freud and John Minton, for example, who saw the importance of Spencer, his new work was for the most part too secular for the Neo-Romantic impulse.

There is a great difference between the English writers on Spencer in the forties, working in the isolated conditions of the war and its aftermath, and the contemporary writing of James Thrall Soby in New York, where art activities were far less restricted. Soby's 1948 essay,[130] probably the most perceptive piece of writing on Spencer in his lifetime, was written shortly after his monograph on Giorgio de Chirico published in connection with an exhibition at the Museum of Modern Art, and is marked by an awareness of the Symbolist residue in early modern painting which a writer confined to England would have had difficulty sharing.

After 1950 Spencer was able to look back with a certain dispassion on 'all the varied mental journeys I have made

since 1932. . . . It has been an interesting and lonely furrow I have ploughed and a lot of somewhat freakish stuff has grown from it'.[131] Though Spencer had not lost his old fire, a quality of reflection and nostalgia is sometimes perceptible. In 1951 he reverted to his plans for the Church House, stressing the continuity of the new work with the earlier. Though *Christ Preaching at Cookham Regatta* was conceived as belonging to the new river-aisle of the Church House, the real connection with the thirties is tenuous; he was adding to, but not reconsidering, earlier ideas.

Christ Preaching at Cookham Regatta was based, Spencer said, on the idea of 'Christ preaching from the Lake of Gennesareth. As far as the fact of Christ having gotten himself into a boat in order to teach the people therefrom because of the press of the people on the bank, it keeps to the story, but after that it becomes my story, which is Christ in this world and expressing his love for it.'[132] The descriptions in Spencer's letters of his progress with the drawings show how vividly the memories of the regattas of his childhood flowed back into his mind; he remembered the traditions, the social nuances – which intrigued him particularly – even the characteristic mannerisms and language of the well-to-do Cookhamites. Though conceived as a religious work, the painting shows religion in a secular context. 'Why do I want the subject presented in this way? Because Christ was very much in this world and was made flesh and dwelt among us. You can't have anything more in the world than Cookham Regatta.'[133]

Spencer's capacity to spring a sudden surprise stayed with him to the end. In 1958 he was commissioned to paint a *Crucifixion* for the chapel of Aldenham School (no. 276). Inspired by the laying of main drains, which left a pile of rubble in Cookham High Street, Spencer envisaged a Calvary with Christ seen from the back and the focus on the thieves, who are placed to form a small circle with Christ and therefore face the spectator. The painting could hardly be more different from the calm Balkan *Crucifixion* (no. 65) of 1921, Spencer's only previous treatment of the subject. His drawing of the vituperation of the malefactor who thrusts himself forward to torment Christ, and the brutishness of the labourer who, with nails in his mouth like sharp teeth, swings his mallet to drive the nail through Christ's hand so hard that the force lifts him off the ground, is astonishing. Nowhere else is Spencer prepared to look evil so squarely in the face.

At the time of his death in 1959 Spencer was far outside any mainstream developments in British art. The writers who helped to sustain his reputation with an appreciative public pictured him, with justice, as a dedicated religious eccentric expressing a vision of universal brotherhood through love; few remembered that Spencer had had a successful, conventional art education, had made a widely respected contribution to English art before the First World War, and had gone on from there to receive the unstinted praise of critics in the twenties. As Spencer increasingly withdrew into himself, his name was frequently linked with those of other outsiders in the history of English art, and most aptly with that of Blake.

Spencer shared with Blake a fervent belief in the primacy of imagination, a dislike of authority, a mistrust of reason, a conviction that 'All Religions are One',[134] and a search – in the Church House especially – for a personal mythology such as Blake had evolved in the Prophetic Books. Like Blake he believed that 'energy is the only life and is from the body';[135] he endorsed sexual freedom, and the virtue of the whole man, his sinfulness notwithstanding. Spencer can be approached closer still through historical parallels by considering, in addition, certain aspects of Whitman's faith: both believed in the sanctity of all material things, both were sensualists and valued the body to an almost narcissistic degree as a medium through which to experience the world. A sense of the wholeness and inclusiveness of creation is common to both (Whitman was as attracted to the garbage floating on the East River as he ferried from Brooklyn as Spencer was to the post-Bank Holiday litter on Hampstead Heath). *The Leaves of Grass*, like the Church House, was an attempt to encapsulate a life's work and experience within a single artistic framework.

The picture of Spencer drawn by writers who knew him only later in his life, as an isolated spiritual phenomenon emerging from a nebulously conceived English tradition, though not altogether without foundation – Spencer was in his nature an imaginative, single-minded individualist – neglects the peculiar character of the period in which Spencer grew up: the period of first release from Victorian orthodoxies about family and religion, when human instincts gradually ceased to be subjects of fear, religion was experienced as revelation as well as imposed as dogma, and sexuality was not only studied as science but began to be regarded by men like Edward Carpenter and Havelock Ellis as a creative and moral force. It was also a period when Blake's reputation was steadily rising and Whitman's prestige in England was phenomenal. There is an element of genius about Spencer which is not diminished by admitting his historical context.

NOTES

Reference numbers refer to the Tate Gallery archive
except where otherwise specified.
The dates of manuscripts, either autographed or ascribed,
are given in brackets.

1. 733.3.21 (1939).
2. 733.3.21 (1939).
3. 733.2.52 (1936).

4. 733.2.87 (1941).
5. 733.3.21 (1939).
6. Quoted in Richard Carline, *Stanley Spencer at War*,
Faber 1978, pp. 29–30.
7. See Maurice Collis, *Stanley Spencer. A Biography*,
Harvill 1962, p. 35.
8. 733.2.41 (1935).
9. Carline, op. cit. p. 30.
10. 733.2.57.
11. Mentioned in a letter from Stanley to Sydney Spencer,
18 May 1911.
12. 733.3.21 (1939).
13. 733.2.85 (1941).
14. R. Gathorne-Hardy (ed.), *Ottoline. The Memoirs of
Lady Ottoline Morrell*, Faber 1963, p. 252.
15. Stanley Spencer to Christopher Hassall,
letter of 8 April 1954. 733.1.669.
16. 733.2.75 (1942).
17. 733.2.85 (1941).
18. On this subject see Michael Levey.
'Botticelli and Nineteenth-Century England',
Journal of the Warburg and Courtauld Institutes, vol. 23, 1960.
19. *Art in My Time*, Rich and Cowan 1933, pp. 130–1.
20. *Fortnightly Review*, January 1911, reprinted in
A Free House . . . the Writings of W. R. Sickert,
ed. Osbert Sitwell, Macmillan 1947, p. 106.
21. Wyndham Lewis, *Rude Assignment*, Hutchinson 1950, p. 105.
22. *Outline. An Autobiography and Other Writings*,
Faber 1949, p. 90.
23. 733.2.46 (c. 1936), and see Sir Edward Beddington-Behrens,
Look Back, Look Forward, Macmillan 1963, p. 92.
24. 733.2.46 (c. 1936).
25. Clive Bell, *Potboilers*, Chatto 1918, pp. 199, 228.
26. See Michael Holroyd, *Augustus John. The Years of Innocence*,
Heinemann 1974, p. 266.
27. *Poet and Painter. Being the Correspondence between
Gordon Bottomley and Paul Nash 1910–1946*,
ed. C. C. Abbott and A. Bertram,
Oxford University Press 1955, p. 154.
28. Letter of 26 March 1913, quoted in Christopher Hassall,
Edward Marsh, Patron of the Arts, Longmans 1959, p. 244.
29. 'Art', 1914, in *The Collected Works of Isaac Rosenberg*,
ed. Ian Parsons, Chatto, 1979 edition, p. 297.
30. In the *Cambridge Magazine*, 23 November 1912, reprinted
in *The Prose of Rupert Brooke*, ed. Christopher Hassall,
Sidgwick & Jackson 1956, p. 190.
31. *Rhythm* vol. 1 no. 1, summer 1911.
32. Letter to Gwen Raverat, in *The Letters of Rupert Brooke*,
ed. Geoffrey Keynes, Faber 1968, pp. 418–19.
33. 733.1.669 (1954).
34. Letter to Christopher Hassall c. 1954, 733.1.671; and see
a second letter to Hassall of 15 January 1958, 733.1.670.
35. Letter to Christopher Hassall 8 April 1954, 733.1.669.
36. 31 May 1914.
37. In the *New Age*, 28 May 1914.
38. See letters to Henry Lamb of c. October 1913, TAM 15a 1/52;
undated (but wartime), TAM 15a 4/52; and 27 May 1915,
TAM 15a 28/52.
39. 733.3.21 (1935).
40. 733.2.290 (? 1947).
41. 733.3.1. (1937) and 733.3.21. (1939).
42. Frank Rutter in the *Sunday Times*, 27 February 1927,
and in the *Christian Science Monitor*, 21 March 1927,
and a draft reply (probably not sent) from Spencer
to the *Christian Science Monitor*.
43. 733.3.1. (December 1937).
44. 733.1.182 (1956).
45. 733.2.44. (? 1936).
46. Ibid.
47. 733.3.10. (1938–43).
48. Imperial War Museum file 290/7.
49. Stanley Spencer to Florence Image, letter of 16 May 1918.
50. 733.3.1. (December 1937).
51. Ibid.
52. *Stanley Spencer by his Brother Gilbert*,
Gollancz 1961, p. 153.
53. 733.2.128 (11 July 1942).
54. 733.3.16 (1939–41).
55. 733.2.271 (September–October 1944).
56. Letters to Henry Lamb of 27 April 1914, TAM 15a 6/52,
and undated (but 1914-5), TAM 15a 29/52.
57. Letter to Henry Lamb 17 July 1917, TAM 15a 1/52.
58. *Stanley Spencer by his Brother Gilbert*, op. cit. p. 153.
59. *Poet and Painter*, op. cit. p. 151.
60. Hassall, *Edward Marsh*, op. cit. p. 504.
61. Ibid.
62. *Daily Mail*, 7 February 1929.
63. 733.1.206a.
64. *The Times*, 30 November 1915, and see Stanley Spencer
to Sir William Rothenstein, undated letter, 733.1.1344a.
65. 28 February 1927.
66. 25 February 1927.
67. 25 February 1927.
68. 12 March 1927.
69. Quoted in Carline, op. cit. p. 145.
70. Ibid.
71. Arthur Hind, 'Some Remarks on Recent English Painting',
Studio, January 1925.
72. 6 March 1927.
73. Spencer to Henry Lamb, undated letter
(c. midsummer 1916), TAM 15a 29/52.
74. *Modern Painting in England*, Country Life, 1937, p. 72.
75. 733.2.26. (1936).
76. *The Times*, 17 December 1932.
77. *Since Fifty. Men and Memories 1928–38. Recollections of
Sir William Rothenstein*, Faber 1939, p. 96.
78. Gordon Bottomley to Sir William Rothenstein, letter of
4 June 1934, quoted in *Since Fifty*, op. cit. p. 216.
79. Quoted in Carline, op. cit. p. 111.
80. Letter of 22 October 1918, 756.46.
81. 733.2.7. (c. 1932–7).
82. *Stanley Spencer by his Brother Gilbert*, op. cit. p. 160.
83. *The Listener*, 18 May 1950.
84. Reported in *The Evening News*, 6 December 1932.
85. *The Times*, 5 May 1934, and the *Saturday Review*,
12 May 1934.
86. *New Statesman*, 12 May 1934.
87. 26 and 27 April 1935.
88. Sickert in the *Daily Telegraph*, letter dated
27 April 1935, and John in *The Times* of 15 May 1935.
89. 'Super- and Sub-Realism: Mr Stanley Spencer and
the Academy', *The Nineteenth Century and After*, June 1935.
90. *The Listener*, 17 February 1932, and subsequent issues.
91. Letter of 2 January 1933, 733.2.165.
92. *Since Fifty*, op. cit. p. 96.
93. Letter of early April 1915, quoted in Hassall,
Edward Marsh, op. cit. p. 345.
94. *Evening News*, 6 December 1932.
95. In the artist's preface to *Stanley Spencer*,
Tate Gallery exhibition catalogue, 1955.
96. 733.2.290 (? 1947), quoting a letter to Hilda Carline
of 1923.
97. 733.2.3 (11 November 1947).
98. 733.2.3 (11 November 1947).
99. Quoted in Carline, op. cit. p. 116.
100. Letter from Henry Tonks to Selwyn Image, reported in
Stanley Spencer by his Brother Gilbert, op. cit. p. 31.
101. 733.3.6 (? January 1938).

102. Ibid.

103. Ibid.

104. The drawing was reproduced in the Chatto & Windus Almanac for 1927.

105. 'What Next in Art?', *Studio*, April 1935.

106. 733.2.128 (11 July 1942).

107. 733.2.62 (30 July 1942).

108. *Sunday Times*, 19 December 1937.

109. Preface to Tate Gallery exh. cat., op. cit.

110. 733.2.368 (15 January 1948).

111. 733.2.3 (11 November 1947).

112. 733.2.123 (*c.* 26 November 1942).

113. 733.2.258 (July 1944).

114. Letter to *The Times Literary Supplement*, 21 April 1972.

115. 733.2.258 (July 1944).

116. Hassall, *Edward Marsh*, op. cit. p. 567.

117. *Since Fifty*, op. cit. p. 97.

118. Letter to Richard Smart of Arthur Tooth & Sons, 733.2.60 (1941).

119. Letter of 25 December 1939, Imperial War Museum file GP 55/31a.

120. Letter of 15 May 1940. Ibid.

121. Letter to the Secretary of the War Artists' Advisory Committee, received 1 June 1940. Ibid.

122. 733.2.45 (1940).

123. 733.2.49 (1936).

124. *Stanley Spencer. Resurrection Pictures 1945–50*, intro. R.H. Wilenski, Faber 1951, p. 3.

125. 'Super-nature versus super-real', in *Wyndham Lewis the Artist, from 'Blast' to Burlington House*, Laidlaw 1939.

126. *The Listener*, 18 May 1950.

127. 733.2.151 (? 1942).

128. 'Stanley Spencer', *Studio*, July 1943.

129. *Painting since 1939*, British Council 1946, p. 158.

130. In *Contemporary Painters*, Museum of Modern Art, New York, 1948.

131. Letter to Charlotte Murray, 16 January 1948, 733.2.369.

132. Letter to Daphne Robinson, 7 November 1952, 733.1.1265.

133. Letter to Daphne Robinson, 20 December 1951, 733.1.1249.

134. Title of a Tract by Blake, 1788.

135. From *The Marriage of Heaven and Hell*, 1790–3.

1 The Early Years 1907–1915

Stanley Spencer's interest in art, which he shared with his younger brother Gilbert, was probably first aroused by the usual assortment of late Victorian prints which hung on the walls of the family home, 'Fernlea'. These included Millais's *Ophelia* and *Cherry Ripe*, Rossetti's *Annunciation*, which hung in the bedroom, and several others by unknown artists, with names like *The Bengal Lancer* and *A Sailor and his Lass*. Perhaps more significant were three landscapes of the Cookham neighbourhood by a local amateur artist, William Bailey, which hung in the dining room. The boys soon got to know Bailey, and it was his daughter Dorothy who gave Spencer and Gilbert their first painting lessons. Spencer was also attracted by the work of book illustrators and he told Gilbert that he would like to draw like Arthur Rackham (G. Spencer, p. 52). These influences can still be seen in *The Fairy on the Waterlily Leaf* (no. 1), drawn in 1910 as an illustration to a local writer's fairy tale. Regular readings from the Bible prescribed by his mother also gave Spencer a familiarity with both the Old and New Testaments, which, when combined with his love of Cookham, was to form the basis of his art for the rest of his life.

At the Slade he joined a talented group of future artists including David Bomberg, C. R. W. Nevinson, Paul Nash, Mark Gertler and Edward Wadsworth, all of whom were to establish important reputations in later years. They were taught by Henry Tonks, one of the finest teachers of the day, whose emphasis on excellent draughtsmanship was to have a lasting influence on Spencer's working methods. In the drawing classes he rapidly acquired a proficiency in a style which owed much to the Pre-Raphaelites and old master drawings. This is particularly evident in the drawings which he made for the Slade Sketch Club, like *The Last Day* (no. 2) and *David and Bathsheba* (no. 13).

In between the drawing classes Spencer taught himself to paint, working mainly at home in Cookham, to which he returned every evening. His first surviving painting, *Two Girls and a Beehive* 1910 (no. 3), shows a tentative, unformed style and dark palette, yet contains most of the principal themes which were to dominate his painting over the next few years. Spencer's experience and skill expanded rapidly through a study of the early Italian and Flemish painters both in reproduction and in exhibitions like the Grafton Galleries' exhibition of old masters held in aid of the National Art-Collections Fund in 1911, which included works attributed to Duccio, Masaccio, Gozzoli and Signorelli.

In the meantime Spencer's painting developed rapidly and *John Donne Arriving in Heaven* 1911 (no. 8) shows a greater control of the medium, together with a more than passing reference to contemporary art as it was practised by the young painters at the Slade. It was chosen by Clive Bell for his Second Post-Impressionist Exhibition, in late 1912. Spencer, however, remained on the fringe of the contemporary art factions, refusing to be identified with any particular style and clinging to his own intensely personal vision of the Bible and Cookham. Only in *Apple Gatherers* 1912–13 (no. 15) is the influence of Impressionism briefly apparent in Spencer's art, probably because of his new friendship with Henry Lamb, an artist six years his senior and a founder member of the Camden Town Group. Lamb had studied Gauguin in France and his enthusiasm was passed on to Spencer.

In 1912 Spencer's career at the Slade reached its peak when he was awarded the Melville Nettleship Prize and the Composition Prize for *The Nativity* 1912 (no. 10), which is set in Cookham, and shows a return to the detailed realism of Pre-Raphaelite painting; Spencer's reputation was growing.

When Spencer left the Slade in 1912 he lived at home, painting in a succession of temporary studios including the disused 'Ship' cottage and the barn at Ovey's farm across the road from 'Fernlea'. The period was one of intense pleasure for Spencer, who produced a series of outstanding works including *The Centurion's Servant* 1914 (no. 25), which was bought by Lamb, and *Zacharias and Elizabeth* 1914 (no. 21). Writing about the years 1912–15 some time later the artist recalled: 'When I left the Slade and went back to Cookham I entered a kind of earthly paradise. Everything seemed fresh and to belong to the morning. My ideas were beginning to unfold in fine order when along comes the war and smashes everything' (Robinson, p. 20). In later life he was to use these pre-war paintings as the touchstone by which he judged his work.

1 The Fairy on the Waterlily Leaf

c. 1909
Pen and ink
41.9 × 30.5 cm/16½ × 12 ins
Lent by the Stanley Spencer Gallery, Cookham

Spencer gave this drawing to a boyhood friend, Ruth Lowy (later Lady Gollancz), as a wedding present on 22 July 1919.

It is usually thought that the drawing was a Slade Sketch Club subject, but it is not mentioned in the list which Spencer later made of compositions done at the School (Tate 733.2.164). When Lady Gollancz asked him to identify the story, he replied 'I do not know that my picture is called anything. The lady on the waterlily leaf is a fairy if you please, and of course the boy on the bank is Edmunds, but honestly I do not know what the picture is all about' (Quoted by Victor Gollancz, *Reminiscences of Affection*, London, 1968, p. 110). Edmunds was a model who posed at the Slade. What Spencer omitted to tell Lady Gollancz was that the drawing was produced *c*. 1909, 'for a Miss White of Bourne End', who had asked him to illustrate a fairy-tale she had written. The drawing was rejected because 'the figure of the girl was too hefty' (notes probably made in the forties, Tate 733.3.45). As Richard Carline has pointed out (p. 27), the model for the principal figure was his ample cousin Dorothy Wooster, who also appears in *Two Girls and a Beehive* 1910 (no. 3).

EXHIBITIONS
National Gallery, *Twentieth Century British Paintings*, 1940
Leeds, 1947 (85)
Worthing, 1961 (1)
Plymouth, 1963 (58)
Arts Council, 1976–7 (52), repr.
West Surrey College of Art and Design, Farnham, *Sir Stanley Spencer*, 1977 (31)

REFERENCES
E. Rothenstein, 1945, pl. 1
Carline, p. 27
Robinson, 1979, p. 11, pl. 4

1

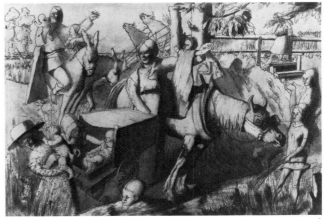

2

2 The Last Day

c. 1909
Pen and wash
40.6 × 58.4 cm/16 × 23 ins
From the collection of the late W. A. Evill

In this drawing Spencer visualised the world at the moment of its final dissolution with the coming of Christ over Cliveden Woods, of which the two cows have the first intimation. In the foreground a mother steadies her child on the back of a cart-horse, the infant's outstretched hands revealing the stigmata as he looks towards the eastern sky. Round about them the events of everyday life continue as usual.

Spencer's strong feeling for nature and a sense of place heightened by memory were important ingredients in all his figure paintings. The deep-seated and poetic nature of these feelings is apparent in his commentary on the drawing written in 1944: 'The eastern aspect of Cookham had a look of great promise. Hearing the crowing in the early morning, my thoughts would veer to the sky above Cliveden Woods. Whatever the sky happened to be, it always had that special meaning when seeing it over the woods.' The picture was, he continued, 'an effort to express what I love in this place. . . . Vision gives birth to itself . . . and the joy one feels . . . causes other joys to join in. . . . But vision may work both ways; it bloweth where it listeth'. (Quoted by Carline, p. 125).

The drawing is one of thirteen set subjects which the artist did at the Slade School from 1909 to 1912.

EXHIBITIONS
Leeds, 1947 (92)
Arts Council, 1954 (8)
Worthing, 1961 (3)
Brighton, 1965 (208)

REFERENCE
Carline, p. 125

3 Two Girls and a Beehive

1910
Oil on canvas
48 × 48 cm/19 × 19 ins
Lent by a Private Collector

During the fifties, Spencer recalled: 'In the four years I was at the Slade I did about three days' painting from one model – three days out of four years! Tonks taught me to draw and was very critical of it' (Carline, p. 29). Instead he taught himself to paint, working mainly in oils and developing a technique which was largely his own invention. His method was to make a number of preparatory sketches in pen, pencil, and sepia wash, sometimes accompanied by small oil studies of the projected composition to check the overall effect (see nos. 20 and 29). Then he transferred the drawing to the squared canvas. In the earlier paintings the under-drawing often shows through the thin paint surfaces. On some occasions the artist redrew outlines over the surface of the paint to emphasise an element of detail or volume. Having drawn the composition on the canvas, Spencer worked close to his easel and rarely stood back to survey the effect (Carline, p. 29).

It is surprising, therefore, to find him, in this very early painting, using a reasonably competent painting technique, together with many of the elements of subject matter which dominated his painting for the rest of his life. The two girls are Dorothy and Emily Wooster, the butcher's daughters, whom Spencer and his brother Gilbert accompanied on walks to Cliveden and down Mill Lane, which is the setting for the painting. He later recalled that the picture 'marks my becoming conscious of the rich religious significance of the place I lived in. My feeling for things being holy was very strong at this time' (Tate 733.3.1). In 1937 he called the painting '. . . a fusion of my desires . . . the place, the girls, and the religious atmosphere'. To emphasise this religious feeling, Spencer added the shadowy figure of Christ, who emerges from behind a bush in the background. This personage was to return in later paintings in numerous guises: as Christ himself, a disciple, or a prophet. Some of these figures bear a passing resemblance to the artist's father, William Spencer. In others the artist himself appears as a kind of alter-ego, giving blessing and approval to the events taking place (see no. 141).

The picture is painted in comparatively dark tones, further emphasised by the heavy black iron fence. Within a year these

3

colours gave way to a lighter palette and a more sophisticated painting technique in Spencer's next important picture, *John Donne Arriving in Heaven* (no. 8).

An early study for the pose of the two girls (26.7 × 24.8 cm/ $10\frac{1}{2}$ × $9\frac{3}{4}$ ins, Tate Gallery archives, 733.11.2, *recto*) shows Spencer using a thin pencil and wash technique. Dorothy Wooster had already modelled for another drawing, *The Fairy on the Waterlily Leaf c.* 1909 (no. 1), and a number of other studies: *Dot in Strand Meadows c.* 1907–9 (now lost); *Melancholia* 1911 (pen and pencil, 19.1 × 28.6 cm/$7\frac{1}{2}$ × $11\frac{1}{4}$ ins, Tate Gallery archives, 733.11.1, insc. '11/11/1911 Melancholia'). Mill Lane was also the setting for a small oil study of *The Piebald Pony* (Private Collection).

EXHIBITIONS
Leger Gallery, 1939 (16)
ICA, *Forty Years of Modern Art*, 1948 (90)
Tate Gallery, 1955 (1)

REFERENCES
Wilenski, 1924, pl. 1
E. Rothenstein, 1945, pl. 3
J. Rothenstein, p. 173
G. Spencer, p. 109
E. Rothenstein, 1962, repr.
Carline, pp. 27–8

4 Jacob and Esau

1910–11
Pen, pencil and wash
34.3 × 24.1 cm/$13\frac{1}{2}$ × $9\frac{1}{2}$ ins
Lent by the Trustees of the Tate Gallery

The subject is taken from Genesis 25:29–34, in which Esau, hungry after an unsuccessful hunting expedition, sells his birthright as Isaac's first-born son to his brother Jacob in return for 'bread and pottage of lentiles'. Jacob, 'a plain man, dwelling in tents', sits on the left talking to the more imposing figure of Esau, 'a cunning hunter, a man of the field'.

The work was executed between 1910 and 1911. Ruth Lowy bought the drawing for £5 in 1911. Sir Victor Gollancz quotes (in *Reminiscences of Affection*, p. 110) a letter acknowledging payment for this study: 'July 10th 1911. . . . "Many thanks for the cheque. I am much to [sic] modest a kid to sign my works, nevertheless I will sign that." In the event he didn't.'

In the forties Spencer recorded that the drawing was one of thirteen studies which he made for the Slade Sketch Club (Tate 733.2.164). This is confirmed by Mrs Clare Winston, a friend and fellow student at the Slade, who recalled: '. . . "Jacob and Esau" was one of the set subjects. Stanley was a very conventional draughtsman in the early days, as all were at the Slade, pleased with *detailed* accuracy. . . . The Sketch Club rules were few. They were to be on a small scale, anonymous but numbered. The professor, in this case Tonks, walked round criticising. All of us trembling in anticipation lest he missed you out as unworthy or sharply criticised' (letter to the compiler of the Tate Gallery catalogue, 25 April 1974). In a letter to the compiler of the Tate Gallery Catalogue (14 April 1974), Gilbert Spencer commented: 'The vital necessity of Cookham as the backcloth for so much of his work was the fact [that it is] round

4

the corner where he drew *Jacob and Esau* but I can find nothing characteristic in this nor an earlier one just as powerfully expressed called *Maternity*. However, wedged in with these was a small composition called *Feeding the Motherless Calf* [Private Collection] (Amy Hatch seen through the bars of a wrought iron gate just round the corner of his beloved Mill Lane). . . . I have often amused myself noticing all the other material he collected all within arm's length around him. He made no on the spot studies for this. . . .'

In a note written on 14 May 1949 Spencer recalled that the study was made near Cliveden: '. . . just before getting there we used to sit in among some felled trees and there while I thought out something Syd (his brother) would read about Jacob and Esau or read the song of Solomon. The land seen at the back of the figures . . . was what we gazed out onto as we sat.' (Tate 733.3.85).

EXHIBITIONS
British Council, Johannesburg, *Empire Exhibition*, 1936 (702)
National Gallery, *British Paintings since Whistler*, 1940 (325)
Leeds, 1947 (84)
Arts Council, 1954 (10)
Worthing, 1961 (2)
Plymouth, 1963 (59)
Arts Council, Cardiff, 1965 (1) and subsequent tour to Bangor, Haverfordwest and Swansea
Cookham, summer 1973 (addendum 36)

REFERENCES
Wilenski, 1924, pp. 10–11, pl. 28
Sir Victor Gollancz, *Reminiscences of Affection*, 1968, p. 110

5 Scene in Paradise

1911
Pen and ink
34 × 40 cm/13½ × 15¾ ins
Lent by the Slade School of Fine Art, University College London

This drawing was submitted to the Slade Sketch Club in 1911.

Years later Spencer wrote that the drawing brought together several important elements in his life: 'I made the central theme of this composition a clothes horse, which was a sort of house I liked being in when it was standing round the kitchen fire, and in front was a mother holding a baby, who was reaching out and taking hold of the long hair of two bearded old men, who are reading Bibles. On the left, there is a nude standing. It is significant to me that I have tried to bring the three experiences of my life together, quite unconsciously, namely the Slade with the life drawing (the nude is just a model), the life at home, and the feeling the Bible gave me' (Tate 733.3.16, notebook written *c*. 1940) (identified and recorded by Carline).

The style of the drawing, with its firm outlines, heavy cross-hatching and elongated angular poses, shows Spencer's interest in old master drawings, particularly those of northern Europe (significantly he had begun a drawing *c*. 1911 entitled *Melancholia*, based on Dürer's etching of the same subject) (Tate 733.11.1). These had also influenced the Pre-Raphaelites, with whose work Spencer's early pictures were often compared by critics like P. G. Konody (*Observer*, 1920).

EXHIBITIONS
RA, *Slade Centenary Exhibition*, 1971
London, Fine Arts Society, *Treasures from University College and the Slade*, 1978

REFERENCES
Carline, pp. 25, 26, pl. 2

5

6 Moses and the Brazen Calf

1911
Pencil and sepia wash
20.3 × 21.9 cm/8 × 8⅝ ins
Lent by Mr and Mrs Peyton Skipwith

The subject of the picture is taken from Exodus 32. According to the late George Charlton, artist and teacher at the Slade School, this study was probably a Slade Sketch Club subject, although Spencer's own list of Sketch Club subjects (Tate 733.2.164) made in the fifties contains no reference to the work. The use of pencil and sepia wash was a new departure by the artist, who had previously relied on concisely drawn pen studies like *The Last Day* (no. 2). After the First World War

6

Spencer relied almost entirely on sepia drawings as studies for his paintings (see no. 43). The raised arms of the worshippers on the left are an early example of the expressive gestures used by the artist in his later paintings (see for example no. 236).

7 Man Goeth to his Long Home

1911
Pencil, pen and wash
43 × 31.8 cm/17 × 12½ ins
Lent by the Trustees of the Tate Gallery

This was a Slade Sketch Club set subject, executed in 1911. The theme was taken from Ecclesiastes 12:5: 'Also when they shall be afraid of that which is high, and fears shall be in the way, and the almond tree shall flourish, and the grasshopper shall be a burden, and desire shall fail; because man goeth to his long home, and the mourners go about the streets.' The landscape in the background is a view looking south from the corner of Carter's shed by Lambert's stables, Cookham. The tree and the chain fence have been added. Spencer used the same landscape again in 1912 for *Joachim among the Shepherds* (no. 12a) (information given by Gilbert Spencer in the Tate Gallery catalogue, 1968, p. 666).

7

EXHIBITION
Leicester Galleries, 1942 (4)

8 John Donne Arriving in Heaven

1911
Oil on canvas
36.8 × 40.6 cm/14½ × 16 ins
s. *verso*, 'S. Spencer/1911/Cookham'
Lent by a Private Collector

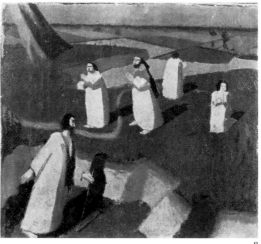

8

Spencer was given a copy of John Donne's *Sermons* in 1911 by his friends and fellow students at the Slade, Jacques and Gwen Raverat. It was one of these sermons which inspired the picture. In a lecture to the Ruskin Drawing School, Oxford, in 1923, he explained: 'I have always loved reading Donne, though I understand a little of it.' He interpreted Donne's 'Going to Heaven by Heaven' as meaning going 'Past Heaven, alongside it', and he 'seemed to get an impression of a side view of Heaven as I imagined it to be, and from that thought to imagining how people behaved there. . . . As I was thinking like this I seemed to see four people praying in different directions' (Carline, p. 30). Though Spencer said the picture was done from imagination, he later told his brother Gilbert that 'Heaven' in this case was a part of Widbrook Common, near Cookham (G. Spencer, p. 110).

Spencer took the picture up to the Slade for the monthly composition criticism with Henry Tonks. He reported the subsequent 'crit' in a letter to his brother Sydney: '"I don't like this as much as the drawing," said Tonks, "It has no colour, and is influenced by a certain party exhibiting at the Grafton Gallery a little while ago" – the damned liar!'

Spencer's angry denial of Tonks's implication that he was influenced by the First Post-Impressionist Exhibition at the Grafton Galleries, in 1910, was clearly not accepted by Clive Bell, who included *John Donne* in the Second Post-Impressionist Exhibition of 1912. Here the painting was hung in the end gallery at the Grafton, together with works by Matisse, Vlaminck, Picasso, L'hôte, Wyndham Lewis, and Fry himself. *The Connoisseur* suggested that he 'would do better to cast off

the artificial conventions of Post-Impressionism: his *John Donne Arriving in Heaven* shows conviction, a fine sense of colour and a feeling for composition. It needs all these qualities, however, to prevent the spectator from feeling that the subject is a representation of some clumsily modelled marionettes' (*The Connoisseur*, November 1912, p. 192).

Spencer's aversion to being associated with artists of the modern movement may have been connected, as Richard Carline has suggested (p. 30), with the artist's loyalty to the conservative Tonks. Also there seems to have been little love lost between Spencer and Fry (Carline, p. 31). The latter's writings, with their insistence on formal values, held little attraction for Spencer who, though he would have approved of Fry's championing of the early Italian and Flemish painters, must have found his ideas on abstraction disturbing, in the face of his own intensely naturalistic art.

For Spencer Post-Impressionism and the formal values of Cubism (Robinson, p. 16) were probably less important than the influence of early Italian painters, Giotto, Masaccio, Fra Angelico and others, particularly as most of his paintings were of religious subjects. At the Slade he was associated with a group of students including Nevinson, Gertler, Roberts and others, who called themselves 'Primitives'. Inspired by Pre-Raphaelite art and the writings of John Ruskin, this faction was highly enthusiastic about the early Italians, as Nevinson later recalled (Leder, p. 19). In 1911 Spencer's interest was further inspired by a gift of Ruskin's *Giotto and his Works at Padua* (see no. 11) by the Raverats. The simple austere forms of Giotto's pictures (which Spencer would have known only from black and white illustrations) were an important influence both on *Study for Joachim among the Shepherds* 1912 (no. 11), and *John Donne*. After the rather tentative style of *Two Girls and a Beehive* 1910 (no. 3), the picture shows a new skill in handling space and form, although there is still little interest in colour. However, Spencer's style was not yet firmly established, and in *Apple Gatherers* 1912–13 (no. 15) new influences appear.

A pen and wash drawing *Study for John Donne Arriving in Heaven* 1911 (29.8 × 31.8 cm/11¾ × 12½ ins, Private Collection) is probably the one referred to by Tonks. Spencer also made a small oil study on board, *Study for John Donne Arriving in Heaven* (16.5 × 16.5 cm/6½ × 6½ ins, Private Collection), which is almost identical to the finished work.

EXHIBITIONS
Grafton Galleries, *Second Post-Impressionist Exhibition*, 1912 (149) and 1913 (175)
Goupil Gallery, 1927 (58)
Leger Gallery, 1939 (13)
Tate Gallery, 1955 (2)
RA, *Post-Impressionism*, 1979–80 (342)
On loan to Exeter Museum and Art Gallery since 1974

REFERENCES
Wilenski, 1924, p. 11, pl. 12
C. Johnson, *English Painting from the Seventh Century to the Present Day*, London 1932, p. 328
G. Spencer, p. 110
M. Collis, 1962, p. 243
Carline, p. 30
Robinson, 1979, pp. 12, 16, pl. 5

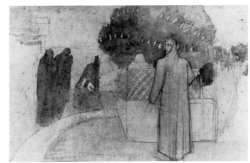

9

9 First Sketch for The Nativity

1912
Pencil, red chalk and grey wash
22.9 × 34.3 cm/9 × 13½ ins
From the collection of the late W. A. Evill

This drawing established the basic format of *The Nativity* 1912 (no. 10), but shows that Spencer introduced substantial changes on the extreme left of the composition in the final painting. Here he replaced the path along which the Three Wise Men walk to enter the garden by an iron fence which bounds the extended wooden paling. In a gap between these one of the Wise Men is shown kneeling to worship the Christ Child. There is no sign of the manger in the drawing and it is possible that it was originally placed behind the fence. In the painting this awkward siting is changed and the manger appears in the foreground beside the heavy Giottesque figure of the Madonna.

The result of the changes is a more richly varied composition. It is notable that Spencer often began with a relatively simple idea made up of basic abstract forms (in this case the curve and counter-curve of the path and fence), and moved to a more elaborately detailed solution in the painting (see for example nos 43 and 44).

This is one of Spencer's earliest uses of pencil and wash in a painting study; the addition of some red chalk details (which the artist used briefly in 1912–13) may show his dissatisfaction with the grey wash, which was soon to be replaced by sepia.

EXHIBITION
Brighton, 1965 (215)

10 The Nativity

1912
Oil on panel
102.9 × 152.4 cm/40½ × 60 ins
Lent by the Slade School of Fine Art, University College London

The Nativity was the set subject for the Slade Summer Composition Prize for 1912. It gave Spencer his first opportunity to work on a large scale as the size of the work was prescribed in the rules of the competition. In keeping with his usual practice, he painted the picture in Cookham, in Ovey's Barn. When he had completed it he took the picture up to London for

assessment at the Slade, where it was at once recognised as an outstanding achievement. The work was awarded the Nettleship prize for figure painting which Spencer shared with Gilbert Solomon (Carline, p. 33).

Writing in 1941, Spencer criticised his treatment of the baby in the manger, a late addition which does not appear in the preparatory drawing (no. 9). He then goes on: 'The couple occupy the centre of the picture, Joseph who is to the extreme right doing something to the chestnut tree and Mary who stands by the manger; they appear in their relationship with the elements generally, so that Mary to the couple in contact with one another seems like some preponderating element of life, just another big fact of nature such as a tree or a waterfall or a field or a river. Joseph is only related to Mary in this picture by some sacramental ordinance. . . . This relationship has always interested me and in those early works I contemplated a lot of those unbearable relationships between men and women' (Tate 733.2.85).

The painting shows a sharp change of style from the simple blocky forms of *John Donne Arriving in Heaven* 1911 (no. 8) to a new emphasis on richer colour and carefully painted detail. As in the 1911 picture, Spencer turned to the early Italian painters together with modern art for his inspiration. The scene bears a considerable resemblance to Quattrocento nativities, and the artist may have chosen the outdoor setting, with the fences acting as a crude form of architecture, in imitation of Piero della Francesca's *Nativity*, which he would have seen in the National Gallery. Piero, recently popularised by Roger Fry and others, may also have been the source for the heavy, simplified forms of the figures, and their arrangement in isolated groups around the simple divisions created by the

fences. Spencer's taste was eclectic, however, and, as Andrew Causey points out in his introductory essay, the figure of Joseph bears a resemblance, in reverse, to Botticelli's Mercury in *Primavera*. The role of modern art is less easy to define but Gauguin, significantly a 'modern Primitive', may have been a source for the mask-like faces of the figures. Duncan Robinson has suggested (p. 18) that the steep recession on the left towards the skyline, and the composition, sharply divided horizontally by the fence in the foreground, are reminiscent of Gauguin's *Bonjour Monsieur Gauguin* and *Little Girl Keeping Pigs*, from his Breton period, *c*. 1889. Spencer could have studied Gauguin at the Stafford Gallery in 1911, and at 'Manet and the Post-Impressionists' in the winter of 1910–11, where forty works by the artist were exhibited. Gauguin's influence is also present in *Apple Gatherers* (no. 15), begun in the same year. The care with which the landscape and flowers are painted and the sharp definition of the picture reaffirm Spencer's earlier interest in the Pre-Raphaelites.

In the picture Spencer followed the precedent set by *Two Girls and a Beehive* (no. 3) and *John Donne Arriving in Heaven* (no. 8) by placing the scene in a familiar Cookham setting, in this case, as Richard Carline has suggested, a view towards Sir George Young's estate. In this work landscape assumes a larger role, with the woods, field and plants contributing to the special atmosphere of the event. In 1935 Spencer recalled the source of his inspiration: 'The marsh meadows full of them (the flowers) leave me with an aching longing, and in my art that longing was among the first I sought to satisfy . . . (It) celebrates my marriage to the Cookham wildflowers. It is our way, not only of joining in the creation, but in a way, sharing the creation, because we, in a way, recreate' (Carline, p. 33).

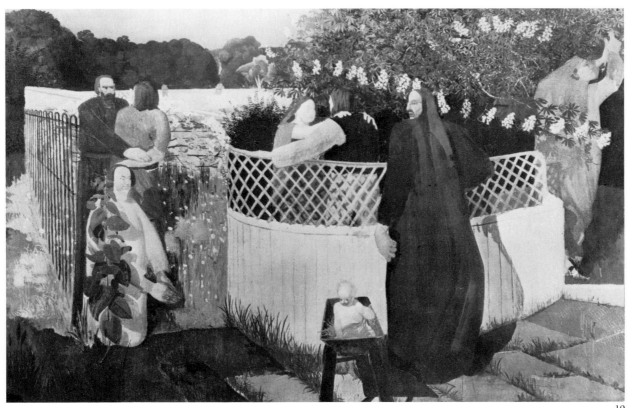

10

Spencer normally tried to relate his ideas to places which held a particular significance for him, and with a few exceptions, notably *The Beatitudes of Love* (nos. 188–90) and *Christ in the Wilderness* (nos. 194–201), all his subsequent imaginative paintings were placed in recognisable settings. He explained his feelings in a lecture on composition to the Ruskin Drawing School, Oxford, in 1922: 'I am very slow at assimilating my surroundings, but once they are, then they begin to have for me a great meaning. Some artists think that meaning cannot be expressed. Well, if I thought that the only way to express what I know about Ferris Lane . . . near my home, was to be done, as I have sometimes had to do it to passing motorists, by just shouting ''First on the right, second on the left'', I should just burst. I shall do a picture some day with these words as a title' (Carline, pp. 33–4).

EXHIBITIONS
Tate Gallery, on loan 1921–2
NEAC, 71st Retrospective Exhibition, 1925 (102)
NEAC, Manchester, Retrospective Exhibition 1925 (140)
Vienna Secession, *Meisterwerke englischen Malerei aus drei Jahrhunderten*, 1927 (344)
Amsterdam, Stedelijk Museum, *Twee Eeuwen Engelse Kunst*, 1936 (142), repr.
Venice, Biennale, 1938 (72)
New York, World's Fair, *Contemporary British Art*, 1939 (131) and British Council Canadian Tour 1939–40 (131) and USA tour, 1942 (94)
Leeds, 1947 (1), repr.
British Council, South Africa, *Contemporary British Paintings and Drawings*, 1947 (105)
Birmingham City Art Gallery, *Modern Painters*, 1949
Bristol, Festival Exhibition, 1951
Tate Gallery, 1955 (3)
British Council, Oslo and Copenhagen, *Contemporary British Art*, 1956
Aberdeen Art Gallery and Industrial Museum, 1957
British Council, New York, *Masters of British Painting 1800–1950*, 1957
Plymouth, 1963 (2)
Arts Council, Welsh Committee, *Stanley Spencer, Religious Paintings*, 1965
RA, *The Slade 1871–1971*, 1971 (22)
Arts Council, 1976–7 (2)

REFERENCES
Wilenski, 1924, pl. 3
Apollo, III, 1926, p. 5, repr.
C. Johnson, *English Painting from the Seventh Century to the Present Day*, London 1932, p. 331
The Studio, no. 125, 1943, p. 50
E. Rothenstein, 1945, pl. 2
G. Charlton, 'The Slade School of Fine Art', *The Studio*, October 1946, p. 8, repr.
J. T. Soby, *Contemporary Painters*, New York (MOMA), 1948, p. 123
E. Rothenstein, 1962, p. 2, pl. 1
M. Collis, 1962, pp. 39, 41, 69, 243
Carline, pp. 33, 207
Robinson, 1979, p. 18, pl. 13 (in colour)

11 Study for Joachim among the Shepherds

1912
Pen, pencil and wash
40.5 × 37 cm/16 × 14⅝ ins
[on sheet] 56.2 × 38 cm/22⅛ × 15 ins
insc. 'S. Spencer 1912'
Lent by the Trustees of the Tate Gallery

This is a detailed study for the oil painting of *Joachim among the Shepherds* 1912 (no. 12a. See addenda, p. 230). It was painted in 1912, shortly after the artist had left the Slade School. According to Spencer the work was influenced by Ruskin's

11

book on the Arena Chapel, *Giotto and his Works at Padua*. In it the artist would have read the quotation beside the Dalziel woodcut after Giotto's *Joachim Returns to the Sheepfold*: 'Then Joachim, in the following night, resolved to separate from his companions; to go to the desert places among the mountains, with his flocks; and to inhabit those mountains, in order not to hear such insults. And immediately Joachim rose from his bed, and called about him all his flocks, and goats, and horses, and oxen, and what other beasts he had, and went with them and with the shepherds into the hills' (Cook and Wedderburn, *Works*, XXIV, p. 50).

Spencer visualised the scene taking place in a favourite part of Cookham: 'I liked to take my thoughts for a walk and marry them to some place in Cookham. The ''bread and cheese'' hedge up the Strand ash-path was the successful suitor. There was another hedge going away at right angles from the path and this was where the shepherds seemed to be. We had to walk single-file along this path and the shadows romped about in the hedge alongside of us. And I liked the hemmed-in restricted area feeling in that open land. . . . That endless path! Could nothing be done to ''jolly'' it up? And then Joachim and the shepherds gave it their blessing, and saved me from getting bored' (written in 1937, quoted Carline, p. 28).

The drawing differs from the oil painting in a number of ways: in the oil the figure of Joachim on the right has been brought to the foreground of the composition, and the landscape background and the trellis have been eliminated in favour of an arch of foliage. The shepherds remain roughly in the same postures, but the figure on the far left appears hatless in the oil painting. Joachim is shown holding a sheep, and the one in the lower foreground of the drawing has been eliminated.

The artist also made a small woodcut (no. 24), which is more closely related to the painting. An oil sketch (22.2 × 15.9 cm/ 8¾ × 6¼ ins) showing the three shepherds on the left of the composition is also in the exhibition (no. 12).

EXHIBITIONS
NEAC, winter 1912 (5), as *Joachim among the Sheepcotes*
National Gallery, *British Painting since Whistler*, 1940 (326) as *Joachim among the Shepherds*
Leeds, 1947 (76)
British Council, South Africa, *Contemporary British Paintings and Drawings*, 1947–8 (108)
Arts Council, 1955 (15)
RA, 1956 (690)

REFERENCES
Wilenski, 1924, pl. 31
E. Rothenstein, 1945, pl. 4
Michael Ayrton, *British Drawings*, 1946, pl. 40 (in colour)
J. Rothenstein, *Modern English Painters, Lewis to Moore*, 1956, p. 175
M. Collis, 1962, pp. 26–7, 243
Carline, p. 28
Robinson, 1979, p. 14, pl. 6

12 Study for Joachim among the Shepherds

c. 1912
Oil on paper
22.2 × 15.9 cm/8¾ × 6¼ ins
Lent by a Private Collector

The fine oil sketch is a study for *Joachim among the Shepherds* (no. 12a. See addenda, p. 230), painted in 1912. It is closely related to the pen study (no. 11) for the painting, where it reproduces the left-hand half of the composition. The oil sketch differs only in the fence, omitted in the drawing, which appears as a few roughly drawn charcoal lines running diagonally across the foreground. In the oil painting the landscape background was removed and the farthest man appears hatless.

The carefully inter-related poses of the three figures are the forerunners of the more complicated groups found in the figure paintings of the thirties.

12

12a Joachim among the Shepherds

1913
See addenda, p. 230

13 David and Bathsheba

c. 1912
Pen and grey wash
30.5 × 31.8 cm/12 × 12½ ins
From the collection of the late W. A. Evill

13

The drawing is another of the series which Spencer made for the Slade School Sketch Club (see no. 4). In a note on the picture for the Brighton exhibition of 1965 (no. 238), Wilfrid Evill recalled: 'This is a very early drawing, probably about 1912, and represents, so I am told, a struggle between David's lesser and higher self. . . .' Evill's information must have come directly from the artist.

Spencer's interpretation of the biblical story is confusing, but the two central figures in the drawing must represent David's two conditions: the seated figure, armed but holding a sheaf of wheat in his left hand, symbolises his 'higher' self, perhaps as a soldier and leader of the people of Israel. He is attached by a chain to his 'lesser' self, who is being pinned to the ground by Bathsheba (II Samuel 11), represented here as a seductive Pre-Raphaelite beauty. The lyre beside him further emphasises his distraction from affairs of state by the woman, whose husband, Uriah the Hittite, he later caused to be killed. The other figure in the background is less easy to explain, but may represent David yet again, this time in an earlier episode (I Samuel 20) where he hides in a field to await the pre-arranged signal from Saul's son Jonathan to tell him to flee the country. Spencer did not repeat this unusual attempt at religious allegory and other Sketch Club drawings such as *Jacob and Esau* (no. 4) are more straightforward representations of biblical themes.

The style of the drawing is still derived from Spencer's interest in book illustrators like Arthur Rackham, and the Pre-Raphaelites; but the two sheep resemble those in Giotto's Arena Chapel fresco *Joachim among the Shepherds*, a subject which he illustrated in the same year (no. 12a).

The old-fashioned subjects set for the Sketch Club must have seemed anathema to some of Spencer's contemporaries at the Slade, but the frequent biblical subjects were important for the artist in bringing together his early feelings for Cookham and the Bible (see no. 10).

14

14 Study for Apple Gatherers

c. 1912
Pen, pencil and wash, squared for transfer
27.8 × 32 cm/10⅞ × 12⅝ ins
Lent by the Trustees of the Tate Gallery

This is probably the drawing which was done as a set subject
for the Sketch Club at the Slade School in 1912. This
preliminary drawing for *Apple Gatherers* 1912–13 (no. 15) shows
the same general design as the finished oil painting, but differs
in several respects. The oil is a more compact composition, with
the figures filling the whole space, and the two central figures
crowding up to the edge of the canvas. The man in the right
foreground has his left instead of his right hand in the basket,
and a barrel has been added in the centre between the two
groups. Like the finished picture, the drawing was purchased
from the artist by his early patron, Sir Edward Marsh.

15 Apple Gatherers

[repr. in colour on p. 65]
1912–13
Oil on canvas
71.5 × 92.5 cm/28 × 36¼ ins
Lent by the Trustees of the Tate Gallery

Painted at Cookham in 1912–13, *Apple Gatherers* was a Slade
Sketch Club subject. It was entered for the Slade School prize of
£25, available to fourth-year students, which the artist won.

Spencer imagined the scene taking place in an orchard
beyond 'Fernlea' garden, which could be seen from the nursery
window. According to Richard Carline (p. 34), the artist felt that
the apple gatherers were the 'natural outcome' of the place.

Writing in 1936, he recalled the impression made on him by
such a view of nature: 'When at the end of each day it had
begun to get too dark to paint in the kitchen of "Wisteria"
where . . . I was painting *Apple Gatherers*, I used, sometimes, to
stand on a little landing . . . and look from the cottage window
to the still bare branches of some spindle-like trees which were
hidden in a confusion of overgrown yew hedge and other
shrub-stuff, and there watch and listen to a blackbird which
could be seen in the dusk, making a little darkness . . . among
those few criss-crossing twigs and thin branches; the notes
sounded more local and imminent as darkness came on'
(Carline, p. 34).

An important influence was Spencer's friendship with the
artist Henry Lamb, whom he had met through a fellow Slade
student, Darsie Japp, in June 1913. Lamb, already an established
artist and founder member of the Camden Town Group, had
spent 1910 to 1911 in Brittany, where he had made a particular
study of Gauguin. Spencer was already aware of the Post-
Impressionists (see no. 8), but Lamb's influence was probably
decisive.

Apple Gatherers shows the artist beginning to use the non-
perspectival space, distortions of scale and form, and a new
stress on the picture surface common to the artists of the Pont
Aven School. The facial characteristics of Spencer's figures also
reveal his debt to Gauguin. Leder and Robinson (p. 16) both cite
the latter's *Christ in the Garden of Olives* 1889 (canvas, 72.4 ×
91.4 cm/28½ × 36 ins, West Palm Beach, Florida, Norton
Gallery and School of Art), exhibited in the 1910 Grafton
Gallery exhibition, as the original source for the painting.
However Lamb's own French-influenced pictures, for example
Fisherfolk c. 1912 (Fine Art Society), with its sharply receding
figure composition, were probably of equal importance.

According to Gilbert Spencer (1961, p. 192), the artist told
him shortly before he died that *Apple Gatherers* was painted on
top of his first attempt to paint a Resurrection. So far as Gilbert
Spencer could recall, this composition consisted of an avenue of
cypresses, with the resurrected floating up from the trees like
angels. X-ray photographs of the picture taken in October 1961,
while showing various *pentimenti* to the existing work, do not
confirm the presence of another composition underneath. This
is due to a high lead content in the layer of priming over the
earlier composition which prevented X-ray penetration beyond
this point. However, photographs taken in strong raking light
have revealed the outline of the head and shoulders of a
woman, seen upside-down, in the area now occupied by the
basket of the right-hand figure in the centre foreground.
According to the compiler of the Tate Gallery catalogue (1968,
p. 667), this figure is Giottesque in conception, and conforms to
Gilbert Spencer's description of the original composition. A
study for *Apple Gatherers* (no. 14) is included in the exhibition.

Leicester, *Contemporary Art*, 1936 (60)
Venice Biennale, 1938 (British Pavilion, 67)
British Council, Northern capitals, *Contemporary British Art*, 1939 (105)
Leger Gallery, 1939 (21)
National Gallery, 1940 (132)
British Council, North Africa, *Contemporary British Art*, 1945 (74)
Tate Gallery, 1955 (5) pl. 1

REFERENCES
Wilenski, 1924, p. 11, pl. 4
E. Marsh, *A Number of People*, 1939, p. 359
E. Rothenstein, 1945, pls 9–10
J. T. Soby, *Contemporary Painters*, New York, 1948, p. 123
A. Bertram, *A Century of British Painting, 1851–1951*, 1951, p. 105
G. Spencer, 1961, pp. 112, 115, 192
M. Collis, 1962, pp. 36–7, 39–41, 243
E. Rothenstein, 1963, pl. 2 (in colour)
Carline, pp. 34, 36, 161
Robinson, 1979, pp. 17–18, pl. 9 (in colour)

16 The Visitation

1912–13
Oil on canvas
43 × 43 cm/17 × 17 ins
Lent by a Private Collector

The models for this painting were 'Dot' Wooster the butcher's daughter and Peggy Hatch, Spencer's cousin, who was a milkmaid. The picture was painted in the old schoolroom at the bottom of the garden of 'The Nest', next door to 'Fernlea'. Through the schoolroom door can be seen the sheds of The King's Arms and the roof of 'Lindworth', the house which Spencer bought when he returned to Cookham in 1932 after completing the paintings at the Burghclere Chapel.

As in *John Donne Arriving in Heaven* 1911 (no. 8), Spencer was probably influenced by his reading of Ruskin's *Giotto and his Works at Padua*, particularly (as C. Leder has pointed out) by Ruskin's commentary on *The Salutation*. The composition, however, owes more to Masaccio, and the pair of right-hand figures in the *Tribute Money* in the Brancacci Chapel in Florence, which appeared in one of Spencer's Gowans and Grays art books, as a separate plate. Masaccio too is probably the source of the massive, broadly painted figures of Mary and Elizabeth. The simple framing device of the doorway is commonplace in the Visitation iconography of the Trecento.

16

There are at least two surviving studies for the picture: *Study for The Visitation* (oil on paper, 35.6 × 19.1 cm/14 × 7½ ins, Private Collection) is a preparatory sketch for the figure of Mary; *Study for The Visitation* (pencil, pen and indian ink, 35.6 × 35 cm/14 × 13¾ ins, Private Collection) is a drawing for the final painting. A strip of paper added to the left shows that Spencer widened the doorway by about a third to accommodate the figure of Mary. It was acquired by Jas Wood.

REFERENCES
Wilenski, 1924, pp. 13, 14, 15, pl. 7
J. T. Soby, *Contemporary Painters*, p. 123
Wilenski, 1933, pp. 284, 285
E. Newton, 1947, pl. 2 (in colour)
Carline, p. 36

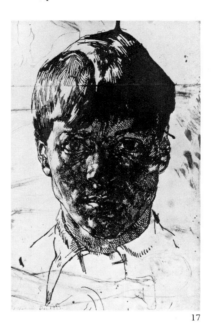

17

17 Self-Portrait

1913
Pen and ink
21.6 × 35.6 cm/8½ × 14 ins
inscbl. 'Dec. 1913', inscbr. 'To John Rothenstein/from Stanley Spencer'
Lent by Sir John Rothenstein CBE, KCSG

This drawing and three others are related to the Tate *Self-Portrait* (no. 23), which Spencer was painting during 1914. However the neck, which plays such a prominent part in the painting, is covered by a collar in the drawings; the head too is not held so high. Spencer learned his pen and ink technique with its use of heavy cross-hatching, reminiscent of old master drawings, at the Slade School. It was gradually abandoned after the war in favour of pencil and sepia wash which permitted more flexibility, particularly in painting studies which might require adjustments.

There are at least three related pen and ink self-portraits made in 1913: *Self-Portrait* (Williamson Art Gallery, Birkenhead); *Portrait of the Artist* (no. 18) and *Self-Portrait* (Private Collection).

EXHIBITIONS
Arts Council, 1954 (11)
Arts Council, 1976–7 (54)

REFERENCE
E. Rothenstein, 1945, pl. 55; *idem*, 1962, pl. 55

19

REFERENCES
Carline, pp. 36, 38, 46, 154, 207
W. Wilson, *Christian Art Since the Romantic Movement*, Burns and Oates, 1965,
p. 69, pl. 12

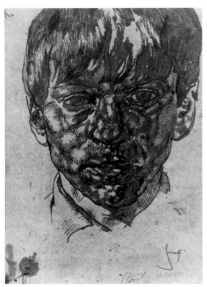

18

18 Portrait of the Artist

1913
Pen and ink on card
34.2 × 24 cm/13½ × 9½ ins
sdbr.
Lent by a Private Collector, London

One of at least four pen and ink self-portraits made by Spencer
during 1913 which were probably made as studies for the Tate
Self-Portrait (no. 23), begun in the next year. The drawing
resembles the other self-portraits in showing the artist dressed
in an open-necked shirt, but in this the head is tilted slightly to
the left and downwards, whereas in the other drawings Spencer
looks directly out of the picture.

19 Study for Zacharias and Elizabeth

c. 1913
Pencil and sepia wash
26.7 × 26.7 cm/10½ × 10½ ins
Lent by a Private Collector

This fine picture is a study for *Zacharias and Elizabeth* (no. 21),
painted in 1914. In transferring the design to the canvas,
Spencer increased the size of the wall in relation to the
foreground figures of Zacharias and the angel, and gave it a
curved form, which divided the picture more emphatically into
three, pushing the landscape into the top of the canvas. Minor
changes were also made in the poses of Zacharias and Elizabeth
and the foliage surrounding them, in the upper right
background.

20 Study for Zacharias and Elizabeth

1914
Oil on paper glued to board
squared for transfer in pencil
30.5 × 24.5 cm/12 × 10 ins
Lent by a Private Collector

This fine oil sketch is a study for the upper central landscape
background of *Zacharias and Elizabeth* (no. 21), painted in 1914.
It is probably the 'small painting' which Spencer referred to in
a letter to the artist Henry Lamb dated 7 March 1914 (see no. 21,
Carline, p. 46). Although Spencer had made at least one oil
sketch before, for *John Donne Arriving in Heaven* 1911 (no. 8),
it was not his usual practice to paint studies for details of his
pictures, and there are no other existing landscape sketches.

The picture was given to James Wood, a fellow artist and
friend who had met Spencer before the war. Wood was
particularly enthusiastic about his pictures at this time.

EXHIBITIONS
Goupil Gallery, 1927 (71)

20

21 Zacharias and Elizabeth

[repr. in colour on p. 66]
1914
Oil on canvas
152.4 × 152.4 cm/60 × 60 ins
Lent by a Private Collector

The picture is taken from Luke 1. Spencer began work on the composition in December 1913, when he told Henry Lamb: 'I have a big square canvas, . . . I am going to have it out on this canvas if it's the last act, as Brer Rabbit would say . . .' (Carline, pp. 36–7). He was painting it by 7 March 1914, when he invited Lamb to come to Cookham to see '. . . my big Zacharias picture just begun'. Again on 1 April he reported 'I am doing a small painting of it as well. I do this between 5 and 7 in the evening' (Carline, p. 46). This was probably the small study of the landscape background which he later gave to Jas Wood (see no. 20).

The scene was painted from memory, of the view from the back window of the staircase landing on the second floor of 'Wisteria Cottage', looking towards Cliveden Woods. He was allowed to paint there by the owner, Jack Hatch the coalman, and his family. The garden, which belonged to St George's Lodge, is now part of John Lewis's Odney Club.

In 1937 the artist described the feelings which had inspired the picture: 'I wanted to absorb and finally express the atmosphere and meaning the place had for me. . . . It was to be a painting characterising and exactly expressing the life I was, at the time, living and seeing about me. It was an attempt to raise that life round me to what I felt was its true status, meaning and purpose. A version of the St Luke passage, the gardener dragging the branch of ivy, and Mrs Gooden giving me permission to walk about the garden of the untenanted St George's Lodge, resulted in this painting. . . . The whole of what I hoped was dependent on the reality of everyday life' (Tate 733.3.1).

To this intense awareness of 'place', Spencer added the biblical elements of St Luke: 'Zacharias appears in the foreground at an altar. Sweeping down on him is an imagined angel. Further back among the grass and just by an old yew hedge Zacharias appears again with Elizabeth. Elizabeth has her arm crooked, and rests it on a tray-like frond of the yew. Her hand disappears into the tree. Behind the wall and to the left is a kneeling figure and above the wall in the top of the picture just by the sky is another head and shoulders of a figure. She is Elizabeth again, on her own, just as Zacharias is alone (with the angel), as he is making his sacrifice. It just wanted someone in that juncture of the wall and the greenhouse' (written in 1959).

The introduction of several versions of Zacharias and Elizabeth in the same painting was probably inspired by the multiple narrative pictures of the early Italian masters, which Spencer was studying at this time. The high wall which encloses Zacharias was an expression of the artist's sense of mystery and 'feeling of wonder at what was on the other side' (Tate 733.3.1).

When the picture was exhibited at the New English Art Club in 1920, it provoked the kind of equivocal reaction from the critic P. G. Konody which was to continue throughout the artist's career. While recognising his talent and the sources of his art in the Pre-Raphaelites and the early Italian masters, Konody questioned Spencer's ability to express his vision in an acceptable manner: 'It is not a picture to be dismissed with an impatient shrug,' he wrote in the Observer for 4 January 1920, 'for it has a sense of awe that makes unquestionably a very powerful and direct sense of appeal, quite apart from the charming landscape background painted with a Pre-Raphaelite's love of elaborate detail. But the picture gains nothing from the grotesque treatment of the figures. . . . Zacharias himself being disguised as a chef. . . . If the buildings and ruins of the Giottesques often lacked architectonic stability, the primitive painters nevertheless did their best to make their walls look like walls. In Mr Spencer's picture the . . . screen-like erection behind the central group looks more like a portion of an enamel bath than like a wall.'

In a letter to Henry Lamb of 27 April 1914, Spencer reported (Tate Tam 11): 'I am trying to do my Zacharias thing in "basso relievo", is that what they call it? I am doing it with modelling clay but I am going to do it with stone. I do not like clay. I itch to do trees in it, not damnable conventional trees, but trees as they are in my painting of this picture' (Carline, p. 38). As Carline suggests, the artist was probably inspired by two favourite artists, Donatello and Ghiberti. Nothing survives of the relief or of another which Spencer planned of The Centurion's Servant (no. 25).

Spencer made a small pen and ink sketch for the painting. A watercolour study for the foreground figure of Zacharias is also included in the exhibition (see display case).

EXHIBITIONS
NEAC 61st Exhibition, 1920 (12)
Tate Gallery, 1955 (6), pl. 6
Plymouth, 1963

REFERENCES
Wilenski, 1924, p. 12, pl. 5
E. Rothenstein, 1945, pls 5–7
J. Rothenstein, Modern English Painters, II, Lewis to Moore, 1956, pp. 164, 174, 179, 186, pl. 15
R. Shone, A Century of Change, pl. 25
Carline, pp. 36, 38, 46, 154, 207
Robinson, 1979, p. 14, pl. 7
J. Rothenstein, 1979, pl. 2

22 Cookham

[repr. in colour on p. 69]
1914
Oil on canvas
45.1 × 54.6 cm/17¾ × 21½ ins
Lent by Carlisle Museum and Art Gallery

Though this is one of the first pure landscapes which Spencer painted, he had already had considerable practice with the landscape settings for John Donne Arriving in Heaven 1911 (no. 8), which has a similar elevated viewpoint, The Nativity 1912 (no. 10), and Zacharias and Elizabeth 1914 (no. 21). This accounts for the considerable skill which he employed in the compositional arrangement of the painting and the dappling effect of the light filtering through the clouds onto the fields and distant hills. According to Richard Carline, Spencer considered this picture to be the most successful of his early

landscapes, and its carefully observed naturalism formed the basis of all the later paintings in this genre.

The picture was bought by Eddie (later Sir Edward) Marsh, an early patron, who also purchased *Apple Gatherers* 1912–13 (no. 15) and other works.

EXHIBITIONS
Leeds, 1947 (3)
Sir Edward Marsh Memorial Exhibition 1973 (22)
Arts Council, *Three Masters*, 1961 (22)
Carlisle City Art Gallery, *William Rothenstein, A Unique Collection*, 1972 (52)

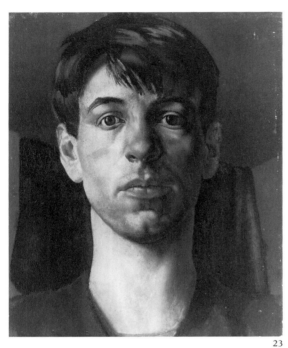

23

23 Self-Portrait

1914
Oil on canvas
63 × 51 cm/24¾ × 20 ins
Lent by the Trustees of the Tate Gallery

The picture, Spencer's first oil self-portrait, was painted in 1914, not 1913 as stated by Wilenski (1924) and J. Rothenstein (1956, pl. 16). In a letter to Henry Lamb dated 7 May 1914 Spencer commented: 'I must stop now and go on with my portrait that is getting on at last' (Carline, p. 47). He was still working on it when war was declared on 4 August 1914. The picture was seen in the artist's studio in 'Wisteria Cottage' by Eddie Marsh, an important early patron, who bought it for £18. When asked by Marsh why he had painted it so large, Spencer replied: 'Next time I start a portrait I shall begin it the size of a threepenny bit' (Carline, p. 39).

The composition is unusual in Spencer's œuvre in its well-modelled forms and concern for the qualities of oil paint, which indicate an interest in the methods of the old masters. In an unpublished Courtauld MA thesis, Carolyn Leder has suggested that the artist was influenced by the National Gallery *Portrait of a Youth wearing a Red Cap* by Botticelli, which he would have seen on his occasional visits to the Gallery before the war.

EXHIBITIONS
CAS, *Paintings and Drawings*, 1923 (1)
British Empire Exhibition, Wembley, 1924 (Q.16)
NEAC, *Retrospective Exhibition*, 1925 (214)
Artisas Britannicas, Buenos Aires, 1928 (231)
Whitechapel Art Gallery, *Contemporary British Art*, 1929 (264)
Venice Biennale, 1930 (British Pavilion, 137)
Graves Art Gallery, Sheffield, 1934 (197)
Leicester Galleries, *Fifty Years of Portraits*, 1935 (53)
British Council, Johannesburg, *Empire Exhibition*, 1936 (697)
Venice Biennale, 1938 (British Pavilion, 68)
British Council, New York, World's Fair, *Contemporary British Art*, 1939 (312), Canadian Tour, Boston and Chicago, 1939–40 (132), and Toledo, 1942 (95)
Leeds, 1947 (2, repr.)
British Council, European Tour, *Twelve Contemporary Painters*, 1948–9 (47)
ICA, *Ten Decades*, 1951 (183)
Leicester Galleries, *The Collection of the late Sir Edward Marsh*, 1953 (49)
Tate Gallery, 1955 (8)

REFERENCES
Wilenski, 1924, as frontispiece
E. Marsh, *A Number of People*, 1939, pp. 359–60
J. Rothenstein, *Modern English Painters, Lewis to Moore*, 1956, pp. 165–6, pl. 16
M. Collis, 1962, pp. 38, 40, 243
J. Rothenstein, *British Art since 1900*, 1962, pl. 92
E. Rothenstein, 1963, pl. 3 (in colour)
Carline, pp. 39, 47
Robinson, 1979, repr. frontispiece

24 Joachim among the Shepherds

1914
Woodcut
8.2 × 9.4 cm/3¼ × 3⅝ ins
Lent by Richard Carline Esq.

This small woodcut is derived from the oil painting of *Joachim among the Shepherds* (no. 12a, see addenda, p. 230), painted in 1912.

In a letter to Henry Lamb dated 1 April 1914 (Tate Tam 11), Spencer agreed to sell one of the prints to a friend of Lamb's for one guinea, and reported that the painter Darsie Japp had already bought one for a pound. He did not make an edition, but seems to have produced the prints to order, as he informed Lamb in the same letter that his brother Gilbert was going to find him some printer's ink in London, so that he could comply with Lamb's request.

This was Spencer's only venture into the art of the woodcut, but the small design shows an excellent understanding of the medium, particularly in the variations of the texture between the figures and the landscape. The hard, vertical form of Joachim on the right sharply differentiates him from the shepherds with their rounder forms. In adapting the

24

composition from the painting Spencer simplified the picture, eliminating the foliage in the foreground and moving Joachim to the front of the picture from his position half-way behind the fence. Two studies for *Joachim among the Shepherds* are also included in the exhibition (nos. 11 and 12).

25 The Centurion's Servant

[repr. in colour on p. 67]
1914
Oil on canvas
114.5 × 114.5 cm/45 × 45 ins
inscbr. 'Stanley Spencer Sept. 1914' on piece of canvas
turned over edge of stretcher
Lent by the Trustees of the Tate Gallery

The painting is based on Luke 7:1–10. Spencer intended to paint a companion picture, which was never carried out, showing the centurion's messenger appealing to Christ; his pose was to have echoed that of the servant lying on the bed. The two paintings were to be framed as a diptych, with the present picture on the left.

In the painting Spencer made use of a number of homely themes: his mother's account of the Cookham villagers praying round the bed of a dying man and the artist's own 'praying positions' in church, which were 'expressive of peace and contentment'. These were two ideas associated in his mind with the maid's bedroom in the attic of his home. Sometimes, at night, he could hear the servants conversing through the thin partition dividing the room from 'Belmont', the neighbouring house. The Spencer children were never allowed into this room and it acquired an atmosphere of mystery in which they could imagine a mystical event taking place. When the maid came downstairs in the morning the artist 'would not have been surprised to see her face shine as Moses's did when he came down from Mount Sinai' (Tate 733.3.1).

The servant's bed with its white, porcelain-decorated bed-posts is shown in the painting. The artist and his family posed for the four figures praying round the bed.

In an early example of the misunderstanding to which Spencer's work was sometimes subjected, Frank Rutter, reviewing the work in the 1927 Goupil Gallery exhibition, called it: '. . . one of the noblest pictures inspired by the war, a poignant expression of the agony of children during an air raid' (*The Sunday Times*, 27 Feb. 1927).

A small oil study for the painting, which once belonged to Henry Lamb, was sold at Sotheby's on 27 June 1979 (lot 86).

EXHIBITIONS
NEAC, winter 1915 (80)
Goupil Gallery, 1927 (83)
National Gallery, *British Painting since Whistler*, 1940 (188)
Tate Gallery, 1955 (12) dated 1914–15

REFERENCES
The Connoisseur, XLIV, 1916, p. 52
Wilenski, 1924, pp. 17–18, pl. 9
Johnson, 1932, p. 330
Frank Rutter, *Art in My Time*, 1933, pp. 174–6
E. Newton, 1947, pl. 4
J. T. Soby, *Contemporary Painters*, New York 1948, p. 124
M. Collis, 1962, pp. 22–3, 42, 46, 49, 191, 243
Robinson, 1979, p. 20, pl. 12

26

26 Study for The Betrayal (First Version)

1914
Pencil and wash
34.3 × 49.5 cm/13½ × 19½ ins
Lent by the Stanley Spencer Gallery, Cookham

This is one of two wash drawings made as studies for *The Betrayal (First Version)* (no. 27), painted in 1914. Spencer used the design with few changes in the final work. In the picture Christ, on the right, is seized by two soldiers, while a young follower flees, leaving his garment behind him. On the left, in an earlier incident, St Peter cuts off the ear of the High Priest's servant. The remaining disciples creep furtively away behind the wall.

Another drawing related to the Betrayal theme is included in the exhibition (no. 77).

27 The Betrayal (First Version)

[repr. in colour on p. 69]
1914
Oil on canvas
40.5 × 51.5 cm/16 × 20 ins
Lent by a Private Collector

The scene takes place behind the schoolroom in the Spencers' back garden at 'Fernlea', Cookham. Over the wall are the Malthouse buildings which appear in *Mending Cowls* (no. 30), painted in the following year. The idea for the picture had come to Spencer in 1914 while he was working on *Zacharias and Elizabeth* (no. 21); while studying the wall which runs down the middle of that painting, he had made a drawing of the disciples escaping from the scene of the Betrayal (this is probably the drawing in the Tate Gallery Archives, 733.3.81, p. 14). In the painting he had shown the moment when Simon Peter prepares to strike off the ear of the High Priest's servant (John 18), while the two soldiers on the right grasp Christ's robes. The unusual naked figure running through the centre of the composition leaving his garment behind is drawn from a passage in St Mark (Mark 15:51–2); 'And there followed him a certain young man, having a linen cloth cast about his naked

body: and the young men laid hold on him; and he left the linen cloth, and fled from them naked.'

Spencer was particularly interested in the furtive withdrawal of the disciples behind the wall which had been the original inspiration for the painting. Writing in 1937 he commented: 'For some time I had the motive [sic] in my mind of the disciples walking away. I was interested in the rhythm of the movement of the disciples produced by the disturbed thoughts at what was taking place. In Peter whose cloak is raised by the movement of his arm to strike off the ear of the High Priest's servant, I imagined he was irritated by the success of the High Priest's venture and the glib way he was marching off with Christ.' (Tate 733.3.1). Spencer was to repeat the successful devices of St Peter's cloak and the fleeing disciples in his second version of *The Betrayal* (no. 78), painted in 1923.

There are several studies for *The Betrayal* 1914: a sketch in the Tate Gallery Archives (Tate 733.3.81, p. 14), which is dated 1912, and is probably the original study; *Study for the Betrayal (First Version)* 1914 (see no. 26) is a working drawing for the central figure group. Another wash drawing, *Study for The Betrayal (Second Version)* (no. 77), is a later variation on the present composition.

28 The Resurrection of the Good and the Bad

1915
Oil on canvas, diptych
each 65 × 79 cm/25½ × 31 ins
Lent by a Private Collector

The picture was painted in the attic of the 'Ship Cottage', Cookham, where Spencer also worked on *Mending Cowls* 1915

(no. 30), parts of *The Centurion's Servant* 1914 (no. 25), and *Swan Upping* 1915–19 (no. 33).

This is Spencer's earliest treatment of the Resurrection, a theme which remained central to all his imaginative paintings. The unusual shape of the two compositions is due to the artist's plan that the pictures should be placed above the chancel arch in Cookham Church, a scheme which was never carried out.

In the paintings the Resurrection of the Good takes place on the left, and that of the Bad on the right. Spencer disliked the concept of rigid divisions between sinners and the faithful, and, despite his delight in the Book of Revelations, chose to eliminate Hell, replacing it with a world in which all might achieve everlasting life. In 1940 he confided to his diary: 'I cannot see Christ standing in Hell and giving a turn to some thumbscrew or scorching someone's shinbone, and being quite happy and harmonious in doing so.' Instead all would be saved with minimum discomfort: 'I love the Revelation and all it says but when I did the first biggish paintings of *The Resurrection of the Good and the Bad* . . . the punishment of the bad was to be no more than their coming out of the graves was not so easy as in the case of the good' (Tate 733.3.1). He further emphasised these differences by painting the Resurrection of the Good (on the left) in lighter colours, and covering the graves in flowers and grasses. The Bad break out from beneath plainer mounds.

Spencer used a similar opening-graves scene again in *The Resurrection, Cookham* c. 1920–21 (no. 55), but came closer to the present format in the centre right of *The Resurrection, Cookham* 1924–6 (no. 89).

A study for this painting was exhibited at the Goupil Gallery exhibition, 1927 (62).

EXHIBITION
Goupil Gallery, 1927 (52, 55)

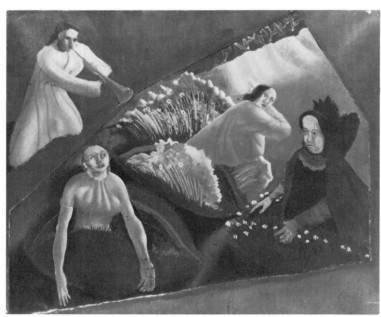
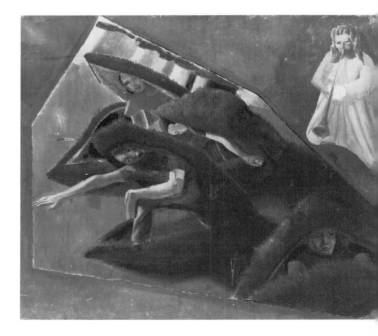

28

2 War and Marriage 1915–1927

During the period of Spencer's war service at Beaufort War Hospital, Bristol, and in Macedonia, he was unable to continue with his painting, and most of the few sketches which he made (see no. 32) were either given away or lost in the final assault on the Bulgarian lines. In April 1918, however, while he was still at the front, the Ministry of Information attempted to obtain his services as an official war artist as a substitute for the sculptor Jacob Epstein who for some reason was unacceptable to the War Artists' Committee. Because of bureaucratic obstructions Spencer was unable to leave his regiment, but on his return to England in December 1918 he submitted a series of new war studies to the Ministry, and was immediately commissioned to paint a large picture, *Travoys* (no. 34), depicting an event which he had witnessed in Macedonia. Before starting work however he completed *Swan Upping at Cookham* (no. 33) which had remained unfinished in 1915. *Travoys* was an immediate success when it was shown later at the War Paintings Exhibition in Burlington House, but Spencer refused a further commission from the Ministry of Information for two additional war pictures. Writing to Henry Lamb in July 1919 the artist explained: 'I set to work, but before many days elapsed, I began to feel too much as if I was cooking, so I wrote at once to Yockney to knock me off the job' (Carline, p. 112).

Superficially Spencer's life in Cookham returned to its relaxed pre-war routine. As he later recalled, 'I still felt – more surely if anything – the significance of what I had always felt here' (Robinson, p. 22). But his wartime experiences had undoubtedly had an unsettling effect on him, and this was exacerbated by cramped conditions and family tensions at home. In 1920, he was invited to stay with Sir Henry and Lady Slesser at their home across the river in Bourne End. Here, in a studio overlooking a backwater of the Thames, he began a series of religious paintings which were a continuation of his pre-war canvases. These included *The Last Supper* (no. 41), *Christ Carrying the Cross* (no. 45) and *Christ's Entry into Jerusalem* (no. 57), all set in the familiar surroundings of Cookham, and painted in the new paler tones which Spencer adopted after the completion of *Travoys* (no. 34) in 1919. Several smaller works from this time, such as *Bonds Steam Launch, Cookham* (no. 48) and *Rending the Veil of the Temple* (no. 66), also show that the artist was taking a renewed (if shortlived) interest in the work of his contemporaries, in particular Nevinson and Bomberg.

In the meantime Spencer was invited by Sir Michael Sadler to submit studies for the proposed decoration of Leeds Town Hall (see no. 42). The project fell through but it gave Spencer the opportunity to think in terms of large scale paintings in an architectural setting. This was to help him at Burghclere. Later, in June 1920, Spencer joined his brother Gilbert and Henry Lamb at Durweston, Dorset, for a short spell of landscape painting (see no. 50).

On his return in July Spencer's fruitful stay at the Slessers came to an end when he was invited by Muirhead Bone to paint a series of pictures for a war memorial in Steep village hall, near Petersfield (see no. 64). This commission, too, fell through, due this time to delays on the part of the artist; but Spencer did complete two other works, *Unveiling Cookham War Memorial* (no. 68), commissioned by Sir Michael Sadler, and *The Crucifixion* (no. 65), which may have been related to the Steep decoration.

Growing increasingly attached to Hilda Carline, who was to become his wife in 1925, he accompanied the Carlines in July 1922 to Yugoslavia attracted by memories of his wartime experiences in Macedonia. On the journey he painted some of his finest early landscapes (nos. 69, 72). Back in England Spencer enrolled in the Slade School for the Spring term, 1923, before going to stay with Henry Lamb at Poole, Dorset, in April. Here he composed a series of war studies based on his experiences in Bristol and Macedonia. These were seen by Mr and Mrs J. L. Behrend, who decided to commission him to paint the mural decorations for the Memorial Chapel at Burghclere.

Spencer returned to London in October 1923, and used Henry Lamb's studio on the top floor of the Vale Hotel, Vale of Health (see no. 83). Here he began work on his most important picture to date, *The Resurrection, Cookham* (no. 89), which was developed from ideas conceived as early as 1920 (see no. 55). Work on the big nine by eighteen-foot canvas began in February 1924 and took up much of Spencer's time until it was completed in March 1926. When it was exhibited at Spencer's first one-man exhibition at the Goupil Gallery in February 1927 it created a sensation, and firmly established his reputation as one of Britain's leading artists. In the meantime Spencer completed a commission for 25 illustrations to an Almanac for Chatto & Windus. In 1927 he began his most important commission, the Sandham Memorial Chapel at Burghclere.

29

29 Study for Mending Cowls

c. 1915
Oil on board
15.2 × 15.2 cm/6 × 6 ins
Lent by a Private Collector

One of the earliest surviving oil sketches made by Spencer as preliminary studies for his larger compositions. These were probably used to establish the overall design and tonal values before work began on the canvas. The tones of grey and blue-grey used in the sketch reappear in paintings of the immediate post-war period like *Christ Carrying the Cross* 1920 (no. 45) and *Bonds Steam Launch c.* 1920 (no. 48).

Spencer gave the sketch to the artist James ('Jas') Wood, who had also bought *The Visitation* 1912 (no. 16). Wood had

originally tried to buy *Mending Cowls* 1915 (no. 30), but he was probably outbid for the work by Henry Lamb. In a letter written to Wood in May 1916 Spencer told him: 'You must see Lamb about the Cowl picture and fight it out with him.' He went on, 'I can quite understand you having some misgivings when you saw it as it has a sort of "suppressed emotions" tendency. But I did that thing not because of the "composition" it made; some people might say it had a "fine sense of solid composition", such people know nothing of the feelings that caused me to paint it. There are certain children in Cookham, certain corners of roads and these cowls, all give me one feeling only. I am always wanting to express that' (Tate Tam 19). Obtaining the oil study must have compensated Wood, at least in part, for his failure to buy *Mending Cowls*.

Spencer did not record the picture in his extensive painting lists (Tate Tam 733.3.12 and 733.3.88), and it has never previously been exhibited.

30 Mending Cowls, Cookham

1915
Oil on canvas
109 × 109 cm/43 × 43 ins
Lent by the Trustees of the Tate Gallery

A view of the Cookham oasthouses from the nursery window of 'Fernlea'. The picture was painted in the attic of the 'Ship Cottage'

30

from a small oil study taken directly from the subject (see no. 29). Spencer was about to begin the picture when he wrote to Henry Lamb (24 March 1915, Tate Tam 11) enclosing a small pencil sketch; on 19 July he informed Lamb that it was finished.

The artist described his intense feeling for the cowls in a note made in Port Glasgow in 1944: 'They seemed to be always looking at something or somewhere. When they veered round towards us, they seemed to be looking at something above our own nursery window, and when they turned away to be looking down. The earth by the base of these very big malthouse buildings was never visited by us, so that they were a presence in the midst of the maze of Cookham. From wherever seen, they were somehow benign. With their white wooden heads, they served as reminders of a religious presence' (Carline, p. 44).

The cowls reappear in the background of *The Betrayal (First Version)* 1914 (no. 27), and *The Betrayal (Second Version)* 1923 (no. 78).

EXHIBITIONS
NEAC, 1915–16 (150), as *Mending Cowls*
CAS, *Paintings and Drawings*, Grosvenor House, 1923 (103)
Goupil Gallery, 1927 (81)
British Institute of Adult Education tour, *A Loan Exhibition of Paintings and Drawings*, 1935–6
Leger Gallery, 1939 (24), as *Mending Cowls, Cookham (1914)*
Oldham, *Paintings of Today*, 1940 (7)
English Speaking Union, USA tour, *British Art, The Last Fifty Years, 1900–1950*, 1951 (34)
Newcastle-upon-Tyne, Laing Art Gallery, 1953 (39)
Tate Gallery, 1955 (11)
Leicester Galleries, *The J. L. Behrend Collection*, 1962 (33, repr. p. 10)
RA, 1963 (83)

REFERENCES
Wilenski, 1924, pp. 15–16, pl. 7
Johnson, 1932, pp. 328–9
E. Newton, 1947, pl. 1 (in colour)
G. Spencer, 1961, p. 112
M. Collis, 1962, p. 74 as painted in 1912 (243)
Carline, pp. 44, 48, 158

31 The Supper at Emmaus

1915
Pencil and sepia wash
22.9 × 24.1 cm/9 × 9½ ins
From the collection of the late W. A. Evill

The subject is taken from Luke 24:13–31. In the picture Spencer has chosen the moment when Christ, seated on the right, is recognised by the disciples as he blesses and breaks the bread. The study is drawn in Spencer's early 'Giottesque' style using a minimum of detail, and placing great emphasis on the gestures of the three participants. The benches were probably copies from ones the artist had seen in Cookham.

Spencer included an identical study in a letter to Henry Lamb of 13 May 1915 (Tate Tam 11), shortly before he joined the RAMC. Another version (10.2 × 10.2 cm/4 × 4 ins, badly foxed) is in a Private Collection.

Although he painted further New Testament scenes after the war, Spencer did not attempt to use this study for an oil painting.

31

EXHIBITIONS
Leicester Galleries, 1951 (19)
Arts Council, 1954–5 (12)
Brighton, 1965 (216)

32 Portrait of a Soldier

1917
Pencil drawing on a page from a notebook
16.5 × 12 cm/6½ × 4¼ ins
inscbl. 'S. Spencer, Salonica, 1917'
Lent by William Darby

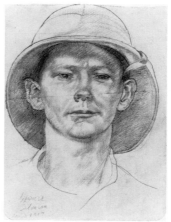

32

In December 1917 Spencer wrote to his sister Florence: 'I am doing drawings of several fellows in this ambulance (66th). One I am doing of the SM ought to turn out well'; and on 14 December he again reported that, while in hospital, 'I draw heads all day long while I am in here' (Tate 756–9).

Spencer's work during the war was confined to portrait drawings of fellow soldiers (see display case), which he began at Beaufort Hospital in Bristol, and continued to do at Tweseldown military camp, and in Macedonia. The few other small sketches which he made (including an early study for *Travoys*, no. 34) were lost when they were left behind in the last big campaign on the Macedonian front. Only one tiny sketch survives which records Spencer's return journey to England through Europe in 1918 (see display case).

Because Spencer usually gave away his portrait drawings to the sitters they have rarely survived – not surprisingly, as these

fragile pieces of paper would probably have received rough treatment in the ensuing military campaigns. To date there are only two known drawings from this period: the present work, probably brought back to England by the soldier himself, and an earlier drawing (see display case).

33 Swan Upping at Cookham

[repr. in colour on p. 70]
1915–19
Oil on canvas
148 × 115.5 cm/58¼ × 45¾ ins
insc. 'S. Spencer 1915–1919' on back of stretcher
Lent by the Trustees of the Tate Gallery

Spencer began the picture on 24 March 1915 in the attic of the 'Ship Cottage', Cookham, but only the top half had been painted when he enlisted in the RAMC in July. It was completed on his return to Cookham after demobilisation in 1919.

The theme of the painting is the annual swan upping or swan hopping, when officials of the Companies of Vintners and Dyers, who by royal licence own the swans on the river Thames, collect the young birds for marking. In the picture the birds are taken ashore in carpenters' bags at the landing stage outside Turk's Boat House, near the Ferry Hotel, Cookham. In the background is Cookham Bridge (see no. 46).

The idea for the picture came to Spencer in church: 'I could hear the people going on the river as I sat in our north aisle pew', he wrote in Port Glasgow in the forties (Carline, p. 44). This gave him the desire to take 'the in-church feeling out of church', and transfer it to another part of Cookham, in this case the river. These feelings were given their final form when he saw the swans, each in a carpenter's bag, being taken through the village in a wheelbarrow, and the Bailey girls, who appear in the painting, carrying old chair-cushions down to the river.

In preparing for the picture the artist avoided making studies by the river, as he did not wish to be affected by outside influences (Tate Gallery, catalogue, 1968, p. 673). He painted a small oil study which was once in the Behrend Collection, and made a number of drawings (letter to Henry Lamb, May 1915, Tate Tam 11). Only afterwards did he visit the river to see if he had achieved the atmosphere he was looking for.

The picture was purchased from the artist by J. L. Behrend, the patron who also commissioned the Burghclere Chapel.

REFERENCES
Wilenski, 1924, pp. 16–17, pl. 10
Johnson, 1932, pp. 329–30, repr. p. 476
M. Chamot, 1937, p. 73
E. Rothenstein, 1945, pp. 10–11, repr. p. 20 (in colour)
E. Newton, 1947, pl. 6
J. T. Soby, Contemporary Painters, New York, 1948, p. 12, repr. p. 125
G. Spencer, 1961, pp. 112, 135, 152
M. Collis, 1962, pp. 65, 243
Carline, pp. 44, 46, 110, 112
Robinson, 1979, pl. 16 (in colour)

34 Travoys with Wounded Soldiers Arriving at a Dressing Station at Smol, Macedonia

[repr. in colour on p. 68]
1919
Oil on canvas
182.9 × 218.4 cm/72 × 86 ins
Lent by the Trustees of the Imperial War Museum

Spencer painted this picture for the Ministry of Information in his bedroom at 'Fernlea', Cookham, moving later to Lambert's Stables, which was better lit and roomier. It is based upon his experiences on active service in Macedonia. The event depicted is the scene at a dressing station during an attack on Machine Gun Hill in the Dorian-Vardar section made by the 22nd Division about the middle of September 1916. The wounded were brought down to the dressing stations by means of the mule-drawn stretchers shown in the painting. Spencer recalled the experience in a letter to Hilda Carline in the summer of 1923: 'I was standing a little away from the old Greek church, which was used as a dressing station and operating theatre, and coming there were rows of travoys with wounded and limbers crammed full of wounded men. One would have thought that the scene was a sordid one, a terrible scene . . . but I felt there was a grandeur . . . all those wounded men were calm and at peace with everything, so that pain seemed a small thing with them. I felt there was a spiritual ascendency over everything.' (Carline, p. 112). Spencer again tried to express this feeling of calm in a notebook of 1937: '. . . [it] is intended to convey a sense of peace in the middle of confusion. The figures on the stretchers treated with the same veneration and awe as so many crucified Jesus Christs and not as conveying suffering but as conveying a happy atmosphere of peace. Also like Christs on the Cross they belong to another world from those tending them' (Tate 733.3.1).

The origin of the MOI commission was a recommendation by the artist Muirhead Bone in 1918 that Spencer, then on active service, should be made a war artist. A. Yockney, in charge of the war artists at the Ministry, suggested as the subject of his first picture a religious service at the front (Imperial War Museum archives). Spencer's initial enthusiasm for this project was thwarted by the MOI's failure to secure his release from his regiment. It was only in December 1919, invalided out of Macedonia on the 'Y' (malaria sufferers) scheme, that he was able to start work on the painting.

Unfortunately all the sketches which Spencer had made in Macedonia, including the original drawing for *Travoys*, made in 1917, had been left behind with his other personal effects and those of his companions in a bath-house in Smol, when the Berkshire Regiment was involved in the last big offensive of the war. Despite attempts by Yockney, these were never recovered, and Spencer had to recreate his ideas from memory, doing so in a series of small wash drawings depicting scenes from the front, which he then submitted to Yockney (see no. 35). By 6 February 1919 Spencer reported that 'the picture is begun and goes apace' (Imperial War Museum archives), and by June, when Yockney and Bone visited him in Cookham, it was completed.

In the process of designing the picture Spencer made a number of sketches of travoys scenes, including *Travoys along Sedemli Ravine* (no. 35), and *Wounded Being Carried by Mules* (no. 36). These two works were either intended as separate pictures, or were rejected in favour of the much bolder composition which was finally adopted. In transferring this design to the canvas, Spencer made a number of changes; he enlarged the beautiful fan-like group of travoys and mules, and the open doorway to the operating theatre, so that this scene nearly fills the picture, while the outbuilding and limbers are reduced in size and pushed back towards the side of the composition. The resulting picture is more monumental in scale, and the effect is to draw the eye in over the inert figures on the travoys and the patient forms of the mules into the warm light of the makeshift operating theatre. Spencer probably made other working drawings for all the details of the painting, but only five seem to have survived. Of these four are individual pencil sketches for the travoys and the wounded lying on them. Another, *Travoys with Wounded Soldiers* (18 × 23 cm/7 ×9 ins, Imperial War Museum), is a study for the oil painting.

Originally *Travoys* was intended to be the first of a series of Macedonian war pictures, and Yockney had already given Spencer a further two-month commission to work on 'two small compositions' (Yockney to Spencer, 18 July 1919, Imperial War Museum archives) probably nos. 37 and 38, which had impressed him and Bone on their visit to Cookham in June 1919. However, the spirit of inspiration which had remained with Spencer since his return to Cookham had now faded and in July 1919 he told Yockney that he seemed 'to have lost my ''Balkanish feelings'' and I do not like doing things that are not absolutely my best works'. He was not to return to the theme of his war experiences until 1923, when he began work on the designs for what became the Sandham Memorial Chapel at Burghclere.

EXHIBITIONS
RA, *The Imperial War Museum, The Nation's War Paintings*, 1919–20 (75)
Manchester City Art Gallery, 1920 (120)
Tate Gallery, on loan 1921–4
Society of Scottish Artists, 1930–31
Arts Council, 1961 (24)
Plymouth, 1963 (6)
Arts Council, 1976–7 (3)

REFERENCES
Wilenski, 1924, pp. 19–20, pl. 11
J. Rothenstein, *English Artists and the War*, London 1931, pl. LXII
C. Johnson, *English Painting from the Seventh Century to the Present Day*, London 1932, pp. 330

M. Chamot, *Modern Painting in England*, London 1937, pp. 74–5
Studio, 118, 1937, repr. p. 229
E. Newton, 1947, pl. 8
J. T. Soby, *Contemporary Painters*, New York 1948, pp. 125–6
M. Collis, 1962, pp. 38, 52, 67
Caline, pp. 86, 110, 112–4, 120, 145, 209, pl. 15. 16. 17
Robinson, 1979, pp. 22–3, pl. 14

35 Travoys along Sedemli Ravine

1919
Pencil and sepia wash
24.1 × 25.5 cm/9½ × 10 ins
Lent by the Trustees of the Imperial War Museum

The sketch is one of several drawings which Spencer made while working as a war artist for the Ministry of Information upon his return from war service in Macedonia.

After completing *Travoys with Wounded Soldiers* 1919 (no. 34) for the Ministry, Spencer found his interest in war painting beginning to fade. In an attempt to persuade him to continue his work, the artist Muirhead Bone suggested through the Ministry that Spencer should work for an additional month enlarging some of the drawings originally submitted to them for approval (letter to Spencer, 18 July 1919, Imperial War Museum archives). Of these *Sedemli Ravine* was singled out as being the only composition which was already suitably complete.

Spencer had been to Sedemli Ravine while serving with the 68th Field Ambulance, which was camped at Corsica near Carasuli, forty miles north of Salonika and ten miles from the Bulgarian lines. At the time his duties involved handling the transport mules and, as he recalled in his unpublished memoirs 'At Corsica Camp I used to go with parties of about ten or twenty men with stretchers to . . . the Sedemli ravine, which was a river bed sometimes with river and sometimes dry, to where one met the regimental stretcher-bearers' (Carline, p. 72). The sketch records this experience, and shows the mules and travoys carrying their wounded with their attendant orderlies and muleteers, proceeding along the edge of the river bed.

REFERENCE
Carline, pp. 72, 75, 208, pl. 11

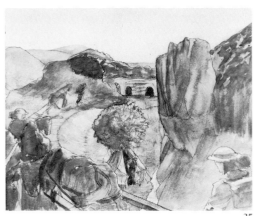

35

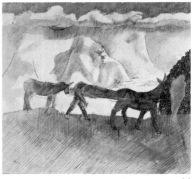

36

36 Wounded Being Carried by Mules in Macedonia

c. 1918
Pen and wash drawing
14 × 17 cm/5½ × 6⅝ ins
Lent by the Piccadilly Gallery

Another of the sketches made by Spencer upon his return from active service in Macedonia. In this small study a wounded man is carried on a stretcher slung between two mules, a variation on the travoys which appear in *Travoys along Sedemli Ravine* (no. 35). Spencer later explained some of his feelings about Macedonia in his reminiscences: 'I had got out at Karasuli', he wrote, 'and with a small group of field ambulance men were assembled on the little road track, similar to the one that goes along the bottom of Cockmarsh Hill [Cookham], I thought: . . . along this track, which wandered along the foot of some line of hills . . . from Karasuli to Kalinova, most of what was vital to me in Macedonia was felt. Whatever the number of kilos it is, 10 or 20, each one is a part of my soul' (Carline, p. 71). The drawing may have been among those which Spencer submitted to the Ministry of Information in 1918 (see no. 34) as ideas for officially commissioned war paintings.

EXHIBITION
Piccadilly Gallery, 1978 (12)

37 Scrubbing Clothes

1919
Oil on millboard
17.8 × 22.9 cm/7 × 9 ins
Lent by a Private Collector

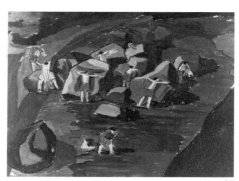

37

One of two oil sketches depicting soldiers on the Macedonian front in the First World War (see also no. 38). The composition was later included in expanded form as part of the Todorovo scenes in the Burghclere Chapel. In the scene men of the Field Ambulance, to which the artist belonged, scrub their clothes on boulders by the banks of the river in the Struma valley (Tate Tam 19, *c.* 1930).

 This sketch and *Making a Red Cross* (no. 38) were probably preliminary designs for two small paintings commissioned by A. Yockney for the Ministry of Information in June 1919 (Imperial War Museum archives). A. Yockney and Muirhead Bone, who was involved in the War Artists' scheme, had both been impressed by *Travoys with Wounded Soldiers Arriving at a Dressing Station in Smol, Macedonia* (no. 34), and hoped that Spencer would continue to paint for the Ministry. But Spencer asked to be released from the commission as he felt he had lost his 'Balkanish' feelings. 'Had [the commission] lasted for a number of years', he wrote, 'I should not have turned it down, for I still have hope in the next few years to do something good out of my Balkan experiences' (Imperial War Museum archives). In fact, Spencer returned to his war painting ideas again in 1921–2 with the support of Muirhead Bone, who commissioned him to paint a War Memorial for Steep village hall (see no. 64). The paintings for the Burghclere Chapel included elements of both the small 1919 oil sketches, as part of *River Bed at Todorovo*, the decoration of the upper register of the south wall.

EXHIBITIONS
Goupil Gallery, 1927 (66)
Arts Council, 1976–7 (5)

38 Making a Red Cross

1919
Oil on millboard
17.8 × 22.9 cm/7 × 9 ins
Lent by a Private Collector

The second of two oil sketches (see no. 37) of soldiers on the Macedonian front in the First World War. In the picture men of Spencer's unit lay out a red cross made of broken tiles and rocks taken from a nearby river bed, as a recognition signal to aircraft. Later, when he was painting the Burghclere murals, the artist adapted the painting, together with *Scrubbing Clothes*, as the central part of *River Bed at Todorovo*.

EXHIBITIONS
Goupil Gallery, 1927 (64), exhibited as *Hospital Signal for Aircraft Study*
Arts Council 1967–7 (4)

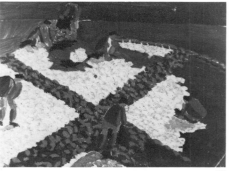

38

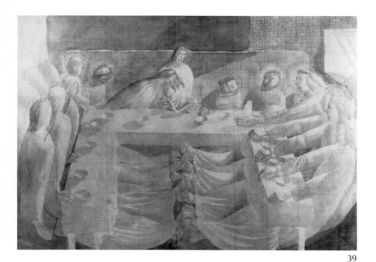

39

40

39 Study for The Last Supper

c. 1919
Pencil and wash
53.3 × 73.6 cm/21 × 29 ins, squared for transfer
Lent by a Private Collector, London

A study for *The Last Supper* (no. 41) painted in 1920, this
unusually large composition is probably the design mentioned
by Spencer to Henry Lamb in a letter dated 3 September 1919
(Carline, p. 123). With the exception of some minor alterations
to correct the perspective the design was transferred directly to
the canvas. At this time Spencer was making increased use of
highly finished wash drawings as studies for his paintings (see
also no. 43), and by 1922 they had almost entirely superseded
the small oil studies which he had relied on before the war. The
drawing was originally owned by Mr and Mrs J. L. Behrend.

EXHIBITION
Arts Council, 1954–5 (14), pl. 1

REFERENCE
Carline, p. 123

portraits, is painted in the dark tones also found in the Tate
Self-Portrait (no. 23) of 1914, and which persisted until about
1932, when his use of colour became brighter, and the forms
more broadly brushed. The view of the fireplace shows an early
interest in decorative background detail which later crowded
the sitters in his portraits of the forties and fifties.

A preparatory study for this portrait is on the verso of *First
Study for Opening Graves for the Resurrection c.* 1920 (no. 54).

EXHIBITIONS
Leeds, 1947 (5)
Piccadilly Gallery, 1978 (1)

40 Portrait of Lady Slesser

c. 1920
Oil on canvas
71 × 61 cm/28 × 24 ins
Lent by a Private Collector

Spencer first met Henry Slesser (later Sir Henry Slesser,
Solicitor General in the Labour government of the twenties) and
his wife, Margaret, when his friends the Behrends took him and
Gilbert Spencer to tea with them at 'Cornerways', Bourne End,
near Cookham in November 1919. The Slessers invited him to
stay with them and, needing somewhere to work in peace, he
readily accepted, though he did not finally move in until April
1920. At 'Cornerways' he was given a bedroom which
overlooked a reach of the Thames, and it was here that he
painted nearly twenty pictures during the year of his stay,
including *The Last Supper* 1920 (no. 41).

This picture, one of Spencer's most accomplished early

41 The Last Supper

1920
Oil on canvas
91.5 × 122 cm/36 × 48 ins
Lent by the Stanley Spencer Gallery, Cookham

In 1915, shortly after he had finished *Mending Cowls* (no. 30),
Spencer used the interior of the building for a sketch of the
Last Supper. After the war was over, in 1919, he returned to the
subject, reporting to his friend Henry Lamb on 3 September:
'I have nearly finished a composition of the Last Supper which
I think you will dislike in the same way that you dislike the
Entombment.' This composition was probably the one exhibited
in the drawing section (no. 39). However it was not until April
1920, when he went to live with the Slessers, that he was able
to begin work on the painting, which he completed during the
summer of that year. By 22 July he was writing to Lamb again

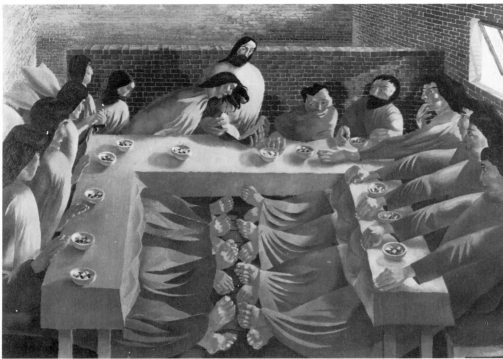

41

to report that he had completed *The Last Supper*, but he felt it 'has not got the nice feeling that the drawing has got somehow' (Tate Tam 11).

His own doubts were not shared by others, and there was talk of the Contemporary Art Society buying it. Henry Slesser, however, 'liked it so much that . . . he does not want it to leave the house' (*ibid.*), and he duly purchased the picture for £150. The painting was then hung as an altarpiece in the Slessers' private chapel. It is now to be seen in Cookham Church.

The scene of *The Last Supper* takes place inside the Cookham malthouse with the red wall of a grain bin in the background. Christ is shown at the moment he breaks the bread (Matthew 26:26) and, in accordance with tradition, St John sleeps on his shoulder. Spencer would have been aware of these conventions through his study of early Italian painting in the National Gallery and his Gowans and Grays art books. The composition belongs to his early 'Giottesque' style, of large broadly-painted figures in a simple architectural setting. Spencer's three 1915 drawings (10.16 × 25.4 cm/4 × 10 ins, 20.32 × 25.4 cm/ 8 × 10 ins, 20.32 × 25.4 cm/8 × 10 ins, Private Collection) show that he tried out a number of variations of the subject, with the tables viewed from the side and oblique angles, before he settled on the present design, which he could have seen in Giotto's *Marriage Feast in Cana*, in the Arena Chapel, Padua (a Gowans and Gray subject). The extraordinary device of the legs protruding from under the table was a later addition, first appearing in the 1919 study (no. 39).

Spencer's own feelings about the picture were mixed. Writing in 1937, he commented: 'I liked the red wall among the sandy coloured ones. Could not get the feeling of the place which at the beginning was indivisible from a concept I had of Christ, but I could never get it in the picture' (Tate 733.3.1).

Another version of *The Last Supper* was painted in 1922, as part of a predella to *The Betrayal* 1923 (no. 78).

EXHIBITIONS
NEAC, *64th Exhibition*, 1921 (3)
Leger Gallery, 1939 (15)
National Gallery, *British Painting since Whistler*, 1940 (150)
CAS, *The Private Collector*, 1950 (256)
Tate Gallery, 1955 (18)
Cookham, 1962, and subsequently Cardiff, Llandaff Cathedral, *Stanley Spencer, Religious Paintings*, 1965
Arts Council, 1976–7 (6)
In recent years the picture has hung permanently in Cookham Church.

REFERENCES
Wilenski, 1924, pl. 14
E. Rothenstein, 1945, pls. 15–17
E. Newton, 1947, pl. 5
Studio, vol. 119, 1940, p. 185, repr.
J. Rothenstein, *Modern English Painters II, Lewis to Moore*, 1956
G. Spencer, 1961, p. 161
M. Collis, 1962, pp. 69–70, 245
Cookham, Stanley Spencer Gallery, winter 1963–4, repr. on cover
Carline, p. 123
J. Rothenstein, 1979, pp. 73, 118, 130, 144
Robinson, 1979, pp. 25–6, pl. 19

42 Study for the Leeds Decoration

1920
Pencil on paper
50.2 × 34.9 cm/19¾ × 13¾ ins
Lent by Leeds City Art Galleries

In 1920 Sir Michael Sadler tried to persuade the Leeds City authorities to commission a series of large-scale works for the decoration of Leeds Town Hall. Sadler chose six artists, Stanley Spencer, Edward Wadsworth, Albert Rutherston, Jacob Kramer, and John and Paul Nash, who were asked to produce

rough sketches under the supervision of Sir William Rothenstein.

Spencer, delighted at the opportunity to work on a large scale, visited Leeds in March 1920, only to have his preliminary sketch rejected by Rothenstein. Reluctant to exclude Spencer altogether, Sadler invited him up for a second visit on 21 June. This gave him a better opportunity to look about the city, and he was deeply impressed by what he saw. Writing to his sister, Florence Image, on 21 June, he reported: 'It would be impossible to describe the place. . . . Just to give you an idea of what Leeds is like, I poked my head out of my bedroom window the other day and I heard people singing in another building. . . . I was in the worst slums most of the time. The smells were vile but it was very sad and wonderful. I am particularly keen on the washing day in the slum. I have a magnificent idea for the Leeds picture. They hang the washing on a line from the windows, and it swings forward on to some railing in front of the house' (Carline, p. 122). These ideas had clarified by 22 July, when he wrote to Henry Lamb: '. . . I walked about the slums. I noticed that there would be one long road and several little blind alleys leading out of the road. It was these blind alleys that gave me the idea, at least part of it. Everything that happens in these slum homes happens on the pavement, so that you can see the difference between the ''happening'', as you can see all the different lives of the families going on all at the same time. And then the washing is wonderful, each alley is chock full of washing, all blowing upwards. The wind is very blustery in Leeds' (Carline, pp. 122–3).

Spencer incorporated these ideas into the drawing, showing the pony and trap, and washing scenes against the industrial background of the colliery winding wheels. This formed the basis for an oil sketch, *Second Study for the Leeds Decoration* (49.5 × 34.3 cm/19½ × 13½ ins), formerly in the collection of Sir Michael Sadler. Unfortunately Sadler's project fell through and the large-scale paintings were never carried out.

There is a further oil study for the Leeds competition (dimensions unknown), which belonged to the late Sir William Rothenstein. A drawing, *Sketch for a Composition* (9 × 10.5 cm/3½ × 10¼ ins, Carline pl. 18), may be related to the early study rejected by Rothenstein. Another sketch, *Washing, Study for Leeds Decoration* (pencil and wash, 24.5 × 34.5 cm/9½ × 13½ ins) was exhibited at the Piccadilly Gallery, 1978 (16).

REFERENCES
Leeds Art Calendar
Carline, pp. 121–4, 209

43 Study for Christ Carrying the Cross

c. 1920
Pencil and sepia wash
57.1 × 38.1 cm/22½ × 15 ins
sbr. 'Stanley Cookham Spencer'
From the collection of the late W. A. Evill

The drawing is an early study for *Christ Carrying the Cross* 1920 (no. 45). In it Spencer adopted a viewpoint directly opposite his family home, 'Fernlea', in a composition based on the symmetry between the house, and the cross and four bearers passing before it, which are outlined by the spiky tops of the privet hedge. In a later study (no. 44), used for the oil painting, the idea of the onlookers bursting from the windows of the house is retained, but the composition is transformed into a series of diagonals created by the houses and an iron fence in the foreground. 'Fernlea' is moved to the left, and a neighbouring house, 'The Nest', inserted beyond it on the right. The empty foreground is replaced by a crowd of onlookers who stare through the railings. The transition from the severe abstract design of the present study to the crowded events of the canvas

42

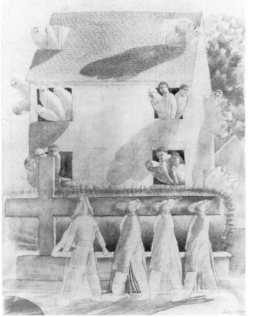

43

shows a development in the artist's thinking from formal to more anecdotal.

This is an early example of the use of pencil and sepia wash, which began to replace pen and ink as the artist's favoured medium.

EXHIBITIONS
Leeds, 1947 (93)
Brighton, 1965 (237)

REFERENCE
Carline, pp. 125, 126

44

44 Sketch for Christ Carrying the Cross

1920
Pencil and sepia wash
36 × 33 cm/14½ × 13 ins, squared for transfer
Lent by Richard Carline

This is the final study for *Christ Carrying the Cross* 1920 (no. 45), in which the scene takes place in front of 'Fernlea', Cookham. It was included in the Goupil Gallery exhibition (15) of 1927, after which Spencer gave it to Richard Carline.

There are at least two other studies for the painting: *Christ Carrying the Cross*, pencil and wash, 25.4 × 22.9 cm/10 × 9 ins (Stanley Spencer Gallery, Cookham); and *Study for Christ Carrying the Cross*, pencil and sepia wash, 57.1 × 38.1 cm/ 22½ × 15 ins (no. 43).

EXHIBITIONS
Goupil Gallery, 1927 (15)
Arts Council, 1954 (15)
Plymouth, 1963 (62)

REFERENCE
Carline, pp. 125, 126, 209, pl. 20

45 Christ Carrying the Cross

[repr. in colour on p. 71]
1920
Oil on canvas
153 × 143 cm/60¼ × 56¼ ins
Lent by the Trustees of the Tate Gallery

Painted while the artist was staying with Sir Henry and Lady Slesser at 'Cornerways', Bourne End, the picture was prompted by Spencer's desire 'to take the inmost of one's wishes, the most varied religious feelings . . . and to make it an ordinary fact of the street, like the edge of a roof' (Tate 733.3.1).

The scene was inspired by a *Daily Mail* report of the death of Queen Victoria, quoted by Sir Henry as an example of journalistic sensationalism, which ran: 'Women publicly wept and strong men broke down in side streets.' This suggested to the artist that at the death of Christ, the Virgin (shown in the foreground) might have moved into a side street to be unobserved. The house is 'Fernlea', and the ivy-covered cottage, 'The Nest', belonged to his grandmother. He associated the cottage window with a large yew tree from which as a child he 'could survey the worlds not only in our own garden, but other gardens beyond. . . .' (Tate Gallery catalogue, 1968, pp. 660–1).

When planning the painting Spencer saw Fairchilds the builder's men going past 'The Nest' carrying their ladders, and this seemed to him 'one part of the "fact" of Christ carrying the cross'. They symbolised Spencer's feelings of joy at '. . . all the common everyday occurrences in the village', which 'were reassuring, comforting occurrences of that joy. . . . I had as a child no thought that Christ had made everything wonderful and glorious and that I might be able later on to join in that glory' (Tate Gallery catalogue, 1968, p. 660).

The events in the painting were inspired by childhood memories of Cookham: 'As youths we stood in a gate opposite our house and watched the people go by on Sundays and in the evenings. The three men in the central part of the bottom of this picture form the onlooker part of the scene. To the left of the picture there is a wide street coming towards the spectator, through the iron palings at the side of which other men peer down at the stooping figure of the Virgin' (*ibid.*, p. 661).

In 1955 the artist described to the compiler of the Tate Gallery catalogue (pp. 660–1) how the painting underwent a series of changes while it was being composed: 'The movement of the way to Calvary passes from the right to the left. Rather the movement of a breaker approaching the shore. . . . The Cross as far as its position in the picture is concerned is right enough, but I still feel it is a pity that I failed to arrive at the notion I hoped for. I had made several drawing attempts of the Cross and disciples ranged somewhat procession-wise either side of it, some of the soldiers helping in the carrying of the Cross . . . some escorting them.' This stage is shown in no. 43. The idea was substantially modified to include the foreground figures and the builder's men.

A pencil and sepia wash drawing, *Study for Christ Carrying the Cross* (no. 43), is an early study for the painting; and a further sketch, no. 44, is a working drawing for the final composition. Another drawing (24.5 × 22.9 cm/10 × 9 ins) in the Stanley Spencer Gallery, Cookham, shows a detail of the house on the left.

EXHIBITIONS
Grosvenor Galleries, *Nameless Exhibition*, 1921 (19)
CAS, *Paintings and Drawings*, Grosvenor House 1923 (122)
Tate Gallery, 1955 (17)

REFERENCES
Wilenski, 1924, pp. 27–8, pl. 15
Johnson, 1932, p. 331
Wilenski, 1933, pp. 284–5, pl. 131
M. Chamot, 1937, p. 74
E. Rothenstein, 1945, pl. 14
A. Bertram, *A Century of British Painting, 1851–1951*, 1951, p. 195, pl. 190 (in colour)
G. Spencer, 1961, pp. 158, 167
M. Collis, 1962, pp. 20
Carline, pp. 124–5, 129, 209
Robinson, 1979, p. 23, pl. 15

46 The Bridge

1920
Oil on canvas
121.5 × 122.5 cm/47¾ × 48¼ ins
Lent by the Trustees of the Tate Gallery

According to the artist's records this picture was painted in 1920, although it is dated 1919 in the catalogue of the 1942 Leicester Galleries exhibition. In a note on the picture written in 1937, Spencer recalled that it was painted in the 'Fee School, Maidenhead' (Tate 733.3.1). This suggests that the work was finished before Spencer went to live with the Slessers at Bourne End in April 1920, when he no longer had to use makeshift studios like the Fee School for his larger paintings. This is supported by Gilbert Spencer's comment (Tate Gallery catalogue, 1968, p. 665) that the picture was the last to be painted while the artist was living at 'Fernlea' until his return there in 1959.

Spencer considered the picture a failure, and his future brother-in-law, Richard Carline, had to intervene to prevent him from destroying the work. It was not finally offered for sale until the Leicester Galleries exhibition in 1942, when it was purchased by the National Art-Collections Fund. In 1937 Spencer blamed the environment of the Fee School for his difficulties: 'Somehow I felt suspended and could get no grip,' he wrote (Tate 733.3.1). He went on to suggest that the disposition of the figures on the bridge was successful, but his attempt to capture the atmosphere of Cookham Bridge was not.

In the painting Spencer transformed the cast-iron balustrade of the bridge (shown in *Swan Upping*, no. 33) into a stone structure. The activities on the bridge suggest that the people are watching a boat race on the river and are moving from one side to the other as the boats pass underneath. The Airedale terrier dog in the foreground was called 'Tinker' and belonged to Guy Lacey, who taught the Spencer brothers to swim (Tate Gallery catalogue, 1968, p. 665). The artist found the branch of jasmine which appears in front of the balustrade on the left in King Street.

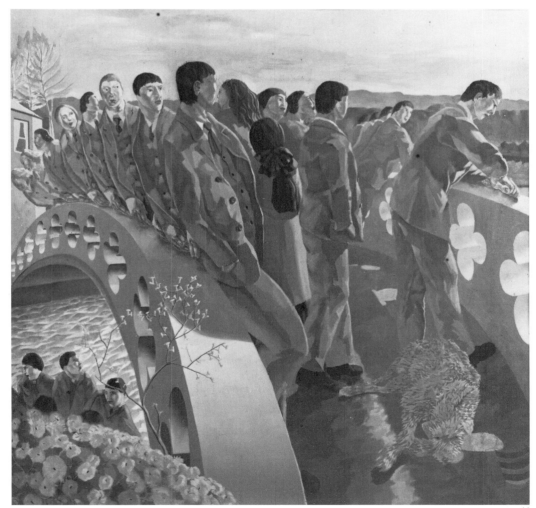

46

This painting shows the new range of paler colours which the artist had begun to use shortly after the completion of *Travoys* (no. 34) in 1919. The flat, almost weightless figures which lean out over the end of the bridge reappear in *Christ Carrying the Cross* (no. 45) and *Christ's Entry into Jerusalem* (no. 57), painted in 1921.

EXHIBITIONS
Leicester Galleries, 1942 (26), as 1919
Cookham, Summer 1963, repr. on cover

REFERENCES
G. Spencer, 1961, p. 158
Carline p. 123

47 Bourne End, Looking Towards Marlow

1920
Oil on board
23.5 × 33 cm/9¼ × 13 ins
Lent by the Government Picture Collection

47

This was painted at the Slessers' house at Bourne End. In 1937 Spencer recalled the picture: 'I liked the shape and colours of the river. Having a good time at Slessers' (Tate 733.3.1). It was bought by Dorelia John, probably on the occasion of Spencer's birthday party on 20 June 1920, when the Johns and Henry Lamb were invited to 'Cornerways' (Spencer-Lamb, Tate Tam 11, 20 June 1920). The artist had met Augustus and Dorelia John through Henry Lamb before the War.

EXHIBITION
Piccadilly Gallery, 1978 (2)

48 Bonds Steam Launch, Cookham

c. 1920
Oil on millboard
34.9 × 54 cm/13¾ × 21¼ ins
s. 'Stanley Spencer'
Lent by a Private Collector

The painting shows the steam launch which took holiday-makers for trips on the Thames at Cookham during the summer months. In his painting lists Spencer dated the picture 1920, and recorded that it was painted while he was staying with the

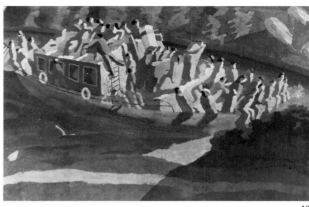

48

Slessers at Bourne End near Cookham. The scene was later incorporated into the upper-left corner of *The Resurrection, Cookham* 1924–6 (no. 89), where it is transformed into Charon's boat crossing the river Styx.

It is not clear whether the painting was intended as an independent work influenced by the proximity of the Slessers' house to the river or as a very early study for *The Resurrection*, on which Spencer did not begin work until 1924. The artist's own lists of the 1930s (Tate 733.3.12) are equivocal, referring to the picture variously as *Bonds Steam Launch Full of People*, in 1937, and *Bonds Steam Boat, Study for the Resurrection*, c. 1938. Given that the idea of a Resurrection had been in Spencer's mind since before the war, and as he usually preferred a long gestation period before beginning to work, it is probable that the latter is a more accurate title. A small oil study, *The Resurrection, Cookham* 1920–21 (no. 55), shows that the artist was actively planning a Resurrection picture in 1920. However, the picture does not include a view of the river.

Stylistically the painting is related to several other pictures of the early twenties (see nos. 55 and 57). It has a dry chalky paint surface, and flattened angular figures which are divided into regular bands of light and dark. To some extent this is a reference back to the simplified forms of *John Donne Arriving in Heaven* 1911 (no. 8); but more important are the resemblances to the work of his contemporaries, William Roberts, David Bomberg and Wyndham Lewis, in the blank faces and the jerky repetitive rhythms of the figures built up of abstract patterns of colour. Richard Cork (*Vorticism*, I, p. 32) has suggested that Roberts was influenced by Spencer during their time together at the Slade School. Certainly Roberts painted a series of unusual compositions during 1912, including *The Resurrection* and *David Choosing the Three Days*, both of which were themes attractive to Spencer. However, the increasing simplification and growing anonymity of the figures, already evident in the latter picture, allied with the more radical developments in Bomberg's work of the same year (*Island of Joy*) in turn influenced Spencer in the early twenties. He moved briefly towards a similar angular faceting of his figures, and the addition of broader areas of relatively unmodulated colour. He also employed a raised viewpoint comparable to the tilted picture plane of the early Vorticist pictures, like Roberts's *Return of Ulysses* 1913, which was well suited to his increasingly crowded canvases.

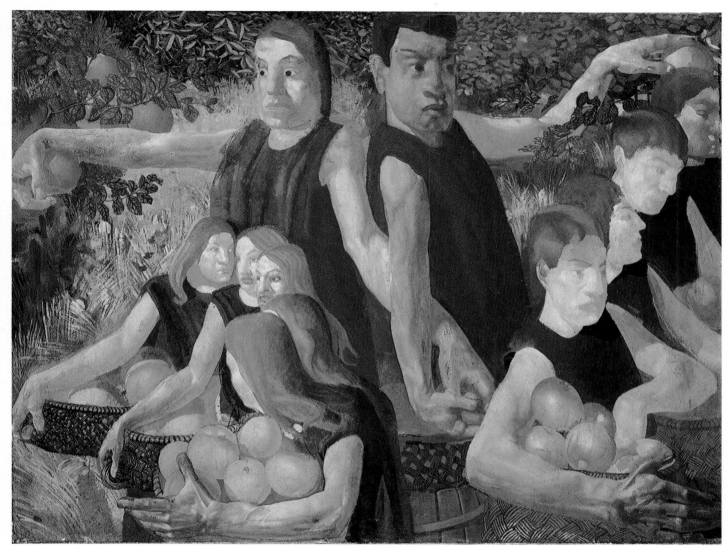

15 Apple Gatherers 1912–13

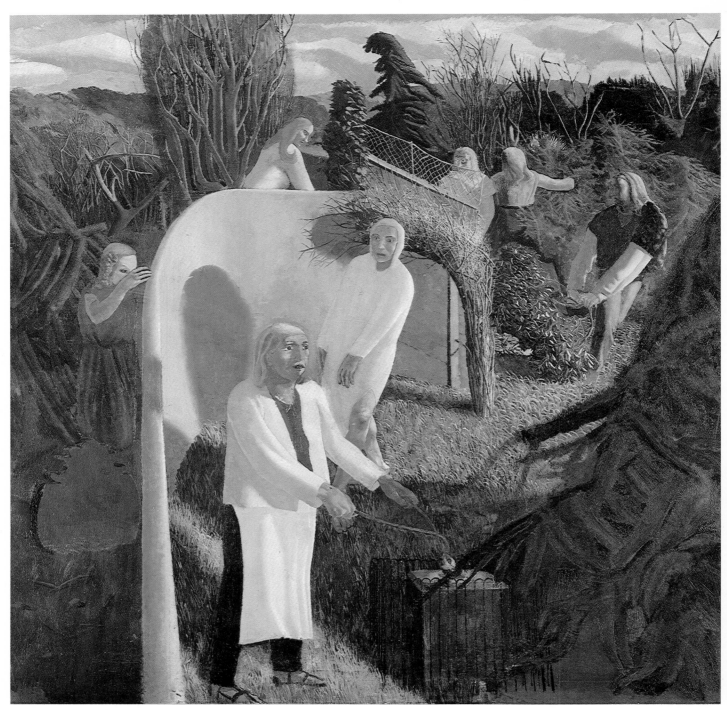

21 Zacharias and Elizabeth 1914

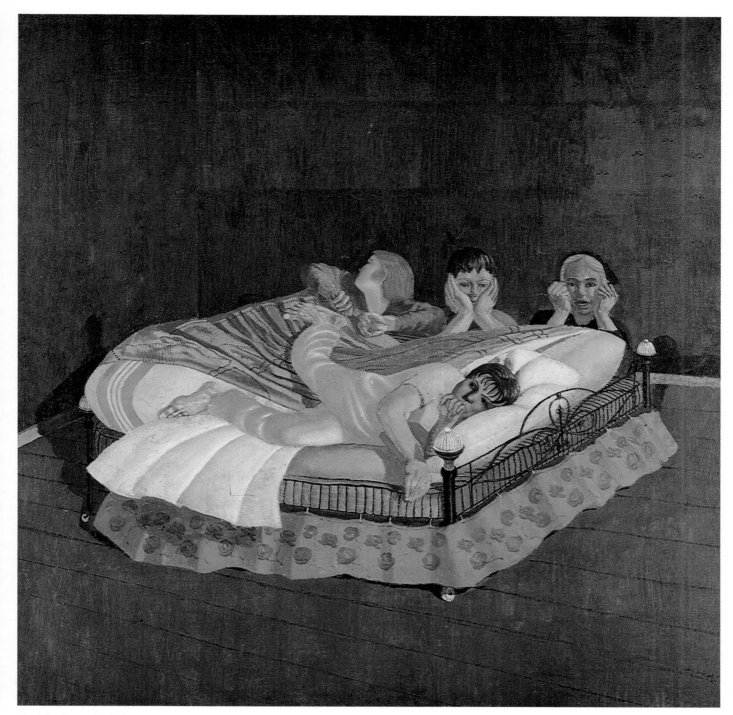

25 The Centurion's Servant 1914

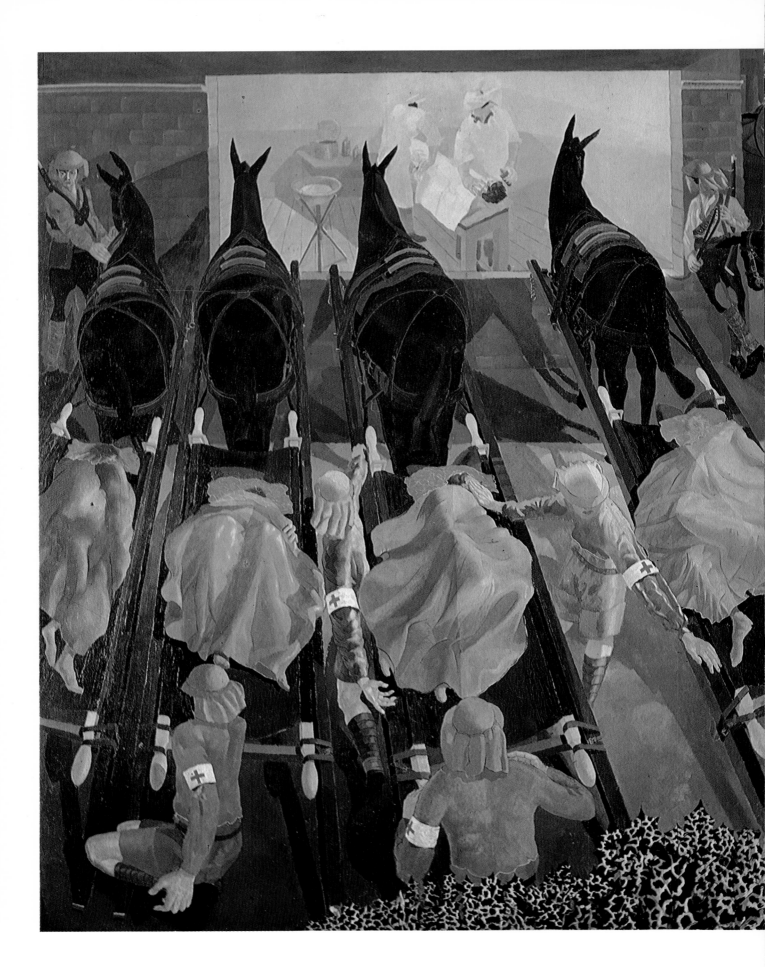

22 Cookham 1914

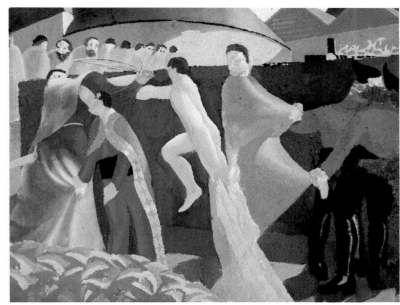

27 The Betrayal (First Version) 1914

34 Travoys with Wounded Soldiers Arriving at a Dressing Station at Smol,
Macedonia 1919

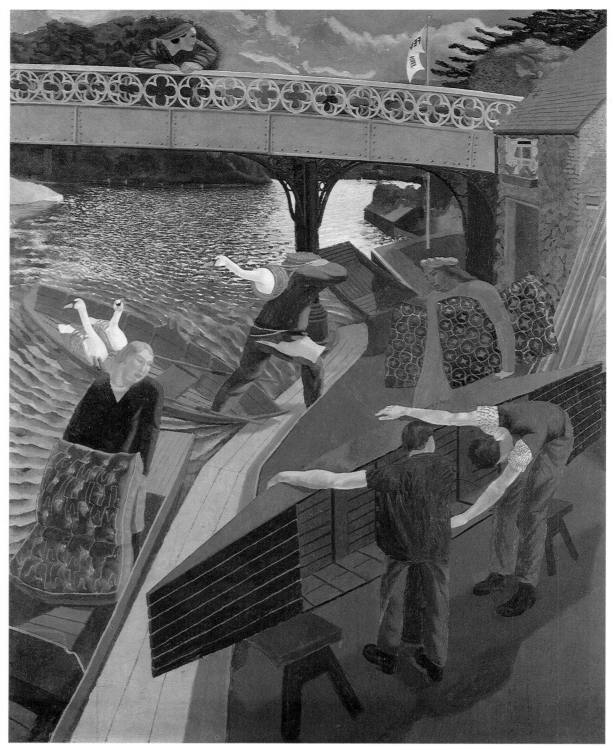

33 Swan Upping at Cookham 1915–19

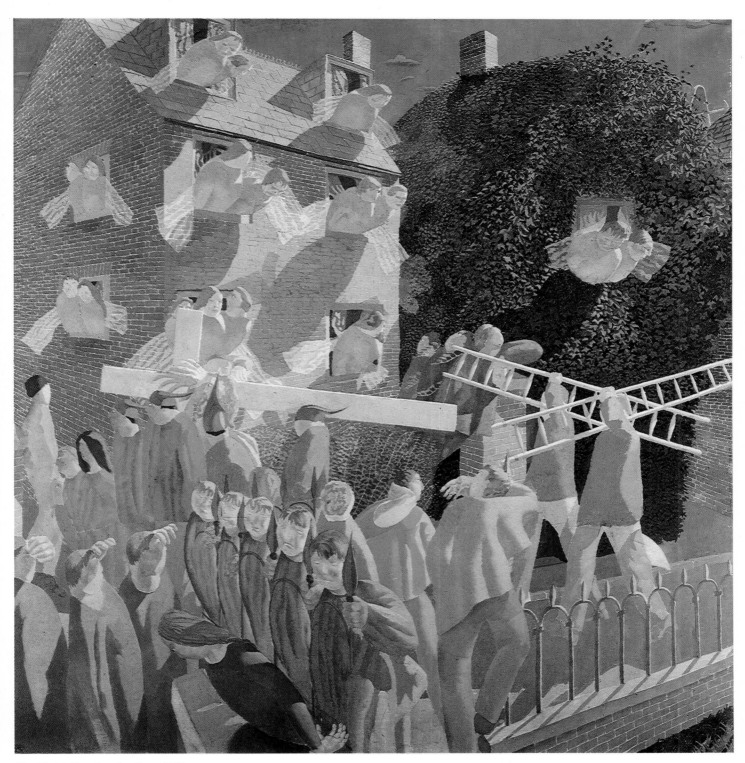

45 Christ Carrying the Cross 1920

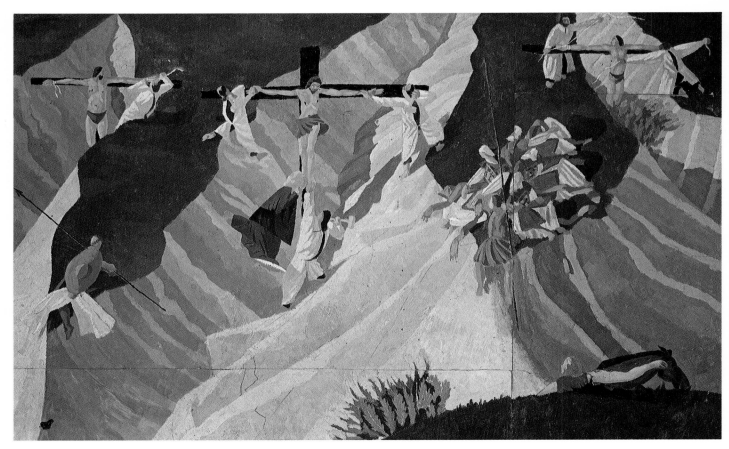

65 The Crucifixion 1921

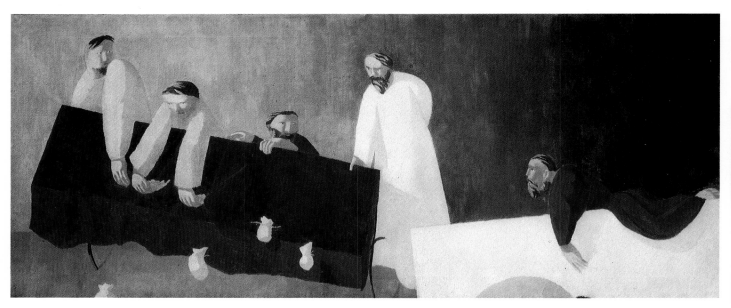

60 Christ Overturning the Money Changers' Tables 1921

49 The Miracle at Capernaeum

1920
Pencil and green wash
20 × 21.5 cm/7$\frac{7}{8}$ × 8$\frac{1}{2}$ ins
Lent by a Private Collector

This small wash drawing is a preliminary study for a painting, *The Paralytic Being Let into the Top of the House on his Bed* 1920 (panel, 29.2 × 33 cm/11$\frac{1}{2}$ × 13 ins, Private Collection), painted in the same year, and including considerable changes in the composition. This, in turn, was probably intended as a study for a larger work which was never begun.

The drawing illustrates Luke 5:17–20: 'And it came to pass on a certain day, as he was teaching, that there were Pharisees and doctors of the law sitting by, which were come out of every town of Galilee, and Judaea, and Jerusalem: and the power of the Lord was present to heal them. And, behold, men brought in a bed a man which was taken with a palsy; and they sought means to bring him in, and to lay him before him. And when they could not find by what way they might bring him in because of the multitude, they went upon the housetop, and let him down through the tiling with his couch into the midst before Jesus. And when he saw their faith, he said unto him, Man, thy sins are forgiven thee.'

In common with most of the other religious pictures which Spencer painted during the 1920s, the event takes place in the village of Cookham. Here, in the High Street, men lower the paralytic through the roof of the ivy-covered cottage called 'The Nest', next door to the Spencer family home of 'Fernlea', the corner of which can be seen on the left of the drawing. The ladders by which the paralytic's assistants hoist him to the roof were inspired by those belonging to the local builders, Fairchilds, which Spencer had seen being carried past in the street. They reappear in another painting of the same year, *Christ Carrying the Cross* (no. 45), in which the event takes place on the same stretch of Cookham High Street.

EXHIBITION
The Piccadilly Gallery, 1978 (14), illus.

49

stonework of the millhouse, and of the repeated patterns of the millrace machinery. It was during the painting of this picture that the artist had his well-known altercation with the local gentry over the shooting of a moorhen, recorded by Gilbert Spencer in his memoirs of his brother: 'An example of my brother's courage arose while he was painting *Durweston Mill*. Nearby, two of the "gentry" were shooting. We had grown to associate "gentry" with barbed wire, policemen, and charges of trespassing at Cookham, and at Durweston feudalism seemed even more powerful. Stan saw these sportsmen shoot a moorhen in the water, and this roused him. He introduced himself disarmingly enough with "That was a good shot" or something of the kind, and before they could extricate themselves from this disguised pleasantry, he demanded to know why they had done it, and vigorously abused their manliness. His manner when annoyed could be quite fierce. . . .' Spencer could be equally 'fierce' when defending his painting, as he demonstrated over the trouble precipitated by the rejection of his paintings at the Royal Academy in 1935 (see no. 149).

50 The Mill, Durweston

1920
Oil on canvas
40.6 × 50.8 cm/16 × 20 ins
Lent by a Private Collector

The picture was painted in the early summer of 1920 while Stanley and Gilbert Spencer were staying at Durweston, in Dorset, while visiting their friend the painter Henry Lamb, who was living at the nearby village of Stourpaine. The close proximity of these two villages, and perhaps a lapse in Spencer's memory, probably caused the variation in the title of the picture, which was first exhibited as *The Mill, Stourpaine*, at the Goupil Gallery exhibition of 1927. In his own papers Spencer makes use of both names (Tate 733.3.12). The picture is one of the most successful of Spencer's early landscapes, showing a fine control of the way the light falls on the

50

EXHIBITIONS
Goupil Gallery, 1927 (46) as *The Mill, Stourpaine*
New Grafton Gallery, 1974 (28), illus.

REFERENCES
Wilenski, 1924, pl. 12
E. Rothenstein, 1945, p. 21, pl. II
G. Spencer, 1961, pp. 155–6

51 Dorset Landscape

1920
Oil on board
25.4 × 30.5 cm/10 × 12 ins
Lent by a Private Collector

One of six canvases and panels painted by Spencer while staying in Durweston, Dorset in 1920 (see no. 50). According to the artist they were painted in a spirit of rivalry with his brother, whose landscapes he believed were generally of a better quality than his own, and with the growing realisation that works in this genre were more commercially acceptable than his religious paintings (Tate 733.3.1). The painting, with its vertical brushstrokes, awkward transitions in depth, and broad areas of flattish colour, is closely related in style to two other paintings of the same year: *Bourne End, Looking Towards Marlow* (no. 47), and *Cockmarsh* (26 × 34.3 cm/10¼ × 13¼ ins, Private Collection).

It was in Dorset that Spencer came to the realisation that he would have to paint landscapes in order to earn a living. He also concluded that it was impossible for him to be 'fully expressive' when painting objects or landscapes set down before him; by this he meant that direct observation interfered with the workings of his imagination. It was for this reason that Spencer always made a strong distinction between landscapes and portraits, and the works painted directly from his imagination, which he felt were most truly representative of his ideas.

EXHIBITIONS
Tooth, 1973
New Grafton Gallery, 1977 (27)

51

52 A Farm in Dorset

1920
Oil on canvas
43.8 × 53.3 cm/17¼ × 21 ins
Lent by Ivor Braka

Another of the pictures painted while Spencer was staying at Durweston, Dorset. In a note made in January 1948 the artist recalled that he had temporarily changed from his pre-war religious imagery to landscape because of 'war depression' (Tate 733.10.143). He also felt the 'challenge' of painting landscapes alongside his fellow artists.

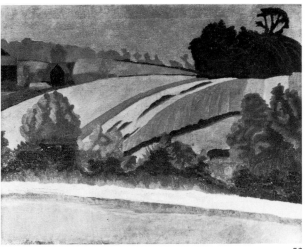

52

53 Looking Towards Cookham Bridge

c. 1921
Oil on board
25.4 × 33 cm/10 × 13 ins
Lent by Richard Carline

It is difficult to date this small landscape precisely, but Richard Carline suggests that it was probably painted while Spencer was staying with Sir Henry and Lady Slesser at Bourne End in 1921. The picture was the only complete early oil in Spencer's possession when he died.

EXHIBITIONS
Leicester Galleries, *Artists as Collectors*, 1963
South London Art Gallery, *Paintings 1914–24*, 1974
Arts Council, 1976–77 (10)

53

54 First Study for Opening Graves for the Resurrection

c. 1920
Pencil and wash
23 × 26.5 cm/9 × 10½ ins
inscbr. 'Slessers 1920–21'
verso portrait drawing of Lady Slesser
Lent by Mrs Annette Lovell

Spencer almost certainly made this sketch while he was staying with the Slessers at Bourne End. In the picture a group of resurrecting figures haul themselves from their graves by means of their tombstones. The artist used the study for the central part of an oil sketch, *The Resurrection, Cookham c.* 1920–1 (no. 55), a forerunner of *The Resurrection, Cookham* (no. 89), completed in 1926.

The portrait drawing on the verso is a preparatory sketch for the oil painting *Portrait of Lady Slesser* (no. 40), painted at Bourne End in 1920.

EXHIBITION
Piccadilly Gallery, 1978 (15)

54

55 The Resurrection, Cookham

c. 1920–1
Oil on board
31.1 × 44.5 cm/12¼ × 17¼ ins
Lent by Miss Pauline Tooth

The event is set in Cookham churchyard with the porch of the church itself appearing in the upper left of the painting. In the centre resurrecting figures pull themselves out of their graves while others, who have already emerged, lean comfortably on their gravestones and watch. The atmosphere is calm and relaxed and there is none of the drama which is usually associated with the events surrounding the Last Day. As in his numerous other representations of the Resurrection, and in keeping with his belief that God was not a punishing avenger but would forgive even wrongdoers, there are few if any distinctions made between the resurrected (see no. 89).

The painting was one of eight works which the artist gave or sold to Sir Henry and Lady Slesser during 1920–1, and which were based almost entirely upon biblical subjects. Spencer had first used the resurrection theme in a diptych, *The Resurrection of the Good and the Bad* (no. 28), in 1915. Shortly afterwards he was to approach the subject again on a much larger scale, when he began *The Resurrection, Cookham* 1924–6 (no. 89), set in the same churchyard; and *The Resurrection of Soldiers* on the end wall at Burghclere (composed in 1928). In both these pictures, and again in the *Port Glasgow Resurrection* series (1947–50), Spencer made use of the idea of the figures rising from their graves. In a sense, therefore, the present small picture can be

seen as a trial run for the much more ambitious painting schemes upon which the artist set to work after leaving the Slessers in 1921.

In common with most of the small paintings and oil studies of the early 1920s, the underdrawing shows through the relatively thin paint surface in a number of places. Elsewhere, particularly on the tombstones, pencil lines have been added on top of the paint surface, probably to accentuate the shape and volume of the otherwise rather flat areas of colour.

Spencer made at least one study for the painting, *First Study for Opening Graves for the Resurrection* (no. 54), inscribed on the *recto* of the composition in the artist's hand 'Slessers 1920–21'.

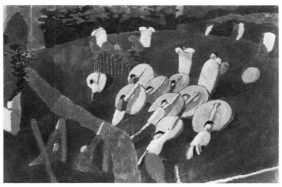

55

56 The Quarry Woods, Cookham

1921
Oil on canvas
49.5 × 67.9 cm/19½ × 26¾ ins
Lent by the Rutland Gallery

The picture, also known as *Bisham Woods*, shows a view of the woods south of the Thames near Marlow. Much earlier, in 1817, the poet Percy Bysshe Shelley had also been attracted by the forest, and had walked and read there during the summer months. It was here that he wrote part of a long political poem which he called *Laon and Cythera*.

56

Painted in broad flattish areas of colour with the light foreground set against the heavy dark mass of the trees beyond, the picture owes much to the work of John Nash, a contemporary at the Slade School. Spencer must have seen paintings like Nash's *Cornfields, Winston, Suffolk c.* 1918 (exhibited Blond Fine Art Ltd, *British Landscape Painting 1900–1960*, no. 19), after he had renewed his acquaintance with the Nash brothers at the Carlines' house after the First World War.

The artist painted another view of this landscape, also known as *The Quarry Woods* (50.1 × 68.6 cm/20 × 27 ins, Private Collection), in 1921.

EXHIBITION
Goupil Gallery, 1927 (44), as *Bisham Woods*

57 Christ's Entry into Jerusalem

1921
Oil on canvas
114.3 × 144.7 cm/45 × 57 ins
Lent by Leeds City Art Galleries

Painted in May and June 1921 while Spencer was living with Sir Henry and Lady Slesser at Bourne End. In a letter dated 14 June to his friend the artist Henry Lamb Spencer reported: 'You will be glad to hear that I am painting another dud! As per usual all the lovely light which I got on the people running down the garden is not to be seen in the painting. But I am going to do another a bit smaller' (Tate Tam 11).

The painting is set in Cookham High Street like its companion-piece, *Christ Carrying the Cross* (no. 45), which the artist had completed late in 1920. In the picture Christ appears riding on a donkey, while people stream down the garden paths or run along the pavement to watch the procession go by. In the background a group of women (recalled from a scene in Devon) watch from behind an iron railing.

In 1937 Spencer commented that the composition had caused him difficulties and he 'could get no clear idea of Christ on the donkey' (Tate 733.3.1). Certainly this is the most insubstantial part of the painting, with the figure of Christ and the animal contrasting sharply with the two robustly painted and deeply expressive forms of the children who run along the sunlit pavement beside him. A pencil and wash study, *c.* 1920 (Private Collection) for the picture shows Christ on the donkey from a much lower viewpoint, throwing the pair into relief and eliminating this difficulty. If Spencer had begun the painting from the top left as described by Richard Carline (p. 29) he may well have found himself short of space when he came to fit in the figure of Christ, which in the study commands a much more central position in the design.

The style of the picture is very close to *Christ Carrying the Cross* 1920 (no. 45), with which it shares the new lighter colours and the strange, flat, weightless figures who seem to float down the garden path.

Spencer had illustrated the subject once before in a Slade Sketch Club drawing, *Christ Rideth into Jerusalem* July 1910 (Private Collection).

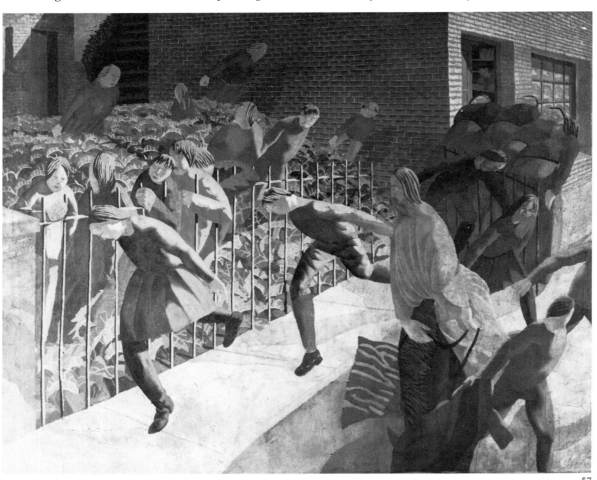

EXHIBITIONS
Leeds, 1947 (14), as *c.* 1925
Arts Council Touring Exhibition, *Decade 1920–30*, 1970 (135), repr.
Arts Council, 1976–7 (7) repr.

REFERENCES
Carline, p. 126
Robinson 1979, p. 25, pl. 17

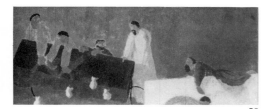

58

58 Expulsion of the Money Changers

1921
Gouache
14.6 × 33 cm/5¾ × 13 ins, squared for transfer
Lent by Sir Antony and Lady Hornby

The picture is a study for *Christ Overturning the Money Changers' Tables* (see no. 60), which Spencer was painting in March 1921 (letter to Hilda Carline, 21 March). When the sketch was transferred to canvas the artist made a few minor changes, particularly to the two right-hand figures, which are given a more curvilinear outline. The use of gouache in a final study is unusual and Spencer normally made use of oil paint on paper for these trial compositions (see no. 65).

REFERENCES
Carline, pp. 126–7, 131, 209
The Art Gallery of Western Australia,
Bulletin 1979, pp. 4–9, repr.

59 St Veronica Unmasking Christ

1921
Oil on canvas
75 × 59.7 cm/29½ × 23½ ins
Lent by the Stanley Spencer Gallery, Cookham

According to Sir Henry Slesser this picture and *Christ Overturning the Money Changers' Table* (no. 61) were to form the wings of a triptych, with the larger *Christ Overturning the Money Changers' Tables* (no. 60) in the centre. It seems probable that *St Veronica* was the last of the three pictures to be painted, as Spencer remarked in his 1937 notes that: 'This idea was suggested to me when I was drawing this notion I had of a single figure of Christ overturning a table [no. 61], by the appearance of Christ's raised arms and the cloth hanging down around him, suggesting an echo of this same form in the veil of Veronica, than by any emotion directly affecting the compositional form as a result of contemplating the significance of the story' (Tate 733.3.1). This transfer of a pose to a completely different subject works well, with St Veronica holding her veil over Christ's mysteriously masked face while his hands grope past her like a man walking in the dark. Behind them, in the shadow of a row of cottages, two

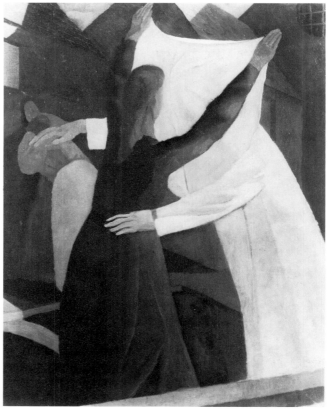

59

women hide their faces, thereby emphasising the daring of the young woman in touching the saviour.

The subject is taken from *The Apocryphal New Testament* (appendix to the Acts of Pilate), ed. M. R. James, Clarendon Press, 1963, pp. 157–8.

REFERENCE
J. Rothenstein, 1979, p. 73

60 Christ Overturning the Money Changers' Tables

[repr. in colour on p. 72]
1921
Oil on canvas
64.5 × 152 cm/25 × 60 ins
Lent by the Art Gallery of Western Australia, Perth

Painted while Spencer was staying with the Slessers at Bourne End. The painting illustrates John 2:15 'And when he had made a scourge of small cords; he drove them all out of the Temple, and the sheep, and the oxen; and poured out the changers' money and overthrew the tables.'

The picture is one of a series of the Life of Christ which Spencer painted between 1919 and 1923. He was working on two different versions of the scene in March 1921 when he included sketches for both ideas in a letter to Hilda Carline: 'Today, having a thick head, I began a painting of Christ tipping the tables over in the Temple. The table which Christ is turning over is warm red and the other table which the man is

climbing over is white. Christ is white. The man on the white table is the same colour as the other table. The two end men leaning over the red table – they are grabbing the cloth to save the money falling off – are yellow. . . . The man who only just shows over the red table is red also. And here [a sketch showing the second version, see no. 61] you have another on the same idea. I like it' (Carline, p. 126).

Sir Henry Slesser reported that the painting '. . . was a gift to me and the idea in it was his, knowing as he did my like of plutocracy' (Art Gallery of Western Australia, *Bulletin*, 1979). Obviously Spencer was thinking in terms of a Renaissance altarpiece when he designed the triptych, an idea which he was familiar with through his collection of Gowans and Grays art books of Renaissance and other masters, and his frequent visits to the National Gallery in London. He was also stimulated by having a specific space to paint for, like Giotto at the Arena Chapel in Padua. In 1922 he produced another series of fine paintings based around *The Betrayal* (no. 78), which may have also been intended for the Oratory; *The Last Supper* 1920 (no. 41) served as an altarpiece there for several years.

The picture's style, which is simple, even severe, belongs to the group of religious paintings related to *The Last Supper*, in which figures are painted against plain, flat backgrounds, in broad areas of colour, only lightly shaded in tones of grey. The red and white upturned tables help to emphasise the shallow space and abstract patterns of the composition. The long floppy arms of the money changers recall those of the disciples in *The Last Supper*. Spencer was probably influenced to some extent by the work of some of his fellow artists, particularly Bomberg, Nevinson, and Roberts, all of whom he had known at the Slade. He would have seen their 'advanced' and often semi-abstract paintings on visits to London, particularly at the *War Artists* Exhibition held at the Royal Academy in 1919–20.

REFERENCES
Carline, p. 126
Art Gallery of Western Australia, *Bulletin 1979*, pp. 4–9, illus. p. 21, details, p. 9, and cover (in colour)

61 Christ Overturning the Money Changers' Table

1921
Oil on canvas
74.9 × 59.7 cm/29½ × 23½ ins
Lent by the Stanley Spencer Gallery, Cookham

This is another of the paintings intended for the triptych in the Slessers' Oratory. It illustrates Matthew 21:12. It was composed, and probably painted consecutively, with the larger picture *Christ Overturning the Money Changers' Tables* (no. 60), which was to form the central panel. Spencer re-used the pose of Christ for the figure of St Veronica in *St Veronica Unmasking Christ* (no. 59), the left wing of the triptych.

EXHIBITION
Arts Council, 1976–7

REFERENCES
Carline, pp. 126–7, 131, 209
The Art Gallery of Western Australia, *Bulletin*, 1979, pp. 4–9, repr.

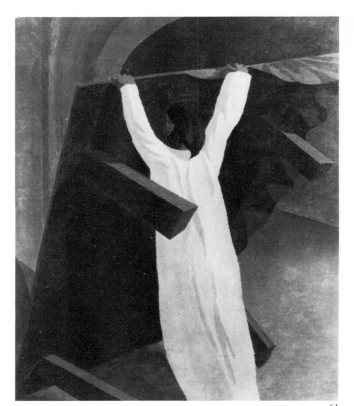

61

62 The Sword of the Lord and of Gideon

1921
Oil on paper stuck to cardboard
62.2 × 56 cm/24½ × 22 ins with insertion 21.6 × 45.5 cm/8½ × 17⅞ ins extending along the top from the right-hand side
Lent by the Trustees of the Tate Gallery

According to Spencer's 1937 painting list (Tate 733.3.1), the picture was painted in 1921, a date supported by Wilenski (1924, p. 21) and Carline (p. 128).

The subject continues the series of post-war religious paintings begun in 1920, although it is exceptional in being an Old Testament theme. It was inspired by the seventh book of Judges which relates Gideon's defeat of the Midianites, and in particular Judges 7:19–20: 'So Gideon, and the hundred men that were with him, came unto the outside of the camp in the beginning of the middle watch. . . . And the three companies blew the trumpets, and brake the pitchers, and held the lamps in their left hands, and the trumpets in their right hands to blow withal: and they cried, The sword of the Lord, and of Gideon. And they stood every man in his place round about the camp: and all the host ran, and cried, and fled.'

The picture shows the moment of panic in the Midianite camp. In the middle a large tent collapses to reveal a row of sleeping soldiers wrapped in blankets; behind, other tents fall as the trumpets blow, and the torches flare red against the night sky.

As Wilenski points out (1924, p. 22), the image of the military encampment was a recollection of the artist's wartime experiences in Macedonia. A similar large military tent occurs in the extreme right arched composition (omitted in the final work) of the working drawing for the right-hand side wall of Burghclere Chapel (no. 82). Items of military equipment also appear in *Feeding the Five Thousand* (no. 63), again painted in 1921.

REFERENCES
Wilenski, 1924, pp. 21–3, pl. 16
Carline, p. 128

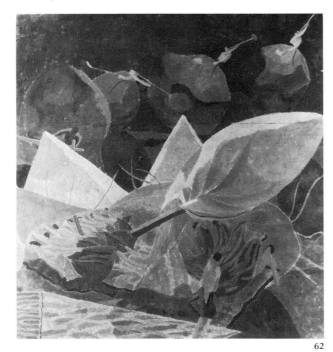

62

63 Feeding the Five Thousand

1921
Pencil and wash
34.9 × 24.8cm/13¾ × 9¾ ins, squared for transfer
Lent by Matthew Pryor

Sir Edward Marsh, an early patron, originally purchased this work from the Goupil Gallery Stanley Spencer one-man show in 1927 for 18 guineas.

The drawing belongs to the series of religious pictures which Spencer painted after the First World War while staying with the Slessers at Bourne End, Bucks, and later at Steep, near Petersfield. In the picture Christ appears in the left centre blessing the bread while the disciples spread out among the crowd distributing the fish from oval baskets. The origins of these striking images were later recalled by Spencer: the baskets under the disciples' arms were derived from bushel baskets of apples, piled up horizontally in a disused cottage, 'The Ship', lent to him to paint in by a farmer cousin before the war. The bread containers were originally canvas water buckets which he had seen during his war service in Macedonia. He had drawn them before in a small sepia sketch, *Soldiers at a Well,*

Macedonia 1919 (Carline, pl. 11), in which a soldier holding a similar bundle of buckets prepares to fill them at a well.

The setting for the miracle is drawn from equally familiar associations, in this case 'a large quarry pit off Terrys Lane', where school treats used to be held. As in all his painting, Spencer sought to link religious experience with places which were known to him (usually round Cookham), thereby alleviating any sense of anxiety which a strange setting might have given him. It is within this context that another comment which he made about the sketch must be taken: 'It seems wild, but instead of lions one saw Mrs Rolf in black having her . . . walk after lunch' (Tate 733.3.1).

Despite the evident success of the picture, the artist was not satisfied with the composition, or rather the exact feeling which he had of the miracle did not properly coincide with his idea of the pit setting: 'It seems to me that much time as I spent considering such compositions as these still they are premature,' he wrote later; 'I know in the thinking of the thing I was drawn towards the pit as being the place. But because the idea was not then clear enough, I was in some way doubting the choice' (*ibid.*).

The composition, which is based on the vortex-like swirl of the disciples and baskets in the centre, and the repetition of curved forms both in the walls of the 'pit' and in the figures of the disciples (Spencer thought they were 'like seagulls hovering over waves'), has similarities with another early post-war painting, *The Bridge* 1920 (no. 46), where the curve of the bridge finds its counterpart in the rows of people who lean back over the railings to watch events on the river. Spencer was dissatisfied with this composition as well, and it is possible that the rhythmic repetition of forms and the sense of movement which are apparent in these two works, and which shortly thereafter became less important in his paintings, were the details which precipitated Spencer's later criticism.

EXHIBITION
Piccadilly Gallery, December 1969

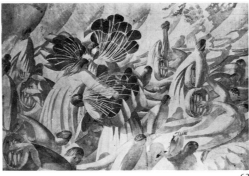

63

64 Scrubbing the Floor and Soldiers Washing, Beaufort Hospital, Bristol

c. 1921
Pencil and grey wash, with some highlighting, on paper
25.4 × 36.5 cm/10 × 14¼ ins
Lent by the Fitzwilliam Museum, Cambridge

The study is drawn from recollections of Beaufort War Hospital. Previously the drawing was thought to be a preparatory study for the Sandham Memorial Chapel at Burghclere. However Richard Carline has suggested that it is one of two studies made in Steep in 1921 for the Memorial Hall commissioned by Muirhead Bone. This is confirmed by an undated draft letter which Spencer wrote to Mary Behrend in the early fifties: 'Then while Bone was away . . . and I was living in apartments [in Steep] at my own expense I did one or two compositions for the Club'. Two or three of these compositions were the first three predella panels of the Burghclere Chapel (Tate 733.1.175).

Despite its failure, the Steep commission gave Spencer the opportunity of clarifying his ideas for the war paintings which were eventually brought together at Burghclere. Elements from the present sketch were used for three panels in the 1923 Burghclere cartoons (no. 82): *Ablutions, Scrubbing the Floor* and *Scrubbing Lockers*. The second drawing referred to by the artist has not been identified.

REFERENCES
Carline, pp. 73, 199, 208, p. 8

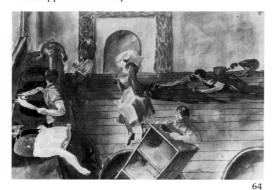

64

65 The Crucifixion

[repr. in colour on p. 72]
1921
Oil on paper, mounted on canvas
66.7 × 107.9 cm/26¼ × 42½ ins
Lent by Aberdeen Art Gallery and Museums

The picture was painted while Spencer was staying with the artist Muirhead Bone at 'Byways', Steep, near Petersfield.

In a note made on 4 September 1957, Spencer explained the source of the peculiar setting of the three crosses in ravines instead of the traditional hill of Calvary: 'The first beginning of the Crucifixion in my mind was the memory I had of some mountain which was in a range . . . dividing Macedonia from Bulgaria. I and some Berkshire Regiment men and some Cyprian Greeks were walking over the snow to the [?] quarters, and away behind it in the dark Christmassy sky were these mountains. This particular one was quite clear and in front of the others and yet you felt it would be wonderful to be on it: it seemed so remote, so long since gathered to the mountains of its forefathers. . . . At intervals slices seemed to have been taken out of it: three long gashes there were. . . . As I walked towards the range I did not at all think of a Crucifixion, every sound was muffled as it seems to be in snow and only the faint jingle and squeaking of the mules' harnesses. But somehow though some

of my worst experiences were ahead of me . . . I felt hopeful' (Tate 733.10.154).

In 1921 Spencer returned to this image, which he sought to link with a new idea which he had for a Resurrection: 'I first in about 1921 made a watercolour study . . . of an ascension. This seemed not to be right. Then I began the crucifixion notion. I wanted to bring the geography . . . of the mountain into one state of being and expression with some great human happening. . . .' Spencer went on to describe the painting: 'Looking broadside at the mountain one sees three ravines fingering their way upwards cleaving its sides and making huge dock-leaf shapes. The crosses have been erected in the bottoms of the ravines and the terminal ends of the transverse bars are over the parapet sides or cliff edge . . . so that the men need no ladders but can get on with the job of nailing and tying of hands by crawling up the parapet sides. These men, the tying malefactor ones and the nailing of Christ ones are in white. . . . The Virgin has slithered down the escarpment side . . . to the base of the cross. Her long robe of dark purple trails and drags a little. . . . I also had three other items. One was the group of priests wagging their heads, one this man who holds Christ's garment. The Centurion seen back of head view leans back against part of the horse's back' (Tate 733.10.154, alternative description Tate 733.10.62).

In its present form the painting is only a small study for a much larger *Crucifixion* (probably on the scale of the 1926 *Resurrection, Cookham* (no. 89), which was never begun. Spencer recalled that the composition was to have been expanded at the top to include the walls of Jerusalem; and to the upper right, along the city streets a view of the Temple shown at the moment the veil was rent in two (Mark 15:37–8). To the left the newly resurrected were to be seen walking the streets still dressed in their funeral shrouds. Spencer abandoned this plan, although another oil sketch, *Rending the Veil of the Temple* 1921 (no. 66), is associated with the projected painting.

It is probable that the projected large *Crucifixion* was intended to form the central portion of the Steep memorial (see no. 64). Spencer's writings give no indication of the ultimate destination of the painting, but the direct reference in the work to Spencer's wartime experiences in Macedonia implies an attempt to link the themes of war and redemption in a composition eminently suited to a war memorial. These ideas re-emerged in *The Resurrection of Soldiers* on the end wall of Burghclere Chapel in 1928, where Christ is again depicted in a Macedonian setting, this time on the Day of Judgement. The studies for the Steep commission may be seen as an intermediate stage in the long gestation period which eventually led to the paintings in the Sandham Memorial Chapel at Burghclere.

EXHIBITIONS
Reading, *Christian Arts Festival*, 1950 (29)
Edinburgh, Royal Scottish Academy, 1952 (286)
Tate Gallery, 1955 (23)
Arts Council, 1961 (26)
Plymouth, 1963 (9)
Arts Council, Welsh Committee, *Stanley Spencer, Religious Paintings*, 1965
Arts Council, *Decade 1920–30*, touring exhibition 1970 (131)
Arts Council, 1976–7 (9)

REFERENCE
Carline, 1978, p. 130

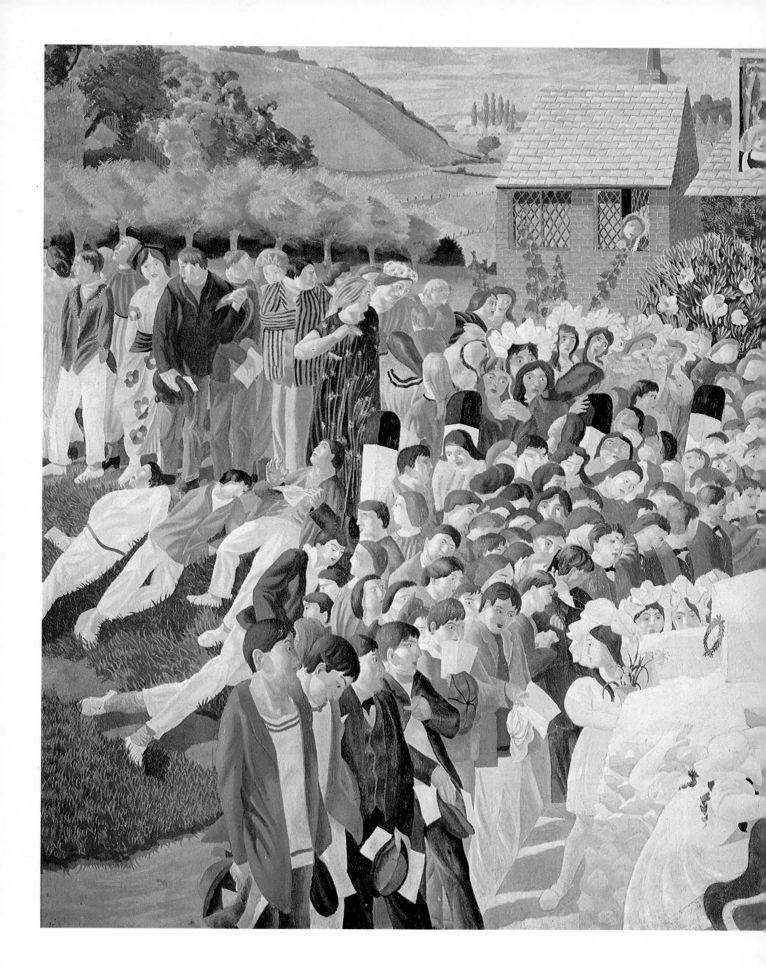

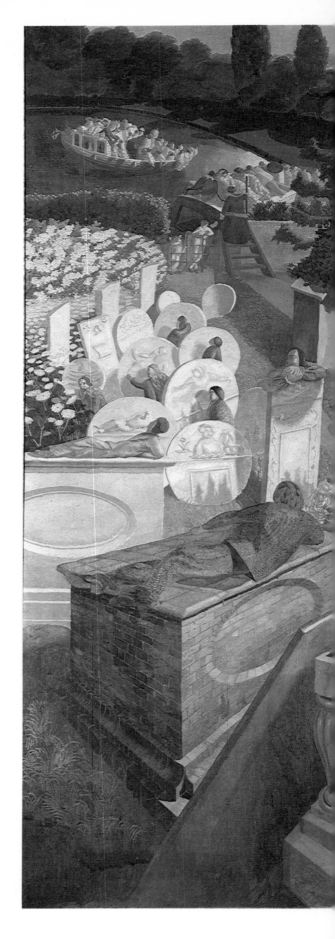

68 Unveiling Cookham War Memorial 1922 (*left*)

89 The Resurrection, Cookham 1924–6 (*right*)

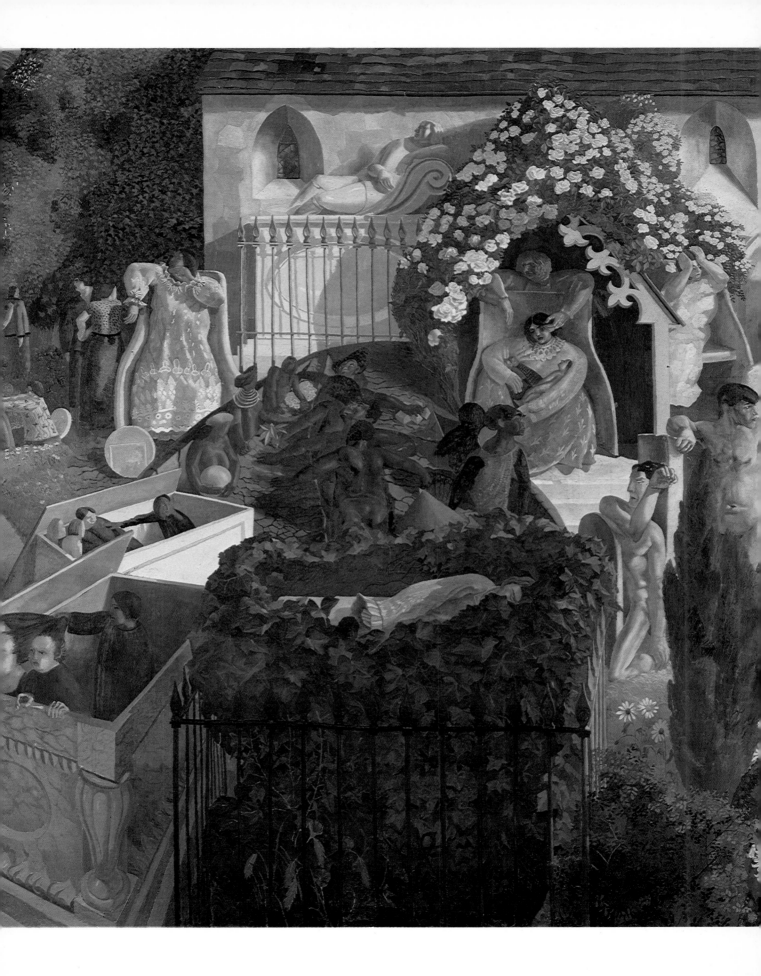

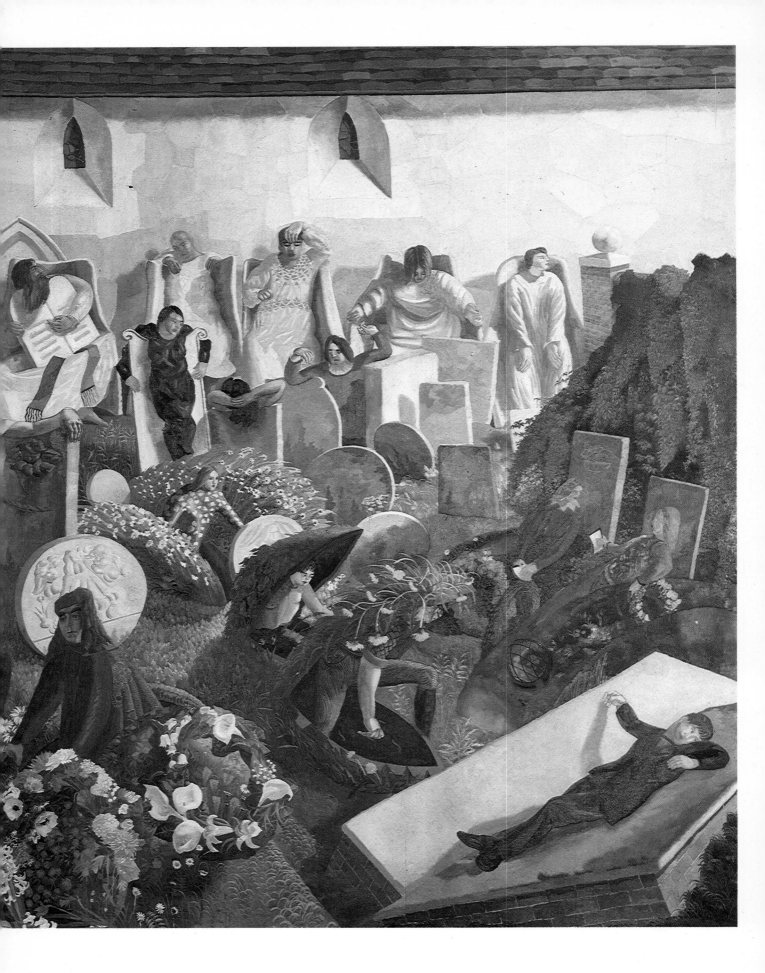

66 Rending the Veil of the Temple

1921
Oil on paper
25.4 × 22.2 cm/10 × 8¾ ins
Lent by a Private Collector

66

The painting illustrates Mark 15: 37–8: 'And Jesus cried with a loud voice, and gave up the ghost. And the veil of the temple was rent in twain from the top to the bottom.'

In the centre of the picture the veil of the temple is shown at the moment it is torn apart, while the terrified priests flee in all directions. Above the roof, to the right, can be seen the distant figure of Christ on the Cross.

Together with *The Crucifixion* 1921 (no. 65) this small picture was intended as a study for a much larger painting of the Crucifixion, which was never painted. In 1937 Spencer recalled that the Temple scene was to form part of the upper right-hand corner of the projected picture, with the Crucifixion taking place in the foreground beneath the walls of Jerusalem. The appearance of the crucified Christ in both paintings indicates that Spencer was still unclear about the final composition at the time the two studies were painted.

The style of this picture may be compared with the more highly 'finished' *Bonds Steam Launch, Cookham c.* 1920 (no. 48).

67 Study for Unveiling Cookham War Memorial

1921
Pencil, squared for transfer
35 × 33.5 cm/13⅝ × 13¼ ins
Lent by the Piccadilly Gallery

This fine study is probably the working drawing for *Unveiling Cookham War Memorial* (see no. 68, begun in 1921), which was commissioned but later rejected by Sir Michael Sadler. The drawing shows that Spencer made a number of changes in transferring the small-scale detailed design to the canvas. The most important of these was the enlarging of the line of young men standing before the memorial, bringing them closer to the

picture plane and thereby creating a better sense of space in the composition; it also enabled him to characterise the foreground figures more successfully. He added the device of the large Union Jack draped over the side of the memorial, covering what was intended in the drawing to be a large vase, or vases, of flowers, tended by a small girl. The flag cleverly filled in a gap which would have been a large, visually uninteresting space in an otherwise crowded and brightly coloured painting.

EXHIBITION
Piccadilly Gallery, 1978 (23)

67

68 Unveiling Cookham War Memorial

[repr. in colour between pp. 80 and 81]
1922
Oil on canvas
155 × 147.4 cm/61 × 58 ins
Lent by a Private Collector

This painting originated from a commission given to the artist by Sir Michael Sadler for 'a sort of religious picture', for which he was to be paid £100. On seeing it, however, Sadler rejected the picture, and Spencer later sold it to Walter Taylor for the reduced sum of £90.

Spencer had begun work on the picture while he was staying with Muirhead Bone in Steep, Gloucestershire. It was completed in 1922 at no. 25 The Square, to which he had moved after a disagreement with Mrs Bone.

In his later writings Spencer virtually ignored this fine painting, either because of its early rejection or because it did not fit in with any particular group or cycle of pictures. Like *Travoys* (no. 34), it remained a 'one-off' picture only loosely connected with the mainstream of the artist's thought during the twenties. He did, however, give a general indication of his intentions in a note in his 1937 picture catalogue (Tate 733.3.1). 'It was,' he said, 'intended to express the absence of hurry . . . and to express the peaceful life that I visualised people could live if there was no war. This place in the picture (the edge of

Cookham Moor) gives rise to a great deal of variety and circumstance . . . and a good situation for the changing degrees of mood of the crowd.'

It is possible that the concept of this painting was a modification of an idea first suggested by Muirhead Bone in 1918 when Spencer was still serving in Macedonia for 'a religious service at the front' for the Ministry of Information (Imperial War Museum archives). Spencer chose to paint *Travoys* instead, but the recollection of the subject may have suggested a similar subject, this time nearer home.

Spencer's only other comment on the painting was recorded by Kate Foster, a Slade School friend (Carline, p. 130–1), when he referred to it as 'my Ascot fashions, my sweet pea colours'. His flippancy belies the quality of the picture, which is full of fine details, particularly in the crowd round the newly unveiled War Memorial. The four men reclining on the grass on the left of the painting recall the figures on the bed in *The Centurion's Servant* 1914 (no. 25), resembling in their uncomfortable attitudes tipped-over tailor's dummies.

A study for the painting is in the exhibition, no. 67.

REFERENCES
Wilenski, 1924, p. 24, pl. 17
E. Newton, 1947 (in colour)
Carline, pp. 130–1

69 Sarajevo, Bosnia

1922
Oil on canvas
61 × 55.9 cm/24 × 22 ins
Lent by the Fitzwilliam Museum, Cambridge

In 1922 Spencer joined Richard Carline, his brothers Sydney and George, sister Hilda, their mother, and a cousin of the family May Piggott, on a painting expedition to Yugoslavia. Richard Carline recalls that the journey was inspired by illustrations in the National Geographic magazine, and for Spencer there was the added attraction of being near Hilda, to whom he was becoming increasingly attached.

The party travelled across Europe, stopping for five days on the way in Vienna, where they used the opportunity to visit the art galleries. Once in Yugoslavia they went to Sarajevo, Mostar, Ragusa, Cataro, Montenegro, Padorizza, and Lake Scutari. They then returned to Ragusa, before going on to Split where they caught a boat to Trieste; from there they travelled back to England overland via Munich and Cologne.

During their stay in Yugoslavia Spencer painted a total of nine landscapes and made a number of drawings and watercolour studies, often painting alongside his companions. While most of the paintings take minarets as their subjects, at least two, *Ragusa* (no. 71) and *River Nareta, Mostar* (no. 72), are composed of more general views of the Yugoslav landscape.

As well as the four paintings in the exhibition, Spencer also painted five other landscapes in Yugoslavia: *The Wooden Minaret, Sarajevo; The Source of the Buna, Mostar* (Benn, 1924, pl. 24); *Lake of Scutari, Montenegro; Turkish Gravestones, Sarajevo* (Benn, 1924, pl. 23) and *Near the River, Sarajevo*. All are in Private Collections.

69

EXHIBITION
Arts Council, 1976–7 (11)

REFERENCES
M. Collis, 1962, pp. 74–5
Carline, pp. 132–4

70 Sarajevo

1922
Oil on paper, mounted on hardboard
35.5 × 25.4 cm/14 × 10 ins
Lent by the South London Art Gallery, London Borough of Southwark

70

Spencer visited Yugoslavia with the specific intention of painting Moslem tombs and mosques of the kind which he had seen in Macedonia during the war, and this subject recurs in at least two other oil paintings done on the expedition, including *The Wooden Minaret, Sarajevo* (Private Collection); and *Near the River, Sarajevo* (Private Collection), in which the same mosque reappears in the background.

The painting once belonged to Sir Edward Marsh, who was an early and appreciative patron of Spencer's work.

In a list of paintings dated 1959, Spencer called the picture *One Minaret, (White), Sarajevo* (Tate 733.3.88).

EXHIBITION
The Bluecoat Gallery, Liverpool, *An Honest Patron, a Tribute to Sir Edward Marsh* (1872–1953), 1976

71 Ragusa (Dubrovnik)

1922
Oil on canvas
54.5 × 60 cm/21½ × 23½ ins
sbr.
Lent by the Piccadilly Gallery

71

This painting differs from the other scenes painted on Spencer's Yugoslavian expedition in being the only one with an entirely rural setting. It was painted with Hilda in the vineyard south of Ragusa with flat-topped trees which influenced the artist when he came to paint the background to *Driven by the Spirit into the Wilderness* (no. 199).

EXHIBITIONS
Leicester Galleries, 1942
Piccadilly Gallery, 1978 (3)

72

72 River Nareta, Mostar

1922
Oil on canvas
55.9 × 60.9 cm/22 × 24 ins
Lent by the Tatham Art Gallery, Pietermaritzburg

This painting with its elevated viewpoint looking out over the River Nareta to the town and the hills beyond is one of the finest of Spencer's early landscapes. The clear greys, buffs, olive greens and soft pinky-beige are tones which had first appeared in *Bonds Steam Launch, Cookham* (no. 48) in 1920. The picture was purchased probably directly from Spencer by Colonel R.H. Whitewell, who donated it to the City of Pietermaritzburg in 1923. It has not been previously exhibited.

REFERENCE
Wilenski, 1924, pl. 24

73 Studies for The Disrobing of Christ

c. 1922
Three studies in pencil and wash
(a) 6.1 × 10 cm/2⅜ × 4 ins, (b) 20 × 8.9 cm/3⅞ × 3½ ins, (c) 7.6 × 12.1 cm/3 × 4¾ ins, squared for transfer
Lent by the Stanley Spencer Gallery, Cookham

The drawings are preliminary studies for *The Disrobing of Christ* (no. 75), painted in 1922. Sketch (a) shows the artist using a rough pencil and wash study to establish the dispositions of Christ and the soldiers with the tent-like garment stretched between them. The other two drawings show the general outline of the final composition; (c) being squared for transfer, probably for the working drawing *Study for the Disrobing of Christ* (pencil and wash, 38.1 × 55.9 cm/15 × 22 ins, squared for transfer, Private Collection).

73

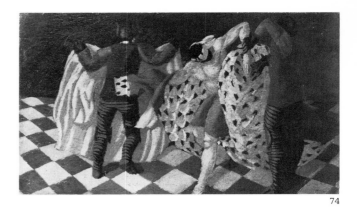

74

74 The Robing of Christ

1922
Oil on wood
35.3 × 59.2 cm/13$\frac{7}{8}$ × 23$\frac{3}{8}$ ins
Lent by the Trustees of the Tate Gallery

The subject of this picture, and of no. 75, is taken from Matthew 27:27–31: 'Then the soldiers of the governor took Jesus into the common hall, and gathered unto him the whole band of soldiers. And they stripped him, and put on him a scarlet robe. . . . And after that they had mocked him, they took the robe off from him, and put his own raiment on him, and led him away to crucify him.'

These two scenes belong to a series of four panels intended as a predella to *The Betrayal (Second Version)* (no. 78). They were painted while Spencer was lodging in Petersfield in 1922. The other two predella panels are *The Last Supper* and *Washing Peter's Feet* (no. 76). When completed, the pictures were found to be too large for their setting.

Spencer mentioned the paintings in a letter to Henry Lamb of 26 May 1922, from Petersfield: 'I am doing a thing now which you will dislike and justly. It belongs to my hosiery department. You will see I had four ideas, two of moments in the Last Supper and two of Christ with the soldiers and they were so consecutive and processional, I had to do them. They came out of their shell so nicely. . . .' (Tate Spencer-Lamb Tam 11).

A series of small studies beneath the working drawing for *The Disrobing of Christ* (Private Collection) shows that *Washing Peter's Feet* and *The Last Supper* were intended to hang on the left of *The Betrayal*, and *The Disrobing of Christ* and *The Robing of Christ* on the right. The central *Betrayal* picture resembles the 1914 version (no. 27) and is shown in the drawing as having the same dimensions as the predella panels.

75 The Disrobing of Christ

1922
Oil on wood
36 × 63.5 cm/14$\frac{1}{8}$ × 25 ins
Lent by the Trustees of the Tate Gallery

See the note on no. 74 above.

The panel shows the moment when, after the mocking of Christ, the soldiers '. . . took the robe off from him, and put his own raiment on him', before leading him away to Calvary. As Carolyn Leder has observed (Stanley Spencer Gallery catalogue notes), the use of the traditional predella format and materials such as oil on wood shows the artist's interest in the painting of the early Renaissance. Spencer continued to use variations on the polyptych idea for the rest of his career.

Three small drawings (see no. 73) are studies for the picture. Another pencil and wash drawing, *Study for the Disrobing of Christ* (38.1 × 55.9 cm/15 × 22 ins, squared for transfer, Private Collection), is the working study for the painting. A series of small drawings on the bottom of the same sheet show the intended disposition of the predella (see no. 74).

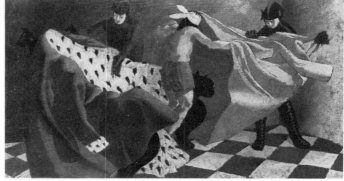

75

76 Washing Peter's Feet

1922
Oil on panel
35.9 × 62.9 cm/14 × 24¾ ins
Lent by Carlisle Museum and Art Gallery

The painting illustrates John 13:1–30. In the foreground Christ washes the feet of Peter, the disciple with the white hair and beard, who has swung round in his seat to make the task easier. He is flanked by two disciples who watch curiously over the backs of their chairs. Others sit on the floor either waiting to be cleansed or drying themselves. Behind them the rest of the company clear the table, recline comfortably, or converse together.

Spencer's unusual composition seems to have caused some confusion when the picture was bought by Carlisle Art Gallery in 1937. William Rothenstein, then Director, 'said that he could not understand it and did not know what it was about' (Tate 733.3.1). Rothenstein was probably distracted by the profusion of everyday details (like the sandals hanging on the chair-back) with which the artist had crowded the scene, and which were essential to his conception of the 'homeliness' of the event, a feeling reinforced by the chairs which were a recollection of 'Fernlea' dining-room. This panel and three others – *The Last Supper* (or *Judas's Question*); *The Robing of Christ* (no. 74); and *The Disrobing of Christ* (no. 75) – were intended to serve as a predella for *The Betrayal* (*Second Version*) 1923 (no. 78). When completed, however, *The Betrayal* proved to be too large to be in keeping with the predella pictures. *The Last Supper* (Private Collection), where the 'Fernlea' chairs also form an important part of the composition, was to be paired with the present picture.

EXHIBITIONS
Tooth, 1936 (26)
Leeds, 1947 (10)
Tate Gallery, 1955 (20)
Arts Council, 1970, *Decade 1920–30* (132)

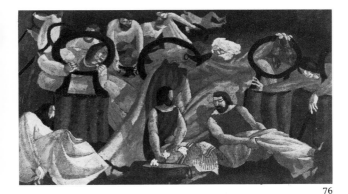

76

77 Study for The Betrayal (Second Version)

c. 1923
Pencil and wash
20 × 21 cm/7¾ × 8¼ ins
Lent by the Piccadilly Gallery

The study shows an intermediate stage in the evolution between the two versions of *The Betrayal* painted in 1914 (no. 27) and 1923 (no. 78). Spencer had adopted the diagonal composition and the background of the later picture, but the foreground is confused by a low wall which bisects the figures of Christ and the High Priest's servants. In the painting the crowd was eliminated and the wall turned to project diagonally into the composition from the right. The corrugated-iron wall of the schoolroom, with the figures of Stanley and Gilbert Spencer leaning against it, which fills the right side of the 1923 painting, is roughly drawn in on the right over the earlier study. Spencer also moved the prone figures of the priests from the right foreground into a less conspicuous position in the left of the oil painting. Christ, Peter and the High Priest's servant appear here substantially as they do in the earlier 1914 version.

EXHIBITION
Piccadilly Gallery, 1978 (24)

77

78 The Betrayal (Second Version)

1923
Oil on canvas
122.7 × 137.2 cm/48 × 54 ins
Lent by the Ulster Museum, Belfast

As in the first version of *The Betrayal* 1914 (no. 27), the scene takes place in the adjoining back gardens of 'Fernlea' and 'The Nest', in Cookham. Here the space in between the brick wall and the corrugated-iron side of the schoolroom (right, in which he was educated) was a 'favourite and mysterious' haunt for the young Spencer and his brother Gilbert; they are shown balancing on the wall and idly watching the events of the Betrayal.

The painting is derived from the earlier 1914 picture (no. 27), borrowing the motifs of the retreating disciples, and the tent-like cloak of Simon Peter as he prepares to strike the High Priest's servant, while Christ steps forward to intervene. In addition Spencer has placed the large bulk of the 'Fernlea' schoolroom on the right, and the curious figures which lie on either side of the path in the lower-left foreground. These he identified as the priests and Pharisees mentioned in John 18:6, who 'As soon then as he had said unto them, I am he, they went backward, and fell to the ground'. Hilda Carline was the model for the fallen figures.

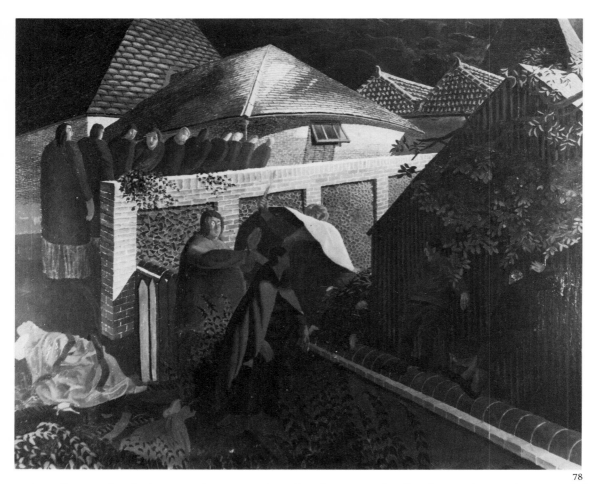

78

As well as varying the iconography Spencer introduced substantial alterations in the basic composition which he had inherited from the 1914 picture. The most important of these changes was the raising of the viewpoint which he had also employed successfully in *Zacharias and Elizabeth* (no. 21) and *Travoys* 1919 (no. 34). By doing this he exchanged the narrow stage-like space of the 1914 painting for a structure made up of two diagonals created by the garden walls, thereby enabling him to include a broader view of the malthouses beyond, and the schoolroom scene on the right. The strong effects of light and shade resulted from Spencer's wish to transform the picture into a 'night' scene, an attempt which he later criticised as being too 'muddy'.

A comparison between the two paintings is instructive in showing the developments which had taken place in Spencer's work since 1914. The most obvious change is the artist's ability to handle space and form; the composition too is much more sophisticated. In the process, however, Spencer lost some of the dramatic intensity of the 1914 painting, where all the events take place in the foreground against the dark wall beyond. This is due partly to the diminution and scattering of the various *dramatis personae*, and partly to the increased variety of detail, the inlaid brick wall, the tiled roofs, and the schoolroom, all of which detract from the central drama of Peter's assault on the servant. Further comparison also shows that the broad flat areas of bright colour and simple blocky forms of the 1914 picture have been replaced by a much more painstaking attention to

detail and a new interest in repeated rhythms and patterns.

All these elements show an art which is moving from a sharp central focus, based upon a single event (as in *Mending Cowls*, 1915, no. 30, *The Visitation* 1912–13, no. 16, or *The Centurion's Servant* 1914, no. 25), towards a composition based on a narrative, in which events scattered throughout the picture are given equal prominence. In the 1922 *Betrayal* Spencer achieved a balance between these two styles, but by 1929, when he painted the Empire Marketing Board pictures (nos. 124–128), the narrative element had achieved the ascendancy, helped by the linked, episodic nature of the five paintings.

Spencer was clearly influenced by his study of early Italian painting in this idea, and he repeated the experiment in a triptych composed of *Christ Overturning the Money Changers' Table* 1921 (no. 61), *Christ Overturning the Money Changers' Tables*, 1921 (no. 60), and *St Veronica Unmasking Christ* 1921 (no. 59). This earlier series was painted for Sir Henry Slesser's Oratory at Bourne End.

EXHIBITIONS
Wembley, *British Empire Exhibition*, 1925 (U.59)
British Council, *British Contemporary Painters* 1946–7 (45) Albright-Knox Art Gallery, Buffalo, California Palace of the Legion of Honour, San Francisco, Cleveland Museum of Art, City Art Museum of St Louis, Art Gallery of Toronto, Worcester Art Museum Arts Council, Welsh Committee, *Stanley Spencer-Religious Paintings* 1965 (7), Llandaff Cathedral, Bangor Art Gallery, Haverfordwest, Swansea, Glynn Vivian Art Gallery

REFERENCES
Wilenski, 1924, pp. 28–9, pl. 26

Belfast Museum and Art Gallery, *Quarterly Notes, Two Recent Art Donations*, 1938, p. 12
Studio, vol. 133, Jan. 1947, p. 19, repr. p. 16
Belfast News Letter, 5 March 1961, repr.
M. Collis, 1962, pp. 25, 243
E. Rothenstein, 1962, repr.
R. Bryan, *Ulster, A Journey through Six Countries*, Faber & Faber, 1964, p. 29
Stanley Spencer's 'The Betrayal', Jean Louise Smith, *Teenways*, March 1974, p. 4
Carline, p. 138

79 Study of Betty McCann

1923
Pencil
55.9 × 37.5 cm/22 × 14¾ ins
inscbr. 'Betty McCann'
verso, drawing of a seated nude, seen from the side
Lent by Richard Carline

The sitter is Betty McCann, one of three sisters who were allowed by their mother to pose for artists. According to Richard Carline, the girls were all very refined and came to artists' parties; Betty McCann, who modelled for the painter James Wood, also went dancing with him at the Savoy. Spencer probably drew her in Carline's Hampstead studio in 1923.

79

80 Self-Portrait

1923
Oil on canvas
49.5 × 34.3 cm/19½ × 13½ ins
Lent by Mr and Mrs David Karmel

This picture is Spencer's second oil self-portrait. It was painted at 10 Hill Street, Poole, in Dorset, where he was staying with Henry Lamb. At the time he was also working on the early designs for Burghclere (no. 82). The artist painted himself in a less idealised pose than in the 1914 *Self-Portrait* (no. 23), leaning his head against the side of the studio door. This picture, which Spencer considered incomplete, may be compared with the *Portrait of Richard Carline* 1923 (no. 84).

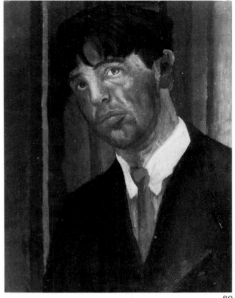

80

81 Still-life

1923
Oil on canvas
33.7 × 43.8 cm/13¼ x 17¼ ins
Lent by the Lynda Grier Collection

Despite Spencer's vigorous denials of the influence of modern art on his work, this still-life, his first, shows that the artist had at least a passing acquaintance with the work of Cézanne. Cézanne almost certainly influenced *The Visitation* 1913 (no. 16), in which Spencer adopted similar tones of green and employed Cézanne's method of leaving areas of unpainted canvas to create highlights. Richard Carline has stated that Spencer never studied Cézanne (p. 31), but the artist's comment that the work of his friend and fellow Slade student, Mark Gertler, showed him incapable of understanding Cézanne implies that Spencer had indeed studied his paintings (Carline, p. 31).

After the war Spencer's work again shows the influence of his contemporaries (see no. 48), although he was beginning to move towards a more personal style by 1923. However his departure into still-life, a new genre, probably persuaded him to look at other artists for a lead, as he had in the case of *John Donne Arriving in Heaven* in 1911. The picture shows an awareness of the work of Cézanne in the angular facets of the crumpled paper-bags, the carefully defined volumes of the oranges, and the unusually rich impasto. The dark overall tonal values of the picture, however, indicate that Spencer was not prepared to adopt the full colour range of Post-Impressionism. It is also probable that he was looking at Cézanne through the work of his English imitators, perhaps even Gertler himself. In his later still-life paintings Spencer abandoned the self-conscious stylish formality of this work for a more relaxed approach based on direct observation and painted in intricate detail.

EXHIBITION
Arts Council, 1976–7 (12)

81

82 Two studies for the Sandham Memorial Chapel, Burghclere

1923
Pencil and sepia wash on paper
each 55.9 × 72.4 cm/22 × 28½ ins
Lent by the Stanley Spencer Gallery, Cookham

Spencer made these two drawings while staying with Henry Lamb at 19 Hill Street, Poole, Dorset, in the summer of 1923. In a letter of 10 June Lamb told Richard Carline: 'Stanley sits at a table all day evolving acres of Salonica and Bristol war compositions. . . .' (Tate Tam 19); and on 31 May Spencer informed Hilda: 'Since I have been home, I have hardly been out at all; I have been so much moved by a scheme of war pictures that I have been making compositions for, that all my time here has been on this. I have drawn a whole architectural scheme of the pictures' (Carline, p. 145). Of these drawings the two side wall compositions are exhibited here; the end wall drawing exists only in the form of a photograph (see showcase).

The two side wall drawings and the missing end wall composition may have been used for a time in a cardboard model for the chapel, which appears in *Hilda Studying a Model for Burghclere c*. 1930 (no. 131).

a) Study for the left-hand side wall

The drawing shows that Spencer made several alterations to the design when he began to work on the Burghclere paintings in 1927. Most important among these was the omission of the operating theatre scene (arched panel second from right), which was replaced in the Chapel by *Kit Inspection* (extreme right in the drawing). The theatre drawing was based on an operation

82b

82a

which the artist had witnessed as an RAMC orderly at the Beaufort War Hospital. He described the scene in a letter to Desmond Chute from Tweseldown Camp in the summer of 1916: 'I am looking back on my "Beaufort" days and now that I am away from the worry of it I must do some pictures of it – frescoes. I should love to do a fresco of an operation I told you about. And have the incision in the belly in the middle of the picture, and all the forceps radiating from it like this [small drawing]' (Stanley Spencer Gallery Collection). The letter shows that as early as 1916 Spencer had in mind a series of pictures commemorating his war experiences.

The space left by *Kit Inspection* was filled at Burghclere by *Stand-To, Macedonia*. The predella panels remained the same, except for *Bed Making*, which was transferred to the third panel on the right-hand wall; it was replaced by *Tea Urns*.

b) Study for the right-hand side wall

Of the arched scenes in this composition only the third, *Filling Water Bottles*, remained unchanged in the Burghclere painting. *Map Reading* (on the left) retained the central figures of the mounted officer and the sleeping men, but becomes a more symmetrical design in the oil painting. In the remaining two drawings, one, the scene second from the left, reappears in the Chapel, much modified, as *Making a Fire Belt*; and *Reveille*, on the extreme left, was eliminated.

In the predella beneath, *Frost Bite* and *Bed Making* on the left are only broadly drawn in. Of the remaining two scenes, *Scrubbing Lockers*, an idea going back to 1921 (see no. 64), remained little changed in the Chapel painting. *Tea Urns* was transferred to the left-hand wall, and an entirely new composition, *Tea in the Hospital Ward*, was substituted.

EXHIBITIONS
Goupil Gallery, 1927 (3) and (7)
Leicester Galleries, 1942 (49) and (50)
Arts Council, 1976–7 (56) and (57)

REFERENCES
Carline, pp. 145–9, pls 25, 26
Robinson, 1979, p. 34, pl. 24

83 The Roundabout

1923
Oil on canvas
52 × 46 cm/20½ × 18 ins
Lent by the Trustees of the Tate Gallery

This was painted at Hampstead when Spencer was working in Henry Lamb's studio on the top floor of the Vale Hotel, Vale of Health; the bedroom window overlooked the fairground. Spencer's choice of the subject may have been influenced by two drawings of the roundabouts at Hampstead given to him by Richard Carline in May 1915. The same fairground is the subject of another painting *Helter Skelter, Hampstead Heath* 1937 (no. 183).

Henry Lamb recalled that it rained heavily on the day the picture was completed. Undaunted, Spencer painted in the reflections on the wet surfaces of the puddles (Nicolette Devas, *Two Flamboyant Fathers*, 1966, pp. 92–4).

EXHIBITIONS
Leicester Galleries, *Selected Paintings, Drawings and Sculpture from the Collection of the late Sir Michael Sadler* 1944 (81)

83

84 Portrait of Richard Carline

1923
Oil on canvas
54.5 × 39.5 cm/21½ × 15½ ins
Lent by Rugby Borough Council

Spencer first met Richard Carline in May 1915 through a mutual friend, Richard Hartley. Carline gave Spencer some drawings which he had admired and they soon became friendly. In 1925 Spencer married Hilda Carline. His friendship with Richard survived after Hilda divorced him in 1937.

In a note made on the painting in 1937 Spencer remembered: 'I liked it and rather enjoyed doing it. Dickey had a very good

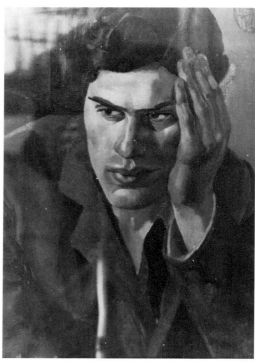

84

edition of *Gulliver's Travels* from which he read occasionally . . .' (Tate 733.3.1). The portrait was painted in Henry Lamb's studio at the Vale Hotel in 1923.

EXHIBITIONS
Goupil Gallery, 1927
Leeds, 1947 (11)
London, Gallery Edward Harvane, *Hampstead One*, 1973 (1)
Cookham, Odney Club, *The Spencers and the Carlines in Hampstead in the 1920s*, 1973 (3)
Liverpool, Bluecoat Gallery *An Honest Patron* (Sir Edward Marsh), 1976
Arts Council, 1976–7 (13)

REFERENCE
Carline, p. 210, pl. 29

85 Panorama, Wangford Marsh

1924
Oil on canvas
43 × 129.5cm/17½ × 50½ ins
Lent by Bradford Art Galleries and Museums

Spencer painted this scene while he was staying in lodgings at Wangford with Mrs Mills in 1924. He was to return at least twice, in 1925 on his honeymoon with Hilda Carline, and again in 1937 after the collapse of his second marriage to Patricia Preece (see no. 181). In a notebook entry written in 1937 he commented that this 'was the first landscape I ever enjoyed painting. I very much like the place. It was a wandering marsh land but full of character . . .' (Tate 733.3.1). The picture is larger and more sophisticated than any which Spencer had previously attempted, and the new elongated format provided the basis for a number of successful landscapes, notably *Cottages at Burghclere* 1930–1 (no. 132) and *Cookham Moor* 1937 (no. 179). Although the picture is usually referred to as *Near Southwold, Sussex*, Spencer's own title, *Panorama, Wangford Marsh*, is more specific in identifying the spot where the picture was painted.

EXHIBITIONS
Leeds, 1947 (15) as *Near Southwold, Suffolk*, and dated *c.* 1925
Arts Council, *Some Twentieth Century English Paintings and Drawings*, 1950

86 Self-Portrait

1924
Oil on panel
24 × 19.5 cm/9½ × 7⅝ ins
Lent by a Private Collector

At the sale of the Behrend collection at the Leicester Galleries in 1962 this small panel was dated 1912. However, Spencer's 1937 catalogue makes no reference to a self-portrait in that year, but does record a 'small self-portrait on wood' (Tate 733.3.1), which he stated was 'done at the Vale Hotel'. As the artist did not begin to use Henry Lamb's studio at the top of the hotel until December 1922 (Carline, p. 138), the evidence points to a later date for the painting. This conclusion is confirmed by Spencer's picture list made *c.* 1941 (Tate 733.3.12), which records a 'small self-portrait' painted in 1924. The artist's appearance also corresponds closely to that of the larger *Self-Portrait* (no. 80) painted the year before while he was staying with Henry Lamb at Poole in Dorset.

EXHIBITIONS
Goupil Gallery, 1927 (86)
Leicester Galleries, *Exhibition of Paintings and Drawings from the Collection of J. L. Behrend*, 1962 (37)

85

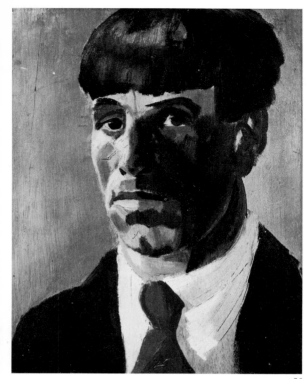

86

destroyed. The remaining two drawings, of which the present work is the most complete, are more careful studies of the sitter's head and shoulders, and were made either as preliminary exercises or as independent portrait drawings or 'heads', as Spencer usually called them. Richard Carline, who also knew Miss Silcox, considers the drawing an excellent likeness.

Spencer had begun to make similar portrait drawings before the war, and continued to do them up until the time of his death in 1959. He seems to have enjoyed this kind of work, and they also provided a useful source of income which did not take up too much valuable painting time.

87

87 Portrait of Miss Silcox

1925
Pencil on paper, sd.
35.6 × 25.4 cm/14 × 10 ins
Lent by Richard Carline

In March 1925, after a protracted courtship, Spencer married Hilda Carline in Wangford Parish Church. She had been a Land Girl stationed at a farm near the village during the First World War and her pleasant memories of those years had prompted her wish to return there for the marriage. After the wedding Spencer and Hilda remained in Wangford, where they were shortly joined by Spencer's brother Gilbert. During their stay they made several expeditions to the nearby seaside village of Southwold (subject of a fine 1937 painting, no. 181), where they visited Miss Silcox, the headmistress of Southwold Girls' School. All three artists had been making portrait drawings of each other, and they now undertook to paint Miss Silcox's portrait, all working together so as not to waste time. The results were not very satisfactory, however, and in a moment of frustration Spencer scraped out his picture, while Hilda's remained unfinished when Miss Silcox became tired of the protracted sittings. It is uncertain whether Gilbert Spencer was able to complete his own picture.

All that has survived from this episode are three preparatory drawings which Spencer made while working on the portrait. One of these, probably the earliest, is a sheet of studies (Private Collection), showing Miss Silcox seated in an armchair, viewed from several different angles. One of these was probably the pose which Spencer used in the painting which he then

88 Turkeys

1925
Oil on canvas
51 × 76 cm/20 × 30 ins
Lent by the Trustees of the Tate Gallery

The picture was probably painted at Wangford (see no. 87). In a reference to the painting made in 1937 the artist called the painting *Turkeys in Holland's Garden* (Tate 733.3.1).

88

EXHIBITION
Tooth, *Pictures Acquired by the Contemporary Art Society* 1932 (24)

REFERENCE
CAS Report 1930–31, 1932, p. 5

89　The Resurrection, Cookham

[repr. in colour between pp. 80 and 81]
1924–6
Oil on canvas
274 × 549 cm/108 × 216 ins
Lent by the Trustees of the Tate Gallery

The picture, Spencer's largest and most important work to date, was begun in February 1924 and was practically finished by 3 March 1926.

It was painted in Henry Lamb's studio in the Vale Hotel, Hampstead, where it stretched the entire length of the room. Because of its height the artist had to stand on a box placed on a table to paint the upper sections of the canvas. A friend, Kate Foster, described the artist at work 'teetering on a box while painting white roses in a corner, just a patch at a time, and holding forth from his elevation on Tonks and the Slade' (Carline, p. 166).

The setting for the painting, Cookham Churchyard with the Thames in the background, was inspired by John Donne's description of a churchyard as being: 'the holy suburb of Heaven' (Tate 733.3.1). Here the newly resurrected emerge in leisurely fashion to experience the joy of their new Thames-side paradise. God the Father and Christ, with a child in his arms, are seen in the flower-covered porch in the centre. They are attended by several 'prophets', or 'thinkers', including Moses, who are ranged in stone seats along the church wall. To their right a group of negroes emerging from their own familiar sun-baked soil gives the painting a universal atmosphere. Spencer himself appears reclining in the hollow created by two adjacent brick tombs in the lower right of the picture.

He adopted this 'open-book' shape to emphasise the 'state of rest and contentment' which has arrived with the Resurrection, and which might be compared with settling down to a good book. The artist reappears, naked, with head in profile to the right, by the porch. His brother-in-law Richard Carline, also naked, kneels beside him. Both 'stilled by the wonder of it all, are inactively thrilled' (Carline, p. 173). Hilda Carline appears no less than three times, smelling a flower by the path on the left, reclining on the ivy-covered tomb in the foreground, and climbing over the stile which leads to the boats on the River of Life, in the top left corner. Nearby a woman dusts her husband's jacket, a recollection of Mrs Spencer, who used to give William Spencer's jacket 'a quick brush down' each time he went out (Tate 733.3.1). The richly dressed figure rising from the flower-decked grave in the foreground is Sir Henry Slesser, wearing his judge's wig. Finally, in the foreground, Spencer showed the wicked being shepherded into the corners of the 'box-like' tombs, as a form of mild retribution (see also no. 28).

As Duncan Robinson has pointed out (1979, p. 29), Spencer has drawn together all his early friends and influences in the calm atmosphere of Cookham after the Resurrection. In 1937 the artist explained: 'No one is in any hurry in this painting. Here and there things slowly move off but in the main they resurrect to such a state of joy that they are content . . . to remain where they have resurrected. In this life we experience a kind of resurrection when we arrive at a state of awareness, a state of being in love, and at such times we like to do again what we have done many times in the past, because now we do it anew in Heaven' (Carline, p. 172).

Spencer had painted three other Resurrection scenes, the first of which was later painted over with *Apple Gatherers* 1912–13. A diptych, *The Resurrection of the Good and the Bad* 1915 (no. 28), is the source for the two figures who climb out of the flower-covered graves in the centre right of the painting; and a small oil study, *The Resurrection, Cookham* c. 1920–1 (no. 55), is probably the earliest surviving idea for the present picture. The artist made a number of drawings while staying with Henry Lamb in Poole, Dorset, in 1922. A fragment (approx. 35.5 × 35.5 cm/14 × 14 ins, torn and folded, Private Collection) is similar in format to *The Resurrection, Cookham* 1926, with Christ and the prophets seated along the church wall, but the building is placed on top of a sloping bank covered in regular rows of graves out of which clamber the resurrected. Another detailed drawing for the composition, dated 1923 (Private Collection), was exhibited at the Goupil Exhibition, 1927 (20), as *Original Composition for the Resurrection*. A pencil and wash study for the negroes was exhibited at the Arts Council Exhibition, 1955 (30); and an oil sketch, *Bonds Steam Launch, Cookham* (no. 48), was used as a study for the pleasure boat in the top left corner of the composition.

When the painting was exhibited at Spencer's one-man exhibition at the Goupil Gallery, February 1927, it created a sensation. *The Times* critic (February 28) thought it: '. . . the most important picture painted by any English artist in the present century . . .' and continued: 'What makes it so astonishing is the combination in it of careful detail with modern freedom of form. It is as if a Pre-Raphaelite had shaken hands with a Cubist.' The *Evening Standard* (February 25) reacted in a similar vein: 'I am quite certain that Stanley Spencer's *Resurrection* is the most original and important picture painted in England since the war.' Roger Fry, whose early enthusiasm for *John Donne* (no. 8) had since waned, was also guardedly impressed: 'Mr Spencer is a literary painter, he works by imagery. Our quarrel with such should not be that they are plastic . . . but that, for the most part, their imagery is so dull and inexpressive. That complaint cannot be levelled against *The Resurrection*. It is highly arresting and intriguing. It is no perfunctory sentimental piece of story-telling, but a very personal conception carried through with unfailing nerve and conviction' (Nation and Athenaeum 12 March). The painting was bought from the exhibition for £1000 by the Duveen Fund for the National Gallery.

EXHIBITIONS
Goupil Gallery 1927 (54), as *The Resurrection*
Tate Gallery, 1955 (25)

REFERENCES
The Connoisseur, LXXVII, 1927, pp. 250–1
The Connoisseur, LXXVIII, 1927, pp. 93–101, 135–6
Wilenski, *The Modern Movement in Art*, 1927, pl. 4

Drawing and Design, II, 1927, p. 105, repr. p. 115
Johnson, 1932, pp. 331, 332
M. Chamot, 1937, p. 74
Studio, CXXVI, 1943, p. 50, repr. p. 51
E. Rothenstein, 1945, p. 14, pls. 21–4
E. Newton, 1947, pl. 9 (in colour)
J. Rothenstein, *Modern English Painters, Lewis to Moore*, 1956, pp. 181–2
G. Spencer, 1961, pp. 172, 174–6
M. Collis, 1962, pp. 77, 80–9, 91, 143, 162, 193, 243
Tate Gallery, *Catalogue*, 1968, p. 661
Carline, pp. 163–75, 190, 198, 201, 206, 211, pl. 32 (detail)
Robinson, 1979, pp. 29–30, pl. 20 (in colour)

90 The Month of January: Afternoon Tea

1926
Pen and ink
24.1 × 42.5 cm/9½ × 16¾ ins
sbr. in pencil 'Stanley Spencer'
insc. by the artist in pencil, centre, 'January', and in another hand, 'Reduce to 4" . . .'.
Lent by Richard Carline

In 1926 Spencer was commissioned by Chatto & Windus to provide twenty-five illustrations to an *Almanac* to be published in 1927. He began work on the drawings in March 1926 shortly after the completion of *The Resurrection, Cookham* 1924–6 (no. 89), and they were completed before the end of the year. Spencer chose to illustrate the changing seasons with scenes from his childhood, life with his friends in London and his marriage to Hilda. The drawings are almost lyrical in their evocation of a quiet domestic existence, and there is no hint of the exaggerated sexual emphasis which appears in the paintings of the late thirties.

Although many of the drawings were later sold or given away, Spencer retained two of the small Almanacs, which he used as diaries for 1927 and 1928 (Tate 733.4.2 and 733.4.3, see display case). In 1935 and 1936 he made use of these illustrations for several of the paintings in the *Domestic Scenes* series (see nos. 164 and 167), squaring up the tiny drawings for eventual transfer to the canvas. As late as 1956 he was using the plate for the month of September for *The Dustbin, Cookham* (no. 271). Spencer frequently used old studies in this manner, turning to them either when inspiration was temporarily lacking, or when the design fitted into a new scheme. Spencer's return to the use of pen and ink in these drawings was dictated by the requirements of the publisher, but the resulting simplicity of style provides an interesting contrast with the crowded detail of the other studies which date from this time (see no. 122).

The drawing shows the Carlines' studio, 14a Downshire Hill, Hampstead. Richard Carline is seen from behind, facing Kate Foster, a Slade School friend. Between them is the tea-tray which Carline and Spencer had brought back from Sarajevo in Bosnia in 1922 (see no. 69).

In *A Private View of Stanley Spencer*, Heinemann, 1972, the drawing is incorrectly described by L. Collis, quoting Lady Spencer (Patricia Preece), as 'showing the standard of cooking Hilda provided. Stanley and Hilda are about to eat or perhaps

have eaten; on the table between them are a teapot and half a dozen open tins. . . . It was far from an exaggerated picture'.

A copy of the book is included in the exhibition (see display case).

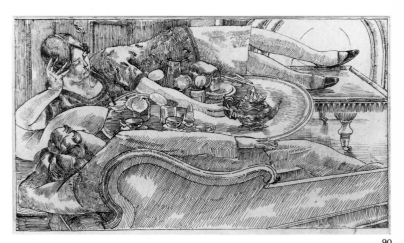

90

EXHIBITIONS
Goupil Gallery, 1927 (34)
Leicester Galleries, *Artists and Collectors*, 1963
Cookham Festival, Odney Club, *The Spencers and the Carlines in Hampstead in the 1920s*, 1973 (9)
London, Harvane Gallery, *Hampstead 1*, 1973 (4)
Arts Council, 1976–7 (61)

REFERENCES
L. Collis, 1972, p. 171
Carline, p. 107, repr.

91 The Month of February: Hilda Drawing

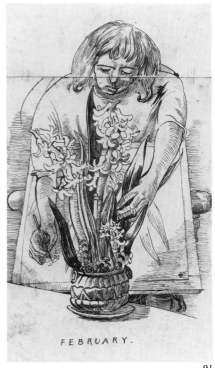

FEBRUARY.

91

1926
Pen and ink, two sheets joined
43.5 × 24 cm/17⅕ × 9¼ ins
insc. with printing instructions in pencil
Lent by Mr and Mrs David Inshaw

This was drawn for the Chatto & Windus *Almanac*, and shows HIlda drawing a hyacinth.

EXHIBITION
Piccadilly Gallery, 1978 (28)

REFERENCE
Carline, pp. 107, 171–2

92 The Month of April: Neighbours

1926
Pen and pencil on paper
53.3 × 30.5 cm/21 × 12 ins, *verso* study for 'March'
insc. in the artist's hand 'April'
Lent by Mr and Mrs David Karmel

Drawn for the Chatto & Windus *Almanac*. Spencer used the illustration in his own copy of the book as the basis for the painting *Neighbours* 1936 (no. 163) in which the near pair of figures was eliminated. The scene is set at the back of 'Fernlea', and was intended to illustrate the different feelings evoked by the neighbouring gardens of 'Fernlea' and 'Belmont'. In the foreground Spencer's sister Annie exchanges gifts with her cousin over the hedge.

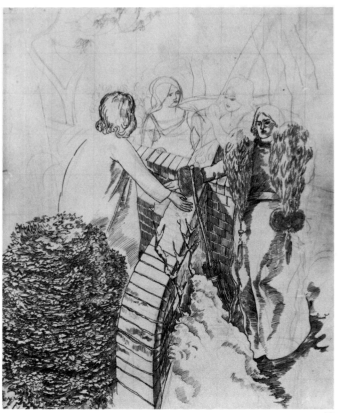

92

93 The Month of May: Cows at Cookham

1926
Pen and ink
43.2 × 35.6 cm/17 × 14 ins
From the collection of the late W. A. Evill

93

Drawn for the Chatto & Windus *Almanac*. The composition was used for the upper part of the 1936 painting *Cows at Cookham* (no. 171).

EXHIBITIONS
Tooth, 1936 (12)
Arts Council, 1961 (20)
Brighton, 1965 (200)

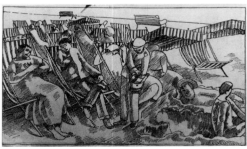

94

94 The Month of August: On the Beach

1926
Pen and ink
21 × 35 cm/8¼ × 13¾ ins
Lent by the Piccadilly Gallery

Drawn for the Chatto & Windus *Almanac*.

The two figures in deck chairs on the left are probably Spencer and his wife Hilda. The beach may be Southwold, which they visited when on their honeymoon at the nearby village of Wangford in 1925 (see also no. 181).

EXHIBITION
Piccadilly Gallery, 1978 (30)

REFERENCE
Carline, pp. 107, 171–2

95 The Cultivator

1927
Oil on canvas
43.8 × 59 cm/17¼ × 23¼ ins
Lent by the Lynda Grier Collection

Painted while the Spencers were staying with Lady Ottoline Morrell at Garsington in 1927. Both Gilbert and Stanley Spencer had met Lady Ottoline through their mutual friend Henry Lamb, and Gilbert had stayed with the Morrells in the early twenties. In an undated draft letter to Richard Carline, Spencer reported his progress on the picture: 'I have at last begun to

work, a big iron hay machine which is unfortunately rusty and presents a pleasing contrast with the lush long grass and flowers in which it is half hidden. Appreciate all you can from this description as of course *it* will be more interesting than the painting itself' (Tate 733.1.265). Spencer had painted a similar subject, *Landscape with Cultivator, Durweston* (55.9 × 40.6 cm/ 22 × 16 ins, Private Collection), in 1920.

95

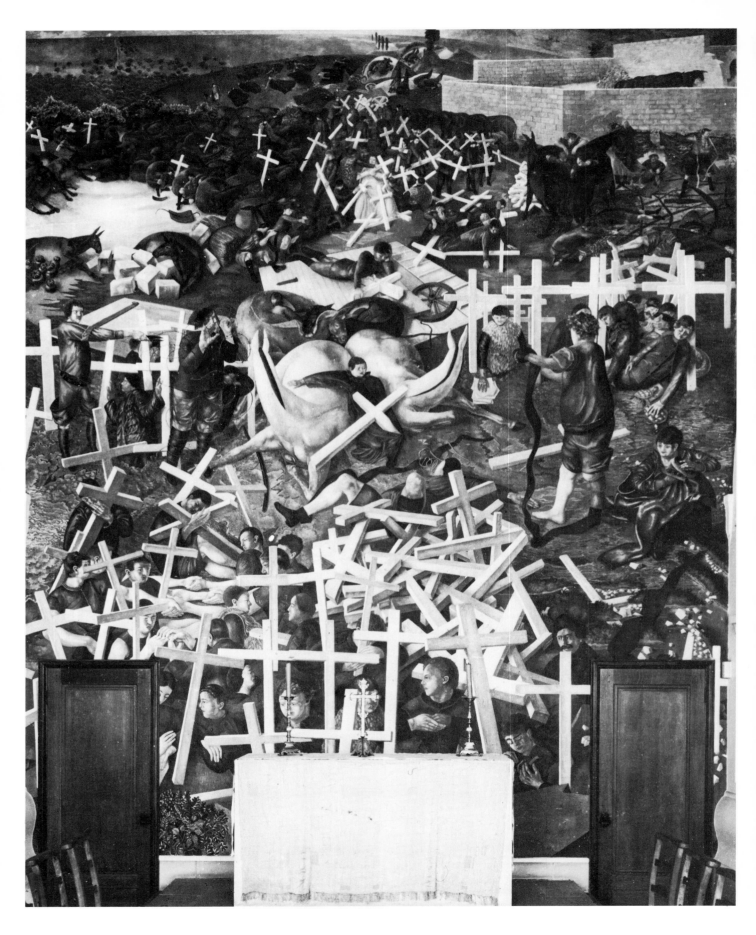

3 The Oratory of All Souls, Burghclere 1927–1932

When Spencer returned from active service in Macedonia in 1918, he was commissioned to paint three official war pictures. Of these only *Travoys with Wounded Soldiers Arriving at a Dressing Station* (no. 34) was completed. However as early as May 1918, when he had first been contacted by the Ministry of Information in Macedonia, Spencer had plans to paint a series of pictures for a 'War Memorial', showing a 'travoys', a 'mule-lines' and others, based on his Macedonian experiences. A number of studies were later exhibited at the Goupil Gallery in 1927 (nos. 37, 38), and dated in the catalogue 1919.

Spencer did not abandon his wartime ideas and in 1919 the artist Muirhead Bone invited him to the village of Steep to paint a series of panels for a war memorial in the village hall. Spencer's ideas, however, had not yet clarified, and the scheme was called off, although not before he had made at least one study (see no. 64), which is the earliest source for three of the predella pictures at Burghclere, *Scrubbing The Floor* (no. 105), *Soldiers Washing* (no. 103), and *Washing Lockers* (no. 119).

By 1924, Spencer's ideas were developing into a more specific and ambitious scheme. In the summer of that year he was staying with Henry Lamb at Poole in Dorset. On 10 June, Lamb wrote to Richard Carline, 'Stanley sits at a table all day evolving Salonica and Bristol war compositions' (no. 82). These drawings were seen by Mr and Mrs J. L. Behrend when they visited Lamb shortly afterwards. On 19 July Spencer wrote to inform Hilda Carline that the Behrends had greatly admired the drawings; and on 16 September he told her that they had decided to build a Chapel to house his scheme. After some consideration Cookham was rejected as a site in favour of Burghclere near the Behrends' Hampshire home. The building was to be in memory of Mrs Behrend's brother, Lieutenant Henry Willoughby Sandham RASC, who died in 1919 of an illness contracted on active service in Macedonia. Spencer's Macedonian pictures were therefore particularly appropriate.

Spencer's plans for the Chapel were reminiscent of Giotto's frescoes in the fourteenth-century Arena Chapel in Padua. The side walls of the building were to be divided into two registers, with an unbroken east wall behind the altar, for which he originally envisaged an

opposite The east wall at Burghclere

arched design which was later eliminated. The building was designed by Lionel Pearson (Spencer had originally wanted George Kennedy) who, at least so far as the interior was concerned, received strict instructions from the artist, including the measurements of the bays and the form of the arches and dado.

The building was dedicated as the Oratory of All Souls by the Bishop of Guildford on 25 March 1927. Spencer, who had already painted two of the north wall canvases (nos. 103 and 105) in London, moved with his family to Burghclere. Here they stayed in lodgings at Palmer's Hill Farm, before moving into 'Chapel View', the cottage built for their use by the Behrends. Spencer had originally planned to paint the Chapel in fresco in emulation of the early Italian masters, and to this end took lessons from Mrs Sargant-Florence, practising the technique on a small scale. But practical difficulties dictated the more familiar technique of oils on canvas. For the larger pictures the canvas was specially made in Belgium, to ensure seamless widths, and the whole was glued to the wall on top of a layer of asbestos cloth. The smaller panels were mounted in the usual way on stretchers.

In executing the Burghclere pictures Spencer relied closely on the original 1923 designs (no. 82), although several changes and substitutions were made, most notably the elimination of the *Surgical Operation* scene, which Spencer felt was too disturbing. The upper and lower registers of the north and south walls were almost equally divided between the Macedonian scenes, and pictures of life at Beaufort Hospital, Bristol, where Spencer had been a medical orderly in 1915–16. These pictures show the almost religious sense of ritual with which Spencer viewed the everyday activities at the hospital. These were intended to symbolise a quotation from St Augustine's *Confessions*, given to him by Desmond Chute at Bristol: '. . . ever busy yet ever at rest, gathering yet never needing; bearing; filling; guarding; creating; nourishing; perfecting'.

The east wall (see opposite), when he reached it in 1928, took nearly a year to complete. *The Resurrection of the Soldiers*, the focal point of the cycle, draws together the other themes of the Chapel into a final conclusion, dominated by the extraordinary white crosses which the soldiers hand in to Christ (see no. 98). Unlike the side walls, *The Resurrection* was only designed after the Chapel was

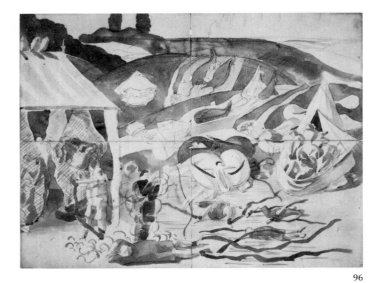

96

built, and went through a number of stages (see no. 96) before Spencer found a satisfactory design.

Violence is notably absent from the war scenes in the Chapel, even in *Stand-to* (no. 110), which shows the soldiers rushing from their dug outs prepared for action, only to find that they are being called to the Resurrection. Instead the moments which Spencer celebrates are the intervals between action when the soldiers busy themselves with the life-enhancing business of washing, eating and relaxation. The intimate detail with which these events are depicted prefigures the increasingly complicated scenes of the thirties. But Spencer rarely achieved again the level of emotional intensity found at Burghclere, and the Chapel remained the apogee of his artistic development.

The artist worked on the Chapel until early 1931 when he moved back to Cookham, where the remaining panels were painted.

The Chapel was given to the National Trust by Mr and Mrs Behrend in 1947.

REFERENCES
Caline, 'New Mural Paintings by Stanley Spencer', *Studio*, November 1928
R. H. Wilenski, *English Painting*, London, 1933, pp. 280–5, pls. 128a, 128b, 129, 130
E. Rothenstein, 1945, pp. 14–5, pls. 25–32
E. Newton, 1947, pls. 12, 14, 16, 18
J. Rothenstein, 1956, pp. 180–4, east wall pl. 17
E. Rothenstein, 1962, detail pl. 7 (in colour)
M. Collis, 1962, pp. 49, 76, 80, 90 ff., 98, 101 ff., repr. facing pp. 88, 89
G. Behrend, *Stanley Spencer at Burghclere*, London, 1965
Carline, pp. 145–61, 176–200, pls. 33, 34, 36, 37
Robinson, 1979, pp. 30–40

96 Study for The Resurrection: Burghclere Chapel

c. 1927
Pencil and sepia wash, two sheets joined
45.7 × 59 cm/18 × 23¼ ins
Lent by Richard Carline

This important study for the end wall of Burghclere Chapel has not been previously recorded. It is difficult to date precisely but probably belongs to 1927, the year in which Spencer began to design *The Resurrection* in earnest. The arched top to the picture, first considered in 1923 (Carline, p. 145), has been abandoned in favour of a horizontal format.

The activities in the picture showing soldiers dressing beneath mosquito nets or climbing out of their tent indicate that Spencer first conceived the Resurrection in the form of a final 'reveille', in which the living emerge to greet the newly resurrected on the battlefield. The resurrecting soldiers and their crosses, which were the successful solution established in the working cartoon, have not yet appeared.

Although the composition was greatly modified in the working drawing (see display case), several details were retained. These include the man entangled in barbed wire, standing centre left; the group of men lying among barbed wire and unwound puttees at the lower right; and the soldier lying between a pair of resurrecting mules in the centre of the sketch. The mules and wagons on the hillside in the background were translated into the far top corner of the final painting. Another detail, the soldiers under mosquito nets in the large tent at the left, was revised in modified form in *Reveille* 1929 (no. 112), the arch-topped painting nearest the entrance on the right-hand side wall at Burghclere.

97 Men and Mules, Study for The Resurrection, Burghclere

c. 1927–8
Pencil and wash
33.7 × 24.1 cm/13¼ × 9½ ins
Lent by Mrs T. A. Hall

A study for the central part of *The Resurrection of Soldiers* on the end wall of Sandham Memorial Chapel, Burghclere. In the picture soldiers and their mules come to life on the Resurrection day. Spencer based the scene on recollections of a dead Bulgarian mule-team and ammunition limber, which he had seen during the war in Macedonia (see no. 100).

The study predates the working cartoon of 1927 (see display case), in which the soldier in the foreground is shown clasping a large white cross. Spencer also enlarged the shattered limber, on which another soldier appears, contemplating the cross which has recently marked his grave.

An oil study of *Men and Mules* is also in the exhibition (no. 100).

REFERENCE
Carline, pp. 193–4

97

Before painting *The Resurrection of Soldiers*, on the end wall of the Burghclere chapel, Spencer made full-scale working drawings from smaller studies which he joined together to test the effect of the complete composition. The design was then transferred to the canvas.

With the exception of a few fragments these drawings are now lost, and the present section is the most complete surviving detail. It shows the pile of crosses discarded by the resurrecting soldiers in the lower right centre of the end wall of the Burghclere chapel.

Spencer explained how the idea came about in a letter written to Richard Carline in 1928: 'All this part of the "cross" idea was thought of as a result of the "squaring up" of the pictures. . . . The whole of the bottom of the picture is a sort of portrait gallery formed by soldiers coming out of the ground and the crosses arranged so as to look like frames. There used to be a sort of frame made, which usually had texts in them, and I have had those frames in my mind, as some of the "frames" in my picture look just like it' (Carline, p. 191).

REFERENCE
Carline, p. 191

98 Working Drawing for The Resurrection of Soldiers, Burghclere

c. 1928
Pencil and sepia wash, two sheets, joined
74.9 × 54.6 cm/29½ × 21½ ins, squared for transfer
Lent by Richard Carline

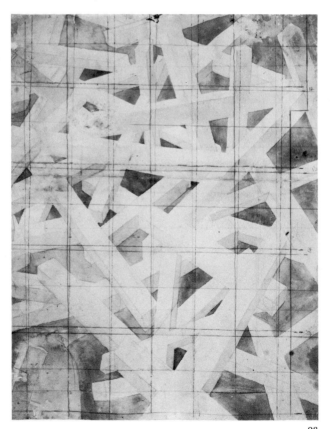

98

99 Two Studies for The Resurrection of Soldiers: Burghclere

1927–8
Pencil and brown wash
(a) 20.3 × 25.4 cm/8 × 10 ins
(b) 27.9 × 53.2 cm/11 × 21 ins, squared for transfer
Lent by Cdr Sir M. Culme-Seymour

Both drawings are studies for the group of newly resurrected soldiers who greet each other in the lower left of *The Resurrection of Soldiers*, in Burghclere Chapel.

99a

99b

99

Drawing (a) shows an early stage in the composition of the painting in which Spencer depicted the two rows of soldiers receding directly back into the picture, with the two figures in the foreground forming a frame round the doorway in the east wall of the chapel. Spencer altered this in the painting by introducing his masterful solution of the crosses (see no. 98), and arranging the two rows of soldiers in a diagonal to the right in order to create a correspondence with the overall perspective design.

The second drawing (b) is a working study for the oil painting. It depicts the linked arms of the six soldiers in the simple abstract rhythms by which Spencer built up the early stages of his compositions at this date. The details of the scene were only added later at the painting stage. Similar studies, most of which are now lost, were made for all the details of the painting. They were then transferred to a large scale cartoon (see no. 98) before being drawn in on the canvas.

EXHIBITION
Arts Council, *Drawings by Stanley Spencer* 1955 (22, 23), as *Soldiers Shaking Hands*, and *Shaking Hands*, and dated *c*. 1926

100 Study of The Resurrection of Soldiers, Burghclere

c. 1926–7
Oil on canvas
30.4 × 50.1 cm/12 × 20 ins
Lent by Mrs Isobel Powys Marks

This small oil sketch was used by Spencer for the central scene in *The Resurrection of Soldiers* 1928–9, on the altar wall of the Sandham Memorial Chapel, Burghclere. It is a recollection of Spencer's wartime service on the Macedonian front, and shows a soldier and two mules on the Resurrection day, which he imagined taking place there.

The picture was exhibited at the Leicester Galleries in 1942, when it was dated 1919, but it is more likely that it was painted *c*. 1926–7, as part of the sequence of the studies for the end wall at Burghclere which the artist was working on at the time (see display case).

In 1928 Spencer described this central detail of the Burghclere painting in a letter to Richard Carline: 'The central motif of this picture is also mules. They are lying on the ground in the same order as when they were harnessed to the timber waggon . . . the wheels and the mules and the men, who were the riders of them, waking up, it being the Resurrection, and

contemplating the surroundings. This that I want to tell you . . . is gruesome. . . . It is that I once saw a scene very similar . . . of riders fallen down between the mules. . . . It helped to show that this idea is very logical . . . you remember I was telling you about this mule idea when we were looking at those Chaldean things in the British Museum. How I thought of those two mules turning their heads round in opposite directions was one day up in the Vale of Health studio. Looking out of the window as usual, I saw the oil-cart, which was always drawn by two sleek-looking horses, and they were both looking round in this manner . . .' (Carline p. 194). Spencer was later to explain that the man resurrecting between the two mules was experiencing the same 'cosy' feeling he had as a child when, after a bad dream, his parents would take him into their bed. The mules, which play an important part in *The Resurrection*, had been the main form of transport in the Macedonian campaign, and Spencer had grown fond of them ('they seemed to reflect the feeling the country gave me') when he handled them as a medical orderly near the front (see nos. 34–6). The cross which is shown in the lap of the soldier in the Burghclere painting has only been sketched in pencil in this study.

EXHIBITION
Leicester Galleries, 1942 (7), dated '1919'

REFERENCE
Carline p. 193–4

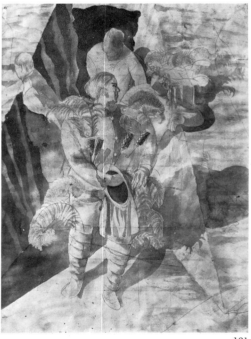

101

101 Camouflaged Grenadier

c. 1928
verso two compositional studies for Burghclere Chapel
Pencil and wash, squared for transfer
50.5 × 36.5 cm/19$\frac{7}{8}$ × 14$\frac{5}{8}$ ins
inscbc. 'Camouflaged Grenadier.9'
Lent by the Trustees of the Tate Gallery

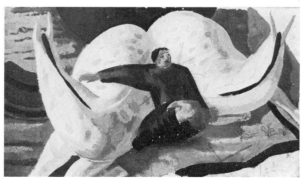

100

This is a study of the soldier emerging from the dug-out in the foreground of the arch-topped painting *Stand-to* (no. 110), in the fourth central bay, nearest the altar, on the north wall of Burghclere Chapel. The man is camouflaged with ferns, and rifle-grenades protrude from his tunic pockets. He was known to the artist as a daring soldier who was killed in action during the Macedonian campaign (information from Gilbert Spencer, quoted in the Tate Gallery catalogue, 1964, p. 662).

EXHIBITIONS
Goupil Gallery, 1927 (5)
Arts Council, 1976–7 (58)

102 Soap Suds: A Scrubbed Floor

1927
Oil on canvas
50.1 × 61 cm/20 × 24 ins
Lent by Richard Carline

Painted in Spencer's Vale Hotel studio in Hampstead, while he was working on *Scrubbing the Floor* (no. 105), the first canvas for the Sandham Memorial Chapel, Burghclere. This can be seen on an easel in the corner of the studio. The artist clearly felt the need for an additional study of the soap suds idea before proceeding with the Burghclere picture.

The scene first occurs in the background of a sketch, *Scrubbing the Floor* (no. 64), which was made for the proposed war memorial in Steep village hall, 1921.

EXHIBITIONS
Goupil Gallery, 1927 (48)
Pittsburgh, Carnegie Institute, N.D. (283)
Stanley Spencer Gallery, Cookham, summer 1976 (40)

REFERENCE
Carline, p. 176

102

103 Soldiers Washing

c. 1927
Oil on canvas
67.3 × 44.5 cm/26½ × 17½ ins
Lent by Whitworth Art Gallery, the University of Manchester

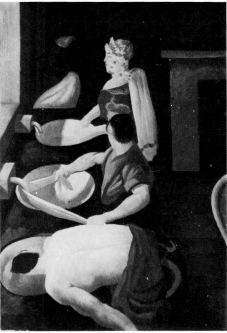

103

An almost identical scene appears, reversed, in the right-hand section of *Ablutions* (no. 106), the second arched composition on the left wall of the Burghclere Chapel.

The idea for the painting goes back to 1921, when Spencer was employed by Sir Muirhead Bone to decorate the Village Hall at Steep. The proposed murals were not carried out but Spencer made the wash drawing *Scrubbing the Floor and Soldiers Washing at Beaufort Hospital, Bristol* in 1916 (no. 64). It shows men washing on the left, and on the right others cleaning lockers in a bath, while another scrubs the floor. All three activities were incorporated, modified in appearance, into separate Burghclere paintings: *Ablutions* (no. 106), *Washing Lockers* (no. 119) and *Scrubbing the Floor* (no. 105), respectively.

Although there is no recorded date for *Soldiers Washing*, the picture cannot have been painted later than 1927, when it was exhibited at Spencer's one-man exhibition at the Goupil Gallery as *Men Washing* (85). It was shown with *Scrubbing the Floor* (no. 105), another study for Burghclere, which is based upon the 1921 drawing, and definitely dated 1927. Spencer probably painted *Soldiers Washing* at the same date, and used it as a study for the Burghclere painting *Ablutions*, completed in the following year.

In this study Spencer adapted the left side of the 1921 drawing (no. 64). He made the composition more compact by reducing the number of washbasins from five to three, and moved the background figure carrying a towel further to the left. The third figure, his head covered in lather, assumed a greater significance in the painting than in the drawing. This is still further emphasised in *Ablutions*, where Spencer placed the washing scene in the right-hand corner of the painting, eliminated the bath, and crowded new figures into the remainder of the canvas.

EXHIBITION
Goupil Gallery, 1927 (85)

104 Convoy of Wounded Soldiers Arriving at Beaufort Hospital Gates

1927
Oil on canvas
213.4 × 185.4 cm/84 × 73 ins
Lent by the National Trust, Sandham Memorial Chapel

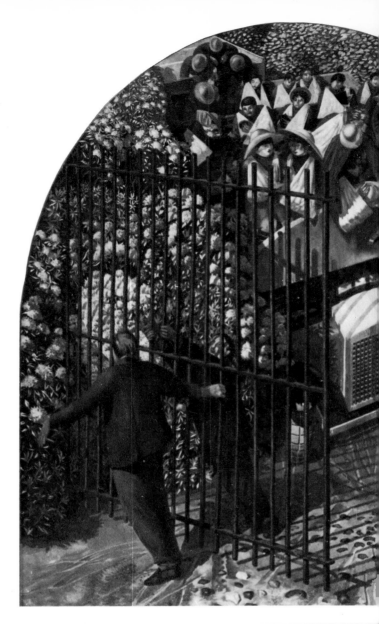

This was the first picture to be painted in Burghclere Chapel after its completion in May 1927. At the time the Spencers were living in lodgings nearby at Palmer's Hill Farm, whence the artist could cycle over the railway bridge to work in the Chapel.

In the painting a gatekeeper pulls open the iron gates of the hospital to allow the entry of a bus crowded with wounded soldiers. Spencer later informed Richard Carline that he liked the shape of the slings on the men's arms, and that to escape boredom they exchanged souvenirs, or looked at the bullet holes in their helmets (Carline, p. 177). The wounded get their first view of the hospital, as Spencer had, from the top deck of a bus (diary account, 1918, Tate 733.3.83). When he came to paint the picture, Spencer could not remember what the roadway looked like, because at the time he had been terrified of the warder, who he feared might pull him in for being improperly dressed or absent without leave. Because of this understandable lapse of memory, Spencer had to introduce the rhododendrons which he found lining the roads round Burghclere. The bunch of keys at the warder's waist were copied from the set used to secure the chapel door (Behrend, p. 8).

In an account written during his return from Macedonia in 1918, he recalled: 'The gate was as massive and as high as the gate of hell. It was a vile cast-iron structure. Its keeper, though unlike that lean son of a hag who kept the gates of hell [in Milton's *Paradise Lost*], being tall and thicker was nevertheless absolutely associated with that capricious . . . being who had charge of all the 'deaduns' and did all the cutting up in all the post-mortem operations. I could imagine him cutting my head off as easily as I imagined him cutting off chunks of beef . . .' (Tate 733.3.83).

In the painting Spencer transformed this unpleasant experience into a brightly painted summertime scene, with the flowering rhododendrons crowding in on either side of the bus. Only the keeper retains his unpleasant appearance. The composition is similar to *Travoys* 1919 (no. 34) in its use of an elevated viewpoint.

105 Scrubbing the Floor

1927
Oil on canvas
105.4 × 185.4 cm/41½ × 73 ins
Lent by the National Trust, Sandham Memorial Chapel

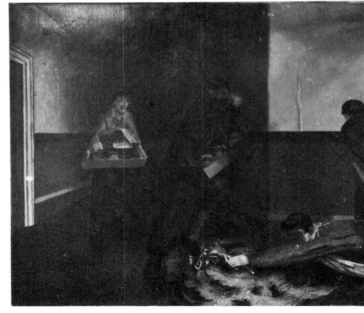

The picture, painted in the Vale Hotel studio in the early part of 1927, was the first of the Burghclere panels to be completed. It is derived from the background of a study, *Scrubbing the*

104

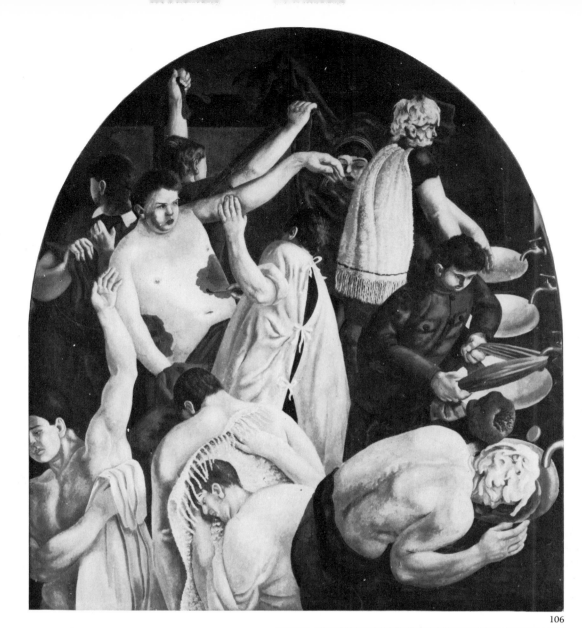

106

105

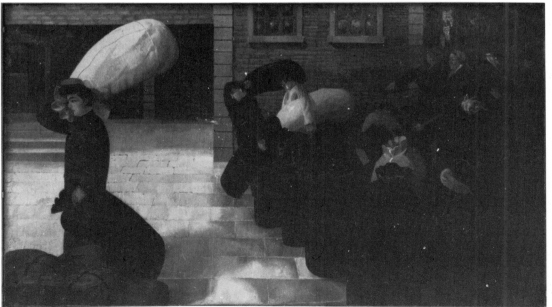

107

Floor and Soldiers Washing, Beaufort Hospital, Bristol (no. 64), made *c.* 1921 for a war memorial in the village hall at Steep, commissioned by Muirhead Bone, but never painted. The study is also the source for two other Burghclere paintings: *Ablutions* (no. 106) and *Washing Lockers* (no. 119).

The scene takes place in Beaufort War Hospital, Bristol. In 1929 Spencer described the picture in a letter to Richard Carline: 'The corridor leads to the main kitchen and stores. . . . The men are fetching bread, etc., from the kitchen and store; the man leaning against the wall is readjusting the loaves of bread on his tray before he continues his journey to the ward' (Carline, p. 176). The man scrubbing the floor was a shell-shocked soldier who had a peculiar way of throwing himself down to do the work (Behrend, p. 6).

Spencer used soap and water to recreate the pattern of soapsuds on the floor of his studio, breaking off to paint *Soap Suds* (no. 102), in which the partially completed *Scrubbing the Floor* can be seen in the background.

The panel was completed in time to be exhibited at the artist's one-man exhibition at the Goupil Gallery, February 1927 (84).

106 Ablutions

1928
Oil on canvas
213.4 × 185.4 cm/84 × 73 ins
Lent by the National Trust, Sandham Memorial Chapel

The picture shows the crowded bathroom at Beaufort War Hospital. In the middle an orderly paints a soldier with iodine, while another concentrates on polishing the taps. According to George Behrend, the artist had difficulty in painting the sponge, which seems to float off the counter next to the basin on the right. 'I sat there, George,' he said, 'for half an hour, trying to think what a sponge looked like; but it was no good. I had to go home and get mine.' (Behrend p. 8). He also washed his hair to get the correct appearance of the soap suds.

The row of basins had first appeared, reversed, in the left-hand side of a sketch, *Scrubbing the Floor and Soldiers Washing, Beaufort Hospital, Bristol* 1921 (no. 64), which was probably a study for the proposed mural in Steep village hall. The sketch was also the original source for *Scrubbing the Floor* (no. 105) and *Washing Lockers* (no. 119). An oil painting, *Soldiers Washing c.* 1937 (no. 103) was probably painted at the Vale Hotel studios before the Spencers moved to Burghclere in May.

107 Sorting and Moving Kit-Bags

1927
Oil on canvas
105.4 × 185.4 cm/41½ × 73 ins
Lent by the National Trust, Sandham Memorial Chapel

This was the second of the Burghclere pictures painted in the Vale Hotel studio, Hampstead, in 1927. It was finished in time to be shown in Spencer's one-man exhibition at the Goupil Gallery in February (80).

The artist described the painting in the same letter to Richard Carline in which he refers to *Scrubbing the Floor* (no. 105): 'Immediately on arrival at the hospital the kit-bags of the soldiers just arrived would be stacked all together in the courtyard. . . . The patients who happened to be not 'bed cases' would point out to the orderlies whichever happened to be their respective bags. The orderlies would then carry them to wherever the patient wanted them, or open them if so required. They were all padlocked' (Carline, p. 177).

Spencer made use of a limited range of colours, browns, greys, and drab creams, in the two Vale studio paintings, in order to reproduce the gloomy atmosphere and institutional decoration of the converted asylum. These colours, which may be compared with *Travoys* (no. 34), were remarked on at the time by Richard Carline (Carline, p. 177). Both canvases are composed of broad areas of simply painted architectural elements, against which the hospital activities are set. The artist had made use of a similar device in *Mending Cowls* 1915 (no. 30). With the exception of *Washing Lockers* (no. 119), composed as early as 1921, the later pictures in the series become increasingly crowded with detail.

A study, *Soldiers Sorting Kit-Bags* (pencil and wash, 17.1 × 24.1 cm/6¾ × 9½ ins, Private Collection), is similar to the oil painting but lacks the steps in the foreground.

108 Kit Inspection

1930
Oil on canvas
213.4 × 185.4 cm/84 × 73 ins
Lent by the National Trust, Sandham Memorial Chapel

Early in 1915 the military authorities appealed for volunteers from amongst the orderlies at Beaufort War Hospital for service abroad. Spencer, who disliked the hospital, put his name forward and was transferred in May to 'W' Company, Royal Army Medical Corps, Tweseldown Camp, near Farnham, for basic training.

In the painting, the only scene in the Chapel devoted to Tweseldown, soldiers lay out their kit on groundsheets in the manner prescribed by army regulations. Although some critics have concluded that Spencer would have found the task onerous (Behrend, p. 8), it is more likely that the artist was interested in the idea of the soldiers each surrounded by his own personal 'world' of possessions. This theme is used again in *Sarah Tubb and the Heavenly Visitors* 1933 (no. 142), where the old woman is shown surrounded by the banal objects of her everyday existence.

In 1928 Spencer told Richard Carline that he was going to omit the scene from the Chapel because the original sketch (no. 82) was unsatisfactory. The rectangular shapes of the groundsheets were too rigid, and the soldier in the foreground was too large to be compatible with the figures in panels on either side (Carline, p. 188). However in 1930 he revised the composition, adding curved edges to the groundsheets and placing the outsize soldier in the centre of the picture, thereby creating a more symmetrically balanced design.

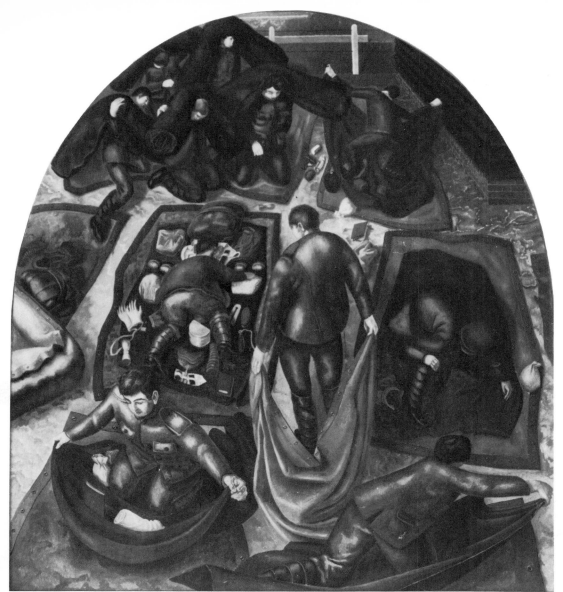

108

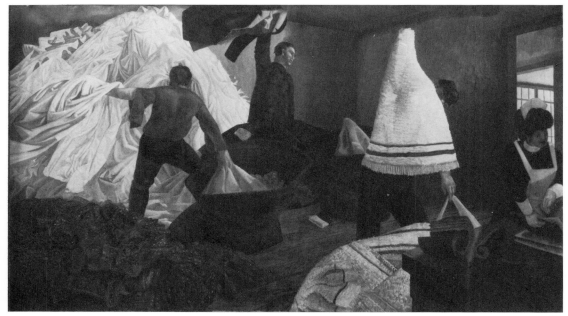

109

109 Sorting Laundry

1927
Oil on canvas
105.4 × 185.4 cm/41½ × 73 ins
Lent by the National Trust, Sandham Memorial Chapel

The laundry was another of the small havens of peace which Spencer found amid the harsh regulated activity at Beaufort Hospital. Here the orderlies were supervised by the lady in the starched cap and cuffs, well away from the bullying Sergeant-Major (Collis, 1962, p. 48). The artist later described the scene to Richard Carline: 'As each orderly called out the name of each article, the laundress would write it down in the respective orderly's "check-book" ' (Carline, p. 177). These were kept handy under their braces. The incongruous pile of spotted handkerchiefs in the left foreground belonged to the inmates of the asylum who were kept in a separate wing of the hospital.

Spencer re-used the curious shape of the towel which half envelops the orderly on the right for *Cutting the Cloth* (no. 127), a panel in a pentaptych painted for the Empire Marketing Board in 1929.

110 Dug-out or Stand-to

1928
Oil on canvas
213.4 × 185.4 cm/84 × 73 ins
Lent by the National Trust, Sandham Memorial Chapel

In 1928 Spencer decided to replace the planned picture of a *Surgical Operation* with another painting called *Stand-to*, a title which was later changed to *Dug-out*, as the composition evolved.

An early study (pencil and sepia wash, 35.6 × 25.4 cm/14 × 10 ins, Private Collection) shows that at first *Stand-to* was an entirely different picture, and consisted of a trench in the lower foreground occupied by two soldiers. Above them lay a sergeant, lit by bursting shells and 'symbolising peace'. Describing the scene the artist recalled: 'As one was lying flat on the bottom of the outpost, one had a feeling that the sergeant reclining on the parapet was like a kind of angel, a supernatural being. One did not see him; one daren't look up. One knew and felt he was there' (Carline, p. 185). Spencer later decided to move this scene, reduced in size, to the top of the *Dug-out* composition. He then eliminated it altogether, painting in its place the barbed wire entanglements which link the picture to *The Resurrection* on the end wall (see p. 96).

This final conception, transformed into *Dug-out*, is the most dramatic and moving of the Macedonian scenes in the Chapel. Spencer explained its meaning in his 1928 letter to Richard Carline: 'The idea . . . occurred to me in thinking how marvellous it would be if one morning, when we came out of our dug-outs, we found that somehow everything was peace and that war was no more. That was one thing – the thought of how we would behave. Another thing I noticed at that time was the quiet way the sergeant would stroll out of his dug-out and tell the men to get ready.

'The picture really depicts the scene I had imagined supposing that at the moment of "stand-to", it had suddenly been realised that the war had ceased. And so the men are about to put on their equipment but have paused as they become conscious of the change. It is a sort of cross between an "Armistice" picture and a "Resurrection" ' (Carline, p. 184). Spencer went on to explain that the soldier's equipment was laid out on the sides of the dug-outs, so that they could put it on quickly when the 'stand-to' order was given. The sergeant, a man whom Spencer knew, emerges from the dug-out on the left equipped and camouflaged for action.

An early drawing entitled *Study for Burghclere Memorial Chapel, Soldiers and Mules* (pencil and wash, 27.9 × 24.1 cm/ 11 × 9½ ins, Private Collection), shows that the artist originally planned to include the dug-out scene in the top of the *Resurrection of Soldiers* on the end wall.

111 Filling Tea Urns

1927
Oil on canvas
105.4 × 185.4 cm/41½ × 73 ins
Lent by the National Trust, Sandham Memorial Chapel

The picture was the last of the four predella paintings to be completed and secured in place on the Chapel wall in 1927. According to the working drawing (no. 82) the picture was originally intended to be the last panel next to the altar on the right-hand wall, with *Bed Making* (no. 117) filling the space directly opposite; a position to which *Tea Urns* was finally assigned in 1927.

The theme of the painting is based on the mystery of the everyday life of the mental patients, who were confined to a separate wing of the hospital. They were only to be seen in the kitchens where orderlies and inmates collected tea urns for their respective wards, from opposite sides of a counter. Spencer saw the inmate who stands with his urn on the far side of the room every day for a year, without discovering who he was, or what lay down the passage behind, into which he disappeared (Behrend, p. 8).

Spencer experienced some difficulties in painting the picture, and an entry in the Chatto & Windus *Almanac* 1927, which he used as a diary (Tate 733.4.2), indicates that late in 1927 the orderlies' heads had to be scraped out and repainted.

112 Reveille

1929
Oil on canvas
213.4 × 185.4 cm/84 × 73 ins
Lent by the National Trust, Sandham Memorial Chapel

Another late addition to the Burghclere scheme, this painting replaced a scene in the 1923 compositional drawing (no. 82) showing an encampment, which was probably the projected 'lights-out' picture referred to by the artist in a letter to Hilda Carline, 31 May 1923 (Carline, p. 148).

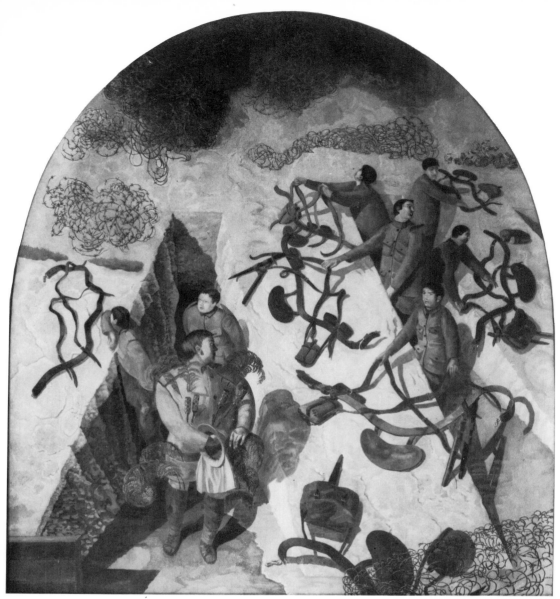

110

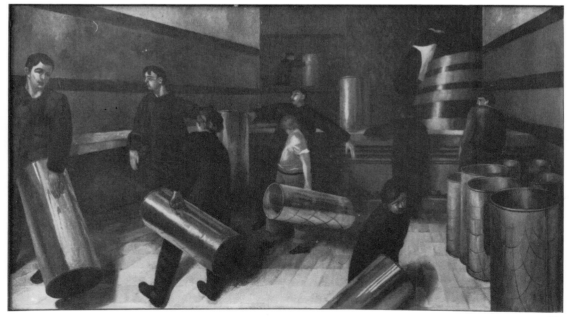

111

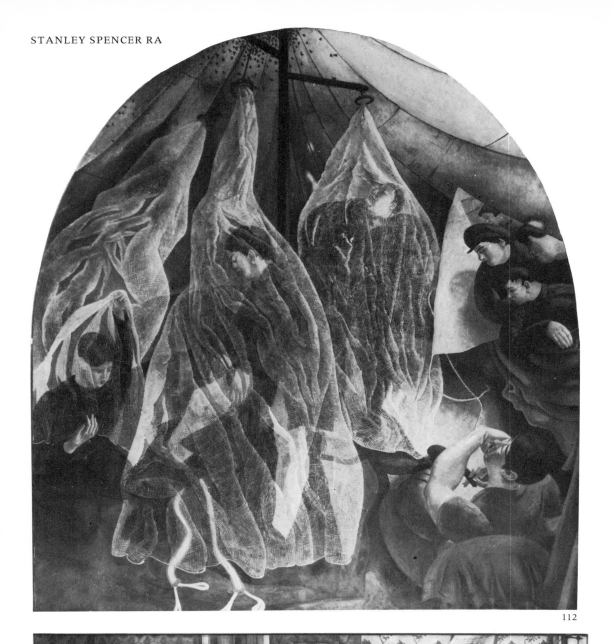

112

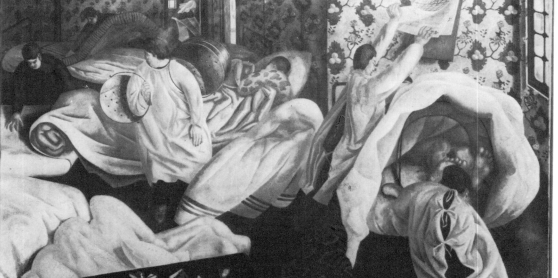

113

Spencer explained the picture to Richard Carline in 1928: 'Each man, as we always did, dresses under his own mosquito net. I shall try, but may not succeed so well to express the fact that though this is a *Reveille* scene, yet the idea is, again, clearly the Resurrection. The men looking in the door of the tent are clearly doing nothing and are free from any hurry. . . . The picture is, as in the other [*Dug-out*, no. 110], a mixture of real and spiritual fact, as the underlying intention is a great feeling of peace and happiness' (Carline, p. 185). The mosquitoes which swarm near the peak of the tent were a constant problem in Macedonia, and Spencer himself was evacuated to England as a malaria case in 1918.

The artist adapted the composition from the left-hand corner of the earliest surviving study for the end-wall Resurrection painting (no. 96), as he explained to Richard Carline in 1928: 'Both things [*Stand-to* and *Reveille*] I thought of as being parts of the big central Resurrection picture, and in the general weeding or rather thinning out they both had to go' (Carline, p. 184). *Stand-to* (no. 110) does not appear in no. 96, and must belong to another Resurrection study, now lost.

The picture is the only tent interior in the Macedonian series, although the artist had incorporated a scene of soldiers lying asleep in a tent in *The Sword of the Lord and of Gideon* (no. 62), in 1921. In a letter dated 3 June 1918 Spencer informed Henry Lamb, then serving in Egypt, that amongst other schemes he was planning to paint 'a picture of a lecture on mosquitoes', as part of his War Artists work for the Ministry of Information (Tate Tam 15). The picture was never painted but a recollection of the idea may have influenced the choice of the present, more intimate, subject.

113 Patient Suffering from Frostbite

1932
Oil on canvas
105.4 × 185.4 cm/41½ × 73 ins
Lent by the National Trust, Sandham Memorial Chapel

Another of the ward scenes from Beaufort War Hospital. The picture was painted in Cookham in 1932. In the background orderlies turn mattresses and change beds, and on the right a doctor and his assistant attend to the frost-bitten patient. It was one of Spencer's tasks at the hospital to scrape the patients' feet.

The nest-like effect created by the bedclothes arched over the soldier's legs had interested Spencer in a different context before. In November 1924, in a letter to Hilda referring to *The Resurrection, Cookham* (no. 89), he mentioned the 'intimate personal feeling' which he was trying to achieve in painting the arm of the figure of Hilda on the ivy-covered tomb: 'I tried to draw your arm when you wear the grey woollen jumper,' he wrote; 'It used to get bell-shaped round the wrist when it wanted washing. . . . As I drew it I got a fresh notion. . . . One sees the hand a little way up the sleeve in a little world of its own. . . .' (Carline, p. 170). This device was developed to even greater effect in *Christ in the Wilderness, The Foxes have Holes* (no. 194), and *The Hen* (no. 201).

114 Convoy of Wounded Men Filling Water-Bottles at a Stream

1932
Oil on canvas
213.4 × 185.4 cm/84 × 73 ins
Lent by the National Trust, Sandham Memorial Chapel

In 1928 the artist described the sketch for this painting (no. 82) in a letter to Richard Carline: 'There is a great crowd of men round a Greek fountain or drinking-water trough (usually two slates of marble, one set vertically into the side of a hill, having a slit shaped hole in it which the other smaller slab fits . . .). What rather amused me was that often above the fountain, you could see the water trickling down the little groove made by it in the rock.

'In this picture the groove of the water-course is indicated on the face of the rocky hill-side. . . . The bottom part of the picture shows men and mules drinking. Above them . . . are men who have climbed up the hill-side and are lying on the little ledges in the hill-side in order to be able to get at the fountain that way, there being too great a crowd below. The peculiar wing-like looking things coming from their shoulders are army mackintoshes, which being only attached to the back of the collar, naturally slide off the backs of the men . . . and droop downwards' (Carline, p. 183).

In the oil painting Spencer replaced the pack on the left-hand mule with a soldier, slung comfortably from the animal's back in a camp chair. A small Spencer-like figure clutching some water-bottles was added beneath the neck of the spotted mule in the foreground of the painting.

The vertical format of the composition, symmetrically balanced, may be compared to *Route March*, which was also painted in 1932.

Spencer used the 'star' shape created by the figures round the fountain in several later compositions, including *Shipbuilding on the Clyde: Burners* 1940 (no. 216) and the early drawings for *Christ Preaching at Cookham Regatta* (no. 279, unfinished).

115 Tea in the Hospital Ward

1932
Oil on canvas
105.4 × 185.4 cm/41½ × 73 ins
Lent by the National Trust, Sandham Memorial Chapel

The picture, the last of the predella scenes, was painted in Cookham in 1932. It shows men seated round a table at teatime in a ward in Beaufort Hospital. According to Richard Carline the slices of white bread and butter shown here were the artist's favourite diet (Carline, p. 183).

The painting replaced another unidentified ward scene shown in the 1923 compositional drawing (no. 82). A study (34.3 × 25.4 cm/13½ × 10 ins, Tate 733.11.6, p. 33) shows the general dispositions of the figures in the painting, but contains some variations in their gestures.

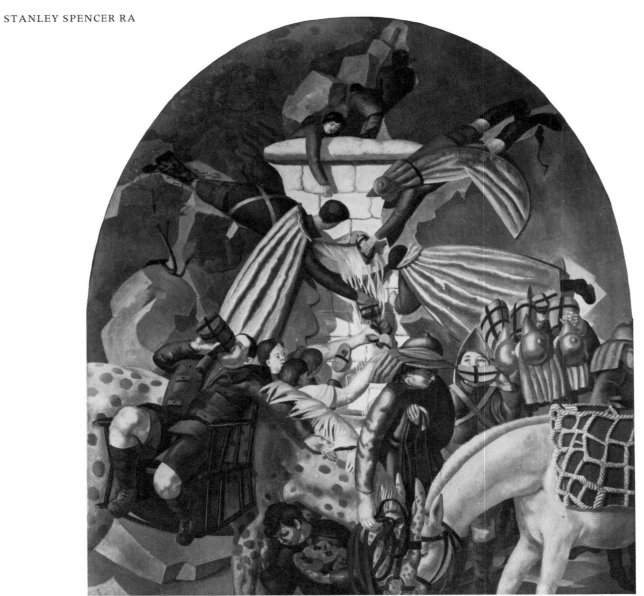

114

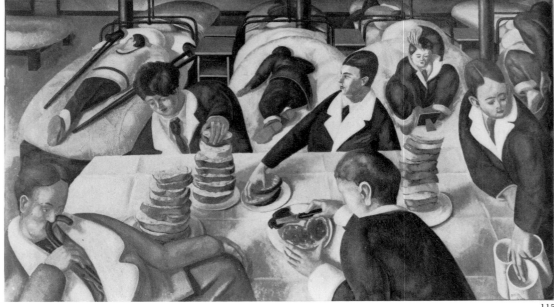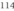

115

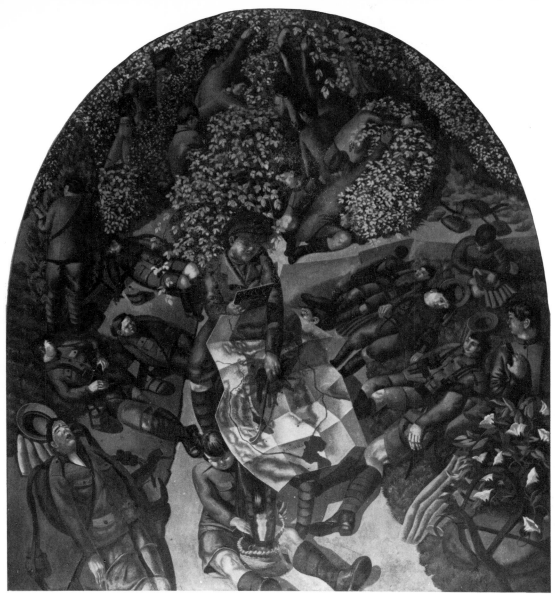

116

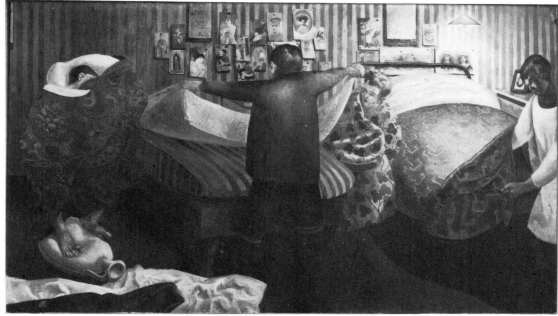

117

116 Map Reading

1932
Oil on canvas
213.4 × 185.4 cm/84 × 73 ins
Lent by the National Trust, Sandham Memorial Chapel

The painting shows a party of soldiers resting while on a route-march in Macedonia. In the centre an officer, the only one who appears in the Chapel, reads his orders and consults a large map, on which the port of *Salonika* is clearly marked. Around him exhausted soldiers sleep on the lush grass, while others, in a rare moment of relaxation, clamber up the bank in the background to pick bilberries.

Commenting on the drawing for the panel (no. 82) in 1928, the artist told Richard Carline: 'The map nearly fills the picture, with men, down below, resting on either side of the road. I loved this scene for the obvious reason of resting and contemplating' (Carline, p. 185). In the painting Spencer reduced the officer and the map to a smaller size, eliminated the man standing in the foreground, and introduced the idyllic scene of the bilberry patch into the background.

Before reaching this final stage, however, he made a large arch-topped drawing (35.6 × 70 cm/14 × 24 ins, Private Collection), showing the present disposition of the foreground, but introducing a deep gulley into the centre, above which soldiers clamber among the bushes. This intermediate solution was abandoned, probably because the crowded composition, with its tiny figures, would have been on a scale incompatible with the other pictures on the south wall of the Chapel.

The painting has the same bright colours and clear details which also occur in *Convoy of Wounded Soldiers Arriving at Beaufort Hospital Gates* (no. 104), painted in 1927. The carefully painted roadside and flowering plants rival the best of Spencer's landscapes, such as *Cottages at Burghclere* (no. 132) of *c.* 1930–31.

117 Bed Making

1932
Oil on canvas
105.4 × 185.4 cm/41½ × 73 ins
Lent by the National Trust, Sandham Memorial Chapel

Together with *Frostbite* (no. 113) and *Tea in the Hospital Ward* (no. 115), this picture was painted after the Spencers returned to 'Lindworth', Cookham, in 1932. In the picture two hospital orderlies make beds, while a patient, swathed in blankets and his feet warmed by a hot water-bottle, waits in a chair nearby.

In the sketch (no. 82) made in 1923, the wall behind appears bare of any decoration, but the painting shows striped wallpaper with a variety of photographs and post-cards pinned to it. Among these Richard Carline has identified photographs of Hilda in the garden at Downshire Hill, Spencer's father in the porch at Hedsor Church where he was organist, and a picture of Unity Spencer as a baby (Carline, p. 182).

118 Making a Fire Belt

1932
Oil on canvas
213.4 × 185.4 cm/84 × 73 ins
Lent by the National Trust, Sandham Memorial Chapel

This painting shows men of Spencer's unit in Macedonia erecting tents and burning off the grass round their camp to create a protective fire barrier. They are using spills, made from pages torn from the *Balkan Times*. The likeness of the soldiers to Spencer himself, both in this picture and in others of the series, was explained by the artist in an undated letter to his friend, Peggy Andrews: 'All my figures are simply "me", putting myself in places and circumstances in which I want to be, but not literally portraits of myself' (Carline, p. 182). This element of wish-fulfilment, already evident in Spencer's work, became increasingly important during the thirties.

The picture, which does not appear in the 1923 compositional drawing (no. 82), was a late addition to the scheme, painted in 1932 after Spencer's return to Cookham. It replaced *Camouflaged Tent*, in which a group of soldiers play cards in front of a large tent, at the entrance to which the unit emblem and number are laid out in coloured stones on the ground. The decision to remove this scene had been made as early as 1928 (Carline, p. 184). The tents in the picture had been transferred from an early drawing study for *Kit Inspection* (no. 108), which Spencer revised before transferring the composition to the canvas.

Despite his absence from the site Spencer succeeded, probably through the use of drawings made in the chapel, in getting the angle of vision to correspond with the other pictures.

119 Washing Lockers

1929
Oil on canvas
105.4 × 185.4 cm/41½ × 73 ins
Lent by the National Trust, Sandham Memorial Chapel

According to Richard Carline this picture had a particularly important place in the artist's recollections of Beaufort Hospital. When at work on the canvas in November 1929, Spencer explained in a letter to Carline: 'The baths were a deep sort of magenta colour and shiny, and when you had a row of them end-view on, they looked marvellous' (Carline, p. 182). The bath house provided a haven where the artist, seen in the picture kneeling between the baths, could work and think without being disturbed.

A version of the scene was included in a drawing study, *Scrubbing the Floor and Soldiers Washing, Beaufort Hospital* (no. 64) made in 1921 for the projected Steep war memorial commission. The baths are shown, seen from above in the foreground of the drawing. Richard Carline also records a preliminary sketch, which shows the prone figure of Spencer facing out of the picture instead of inwards. On the back the artist had written: 'Me scrubbing: I say "me", because I have only to mentally place myself between the baths to feel at once inspired' (Carline, p. 182).

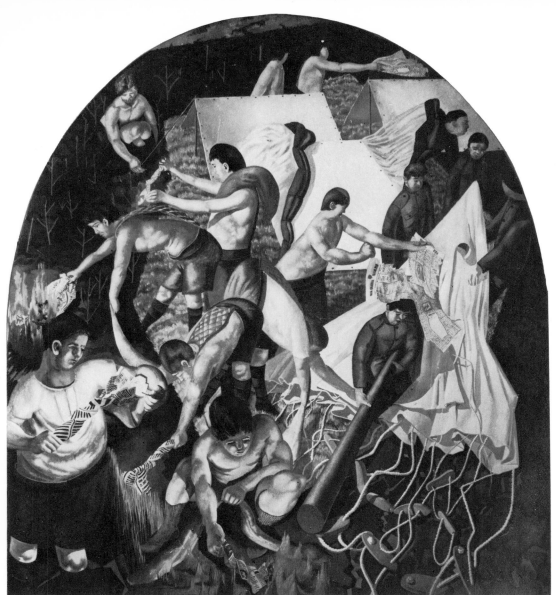

118

119

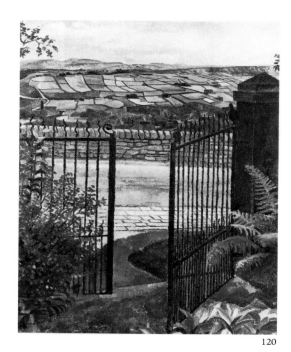

120

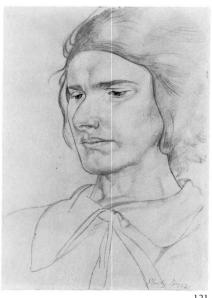

121

120 A Gate, Yorkshire

1928
Oil on canvas
50.8 × 40.6 cm/20 × 16 ins
From the collection of the late W. A. Evill

The picture was probably painted while the artist was staying
with George R. Carline (eldest brother of Richard Carline), who
was keeper of Bankfield and other museums in Halifax.
According to Richard Carline, the scene was painted just in front
of George Carline's house at Warley near the city. In a list of
paintings made by Spencer in 1937 (Tate 733.3.12), he referred
to the picture as *Walls and Fields, Halifax*. The picture was
probably exhibited under the title *Fields at Halifax* in the 1928
Goupil Gallery *Salon* of 1928 (118). Another painting, *Landscape
near Halifax* (canvas, 50.8 × 70 cm/20 × 24 ins, Halifax Art
Gallery), was exhibited at the same show (117).

EXHIBITIONS
Goupil Gallery, *Salon*, 1928 (118)
Brighton, 1965 (198), as *A Gate, Yorkshire Scene*

121 Portrait of Hilda Spencer

1928
Pencil
35.6 × 25.4 cm/14 × 10 ins
sdbr. 'Stanley Spencer 1928'
Lent by the Visitors of the Ashmolean Museum, Oxford

Spencer made several portrait drawings of his wife Hilda while
they were living at Burghclere from 1927 to 1932 (see no. 133).

EXHIBITIONS
New York, Brooklyn Museum, *Watercolour Paintings, Pastels and Drawings by
American and European Artists*, 1933 (112)
Arts Council, 1976–7 (64)

122– The Empire Marketing Board
128 Series

1929
Oil on canvas
Pentaptych:
centre panel 102.9 × 156.5 cm/40½ × 62 ins
inner panels each 102.9 × 64.8 cm/40 × 25½ ins
outer panels 101.6 × 152.4 cm/40 × 60 ins

In 1929, when Spencer was still working on the end wall of the
Burghclere chapel, he received a commission from the Empire
Marketing Board for a series of designs on the theme of *Industry
and Peace*, which would be made into posters and distributed
round the country. Though he generally disliked commissions
on the grounds that they interfered with his own work, Spencer
accepted, and quickly produced two alternative drawing
schemes, each of which was twelve feet long. Not surprisingly,
these designs were rejected as being too large, but a compromise
was reached in which Spencer was to adapt one of the big
designs into a series of five separate panels. These, the artist
later told Mary Behrend in a draft letter (Tate 733.1.175), were
to be made into five posters for which specially adapted display
boards would be made. The second scheme, which the artist
preferred 'of people lying about in a meadow by a river', may
have been used again, at least in part, for *By the River* (no. 151).

The series of five paintings was completed and delivered
within the short space of seven weeks. Although Spencer was
eventually paid for this work the posters were never published.
Later he found the pictures stored in a dirty warehouse, from
which they were finally rescued by one of Spencer's patrons,
Sir Edward Beddington-Behrens, who purchased them from the
Treasury for the original sum of £300 paid to the artist.

Later, in 1937, Spencer wrote a commentary on the
paintings: 'I . . . decided that the whole scheme should consist
of a long sort of room where people gathered together as people

visiting some Eastern town might have gathered together . . . in some sort of caravanserai. To give the impression of a kind of communion of life and people from a variety of callings, trades and professions, I have placed in the central panel an anthracite stove, and round it I have imagined people employed in the town who come to eat their lunch, and to lay the tables. . . . As the room extends to the left we come to a wall [side panel], standing against which is a tall hat and umbrella stand. This wall turns back into the picture and the room has changed into a music room with girls taking their instruments out of their cases [outer panel]; others are drawings on drawing boards, and finally it is at this end an art class with pupils sitting on the donkey trestles. . . . Extending to the right from the central panel the room becomes a shop and a woman is unfolding a piece of material against a screen, and below a man is cutting out material. The shop then becomes a garage in which can be seen the bonnet of a car being lifted, two men putting a tyre on a wheel, and a man sorting out old tyres . . .' (Tate 733.3.1).

From this description it is clear that Spencer intended that the paintings (and therefore the posters) should be seen as a unity. At the time Sir Edward Beddington-Behrens loaned them to the Tate Gallery in the thirties they were mounted as a central triptych in a single frame, with two separate outer panels. Later, when the pictures were sold, the three central canvases, which came to be known as *Cutting the Cloth*, passed into the Wilfrid Evill collection, and the outer panels went to separate owners, at which time the unified identity of the series was almost forgotten. The pictures have been brought together in this exhibition for the first time since the 1940s.

EXHIBITIONS
Tate Gallery, on long term loan, March 1939–45
Worthing, 1961 (9), *The Hat Stand* and *Cutting the Cloth* only
Brighton, 1965 (202), the central three paintings only, exhibited as *Cutting the Cloth*
Stanley Spencer Gallery, Cookham, summer 1967 (14), and subsequently, *The Garage* only

122 Study for The Garage

*c.*1928
Pencil and wash, squared for transfer
48.3 × 61 cm/19 × 24 ins
Lent by Lord Montagu of Beaulieu

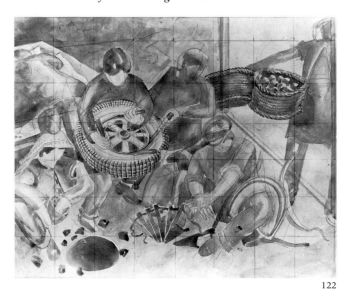

122

The drawing is an early study for the upper right-hand corner of *The Garage* 1929 (no. 128), which Spencer painted for the Empire Marketing Board. Although the drawing is squared for transfer, the artist only retained the figures of the two men working on a wheel in the centre of the composition when he came to work on the oil painting. The girl carrying two apple baskets under her arm who appears at the garage door is a repetition of a motif first used in *Apple Gatherers* (no. 15) in 1912.

EXHIBITION
Stanley Spencer Gallery, Cookham, summer 1978 (38)

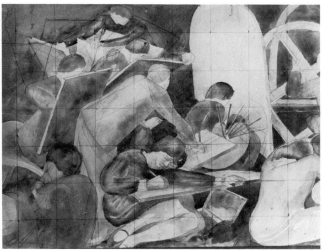

123

123 Study for The Art Class

c. 1929
Pencil and sepia wash, squared for transfer
49 × 62 cm/19½ × 24½ ins
Lent by a Private Collector

This is a working drawing for *The Art Class* (no. 124), one of five pictures on the theme of *Industry and Peace* which Spencer painted for the Empire Marketing Board in 1929. It shows the central group of students arranged round an art teacher and the arch-topped panel in the centre of the painting.

In transferring the composition to the canvas Spencer made a number of changes: the wooden stretchers in the top right of the drawing (used again in *The Builders* 1935, no. 157) were replaced by an upright piano, and the unresolved figure or figures in the lower left were removed and a drawing board inserted.

Another sepia drawing, *Study for The Garage* 1929 (no. 122), also belongs to the *Industry and Peace* series.

EXHIBITION
Piccadilly Gallery, 1978 (34)

124 The Art Class

1928
Left outer panel
Lent by a Private Collector

115

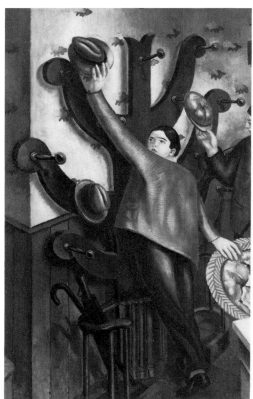

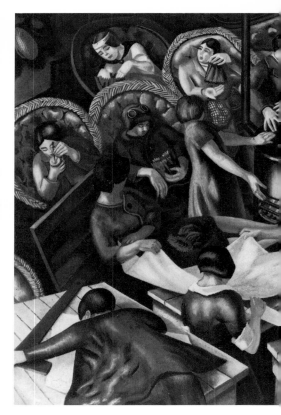

125

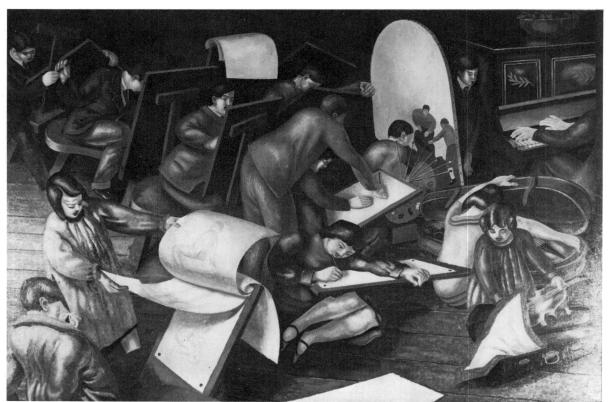

124

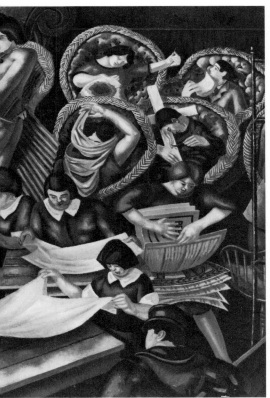

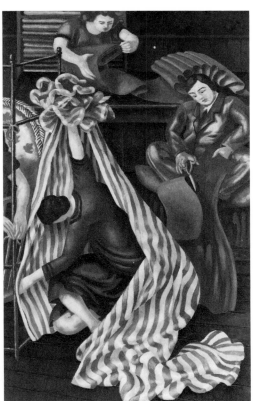

126

127

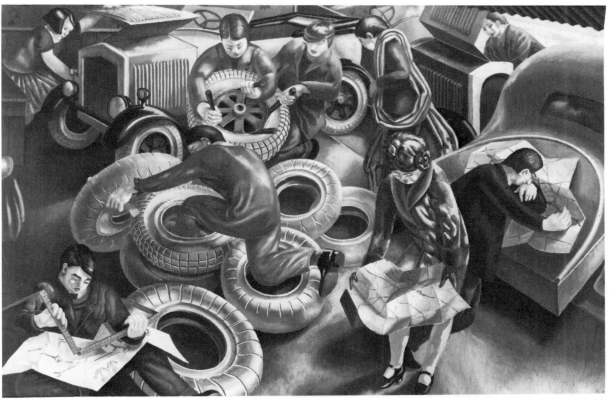

128

The central scene in this painting may be a recollection of the artist's training at the Slade School of Art. In the foreground a student shows her work to a friend, while in the middle a drawing master helps another with his sketch. The large arched canvas to the right is similar to those used in the upper register of the side walls of the Burghclere Chapel, on which he was working at the time, and the artist squatting in front of it with a palette and brush in one hand may be Spencer himself.

To the right of the art class two women can be seen removing musical instruments from their cases while behind a man plays the piano. Portions of this scene were adapted from the numerous drawings which Spencer had made at Bedales Music School while staying at the village of Steep in 1922. These had originally been intended as a decoration for the school refectory, which, like the Steep war memorial commission, was never carried out.

A study for *The Art Class* is also included in the exhibition (no. 123).

125 The Hat Stand

1929
Left central panel
From the collection of the late W. A. Evill

The picture acts as a division between the two rooms containing the art class and the activities round the stove. A similar hat stand recurs in *Hilda Welcomed* 1953 (no. 262) and is probably a recollection of the hallway of Spencer's childhood home, 'Fernlea'.

126 The Anthracite Stove

1929
Central panel
From the collection of the late W. A. Evill

It is difficult to identify any specific setting for the scenes depicted in the series, but it is probable that the initial idea for the row of interlocking rooms came from a study (now lost) which Spencer had made of the interior of the village hall at Steep, near Petersfield, which he had decorated in 1922 (see no. 64). According to the artist this scene consisted of a series of three rooms separated by partitions and containing in the centre a party of men and women grouped round an anthracite stove, playing draughts and reading books.

A drawing, *Party in the Studio* (63.5 × 50.1 cm/25 × 20 ins, Private Collection), is a study for the central section of the painting. The foreground of the drawing showing figures sitting on chairs was replaced by the table-laying scene in the final picture.

127 Cutting the Cloth

1929
Right central panel
From the collection of the late W. A. Evill

The curious partial envelopment of one of the figures in this picture by a tent-like piece of material may have been prompted by a feeling which Spencer, late in 1940, put into writing, about the very different atmosphere he encountered at Lithgow's shipyards in Port Glasgow: 'Men and people generally make a kind of "home" for themselves wherever they are and whatever their work, which enables the important human elements to reach into and pervade the atmospheres of . . . even the most ordinary procedures of work or place' (Spencer/ Dickey, May 1940. Imperial War Museum archives).

128 The Garage

1929
Right outer panel
Lent by Lord Montagu of Beaulieu

Spencer had acquired a car in 1929 to facilitate travel to and from Burghclere, where he was working on the paintings for the Sandham Memorial Chapel. It was probably this novel experience which inspired him to paint *The Garage*, the first occasion upon which he tackled an industrial subject. It was followed in 1935 by an abortive commission to paint a large (40 × 6 ft.) picture for a factory belonging to Sir Montagu Burton; and, in 1936, by a large drawing and two small canvases, entered in a competition to decorate the Cunard liner Queen Mary (see no. 176). Spencer's talents in the painting of large-scale industrial pictures were only properly realised in 1940, in the shipbuilding scenes of Port Glasgow.

A large squared drawing, *The Garage* (no. 123, 50.2 × 62.2 cm/19¾ × 24½ ins, Montagu Collection), is an early study for the painting.

129 The Tarry Stone, Cookham

1929
Oil on canvas
55.9 × 83.8 cm/22 × 33 ins
From the collection of the late W. A. Evill

Painted during a break from work on the Sandham Memorial Chapel, Burghclere, in the summer of 1929. At the time Spencer and Hilda were staying in lodgings in Cookham High Street, where they were joined by Richard Carline and his mother. The Tarry Stone was a touchstone used in races. At the time of painting it was on a small island in the middle of the junction at the top of Cookham High Street.

Another picture, *High Street, Cookham* (70 × 76.2 cm/ 24 × 30 ins, Private Collection), painted at the same time, is a view towards the Tarry Stone from the other end of the village.

129

EXHIBITION
Brighton, 1965 (209)

REFERENCE
Carline, pp. 196, 199

130 Country Girl: Elsie

1929
Oil on canvas
83.8 × 76.2 cm/33 × 30 ins
Lent by a Private Collector, London

Elsie Munday (now Mrs Beckford) joined the Spencer family as a maid in 1928, when they were living at 'Chapel View', Burghclere. She moved with them to Cookham in the autumn of

130

1931, and remained to take care of Spencer after his divorce from Hilda and the failure of his marriage to Patricia Preece in 1937.

The portrait was painted in October 1929 during a break from work on the Burghclere Chapel murals. Elsie is shown standing with her back to the kitchen range at 'Chapel View'. Spencer used the same background in *Workmen in the House* 1935 (no. 156), where she again appears, this time putting on her gaiters in preparation for a motor-cycle ride.

The artist was joined in this spell of portrait painting by his wife, Hilda, who set up her easel beside his and produced her own full-length portrait (illustrated in Robinson, 1979, pl. 21). Spencer greatly admired this painting and, after Hilda's death, asked for the picture, which was still hanging in 'Fernlea' at the time of his death.

Spencer's affection for Elsie continued after she left to get married, and he accorded her the honour of a separate 'chapel' in the Church House scheme (Tate 733.2.430). Although none of the pictures for this room were painted, there exist numerous studies among the Astor *Scrapbook* drawings, showing Elsie going about her daily tasks at Burghclere.

REFERENCES
Carline, p. 199
J. Rothenstein, 1979, p. 97
Robinson, 1979, p. 32, pl. 21

131

131 Hilda Studying a Model for Burghclere

c. 1930
Oil on paper
25.4 × 35.5 cm/10 × 14 ins
inscrev. 'Study for Doner [*sic*] examining plans?'
Lent by Anthony d'Offay

While still at work on the Burghclere Chapel murals, Spencer planned a new series of pictures in which the donors of the chapel, Mr and Mrs Louis Behrend, would be commemorated. In the picture Hilda poses for the figure of a donor, who is lying full-length on the floor to study a cardboard model of the chapel. In the event the series was never painted, and this small study is the only indication of the form it was to take.

EXHIBITION
d'Offay Gallery, 1978 (4), illus.

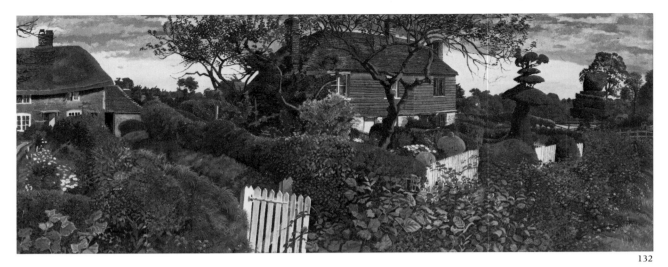

132 Cottages at Burghclere

c. 1930–31
Oil on canvas
62.2 × 160 cm/24½ × 63 ins
Lent by the Fitzwilliam Museum, Cambridge

In May 1927 Spencer moved with his family to the village of Burghclere, where he worked on the Sandham Memorial Chapel.

While he was working on the Chapel Spencer had little time to spare for landscape painting. This is one of a very few landscapes he produced in the vicinity of Burghclere. Others of this period were painted during the summer breaks in Cookham (*The Tarry Stone* 1929, no. 129), or when he was away visiting friends and relatives (*Landscape near Halifax* 1929, Oldham Art Gallery). In this connection Spencer used the long narrow format which he developed first in *Panorama, Wangford Marsh* 1924 (no. 85). Here he exploited it to give a broad view of the lush green cottage gardens, without losing the sense of intimacy created by the foreground details of the brambles and the white garden gate.

EXHIBITIONS
Goupil Gallery, *Salon*, 1930 (56)
Tate Gallery, 1955 (27)
Stanley Spencer Gallery, Cookham, 1969
Cambridge, Kettle's Yard Gallery, *Opening Exhibition*, 1970 (20)
Arts Council, 1976–7 (16)

REFERENCES
Friends of the Fitzwilliam Museum, *Annual Report*, 1930, repr.
Studio, special spring number, 1931, repr. p. 92
F. Rutter, *Modern Masterpieces*, I, London 1935, repr. p. 11
M. Chamot, *Modern Painting in England*, London 1937, p. 76, pl. VII

133 Hilda with Hair Down

1931
Pencil, five sheets joined
61 × 45 cm/24⅛ × 17¾ ins
sbr. in pencil 'Stanley Spencer/1931'
Lent by Richard Carline

A study of Spencer's first wife, drawn at Burghclere. The expansion of the composition through the addition of extra sheets of paper occurs frequently in the artist's drawings and oil studies (see no. 65).

EXHIBITIONS
Arts Council 1954 (28), pl. III
Plymouth, 1963 (72)
Arts Council, 1976–7 (66)

REFERENCE
Carline, p. 212, pl. 41

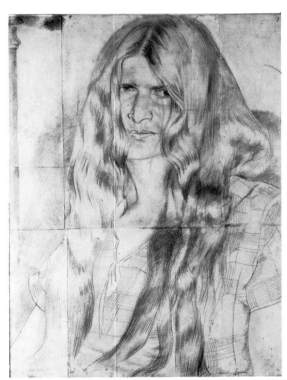

134 Portrait of Mrs Carline

1931
Pencil, two sheets, joined
34.0 × 31.7 cm/ 13¾ × 12½ ins
Lent by Richard Carline

A drawing of the artist's mother-in-law, Mrs Anne Carline. She was the wife of an artist, and the mother of three others. She

herself had begun to paint in 1927. Spencer drew this portrait while she was visiting Burghclere in the summer of 1931.

EXHIBITIONS
Plymouth, 1963 (71)
Arts Council, 1976–7 (65)

REFERENCE
Carline, p. 198

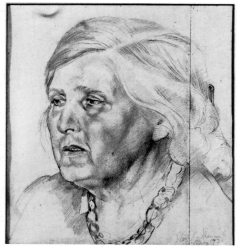

134

135 The Swiss Nurse, Miss Herren

1931
Pencil
34.9 × 25.4 cm/13¾ × 10 ins
sbr. 'Stanley Spencer, 1931'
Lent by Richard Carline

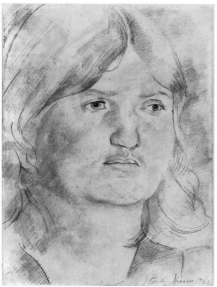

135

A portrait of the Swiss nurse, Miss Herren, who was taken on to look after Hilda Spencer following the birth of their second daughter Unity in 1930, and who remained with the family for several years. The softened outlines and delicate shading are typical of Spencer's numerous pencil portraits of the late twenties and early thirties.

EXHIBITION
Arts Council, 1961 (27)

4 The Years 1932–1945

When Spencer returned to Cookham in 1932 after an absence of nearly eleven years he did so as a respected artist with the success of Burghclere just behind him. This was further made manifest when he was elected ARA the same year, and showed ten works in the British Pavilion at the Venice Biennale. Back in his native village he hoped to make a new start by returning to the peculiar sense of homeliness and calm which had inspired his early art. To this he planned to unite the new experiences of married life which had increasingly preoccupied him at Burghclere. But he was becoming increasingly estranged from Hilda, and was developing a new relationship with Patricia Preece which eventually led to his divorce, and marriage to Patricia in 1937. Equally important, he faced an acute crisis in his art. The majority of the Burghclere pictures had been conceived as early as 1923, and apart from the Empire Marketing Board commission (nos. 124–8) and a few landscapes, he had conceived little that was new between 1926 and 1932.

Spencer's solution to these difficulties was to 'marry' the old childhood atmosphere of Cookham to his new feelings on love in a series of paintings which were to be hung in a special building, the Church House, an idea which had come to him at Burghclere when he had expressed a wish to expand the Chapel paintings through into the flanking almshouses. The scheme was to remain the central focus and subject of his work until his death in 1959.

The series was *The Pentecost, The Marriage at Cana*, and *The Baptism of Christ*, which were united under the umbrella title of *The Last Day*, or *The Last Judgement*. In the *Cana* series the central theme is the marriage feast (no. 261), representing the ideal of marriage. This is associated with a cycle of life, the *Domestic Scenes* (nos. 161–7), and *The Beatitudes of Love* (no. 188), symbolised by the guests going to and returning from the feast. Thus *Cana* is 'a symbol of life through marriage' (Gormley, p. 4), reflecting Spencer's dominant pre-occupation and his interest in the eastern concept of regeneration. The cycle also reflects Spencer's growing interest in sex, and as the series developed during the thirties the early religious idea took on a more secular basis. For the artist sexual and religious ecstacy became almost synonymous.

The other two series were not so clearly set out. *Pentecost* itself was to be set in the malthouses, scene of the earlier *Last Supper* 1920 (no. 41), but it was never executed. The second part, in which the seventy-five disciples were sent forth into the world, is confusingly blended with *Cana* paintings such as *Promenade of Women* 1938 (no. 191) and *A Village in Heaven* 1937 (no. 184), where they are to be seen blessing the everyday life of Cookham. *The Baptism*, which is equally unclear, again belongs to the *Cana* life cycle. People who appear at the wedding have just returned from witnessing the Baptism of Christ at the Odney pool.

All three schemes were united in the concept of *The Last Day*, which like the earlier *Resurrection* paintings of 1914 (no. 28) and 1926 (no. 89) was not a rigid division into good and bad, since this was anathema to the artist. Instead, in *The Last Day*, humanity was to be redeemed and life would carry on almost uninterrupted in a state of enlightenment. Cookham itself was to become a *Village in Heaven* (no. 184), in which the inhabitants, freed from the old moral restraints and blessed by 'disciples', would make love to one another freely in the streets; this was an expression of Spencer's growing preoccupation with the ideas of free love and polygamy inspired by his study of eastern religions.

Spencer made a number of designs for the Church House building, some based on a street plan of Cookham and others on the more conventional concept of a Gothic church with a nave and two aisles. In addition rooms were set aside for particular subjects (see no. 159), and places (*The Regatta* series, no. 279). The building, like the painting series, was so flexible that the scheme never reached a conclusion as one idea gave birth to another. By 1942 Spencer, giving up hope of a patron to build it for him, called it 'an interlocking of subjects as a great chain of events, some New Testament and Biblical and some my own domestic life experiences and other people's everyday life affairs all constituting the Last Judgement . . . a chapel . . . built in the air' (Gormley, p. 7). Recognising these difficulties at an early stage, Spencer designed the paintings so that each could be sold as an independent work of art.

Although Spencer was still working on the paintings for the Church House at the time of his death, the thirties saw the greatest concentration on the subject with the series of *Adorations* (no. 186), *Beatitudes* (nos. 188–90) and *Domestic Scenes* (nos. 161–7) painted between 1933 and 1938. These

paintings were done when Spencer's pre-occupation with sexual matters was at its height, and the rejection by the hanging committee of the Royal Academy of *The Dustman (or Lovers)* 1934 (no. 150) and *St Francis and the Birds* 1935 (no. 149) led to his resignation from the Academy in 1935. Many of the paintings were considered unsaleable by his dealer, Dudley Tooth, and this led to a growing reliance on landscape painting (which he disliked) for his income. This was exacerbated by debts incurred during his courtship of Patricia Preece in 1934–7. Despite these pressures Spencer painted some of his finest landscapes (see nos. 179 and 181) before the Second World War.

Finally in 1938 Spencer was forced to leave Cookham again when Patricia proposed to sell 'Lindworth', which he had made over to her in 1937. After staying briefly with the Rothensteins and Malcolm MacDonald he moved into a room in 188 Adelaide Road, London. Here, in almost complete isolation, he painted his fine *Christ in the Wilderness* series (nos. 194–201), in which he identified with Christ's meditation and suffering. It was a period on which Spencer always looked back with nostalgia. Shortly afterwards war broke out and Spencer once again found himself a war artist working for the Ministry of Information. The period of intense isolation, 1938–9, was over.

During the 1930s Spencer continued to paint a number of large landscapes which measure up to the high standard which he had set in *Cottages at Burghclere* 1930 (no. 132). Except during the war years there was always a strong demand for these paintings, and Tooths sold *The May Tree* only ten days after Spencer had reported its completion on 29 June 1933.

Spencer wrote a humorous account of the difficulties of painting a similar May scene in a letter to Dudley Tooth on 26 May 1943: 'I am tucked away in a deserted corner of a Cookham meadow where there is much may tree and stinging nettle and wild flowers. One of the may trees was dying off when I got to it so of course it is that colour in the painting. Of course, needless to say, soon after I had started the place was visited by the men who are dashing all over the place in queer shaped vehicles [on a military exercise] but my plot is still all right. As soon as they were gone I thought now all is quiet but when I went up yesterday I listened and paused on my way there. Whence there came this bleating in mine ear. As a grim faced Samuel and I approached the vast field [which] was white in the sun with sheep and lambs.'

EXHIBITIONS
Stanley Spencer Gallery, Cookham, 1963 and subsequently
Arts Council, 1976–7 (17), illus.

REFERENCES
E. Newton, 1947, pl. 20
E. Rothenstein, 1945, pl. 43 (in colour)

136 The May Tree

1932
Oil on canvas
86.4 × 137.2 cm/34 × 54 ins
Lent by a Private Collector

137 Portrait of Patricia Preece

1933
Oil on canvas
83.8 × 73.7 cm/33 × 29 ins
Lent by Southampton Art Gallery

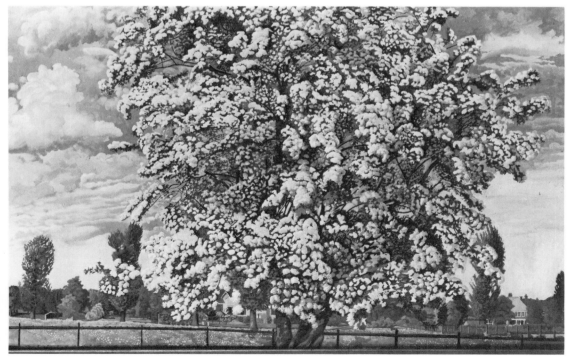

136

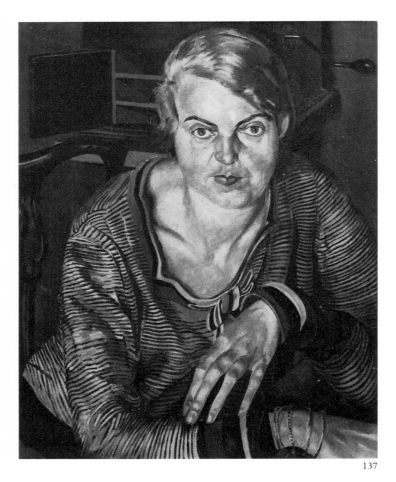

137

Spencer met Patricia Preece at a teashop in Cookham in 1929, an event which he later celebrated in *The Meeting* 1933 (no. 141). She was an artist who had trained at the Slade and with André L'hôte in Paris, before returning to England in 1925, at first living in various lodgings in London before moving to Cookham in 1927. When Spencer first met her he was still living in Burghclere, but they kept in contact, and when he returned to Cookham in 1932 their relationship became more intimate. They were finally married in 1927, shortly after Spencer had been divorced by his first wife, Hilda.

This painting, the first portrait that Spencer painted of Patricia, was done in 'Lindworth', the house which he and Hilda had bought in Cookham, shortly after his return from Burghclere. In it she is shown wearing the same black striped jumper and green pleated skirt in which she appears in *Separating Fighting Swans* (no. 143), painted in the same year. Behind her is the gramophone and record cabinet which can also be seen in the Astor drawing, *Patricia and Gramophone* (Leder, p. 94), in which she is shown dancing round the room. The picture is Spencer's finest formal portrait of Patricia Preece and captures admirably her slack big-boned form. There are also some fine passages of painting in the flesh tones and the still-life of the chairback and gramophone.

Spencer painted two other conventional portraits of Patricia : the first of these, *Portrait in a Garden* 1936 (76.2 × 50.8 cm/30 × 20 ins, Private Collection, Canada) shows her sitting in front of a bed of peonies in the garden of 'Lindworth'. The second

portrait, *Portrait of Patricia* (58.4 × 48.3 cm/23 × 19 ins), remained unfinished at the time of their disastrous marriage in 1937.

Preece's willingness to pose in the nude also enabled Spencer to paint a number of nude portraits of her, two of which include his own self-portrait (see nos 173 and 178).

EXHIBITIONS
RA, summer 1934 (688)
British Institute of Adult Education, touring exhibition, *A Loan Exhibition of Paintings and Drawings*, 1935–6
Southampton Art Gallery, *Opening Exhibition*, 1939 (50)
Tate Gallery, 1955 (28)
Barnsley, Cannon Hall, *Four Modern Masters*, 1959 (25)
Worthing, 1961 (10)
Plymouth, 1963 (19)
Le Havre, Musée des Beaux Arts, *Peintres Anglais*, 1975 (26)
Arts Council, 1976–7 (18)

REFERENCES
E. Newton, 1947, pl. 23 (in colour)
Aldous Huxley, *Point Counter Point*, Penguin Books, Harmondsworth, 1968, repr. on cover
L. Collis, 1972, repr. facing p. 24
Robinson, 1979, pl. 42 (in colour)

138 The Angel, Cookham Churchyard

1933
Oil on canvas
61 × 51 cm/24 × 20 ins
Lent by a Private Collector

The painting shows the stone angel near the entrance to Cookham churchyard, with the church tower in the background. Spencer painted two versions of the scene, the other picture differing only in being slightly larger (76.2 × 63.5 cm/30 × 25 ins). This is the only known occasion on which he repeated a commission.

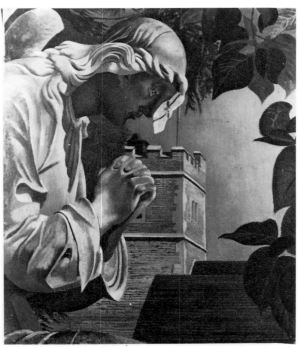

138

The angel also appears in the top right-hand corner of *Parents Resurrecting*, also painted in 1933.

The date, 1934, usually ascribed to the two paintings, is incorrect, as Dudley Tooth, Spencer's dealer, valued one of the canvases at £100 in July 1933.

REFERENCE
E. Rothenstein, 1945, larger version only, pl. 40

139 Builders of the Tower of Babel

1933
Pencil, wash, and oils on paper, arched top
30.5 × 53.3 cm/12 × 21 ins
Lent by a Private Collector

Despite the title, *Building a Church*, by which this picture has hitherto been known, this small oil sketch was intended as a study for a projected commission to decorate the University Library, Cambridge, for which Spencer was probably recommended by his friend Gwen Raverat. In 1937 he recalled using the scene as part of a much larger arched design called *The Tower of Babel*, which was to fill one wall probably in the entrance hall of the library. Another scene of the *Upper Room* at Pentecost was to go opposite (Tate 733.3.1). The original concept called for an allegory of the gradual decay of architecture, in which the tower evolved through history from level to level, until, reaching the top and the modern age, 'only army huts and bungalows' remained. This would account for the otherwise incongruous use of classical columns in the construction of what is otherwise a Gothic structure. The next level of the tower was probably intended to represent the Renaissance or Baroque style. Spencer's curiously eccentric conception of the tower may have received inspiration from his reading of Ruskin, whose book *Giotto and his Works at Padua* had influenced his early paintings (see no. 11). In 1916 he had referred to him as '. . . a fine writer who says some fine things' in a letter to Desmond Chute (Stanley Spencer Gallery Collection). Spencer certainly agreed with Ruskin's belief in the pre-eminence of the Gothic style, which he chose in the early plans for the Church House, made in *c.* 1932.

The sketch in its present form represents only the base of the tower. According to Spencer it was inspired by the sight of men carrying hods of bricks in Fairchilds, the builder's, yard in Cookham (see also no. 45). This scene anticipates the figures in a related painting, *The Builders* 1935 (no. 157). In the upper centre of the study, men 'argue respecting the right way to make pillars', while on the right, masons measure and carve column shafts and Corinthian capitals. This detail was later expanded in a separate picture, *Making Columns for the Tower of Babel* (no. 140). The building is probably based on Cookham Church.

On grounds of style the painting has been dated to 1930 or earlier, but the artist's painting lists consistently place it in 1933 (Tate 733.3.12). This brings it nearer in time to a related painting, *The Builders* 1935 (no. 157).

Evidence for Spencer's conception of the original commission occurs in a number of related drawings. One, in the Tate Gallery archives (pencil drawing 31.7 × 20.3 cm/12½ × 8 ins,

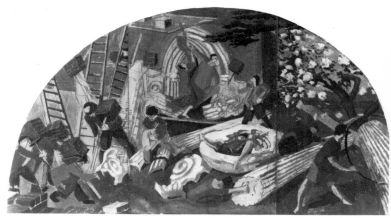

733.3.28), shows a massive tapering tower covered in scaffolding and ladders. This corresponds closely to Breughel's *Tower of Babel* 1563, which he saw at the Kunsthistorisches Museum, Vienna, in 1922. In this case, however, the tower rises from the centre of Cookham, with the oasthouses on the right. The second level of the tower is in the Gothic style, and perched on the top are the 'modern huts and bungalows' mentioned in Spencer's descriptions. A further drawing (35.6 × 66 cm/14 × 26 ins, Private Collection) shows the tower from a lower viewpoint with a ground-floor colonnade supported by squat Corinthian columns. In the foreground masons carve a column, in a scene reminiscent of the present picture.

EXHIBITION
Arts Council, 1976–7 (15), as *Building a Church*

140 Making Columns for the Tower of Babel

1933
Oil on canvas
53.9 × 48.9 cm/21¼ × 19¾ ins
Lent by a Private Collector

This painting and *Builders of the Tower of Babel* (no. 139) are fragments of a proposed commission to decorate the University Library, Cambridge. The scheme fell through, but in an undated account written in the fifties Spencer recalled what was evidently an attempt by his friend, Mrs Raverat, to compensate him for his wasted time: 'Mrs Raverat then offered me a commission . . . to do a picture of the Babel pictures for £300 but I felt she was doing it to try to make up for my disappointment over the Cambridge scheme . . . and did not like to press her to clinch such an offer' (Tate 733.1.175). Despite his reluctance to paint the full scheme, Spencer evidently undertook to paint a part of the design, adapted from the right-hand corner of the small oil sketch *Builders of the Tower of Babel*, which he then either gave or sold to Mrs Raverat.

The scene reappears in a large drawing for the original project (Private Collection), where the masons are shown working on the ground at the base of the tower in the centre of the composition. A further drawing (pencil 30.5 × 20.3 cm/12

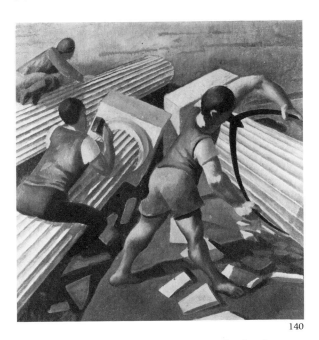

140

× 8 ins, Tate 733.3.28), is a square study for the mason astride the column. As Duncan Robinson has pointed out (Arts Council, 1976–7, 26), the firm modelling of the men at work is similar to that of *The Builders* 1935 (no. 157).

EXHIBITION
Arts Council, 1976–7 (26), as *Making Columns for a Church*

141 The Meeting

1933
Oil on canvas
63.5 × 61 cm/27 × 24 ins
Lent by Dr and Mrs A.D. Taliano

This work was one of the first paintings done by Spencer after his return to 'Lindworth', Cookham, in 1932. It was intended to commemorate his first meeting with Patricia Preece which had taken place in the summer of 1929. Although the event took place in a tea shop (the present Copper Kettle) in Cookham High Street, Spencer has transposed the event to the dark passageway between 'Fernlea' and 'The Nest'. This place had important personal associations for Spencer which dated back to his childhood. The passage had been a vital part of his conception of *Christ Carrying the Cross* 1920 (no. 45), and was to be used again in 1935 for *St Francis and the Birds* (no. 149).

By 1933 Spencer had become increasingly concerned that his old vision was slipping away: the Burghclere designs had, for the most part, been completed in the early twenties, and since then he had composed little of real importance. In the context of this crisis, *The Meeting* can be seen as an attempt to revive the old 'Cookham feeling' of *Zacharias and Elizabeth* 1914 (no. 21) and *Swan Upping* 1915–19 (no. 33), and to combine that early youthful feeling of exaltation with the new sexual ideals which were personified in his image of Patricia. The new and the old feelings were to meet and blend in the deeply religious

atmosphere which prevailed at the bottom of 'Fernlea' garden. Writing in 1937, Spencer made this feeling abundantly clear, while also expressing his reservations at the rather tentative nature of the picture: '[*The Meeting*] was an attempt to do something which had the atmosphere I used to feel before the war, but it does not go far enough. It is more a note for further tendencies I wish to develop' (Tate 733.3.1). The 'further tendencies' were to be *The Beatitudes of Love* series of 1938. Spencer's concern for his past vision also appears in a curious form in Patricia's coat, part of which takes the form of a swan (first noticed by Gormley), and the head of which is completed by Spencer's hand and forearm. This may well be a reference to *Swan Upping* (no. 33), the painting which he had begun in 1915 and completed after his return from the war in 1919, thus symbolically spanning the period when he had first felt his inspiration slipping. Swans occur again in no. 143.

Another detail in *The Meeting* which was to recur frequently in Spencer's painting is the figure on the right of the composition who witnesses the event. This curious personage (in this case Spencer himself) acts as a kind of alter-ego whose function is that of a witness who provides a spiritual seal of approval on the events taking place. Elsewhere (see no. 210) this figure assumes other guises as a disciple or an old man, who bears more than a passing resemblance to Spencer's father.

The style of the painting also represents a change in Spencer's development. The broad simplified forms of the twenties pictures remain (especially in the figure on the right), but the artist has begun to adopt the hard, dry, and often mechanical technique which affected many of his paintings after Burghclere.

EXHIBITION
RA, summer, 1934

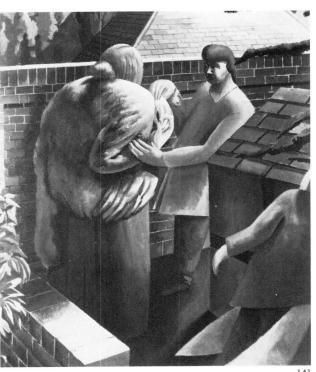

141

REFERENCES
M. Collis, 1962, pp. 199, repr. facing p. 112
A. Gormley, p. 16
L. Collis, 1972, pp. 56, 59

142 Sarah Tubb and the Heavenly Visitors

[repr. in colour on p. 153]
1933
Oil on canvas
94 × 104.2 cm/37 × 41 ins
Lent by Mr and Mrs David Karmel

This picture, begun shortly after Spencer's return to Cookham in 1932, clearly indicates the direction which his work was to take during the next eight years. At Burghclere the artist's figures had become increasingly simplified, with rounded forms and 'football' shaped heads on which the features were only roughly drawn. As Duncan Robinson has pointed out (1979, p. 42), this tendency also appears in the work of William Roberts, a contemporary at the Slade School who, in 1928, began to work in a style probably influenced by Léger's tubular forms. In *Sarah Tubb* Spencer's work can be seen tending in the same direction, with round, broadly brushed forms, relieved occasionally by a return to more detailed painting. As yet the distortion found in the slightly later *St Francis and the Birds* 1935 (no. 149), or *The Dustman* (or *Lovers*) 1934 (no. 150), is confined to exaggeratedly long arms and weighty figures.

Sarah Tubb is among the first in a series of pictures begun in 1933 for the projected Church House, which celebrated the artist's feelings for Cookham and its inhabitants. It is based on the story told to the artist by his father, William Spencer, who recalled how an old inhabitant of the village, Sally Tubb, had been frightened by the extraordinary sunset created by the tail of Halley's comet. Fearing that the end of the world had come, she prayed in the street. In the painting Spencer replaced Sally Tubb with her daughter Sarah, whom he had seen about in Cookham during his childhood.

Contrary to previous interpretations, Sarah Tubb is not simply being comforted in her terror by the Heavenly Visitors. As part of the Church House scheme of the *Last Day* or *Last Judgement*, the events in the painting take place in the 'Heaven' of Spencer's imagination – Cookham. Here Sarah Tubb is greeted by the Heavenly Visitors (clothed in white), and 'presented with all those things which she loved and which were so expressive of what she meant to me. . . . One presents her with a post-card of Cookham Church and another with a framed text' (Tate 733.3.2). These things were not only the paraphernalia of her identity, but were intended to give her a sense of familiarity and calm in her newly resurrected state. For Spencer the Last Day was to be a quiet 'homely' affair in which the only untoward disturbance heralding the transformation of Cookham into Heaven was to be a flash of light in the sky.

In later paintings this evolution was to take the form of a carnival celebration (in *Promenade of Women* 1938, no. 191), or quiet relaxation by the river, in *Christ Preaching at Cookham Regatta*, unfinished) (no. 279).

EXHIBITIONS
Tooth, 1931 (21)
Pittsburgh, Carnegie Institute, *International Exhibition of Painting*, 1933 (133), pl. 7
Sheffield, Graves Art Gallery, *Twentieth Century British Painting*, 1936 (8)
Leicester Galleries, 1942 (17)
Tate Gallery, 1955 (29)
Arts Council, touring exhibition, *Three Masters of Modern British Painting*, 1961 (30)
Plymouth, 1963 (18)
Arts Council, 1976–7 (20)

REFERENCES
E. Rothenstein, 1945, pl. 35
E. Newton, 1947, pl. 13 (in colour)
Studio, 125, 1943, p. 60, repr.
G. Spencer, 1961, pp. 184–5
E. Rothenstein, 1962, repr.
Robinson, 1979, p. 46, pls. 37 (detail, in colour), 38

143 Separating Fighting Swans

1933
Oil on canvas
91.4 × 72.4 cm/36 × 28½ ins
Lent by Leeds City Art Galleries

In 1933 Spencer's concept of the Church House and its paintings was still unclear, and the earliest pictures intended for the building, *The Meeting* 1933 (no. 141), *Sarah Tubb and the Heavenly Visitors* 1933 (no. 142), and *Separating Fighting Swans* are only linked by their mutual dependence on Cookham as their setting. Spencer was aware that the Church House was

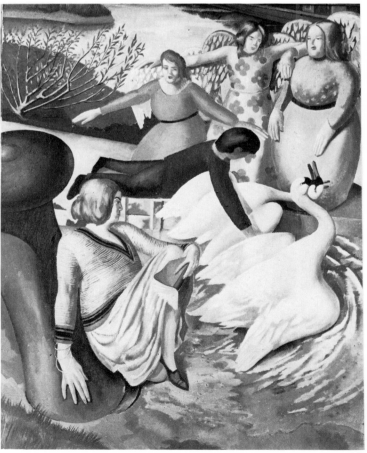

143

unlikely to be built, and so he ensured that all the paintings destined for it were also capable of standing on their own; a practical point made necessary by his need to earn a living.

In *Separating Fighting Swans* Spencer significantly returned to the theme of the river and swans at Cookham, which had been the subject of *Swan Upping* 1915–19 (no. 33), a picture begun in 1915 and completed four years later when the artist returned from the war. As such it bridged two periods in Spencer's artistic life, and it is probable that he saw the present work in a similar symbolic light, representing this time his return to Cookham after an absence of eleven years.

Later, in 1937, Spencer described the picture as 'an effort to combine an incident in my life with a person in my life, and a place in Cookham and a religious atmosphere' (Tate 733.3.1). The scene takes place on the banks of the Thames at My Lady Ferry, Cookham, a place of particular significance for the artist, who had been taken there as a child by his sister Annie. Spencer would play along the river bank while she stood on the wooden causeway, shown here with the angels standing on it, and talk to her friend Miss Elton who used to bring her knitting.

Now, in a place sanctified by childhood memories, and blessed by the presence of the angels, Spencer introduced his latest companion, Patricia Preece (see no. 137). She was wearing her newest outfit and holding the book she was actually reading at the time (L. Collis, p. 58). That summer she and Spencer spent much of their time by the river, boating and going for long walks.

Into this scene Spencer introduced an episode which had taken place in 1923, when he was staying with Henry Lamb at Poole, Dorset. There, in a park, he had expertly separated two fighting swans. The angels were taken from a drawing made at Durweston in 1920 (Tate 733.3.1).

By bringing together these events in a place which held a deep, even religious significance for Spencer, he was able to celebrate his passion for Patricia Preece, before whom he performs a feat of great daring. As Duncan Robinson (1979, p. 46) has pointed out, the relationship of the picture to the Leda and the Swan myth is not accidental. Spencer made several drawings (Private Collection) of Leda and the Swan which may be dated to the early thirties. Patricia Preece is further associated with swans in *The Meeting* 1933 (no. 141), where she appears with one of the birds under her arm.

The complicated personal iconography of this and other paintings of the thirties was to lead to a decline in the popularity of Spencer's figure pictures, culminating in the fiasco at the Royal Academy over *St Francis and the Birds* (no. 149) in 1935. The artist recognised some of these problems in his commentary on *Separating Fighting Swans* written in 1937: '[it] hasn't come off,' he wrote, 'as the different things to be related were too far off from each other and I was hurried', although 'the intention was good' (Tate 733.3.1).

EXHIBITIONS
Tooth, 1933 (21)
Pittsburgh, Carnegie Institute, *International Exhibition of Painting*, 1933 (133), pl. 7
Sheffield, Graves Art Gallery, *Twentieth Century British Painting*, 1936 (8)
Leicester Galleries, 1942 (17)
Tate Gallery, 1955 (29)

Arts Council, touring exhibition, *Three Masters of Modern British Painting*, 1961 (30)
Plymouth, 1963 (18)
Arts Council, 1976–7 (20)

REFERENCES
Studio, 125, 1943, p. 60, repr.
E. Rothenstein, 1945, pl. 35
E. Newton, 1947, repr. p. 113 (in colour)
G. Spencer, 1961, pp. 184–5
E. Rothenstein, 1962, repr.
L. Collis, 1972, p. 58, repr. facing p. 72, and cover, in colour
Carline, p. 160, note 2
J. Rothenstein, 1979, p. 78
Robinson, 1979, p. 46, pl. 40 (in colour)

144 Portrait of a Peasant Woman

1933
Pencil
34.5 × 24.5 cm/13⅞ × 9¾ ins
sbr. 'Stanley Spencer'
Lent by a Private Collector

144

This is one of a fine series of drawings which Spencer made in 1933 while staying at Saas Fee, Switzerland, as the guest of his patron, Sir Edward Beddington-Behrens (see no. 145). According to Patricia Preece, who joined them for the latter part of the vacation, the artist was struck by the traditional headdresses worn at christenings by the local women. He arranged to draw them, with the help of the hotel proprietor, who organised the sittings. The drawing was almost certainly used for the praying woman dressed in black visible in the left-hand panel of the *Souvenir of Switzerland* 1934 (no. 145). Both pictures passed into Beddington-Behrens's collection in 1934.

Another very similar drawing is in a Private Collection.

EXHIBITIONS
Arts Council, 1954 (30)
Piccadilly Gallery, 1978 (39)

145 Souvenir of Switzerland

1934
Oil on canvas
triptych, centre panel 104.8 × 167.6 cm/41¼ × 66 ins,
side panels each 106 × 76.2 cm/41¾ × 30 ins
Lent by Mr and Mrs Nigel Broackes

In 1933 Sir Edward Beddington-Behrens invited Spencer to stay with him at Saas Fee, a village high up in the Swiss Alps, in the hope that 'it might be a source of inspiration for him to see life in the mountains where religion plays such a vital and dominant part in the life of the people'. Beddington-Behrens had first met Spencer some years earlier through his uncle Sydney Schiff, an early patron who had bought *Two Girls and a Beehive* 1910 (no. 3). He became a confirmed admirer after seeing the murals in the Sandham Memorial Chapel at Burghclere, and commissioned Spencer to paint landscapes in Switzerland in return for all expenses on the journey. Although Spencer was beginning to baulk at the pressure of a growing demand for his landscapes, he agreed to go.

Spencer's arrival at Saas Fee, as Behrens later reported in his autobiography, was somewhat incongruous: 'At that time Saas Fee could only be reached by a steep, stony track, and in fact mules were the only means of transport. To see Stanley on mule-back was really a comic sight. Imagine a dark-complexioned little man about four feet ten inches in height, dressed like a tramp, with a dirty hat set at an impossible angle, perched on a mule climbing up the mountain path quite oblivious of its rider' (E. Beddington-Behrens, *Look Back, Look Forward*, Macmillan, 1963, p. 92). Spencer soon settled, however, drawing the peasant women in their Sunday dress, and admiring the villages and chalets; he was particularly enthusiastic about the churches with their primitive paintings, and the wayside shrines, several of which appear in the *Souvenir*. Shortly afterwards they were joined by Patricia Preece, who came out at Beddington-Behrens's invitation and remained behind when their host returned to England. Spencer stayed on to complete the landscape commission, which included *Alpine Landscape – Saas Fee* 1933 (Vancouver Art Gallery).

Upon his return to England, Spencer immediately began work on the *Souvenir of Switzerland*, which was completed in 1934. Like the paintings at Burghclere, which were a memorial to his wartime experiences at the Bristol hospital and in Macedonia, Spencer intended the *Souvenir* to celebrate his stay at Saas Fee. He had avoided painting it on the spot because, as he told Beddington-Behrens, 'He liked to photograph a scene in his mind and then reproduce it long afterwards! (*ibid.* p. 95). "It is much better than if I painted it on the spot because if I feel it sufficiently intensely to paint it from memory it has got to live." ' Memory also enabled him to alter details of the composition, whereas in directly observed landscapes he felt compelled to include everything which he saw before him. His memory therefore acted as a kind of filter which collected only the most significant and moving details of his experience. This period of gestation was an important element in Spencer's approach to painting. It applied to the Burghclere Chapel, and to the late *Cookham Regatta* paintings, which were planned as

early as 1940, but were not begun until the fifties.

In a reference to the *Souvenir* in a notebook of 1937, Spencer described how he had 'liked the secluded and shadowed feeling of Saas Fee', and went on to explain how his feelings for the area were incorporated into the painting: 'Here and there in this broadside of earth were little chapels only about ten feet square and looking like lumps of sugar-loaf in the distance. I loved this mixture of the religious life with the temporal life' (Tate 733.3.1).

On the central panel he commented: 'When I saw the peasants standing on the steps they were like memorials of Switzerland, each standing on its own pedestal. And so in the panel I have felt that each panel was devoted to some aspect of Swiss feeling.' Spencer extended the combination of the spiritual with the temporal (the core of all his imaginative paintings) into the right-hand panel of the triptych. There harvesting and digging are represented alongside women praying at one of the shrines Spencer admired so much. The two activities merge in the kind of union which the artist planned for the Church House in the same year. Spencer himself appears in the painting as one of the worshippers before the shrine in the central panel, immediately in front of the woman who stands on the steps with her arms folded.

The reaction of Beddington-Behrens when he eventually saw the painting seems to have been less than favourable. Patricia Preece was to comment later in her memoirs of her life with Spencer (1972, p. 50) that Behrens preferred the artist's landscapes to his figure compositions. Spencer on the other hand, in a long letter of the early fifties to Mary Behrend, reported that he 'made the mistake of letting him see it before it was finished. He nearly jibbed at buying it and knocked off some of the money he had paid me for my trip to Switzerland' (Tate 733.1.175). Spencer's patron had probably expected an ordinary landscape, but he took the picture and went on to buy other figure paintings, including: *Sarah Tubb and the Heavenly Visitors* 1933 (no. 142), *The Turkish Window* 1934 (no. 147), *The Meeting* 1933 (no. 141) and *The Builders* 1935 (no. 157). Purchases like these made Beddington-Behrens Spencer's most important patron during the 1930s and he bought what Dudley Tooth referred to as Spencer's 'difficult' figure pictures. Beddington-Behrens also tried, with little success, to obtain commissions for the artist, including the ill-fated Boot pictures (nos. 156–157). In 1936 he was still sufficiently enamoured of Spencer's work to invite him again to Switzerland, though significantly the artist stuck to landscapes this time. The journey proved to be something of a disaster, and shortly afterwards this productive relationship between artist and patron ceased.

EXHIBITIONS
British Council touring exhibition to the USA, *British Contemporary Art*, 1946–7
On loan to the Tate Gallery, 1930s
Arts Council, 1976–7 (21), repr. in colour

REFERENCES
E. Rothenstein, 1945, pl. 38 (detail)
M. Collis, 1962, pp. 105–6, 113, 244
Sir Edward Beddington-Behrens, *Look Back, Look Forward*, London, 1963, pp. 92–8, repr. detail (in colour)
L. Collis, 1972, pp. 50–51

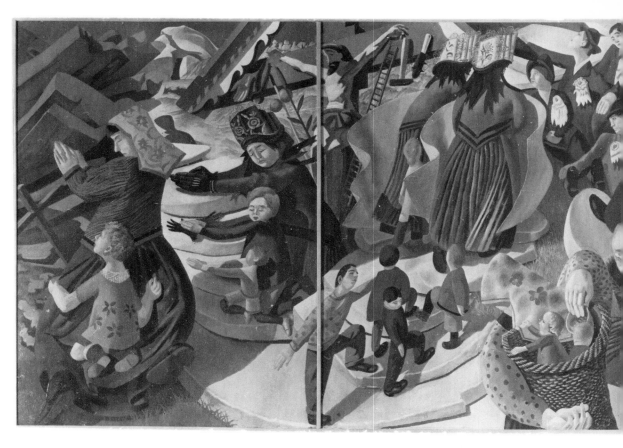

146 Rowborough, Cookham

[repr. in colour on the back cover]
1934
Oil on canvas
76.2 × 61 cm/30 × 24 ins
Lent by a Private Collector

146

The picture was painted from the garden of 'Rowborough', a house just off the road between Cookham Moor and Winter Hill. The white object in the foreground is the back of a garden seat partially hidden by holly. The view is of the fields which lead down to the river Thames. In the distance is Hedsor Hill on which can just be seen the tower of Hedsor Church, where Spencer's father was an organist for many years. Cookham Moor and Cookham village are just off the picture to the right. The direction of the picture is slightly north of east. The owner of the picture has remarked on Spencer's extraordinary perceptiveness in painting the sunflowers in different shades of yellow, a characteristic of the flower which he has observed from his own experience.

EXHIBITIONS
Tooth, *Contemporary British Painters*, 1935 (30)
Leeds, 1947 (23)
Tate Gallery, 1955 (37)

147 The Turkish Window

1934
Oil on canvas
61 × 76.2 cm/24 × 30 ins
Lent by Cdr L. M. M. Saunders-Watson DL

The picture has always been known as *Soldiers Breaking into a Harem*, and dated *c.* 1921–2; however Spencer referred to the painting twice in his notebooks (Tate 733.3.1, 733.3.12), where he called it *The Turkish Window*, and dated it 1934. He went on

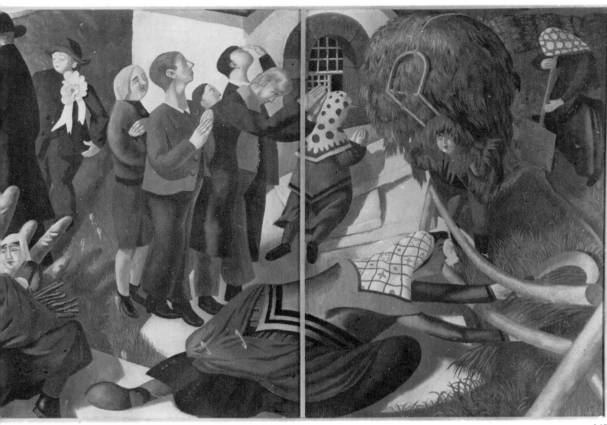

145

to make it clear that this is not an attack on a harem (the men are not in military uniform in any case), but a scene of 'love-making, in which can be seen veiled women in black veils and white shroud-like clothes. A youth gazes up to the woman, and other youths make love to women through the bars' (Tate 733.3.1).

In a further reference the artist explained that the painting should be attached to the right-hand end of *Love Among the Nations* (no. 155), painted in 1935. This is confirmed by a drawing, *Study for Love Among the Nations* (Private Collection), which shows that both paintings were to form part of a long frieze which was never completed. The unusual activities round the window can therefore be explained as forming part of Spencer's ideal image of love-making between different peoples ('love without boundaries'), an idea which he had formed in Macedonia during the war. The wrought-iron grille over the window is probably a recollection from his trip to Yugoslavia with the Carlines in 1922 (see no. 69).

The painting is the first of a series of long, narrow pictures for the Church House, including *Love Among the Nations* 1935 (no. 155), and *Promenade of Women* 1938 (no. 191), which were an important part of Spencer's output during the mid-thirties. Spencer had previously painted a group of coloured people in *The Resurrection, Cookham* 1926 (no. 89).

EXHIBITIONS
Tooth, *British Paintings 1890–1950*, 1963 (24)
Stanley Spencer Gallery, Cookham, 1967–8
In both cases the picture was exhibited as *Soldiers Breaking into a Harem* and dated 1921–2

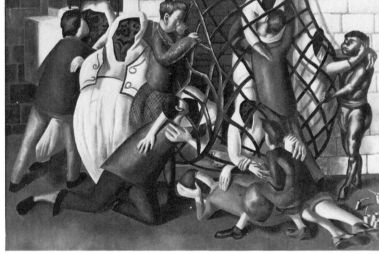

147

148 The Scarecrow, Cookham

1934
Oil on canvas
70 × 75 cm/27½ × 29½ ins
Lent by a Private Collector

Another of the landscapes painted in the garden of 'Rowborough', near Cookham, showing the view over the river Thames to Cliveden. Spencer noticed the scarecrow when he was at work on another landscape, and was attracted by its

131

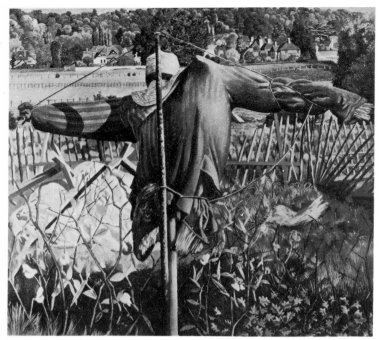

148

shape. Writing in 1938 (Tate 733.3.7), he recalled: 'Left and deserted as it was it seemed daily to become more a part of its surroundings. It was like watching a person slowly changing into a part of nature. And I liked the feeling of it always being there. . . . In the evening he faded into the gloaming like a Cheshire cat.' The picture was sold to the mother of the present owner, who was living in 'Rowborough' at the time.

In a notebook entry made in the forties, Spencer commented that he had used the scarecrow in this painting as the basis for the figure of Christ on the Cross in a *Crucifixion* (oil painting, dimensions and whereabouts unknown), commissioned by 'a Mr John Hobday' of Toronto, Canada, in 1934 (Tate 733.3.1).

EXHIBITIONS
RA, summer 1935 (30)
Amsterdam, 1936, *200 Years of English Art* (144) repr.

REFERENCE
The *Royal Academy Illustrated*, 1935, illus. p. 83

149 St Francis and the Birds

1935
Oil on canvas
71 × 61 cm/28 × 24 ins
Lent by the Trustees of the Tate Gallery

The painting belongs to the street scenes intended for the 'nave' of the Church House, Spencer's chapel in the air conceived in 1932 (see p. 122). It was inspired by two of St Francis's books, *The Little Flowers of Assisi* and *The Mirror of Perfection*, given to him c. 1917, possibly by Desmond Chute, whom he had met at Bristol (notebook, c. 1936, Tate 733.3.1).

According to the artist the composition was developed from a drawing made in 1924 (whereabouts unknown, but reproduced in the Chatto & Windus *Almanac*, 1927, as the title page for

August) showing Hilda Carline reading on a haystack, with a flock of chickens and ducks on the ground below. The birds round St Francis's feet follow this design closely, and the large figure of the saint corresponds to the outline shape of the haystack. Spencer told the compiler of the catalogue of his Tate retrospective that 'the figure of St Francis is large and spreading to signify that the teaching of St Francis spreads far and wide.' He also told Collis (1962, p. 114) that *St Francis and the Birds* 'was imagined by the memory of his father in a dressing gown going to the larder in the passage between "Fernlea" and "The Nest" to get food for the hens and ducks. His trousers were at one time stolen and he went about the village for a bit in his dressing gown. . . '. According to Gilbert Spencer (in conversation with the compiler of the Tate Gallery catalogue, 19 July 1968), the dressing gown was actually one he had bought at Whiteley's and given to the artist. He thought that this exemplified the artist's habit of transposing objects around him, and was not contradictory to Collis's version.

The painting, together with *The Dustman (or Lovers)* 1934 (no. 150), was rejected by the hanging committee of the Royal Academy by the President and Council, when it was submitted for inclusion in the Royal Academy summer exhibition 1935. Spencer resigned as an ARA in protest, and was not re-elected until 1950. Press comments on the painting were generally hostile and a review in *The Field*, 11 May 1935, is typical: 'When he paints St Francis of Assisi as a distorted doll followed by chickens and ducks, he shows a fault, not of the painter's hand, but of his head and heart.' These sentiments were echoed by the *Continental Daily Mail*, 27 April 1935: 'Mr Spencer's St Francis is a caricature which passes the bounds of good taste, which is equally poor in drawing, design and composition. . .'. But the painting was defended by *The Spectator*, 3 May 1935, and the *Manchester Guardian Weekly*, 3 May 1935, which thought that the Academy had made 'a serious mistake'.

Spencer's reaction to the criticism was followed by a letter of defence which for some reason was never sent '. . . I painted this picture of St Francis from a motive of sincere regard for that person and because of the inspiring and graphic nature of the story. . . . In this preaching to the birds I have conceived that St Francis is expressing . . . his union with nature and the romantic wilderness of it. . . . The shapes and forms of St Francis are continuous with the surrounding shapes and forms, which further intensifies the union between them' (draft letter, Tate 733.6.28 c. 1936).

EXHIBITIONS
Leeds, 1947 (28)
Tate Gallery, 1955 (32)
Arts Council, Welsh Committee, *Stanley Spencer, Religious Paintings*, on tour, Llandaff, Bangor, Haverfordwest, Swansea, 1965 (14), repr.
RA, 1968 (471)
Arts Council, 1976–7 (23) repr.

REFERENCES
D.S. MacColl, 'Super- and Sub-Realism. Mr Stanley Spencer and the Academy' in *The Nineteenth Century and After*, CXVII, June, 1935, pp. 703–11
G. Spencer, 1961, pp. 180–81
M. Collis, 1962, pp. 25, 100, 114–17, repr. on dust jacket (in colour)
Robinson, 1979, p. 42, pl. 35 (in colour)
J. Rothenstein, 1979, p. 149

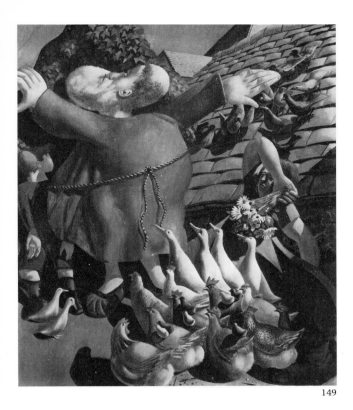

149

150 The Dustman or The Lovers

1934
Oil on canvas
114.9 × 122.5 cm/45¼ × 48¼ ins
Lent by the Laing Art Gallery, Newcastle (Tyne and Wear
County Council Museums)

This belongs to Spencer's *Last Day* or *Last Judgement* series for
the Church House (see p. 122). In the picture the newly
resurrected dustmen and labourers are reunited with their
wives in front of a cottage garden in Cookham. In 1937 Spencer
described the picture as: '. . . the glorifying and magnifying of a
dustman. The joy of his bliss is spiritual in his union with his
wife who carries him in her arms and experiences the bliss of
union with his corduroy trousers. . . . They are gazed at by
other reuniting wives of old labourers . . . [who] are in ecstasy
at the contemplation that they are reuniting and are about to
enter their homes'

The discarded rubbish which the labourer and his wife offer
up to the dustman couple had a particular significance for
Spencer; 'what is rubbish to some people is not rubbish to me,'
he wrote, 'and when I see things thrown away I am all eyes to
know what it is'; moreover, 'these things were bits of the lives
of people to whom they belonged and express their characters'
(Tate 733.3.1).

The sense of 'homeliness', as Spencer called it, which was
created by these unwanted everyday objects had already been

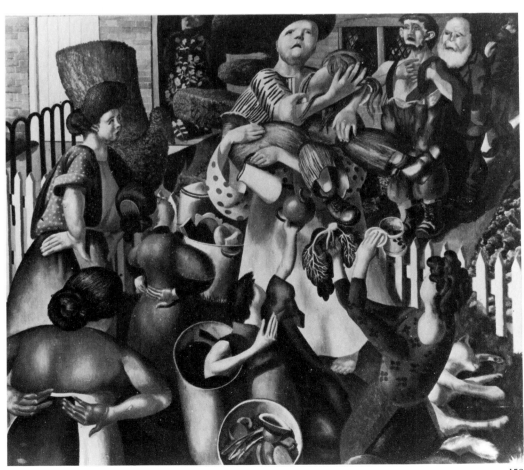

150

133

celebrated in *Sarah Tubb and the Heavenly Visitors* 1933 (no. 142), and was intimately connected with his deeply-felt religious convictions. Within this scheme of things the artist held all things and all people (including dustmen and rubbish) to be of equal significance before God. Of the figures proffering items salvaged from the dustbins he declared: 'Nothing I love is rubbish and so I resurrect the teapot, and the empty jam tin, and the cabbage stalks, and as there is a mystery in the Trinity, so there is in these three and many others of no apparent significance.' That the figure who offers the teapot is Spencer himself gives added significance to the act.

The religious significance which this picture held for Spencer helps to explain his fury when it was rejected by the Royal Academy hanging committee in 1935 together with *St Francis and the Birds* (no. 149). As both *The Dustman* and *St Francis* were important elements in the Church House, the artist must have been justifiably concerned about the future.

It is probable that the picture was intended to hang next to *Parents Resurrecting* 1933 (National Gallery of Victoria, Australia) in the Church House. As Duncan Robinson has pointed out (1967–7, p. 34), the relationship of the dustman and his wife, with the large woman cradling the man in her arms, was further developed in *The Beatitudes of Love* series of 1937–8 (see no. 188).

EXHIBITIONS
Newcastle-upon-Tyne, Laing Art Gallery, *The C. Bernard Stevenson Memorial Exhibition*, 1957 (194) repr.
Stanley Spencer Gallery, Cookham, 1966

REFERENCES
E. Rothenstein, 1945, pl. 39
Laing Art Gallery, Newcastle-upon-Tyne, *The Creation of and Art Gallery*, n.d. (1956), repr. (n.p.)
M. Collis 1962, pp. 114, 117, 138, 244
L. Collis 1972, pp. 57, 64, 75, repr. facing p. 41
Robinson, 1979, p. 42, pl. 39 (in colour), and on dust jacket

151 By the River

1935
Oil on canvas
113 × 182.9 cm/44½ × 72 ins
Lent by University College London

Spencer identified the scene as Bellrope Meadow with Cookham bridge in the distance and the church tower above the trees.

In notes on the painting written in 1942 for an exhibition at the Leicester Galleries, Spencer explained his feelings for the picture: 'It has a charming appearance at dusk. The meadow was slightly wedge-shaped and fairly long: the hedges were white with may and dark trees above. The grass got more milky green as it paled to the white of cow-parsley near the hedges. The place is much frequented by people on Sundays after church. They sit in the grass against the fence and you just see bowler hats, faces, collars and ties, shoulders stuck about here and there looking like so many portrait busts in colour. In this picture the people are doing nothing in particular which gives a better opportunity of conveying the essential atmosphere of the place. Neither the chestnut trees in the distance, nor the near shrubs are doing anything; they are just all "being", and the people are thinking at their ease and, in my opinion, are expressive. The standing figure in a striped coat is carrying a lady's fur coat in bandolier fashion' (Tooth archive). In the foreground sit Spencer, clutching a bunch of wild flowers, and his first wife Hilda, who hands him a letter or diary (a frequent form of communication between them), while their two children Shirin and Unity play about their legs.

Spencer probably intended the painting to have a further meaning beyond that of springtime bliss, for two years after completing the painting he recalled that he had 'wanted a madonna and child and girls laid out in a star pattern around them' (Tate 733.3.1). Though the 'star' pattern was abandoned in the final painting, as it was again in *Christ Preaching at Cookham Regatta* (no. 279), the artist probably intended to retain the dual meaning of the picture in a blending of springtime bliss and religious joy.

The painting is a splendid example of Spencer's ability to create atmosphere in his figure paintings through the evocative nature of the landscape, a point which was often ignored by the critics of the thirties, who all too frequently concentrated on the artist's unorthodox subjects and figure distortions. Landscape had played an important role in Spencer's early paintings, including *The Nativity* 1912 (no. 10) and *Zacharias and Elizabeth* 1914 (no. 21), in both of which the landscape is used to emphasise the intensity of the artist's experience of events taking place. This interest continued unabated until the 1950s when the landscape background, with a few exceptions, tended to be relegated to a less prominent role.

The source of Spencer's interest in the use of landscape in a symbolic role probably dates back to his early study of the Italian 'Primitives', and particularly Giotto's Arena Chapel frescoes, where the simple relationship between figures and landscape forms probably influenced *John Donne Arriving in Heaven* 1911 (no. 8). The second and more important influence came through an early knowledge of the Pre-Raphaelites (a print of Rossetti's *Annunciation*, Tate Gallery, hung in the Spencer home), where the strong emphasis on the symbolic role of landscape found in the work of artists like Holman Hunt and J. E. Millais must have been influential. It was this intense evocation of the English landscape which in part led early critics to see Spencer's work as a late flowering of Pre-Raphaelitism.

Spencer's interest in formal abstract design is very evident in the flower-patterned dress of the young girl who clings to the artist's leg, a shape which is reflected in the bunch of real flowers which he holds above her. This triangular shape reappears in the dress of the woman reclining in the forground, the two-dimensionality of which is echoed by her upper torso and head, which bear some resemblance to some late manifestations of Cubism.

EXHIBITIONS
British Council, *Fine Arts Committee Exhibition*, Venice 1938
British Council, Fine Arts Committee, *British Art*, Europe 1948–9
Carnegie Institute Pittsburgh, n.d.

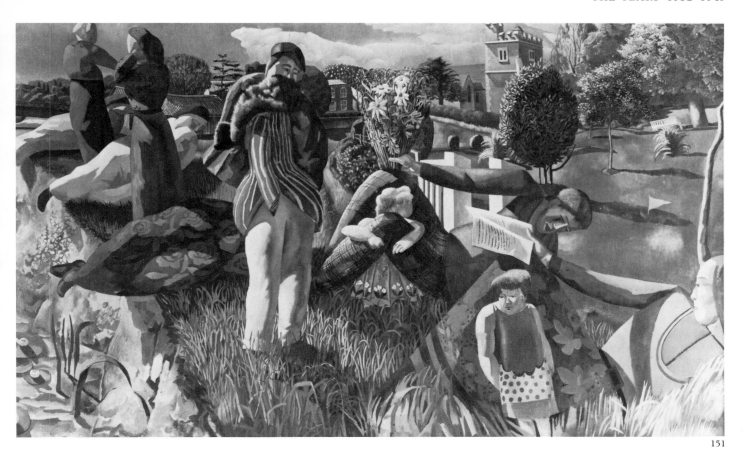

151

152 Pound Field, Cookham

1935
Oil on canvas
50.8 × 76.1 cm/20 × 30 ins
Lent by Southampton Art Gallery

The picture shows a view down across Pound Field to the village of Cookham. It was probably painted during the summer of 1935 when the warm weather made outdoor painting possible. In a letter of 19 December 1935 Spencer's agent Dudley Tooth informed him that the picture remained unsold. Providing dates for Spencer's work during the thirties is difficult because Tooths normally dated the picture from its sale, rather than from the completion of the work. This problem was compounded by the artist's refusal to sign or date his canvases. In the case of *Pound Field, Cookham*, the picture was sold to Southampton Art Gallery on 30 January 1936 (Tooth archive), and was therefore given the date 1936.

EXHIBITIONS
Southampton Art Gallery, *Paintings from the Permanent Collection*, 1939 (45)
Leeds, 1947 (27)
London, Arts Council, *Landscape Painting by Contemporary Artists*, 1949–50 (27)
Bournemouth Arts Club, *Summer Exhibition*, 1952 (53)
Tate Gallery, 1955 (39)
West Surrey College of Art and Design, Farnham, *Stanley Spencer*, May 1977

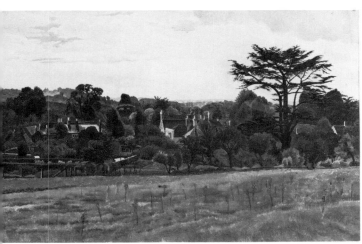

152

153 Madonna Lilies, Cookham

1935
Oil on canvas
43.2 × 53.3 cm/17 × 21 ins
Lent by Leeds City Art Galleries

Spencer began the picture shortly after his return from Switzerland at the end of June 1935 (see no. 170). The picture, which is smaller than his usual 50.8 × 76.2 cm/20 × 30 ins format, follows the artist's common practice of including a detailed flowerpiece set against a garden or landscape background (see no. 168). Spencer pronounced the picture finished in a letter to Dudley Tooth of 18 July 1935 (Tooth archives).

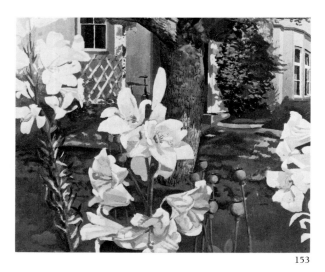

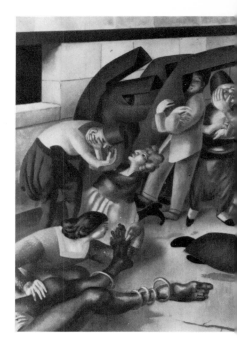

153

EXHIBITIONS
Leeds, 1947 (26)
Leeds, *Acquisitions of the Leeds Art Collections Fund 1913–49*, 1949 (26)
Stanley Spencer Gallery, Cookham, 1967–8

REFERENCES
E. Rothenstein, 1945, pl. 42
Leeds Art Calendar, no. 29, 1955, p. 24

154 Bridesmaids at Cana

1935
Oil on canvas
84.2 × 183.3 cm/33 × 72 ins
Lent by the Ulster Museum, Belfast

In 1935 Spencer showed Bryan Guinness (now Lord Moyne) a series of fifty small drawings on long strips of wallpaper. These studies were made in the early thirties for the *Marriage at Cana* cycle of paintings, symbolising the cycle of life through marriage, on which the artist worked intermittently until 1953.

Guinness chose a complete section of the drawing, provisionally known as *The Legs*, and commissioned Spencer to paint an enlarged version of it (letter to the author, April 1978). The picture in question was *Bridesmaids at Cana*, although Guinness's title recalls its most distinctive feature. It is one of only three pictures of the wedding-feast portion of the cycle which were painted. The others are *The Marriage at Cana: Bride and Groom* (no. 261) and *The Marriage at Cana: a Servant in the Kitchen Announcing the Miracle* (no. 260).

In the painting the marriage feast has taken place and the bridesmaids and guests sit about talking and looking at newspaper photographs of the wedding. According to Mrs Marjorie Spencer (Ulster Museum and Art Gallery files), the

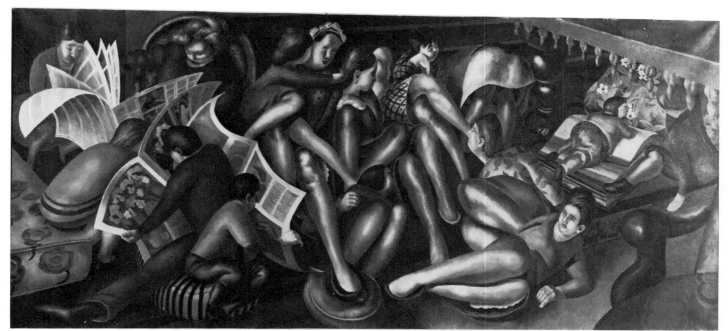

154

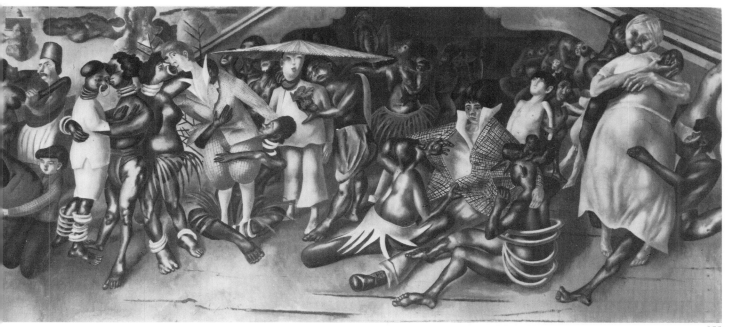

155

scene was based on the young Spencer family collected in the dining-room at 'Fernlea'. The two small boys looking at a wallpaper sample under the table on the right of the composition are probably the two youngest members of the family, Gilbert and Stanley Spencer. Writing about the picture in 1937 Spencer recalled: 'The bank of legs gives me the feeling of security I used to feel when as a child my view did not extend beyond the crest of bent knees' (Tate 733.3.2).

A pencil drawing *The Legs* (147.3 × 109.2 cm/58 × 43 ins, squared for transfer), exhibited at the Piccadilly Gallery in 1978 (56), is a study for the central part of the canvas.

EXHIBITIONS
Dublin, Municipal Gallery of Modern Art, *Exhibition of Work Acquired for the Museums and Galleries of Ireland by Friends of the National Collections of Ireland 1924–64*, 1964 (115), and Ulster Museum, 1964, pl. 7
Arts Council of Ireland, Wexford Arts Centre, and Crawford Municipal Art Gallery, Cork, *Modern and Contemporary Art from the Ulster Museum*, 1979 (6)

155 Love among the Nations

1935
Oil on canvas
95.5 × 280 cm/37⅝ × 110¼ ins
Lent by the Fitzwilliam Museum, Cambridge

Writing in 1937, Spencer called this painting 'a memento of my visits to Mostar and Sarajevo (in 1922), and my feelings for the east generally'; he went on 'The whole picture is a sort of expression of my admiration for the people and negroes etc., by and through love making scenes. I have longed as usual to establish my union with these aspects of life which I feel are definitely to do with me and not cut off by nationality; love breaks down barriers.' (Tate 733.3.1).

Spencer's strong feeling for the East stemmed from his war-time experiences in Bulgaria and Macedonia, which had inspired the Burghclere paintings, and his visit to Yugoslavia

with the Carlines when he had painted several landscapes (no. 69) but no figure pictures. The painting, as Spencer makes clear, is more than a simple memento of his experiences, as the *Souvenir of Switzerland* 1934 (no. 145) had been. He had long been interested in eastern religions (in the 1920s he had read *The Light of Asia* by Sir Edwin Arnold), and through his friend the artist James Wood had learned the philosophy of Islam. From sources like these he had become increasingly convinced of a new order of beliefs in which the division between sacred and profane would be eliminated: 'concepts of good or bad or ugly or beautiful are just obstacles in the way of revelation,' he wrote. Moreover Islam, though not as important as Taoism, provided Spencer with the attractive theory of polygamy, an idea which strongly appealed to him as a solution to his complicated relationships with his wife Hilda and Patricia Preece.

Closely connected to these ideas is Spencer's belief in the central role of sex in his spiritual life, an idea already hinted at in *The Dustman (or The Lovers)* 1934 (no. 150), and made manifest for the first time in this painting. The picture represents the breaking down of the spiritual and cultural barriers between the nations by means of the most intimate communion possible between two people – love-making. He wrote later: 'During the war, when I contemplated the horror of my life and the lives of those with me, I felt the only way to end the ghastly experience would be if everyone suddenly decided to indulge in every degree and form of sexual love, carnal love, bestiality, anything you like to call it. These are the joyful inheritances of mankind' (M. Collis, pp. 138–9). Only in this way would man be redeemed and the new Heaven on earth, already shown in the Burghclere and 1926 *Cookham Resurrections*, become a reality. In the picture, therefore, men and women from different races fondle and embrace one another, while on the right, Spencer himself, dressed in a check jacket, is investigated by two black women.

It was previously supposed that *Love among the Nations* was a complete painting; but Spencer's own writings, the evidence of a drawing, and two hitherto unrecognised incomplete canvases, indicate that the artist had a more ambitious painting, or series of paintings, in mind. These were to have formed an important part of the frieze which constituted the main decoration of the 'nave' of the Church House project. In 1937 Spencer stated that *The Turkish Window* (no. 147) should be attached to the right-hand end of *Love among the Nations*, a statement supported by the picture itself, which contains scenes of love-making between western men and Turkish women. Further evidence comes from a set of four attached drawings, *Study for Love among the Nations* (17.1 × 149.8 cm/6¾ × 59 ins, Private Collection, USA), which show the present painting as the left third of a larger picture, including *The Turkish Window* and other scenes of 'love-making' between blacks and whites. All but the small end section of this drawing exists in the form of two small canvases (Private Collection) drawn, but unpainted, which Spencer must have abandoned in 1935.

EXHIBITIONS
Tooth, 1936 (21), as *Humanity*
Leeds, 1947 (30)

Tate Gallery (Contemporary Art Society), *Seventeen Collectors*, 1952 (229)
Tate Gallery, 1955 (34)
Brighton, 1965 (205)
Cambridge, Kettle's Yard Gallery, Opening exhibition 1970 (5)
Arts Council, 1976–7 (27)

REFERENCES
M. Collis, 1962, pp. 137–9, 244
Burlington Magazine, CVII, 1965, p. 595, repr.
L. Collis, 1972, p. 75, detail repr. facing p. 89
Robinson, 1979, p. 53, pl. 48

156 Workmen in the House

1935
Oil on canvas
113 × 92.7 cm/44½ × 36½ ins
From the Collection of the late W. A. Evill

The painting and its companion, *The Builders*, were originally commissioned by a wealthy builder called Mr Boot who had been introduced to Spencer by an early patron, Sir Edward Beddington-Behrens. The only provision made was that the theme of the pictures should centre on 'building', and that the artist was to be paid a fee of £400 for a picture of an unspecified size. In a letter written to Mary Behrend in the early 1950s (Tate 733.1.91), Spencer recalled that his original

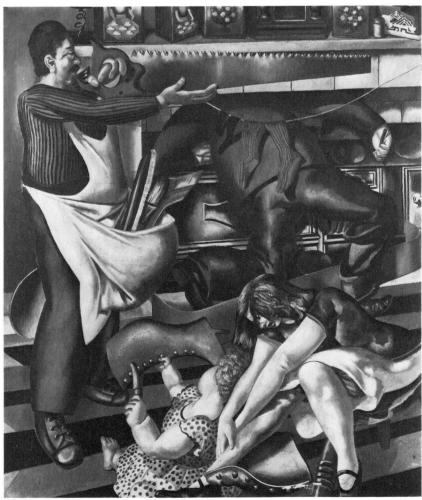

156

intention had been to paint one large picture which was to include interior and exterior scenes of builders at work. However, the painting was begun only two weeks after he had undergone a series of operations for gall-stones, the last of which had taken place on 18 December 1934. Finding himself too weak to carry out his plans for a single large canvas, Spencer decided instead to preserve the principal details of the design in two separate and smaller pictures: *The Builders* (no. 157), and *Workmen in the House* 1935, for which he charged £200 apiece. When the builder saw the completed paintings early in 1935 he refused to accept them and sent Spencer a 'rude letter'. At this stage Beddington-Behrens, who had been responsible for obtaining the original commission, came forward and bought one of the paintings, *The Builders*, for £200, to compensate Spencer at least in part for his expenditure in time and materials. *Workmen in the House* remained in the artist's studio until it was purchased by his solicitor, W. A. Evill, in 1937.

The painting is based on recollections of the interior of 'Chapel View', the house built by the Behrends for Spencer and his family to live in while he worked on Burghclere Chapel (1927–32). In 1937 he wrote a long description of the pictures: '. . . When I was a child one of the greatest incidents of life was changing the wallpaper and seeing what the room looked like with the bed in another corner. . . . In this picture I have felt the sense of it being a home that has been switched and added to by the presence of the workers. . . . The scene is more or less the kitchen of my cottage at Burghclere. The kitchen grate is being mended and the workman is grouting out the cement . . . with an iron wedge. He was asked by the servant (Elsie), bottom right, if he would like her to move the clothes line, but he told her it was not in his way and so one sees it lying across his back, and the stocking on it. He has pulled out the fender so as to get at what he is doing. Below him is the servant buttoning on a gaiter preparing to go out, and the young child (Shirin) who is about two years old is doing what they often do. This little girl was very fond of playing with clothes pegs which she was able to get at with great ease. . . . Being wedge-shaped she felt they fitted on to something. All these things had some purpose and while she was unable to say what that purpose was she thought she would 'test' a few probabilities. Also there was this activity going on round her and, perhaps in imitation of the man with the saw, she takes hold of the first article handy (Elsie's gaiter) and carries out a few experiments on it with the clothes peg' (Tate 733.3.2).

Spencer's evident delight in the pleasures of domestic life was, however, lost on the critics when the picture was exhibited at the Royal Academy in 1935. The Daily Mail reviewer commented: 'Nobody challenges Spencer's ability as a craftsman, the skill of his hand. What many people object to are some of his subjects when they are imagined conceptions.' *Workmen in the House* was nothing but a 'tragicomedy. A queer looking carpenter gazes down the length of an enormous saw. Another man is half-way up the kitchen chimney; in the foreground a distracted housewife and her child sprawl on the floor'.

Spencer had already had two paintings, *St Francis and the Birds* (no. 149) and *The Dustman* (no. 150), rejected by the

hanging committee, and this open hostility to his work caused him to resign his associated membership of the Academy. The criticism of a relatively innocuous painting like *Workmen in the House* made him wary of exhibiting his figure pictures, and fear of further trouble caused him to contemplate cancelling the one-man exhibition at Tooths planned for 1936.

EXHIBITIONS
RA, 1935 (301)
Norwich Castle Museum, *Contemporary British and French Art*, 1938 (47)
British Institute of Adult Education Touring Exhibition, and London, City Literary Institute, *French and English Paintings*, 1939–40
CEMA, *English Life*, 1942 (60)
Paris, Musée d'Art Moderne, 1946 (53)
Leeds, 1947 (29)
Tate Gallery, 1955 (33) repr. on cover
Brighton, 1965 (201)

REFERENCES
Royal Academy Illustrated, 1935, repr. p. 32
Studio, 119, 1940, repr. p. 35
E. Rothenstein, 1945, pl. 45
E. Newton, 1947, pl. 19 (in colour)
M. Collis, 1962, pp. 114, 118
L. Collis, 1972, p. 68
Robinson, 1979, p. 42, pl. 34

157 The Builders

1935
Oil on canvas
111.8 × 91.8 cm/44 × 36⅛ ins
Lent by Yale University Art Gallery; Anonymous Gift

This picture, together with *Workmen in the House* (no. 156), was commissioned by a wealthy builder named Boot who had been introduced to the artist by an early patron, Sir Edward Beddington-Behrens. The agreement called for a painting on the theme of 'building', but when Boot saw the two pictures he refused to accept them, and withheld the £400 fee. In order to compensate Spencer, Beddington-Behrens purchased *The Builders* for £200. *Workmen in the House* remained in the artist's possession until 1937, when it was purchased by Spencer's solicitor Wilfrid Evill.

Spencer drew his inspiration for the painting from several sources: the wooden template being taken down from the brick arch by the two workmen recalls a scene in Hampstead, together with the sight of Mr Head, the builder at Burghclere, checking the fit of the arched compositions which Spencer painted for the niches on the side walls inside the Sandham Memorial Chapel, Burghclere. The workmen carrying hods are a memory of Fairchilds the builders in Cookham. Both these scenes had originally been intended for inclusion in a painting for the University Library, Cambridge, and though the commission was never carried out the hod carriers do appear in a small oil sketch made for one of the paintings, *Builders of the Tower of Babel* 1933 (no. 139). The nesting birds at the top of the painting were to give a 'homely' atmosphere to the busy scene, and Spencer compared the nests to the familiar furniture found in a room: 'nests are beds', as he put it. This effect is assisted by the dappled sunlight which breaks up the hard surface of the brick wall, and plays over the figures of the workmen.

Both *The Builders* and *Workmen in the House* (no. 156),

157

together with *The Scarecrow* (no. 148), were exhibited at the
Royal Academy summer exhibition of 1935, after which
Spencer resigned when *The Dustman (or The Lovers)* (no. 150)
and *St Francis and the Birds* (no. 149), both more controversial
subjects, were rejected.

REFERENCES
M. Collis, 1962, p. 114
Robinson, 1979, p. 42

158 Nude (Patricia Preece)

1935
Oil on canvas
50.8 × 76.2 cm/20 × 30 ins
Lent by W. Parker Dyson

Spencer painted two nudes of Patricia Preece in 1935, the
seated *Nude* (no. 159), and the present 'lying down nude' (Tate
733.3.12, 1940). This picture was his first attempt to depict
Patricia in a reclining position, a form which he repeated in the
more elaborate double nudes of 1936–7 (no. 173) and 1937
(no. 178).

 At the Slade School, Spencer had attended the life classes
between 1908 and 1912, and again briefly in 1923. During this

1

time he had made numerous drawing studies from the nude, including several of the model Betty McCann (see no. 79). After leaving the Slade, however, he confined himself to conventional portraits, explaining in 1947, 'I have never had professional models, not liking the idea' (Tate 733.8.2). This was probably caused by the intensely personal nature of Spencer's figure paintings which gave him a preference for painting nudes only of those he knew well. In these cases the picture lost the character of a studio portrait, and became the symbol of a more intimate relationship between artist and sitter. This was emphasised by the manner in which the figure was crowded towards the surface of the picture plane, a device which also heightened the air of sexual tension. In the later paintings (nos. 173 and 178), Spencer took this a stage further by introducing his own self-portrait along with that of Patricia Preece. The inclusion of the nudes within the Church House scheme indicates that the artist saw the pictures in the context of the theme of sexual liberation found in works such as *Promenade of Women* 1938 (no. 191), and *The Beatitudes of Love*, 1937–8 (nos. 188–90) and the other major Last Judgement paintings.

In his commentary on the nude paintings written in 1947 (Tate 733.8.2) Spencer criticised the picture, commenting: 'The head does not properly belong to the body. I was trying to squeeze it into a 20 × 30 ins [canvas].' This was Spencer's standard size canvas, which he used for both figure paintings and landscapes. Only the small still-lifes and large series paintings deviated significantly from these measurements. Spencer corrected this early difficulty in *Self-Portrait with Patricia Preece* 1936–7 (no. 173), and *The Leg of Mutton Nude*, 1937 (no. 178) by changing the proportions of his canvases to suit the poses which he and his sitter adopted.

159

159　Nude (Portrait of Patricia Preece)

1935
Oil on canvas
76.2 × 50.8 cm/30 × 20 ins
Lent by the Ferens Art Gallery, City of Kingston-upon-Hull

This painting is the first of a series of nudes of Patricia Preece which Spencer painted between 1935 and their marriage in 1937. The artist did not like using professional models and he was delighted when Patricia volunteered to sit for him. At this early stage in the series the portrait is still relatively conventional; it contains none of the unusual devices which Spencer was to use in the later nude portraits. In the late 1940s he commented: 'I want to be able to paint a nude from life and do it as I do a portrait. I mean not so quickly but taking my time. The No. 1 nude (the present picture) is the best in this respect' (Tate 733.8.2).

In a note on the Church House scheme written in April 1947, Spencer stated his intention of including in the building a room containing his 'Nudes'. Here they were 'to show the analogy between the church and the prescribed nature of worship, and human love' (Tate 733.8.6). Spencer was to express these ideas more fully in *Love among the Nations* 1935 (no. 155), and *Love on the Moor* 1937–55 (no. 267).

160　Washing Up

c. 1935
Oil on canvas
61 × 48.3 cm/24 × 19 ins
Lent by Lord Walston

160

141

Spencer may have begun this picture much earlier whilst he was still at Burghclere. On 7 July 1930 he sent Hilda a study of herself with some of the saucepans in the kitchen of 'Chapel View'. He commented: '. . . the light was very sort of smeary where the saucepans were' (information from d'Offay Gallery catalogue, 1978, no. 11). The painting may be compared with the *Domestic Scenes*, painted during 1935–6, which also celebrate the importance of everyday activities. Like these, the picture belongs to the *Marriage at Cana* cycle of paintings conceived after 1932. A drawing for the painting (20.3 × 22.8 cm/10 × 9 ins) is in a Private Collection.

The kitchen at Burghclere also appears in *Workmen in the House* 1935 (no. 156), and *Country Girl: Elsie* 1929 (no. 130).

The Domestic Scenes 1935–6

Spencer painted the *Domestic Scenes* series of nine pictures during the period spanning the summers of 1935 and 1936. The early part of 1935 had seen the quarrel with the Royal Academy (see nos. 149 and 150), and Spencer, now painting specifically for a one-man exhibition to be held at Tooth's gallery in June 1936, therefore decided prudently to reduce the sexual content of his new paintings to a minimum.

The series which resulted was deeply influenced by Spencer's memories of his marriage to his first wife, Hilda, whose presence was to dominate his work for the remainder of his life. Here he recreated the moments in their relationship which had 'the special joy and significance' which meant most to him, like the simple act of dusting a shelf (no. 164), or the moment of calm at the end of the day when the family prepares for bed (no. 162). 'Half the meaning of life,' Spencer wrote in 1937, 'is in my case what the husband and wife situation can produce' (Tate 733.3.1).

As Anthony Gormley has pointed out, these paintings were particularly important to Spencer, as 1935–6 were the very years in which he was seeking a divorce from Hilda and thereby destroying any possibility that these calm domestic events could again take place. In the context of the marital breakdown these pictures begin the process in Spencer's art whereby Hilda was progressively transformed into an idealised image. Free from the difficulties which plagued his everyday life, Spencer could turn to the imaginary world of his paintings in which Hilda could be accommodated to the shape of his feelings: 'My desire to paint', he wrote in 1938, 'is caused by my being unable – or being incapable – of fulfilling my desires in life itself.' Spencer's paintings of Hilda (and the letters which he wrote to her even after she died in 1951, see no. 256) represented for him a kind of ideal 'marriage' of the spirit.

The theme of marriage to Hilda takes another form in the *Domestic Scenes* series, for it also belongs to the *Marriage at*

Cana section of the Church House, which was now beginning to take form in Spencer's mind. In this context the domestic activities are interpreted as the preparations of the guests for the wedding feast. Having witnessed *The Baptism* (no. 259) down at the Odney pool, they now return home to change, or, the ceremony over, prepare for bed. Within the *Cana* series Spencer saw the *Domestic Scenes* as symbols of the blessed state of marriage, as small islands of peace between the large crowded public events of Cana and the Baptism.

Altogether Spencer listed nine paintings of *Domestic Scenes*, including *Choosing a Dress* 1936 (76.2 × 50.8 cm/30 × 20 ins, Private Collection), and *Choosing a Petticoat* 1935 (76.2 × 50.8 cm/30 × 20 ins, Private Collection), which are not exhibited here. Two other paintings which were exhibited at Tooths 1936 exhibition are related to the series: *Washing Up* 1935 (no. 160) and *Crossing the Road* (76.2 × 50.8 cm/30 × 20 ins, The Wadsworth Atheneum).

161 Study for Going to Bed

1935
Pencil and chalk on buff paper, squared for transfer
53.3 × 61 cm/21 × 24 ins
Lent by Cdr Sir M. Culme-Seymour

In this drawing Spencer combined details of two paintings in the *Domestic Scenes* series. Hilda appears at the right removing her stockings, an image which recurs in *Going to Bed* 1936 (no. 162). In the background she is shown again, this time helping Spencer to remove his detachable collar. This was also the subject of a painting, *Taking off Collar* 1935 (76.2 × 50.8 cm/ 30 × 20 ins, Private Collection). There is no corresponding painting for the scene on the left which shows Hilda taking off her dress, but Spencer did paint two related activities: *Choosing a Dress* 1936 (76.2 × 50.8 cm/30 × 20 ins, Private Collection) and *Choosing a Petticoat* 1936 (76.2 × 50.8 cm/30 × 20 ins, Private Collection), for the same series.

It is difficult to ascertain whether the drawing was made before or after the *Domestic Scenes* were painted, but a note written about *Choosing a Petticoat* in 1937 (Tate 733.3.2) points to an earlier date. Spencer commented: 'My concept of married life consists a great deal in its uninterruptedness, so that I did a long frieze as a sort of History of the Buddah, only it was a history of married life showing the varying expressions of this double self . . .'. The present drawing either forms part of this frieze, or was an attempt to compress some of the episodes into an edited version. Eventually, as he was continually being forced to do, Spencer divided the frieze up into the *Domestic Scenes*. As he wrote disconsolately in 1937: 'I didn't like cutting these schemes up into [separate] pictures but what could I do?' (Tate 733.3.2).

EXHIBITIONS
Arts Council, *Some 20th Century English Paintings and Drawings*, 1950 (79)
Stanley Spencer Gallery, Cookham, Opening Exhibition, 1963

In this scene Spencer recalled 'the special joy and significance at Burghclere the moment just before Hilda joined me in bed'. She is shown removing her stockings while their two children, Shirin and Unity, clamber about on the 'mountains' made by Spencer's own knees under the bedclothes (Tate 733.3.1).

The painting also belongs to the *Marriage at Cana* (see no. 261) series intended for the Church House. In this picture the couple and their children have returned home after the marriage feast, where they experience renewed joys in domestic bliss.

The working drawing, *Study for Going to Bed c.* 1936 (no. 161), shows the scene within a larger context. *Going to Bed* also appears as one of six small pencil drawings (10.2 × 7 cm/4 × $2\frac{3}{4}$ ins) used by the artist to test the pictures' appearance when hung together (exhibited d'Offay Gallery 1978, no. 9).

EXHIBITIONS
Tooth, 1936 (15)
d'Offay Gallery, 1978 (12) repr.

REFERENCE
E. Rothenstein, 1945, pl. 44

161

162 Domestic Scenes: Going to Bed

1936
Oil on canvas
76 × 51 cm/30 × 20 ins
s. with initials and d.
Lent by Cdr Sir M. Culme-Seymour

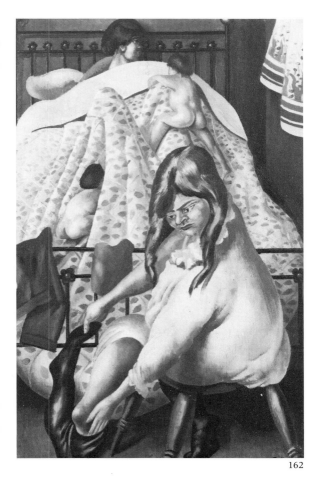

162

163 Domestic Scenes: Neighbours

1936
Oil on canvas
76 × 51 cm/30 × 20 ins
Lent by Mr and Mrs David Karmel

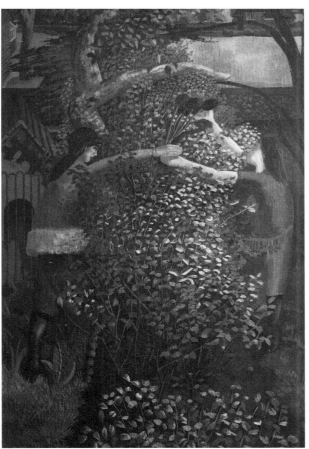

163

The painting is based on Spencer's memories of the back garden at 'Fernlea' and recalls the occasions during his childhood when his sister used to exchange small gifts over the privet hedge with their cousin who lived next door. In his 1937 picture catalogue the artist explained that the picture was intended to convey 'the different feelings evoked by the two gardens' (Tate 733. 3. 1).

For the composition Spencer made use of an ink drawing, *The Month of April*, originally done for the Chatto & Windus *Almanac* in 1926, which, with the elimination of two figures standing in the background, was transferred directly to the canvas. The *Almanac* was also the source for two other paintings of 1936 which recalled childhood memories: *Dusting Shelves* (no. 164) and *Christmas Stockings* (no. 167).

EXHIBITIONS
Tooth, 1936 (7)
Tate Gallery, 1955 (36)

REFERENCE
E. Rothenstein, 1945, pl. 54

164 Domestic Scenes: Dusting Shelves

1936
Oil on canvas
76 × 51 cm/30 × 20 ins
Lent by Dr and Mrs A.D. Taliano

This picture is another of the Cana works which Spencer painted specifically for his one-man exhibition at Tooths in 1936. It is based closely on one of the drawings for the Chatto & Windus *Almanac* for 1927, which was also the source for several other pictures painted in the mid-thirties. In his 1937 catalogue (Tate 733.3.1) Spencer described the picture as 'a memory of "Fernlea", Cookham, my old home and a series of shelves that stood in the corner of the drawing room. The shelves are like so many rooms and, being able to see it each at one glance, pleasing to me. The woman's hand in among the articles on the shelf is like a spiritual presence. . . .' The woman is probably Spencer's sister Annie. In the painting Spencer emphasises the contemplative nature of the activity by showing the woman with her back to the viewer rapt in her work.

A drawing, *Dusting Shelves* (10.2 × 7 cm/4 × 2¾ ins, exhibited at the d'Offay Gallery (1978–9) is mounted with five other domestic scenes. Two further paintings were derived from the *Almanac* drawings: *Christmas Stockings* (no. 167) and *Neighbours* (no. 163).

EXHIBITIONS
Tooth, 1936 (1)
Leeds, 1947 (37)
British Council, Europe, *Twelve Contemporary Painters*, 1948–9
Arts Council, Festival Exhibition, *British Painting, 1925–50 (1st Anthology), 1951* (90)

REFERENCE
E. Rothenstein, 1945, pl. 61

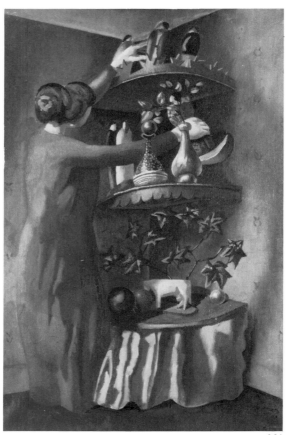

164

165 Domestic Scenes: On the Landing *or* Looking at a Drawing

1936
Oil on canvas
66 × 50.8 cm/26 × 20 ins
s. with initials and d.
Lent by a Private Collector

Stanley Spencer's paintings often contain more than one level of meaning, depending upon the context in which they are seen. *On the Landing* is a good example of this process at work. In a letter dated September 1949 the artist wrote: 'I had wanted the subject of *Looking at a Drawing* to be *On the Landing*, because it was hoped to express the sort of conversational encounters which occur in any part of the house, but as I thought the word "landing" might be mistaken for a river or seaside landing-stage and not a stairs landing in a house I called it *Looking at a Drawing*. Also it is one incident of several drawn and painted incidents all of which were showing prospective guests for the *Marriage of Cana* scheme as and when receiving in their own respective homes the invitations to it' (quoted in d'Offay Gallery catalogue, 1978). Spencer saw the picture as containing two distinct events which are embodied in the alternative titles. First, as *Looking at a Drawing*, it represents a domestic scene in which the artist shows the maid Elsie (see no. 130) a drawing. Second, as *On the Landing*, the painting becomes part of the *Marriage at Cana* scheme, with Spencer and Elsie reading the invitation to the wedding. Each of these events, the secular and

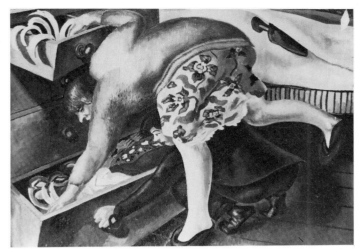

166

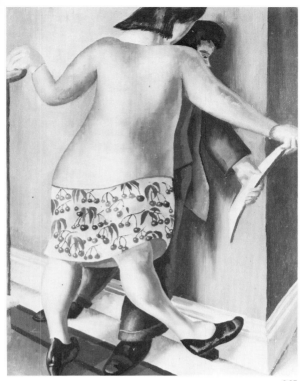

165

the religious, gives added meaning to the other.

The picture is another of the works painted specifically for Spencer's one-man exhibition at Tooths in 1936. Although it belongs to the Cana series, it differs from the other *Domestic Scenes* in showing Elsie the maid instead of Hilda. As such it is the only picture painted for what was to become the *Elsie Memorial* in the Church House. Other scenes survive only as drawings in the Astor *Scrapbook* series (see no. 209).

Stylistically the picture is the earliest example of the image of a small man dwarfed by a vast female figure which was to be the central theme of Spencer's next series, *The Beatitudes of Love*, 1937–8 (see nos. 188–190).

EXHIBITIONS
Tooth, 1936 (18), as *On the Landing*
Stanley Spencer Gallery, Cookham, 1962
d'Offay Gallery, 1978 (13)

166 Domestic Scenes: At the Chest of Drawers

1936
Oil on canvas
50.8 × 66 cm/20 × 26 ins
s. with initials and d.
Lent by a Private Collector

Another of the *Marriage of Cana* series, in this case a scene in which the guests, Stanley and Hilda, are choosing their clothes in preparation for the marriage feast. The collars which spill out of the top drawer reappear in the next painting in the series, *Choosing a Collar* 1936 (Private Collection).

The picture is closely related to *On the Landing* (no. 165), where the small figure of Spencer is again dominated by the larger form of the woman (in this case Elsie). Both these pictures show Spencer's growing interest in expressing the relationships between himself and women, and his enlargement of the female figures probably reflects his subconscious perception of his associations with them. Hilda and Elsie played a dominant part in his life at this time, and as such are given a correspondingly important role. Spencer, a small man, appears either intimately involved with the woman's homely activities or as a lover. The latter is most clearly symbolised by the tiny figure of Spencer who clings round Hilda's legs on the pedestal in the middle of *Love on the Moor* (no. 267), composed a year later, in 1937.

In order to express these ideas Spencer adopted a new compositional format, in which the two principal figures are balanced together in a tightly interlocking design. In *At the Chest of Drawers*, the two forms of Stanley and Hilda are placed one above the other and pressed tightly up against the picture plane by the confining space created by the chest and the unmade bed in the background. *On the Landing* (no. 165) is even shallower and the figures, splayed out flat against each other, are virtually mirror images.

EXHIBITIONS
Tooth, 1936 (2)
d'Offay Gallery, 1978 (14), illus.

REFERENCE
Robinson, 1979, p. 55, pl. 50

167 Domestic Scenes: The Nursery *or* Christmas Stockings

1936
Oil on canvas
76.5 × 91.8 cm/30⅛ × 36⅛ ins
Lent by the Museum of Modern Art, New York; Gift of the Contemporary Art Society, London, 1940

The picture belongs to Spencer's series of *Domestic Scenes*, painted for his first one-man exhibition at Tooths in 1936.
The scene, set in 'Fernlea', recalls Spencer's childhood

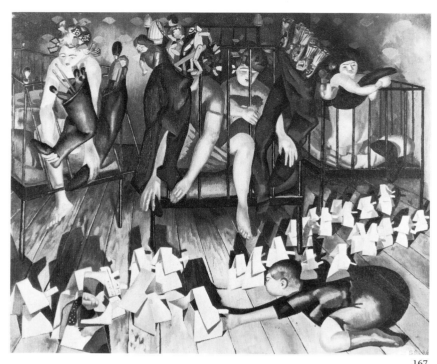

167

experiences of Christmas. He explained the picture to Alfred H.
Barr, Director of the Museum of Modern Art, New York, who
wrote to him in 1947 shortly after the museum had acquired the
work: 'The picture shows a scene in a nursery at Christmas
time. The children, who have their hair done up in bits of rag
called curlers, have come to the bottom ends of their respective
beds to see what is in their Xmas stockings. On the floor a child
is playing with paper nuns, making long processions of them.
As children one cut these out of paper, bent them over and
there was a nun' (MOMA archives).

Spencer's brother Gilbert recorded similar nursery goings-on
in his book Stanley Spencer by his Brother Gilbert; 'As I have said
the floor [of the nursery] was bare, and we played on it with
what we had: the puzzle, the buttons, and later a box of bricks.
But this scarcity of toys started us off on our own account.
Cutting out abstract paper patterns was good value, and this
later spread to paper nuns. How these nuns got into the nursery
through the barrage of non-conformity downstairs is one of the
deeper mysteries, but we processed them all round the room'
(G. Spencer, 1961, p. 37).

Both these accounts make it clear that the speculations of
James Thrall Soby (Director of MOMA's Department of Painting
and Sculpture, 1943–5) contained in a letter to A.H. Barr in
April 1946, now in the Museum records, were distinctly
inaccurate. He interpreted the picture as a dream based equally
on memories of Spencer's Cookham childhood and of a
Christmas at the Macedonian front, the connecting elements
being the kneeling figure of the boy and the 'paper tents' which
form a link with the Burghclere murals and in particular with
the Camp at Kalinova.

The painting is unusual for the Domestic Scenes series in that
it deals with memories of Spencer's early childhood, whereas
most of the others refer to his life with Hilda Carline and their

children Shirin and Unity. In designing the picture Spencer
drew on two sources: the first of these was a drawing which he
had made for the Chatto & Windus Almanac of 1927, The
Month of December: Christmas Stockings, which he reproduced
virtually without change in the upper half of the painting. The
lower half was adapted from another drawing, In the Nursery
1936 (pencil, 25.4 × 36.2 cm/10 × 14$\frac{1}{8}$ ins, MOMA), which
shows three boys playing with a row of paper nuns which
snake across the floor of the nursery; on the right are the vague
outlines of two bed-ends. In making use of the drawing Spencer
adopted a new viewpoint, looking into the room from the
fireplace wall towards the beds; he retains only one small boy
(probably a self-portrait), and a portion of the procession of
nuns. Behind, in what Spencer called 'another form of
anticipated pleasure', the children on the three beds touch the
stockings in an attempt to divine their contents.

EXHIBITIONS
Tooth, 1936 (17)
Venice Biennale, 1938
MOMA, New Acquisitions: European Paintings, 1941
MOMA, Five Paintings by Stanley Spencer, 1943
MOMA, Paintings from the Museum Collection, 1950
Philadelphia, Pennsylvania Academy of the Fine Arts, Contemporary Painting,
1925–1950, 1950–1
MOMA, XXVth Anniversary Exhibition, 1954–5
Minneapolis, Walker Art Centre, Reality and Fantasy, 1954
MOMA, Masters of British Painting 1800–1950, 1956
MOMA, Painting and Sculpture from the Museum Collections, 1969–70
Vienna, Museum des 20 Jahrhunderts, New Objectivity, 1977

REFERENCES
E. Rothenstein, 1945, pl. 58
E. Newton, 1947, pl. 28
G. Spencer, 1961, pp. 36–7
MOMA: Catalogue of the Collection, NY 1977, repr. p. 174

168 Cookham Rise: Cottages

1935–6
Oil on canvas
75.6 × 49.5 cm/29¾ × 19½ ins
Lent by the Lynda Grier Collection

By the mid-thirties Spencer was painting an ever-increasing number of landscapes, partly because of the demands of his agent Dudley Tooth, who found a ready market for them, but also because his deteriorating financial situation forced him to concentrate on works which would command a good price. Despite these pressures the artist produced a number of landscapes and still-life pictures during the thirties which were of a high quality.

This picture may be compared to *Gardens in the Pound, Cookham* 1936 (no. 175), which also combines landscape with detailed flower-painting. Spencer's choice of subject matter was dictated by the seasons, and much of his work was done during the summer months when flowers and foliage were at their best, and the weather conducive to *plein-air* painting.

EXHIBITION
Arts Council, 1975–6 (28)

168

169 Self-Portrait

1936
[repr. in colour on p. 154]
Oil on canvas
61.5 × 46 cm/24¼ × 18 ins
sbr. 'OSS 36'
Lent by the Stedelijk Museum, Amsterdam

The artist's pose in this picture bears a close resemblance to that of his first *Self-Portrait* (no. 23), painted in 1914. In both cases the face is lit from the right and the slightly elongated neck is left uncovered. This revealing picture was painted at a time when Spencer was also working on one of his most intimate and detailed portraits of himself with Patricia Preece, *Self-Portrait with Patricia Preece* 1936 (no. 173).

EXHIBITIONS
Tooth, 1936 (25)
Amsterdam, Stedelijk Museum, *Twee Eeuwen Engelse Kunst*, 1936 (147)
Arts Council, 1976–7 (330)

170 Avalanche, Switzerland

1935
Oil on canvas
45.1 × 59.7 cm/17¾ × 23½ ins
Lent by a Private Collector

Spencer paid a second visit to Switzerland in 1935, again at the invitation of Sir Edward Beddington-Behrens, the patron with whom he had stayed at Saas Fee three years before.

Accompanied by Patricia Preece, Spencer stayed in the town of Zermatt, which they found dull after the beauty of Saas Fee; the hotel was uncomfortable, and the famous sunsets prompted the artist to declare that he infinitely preferred those to be seen over Cookham.

In this small painting Spencer returned to the subjects of the *Souvenir of Switzerland* 1934 (no. 145), in the boy carrying the basket of bread, the traditional headdresses (see no. 144), and the wayside cross by the pile of avalanche debris, which bears a passing resemblance to the left-hand panel of the *Souvenir*.

Three other landscapes were painted in Zermatt: *The Swiss Skittle Alley* (Private Collection); *Geraniums, A Street in Zermatt* (Private Collection) and *Goats at Saas Grund* (Private Collection).

EXHIBITIONS
Tooth, 1936 (19)
Leeds, 1947 (34)

REFERENCE
L. Collis, 1972, pp. 66–7

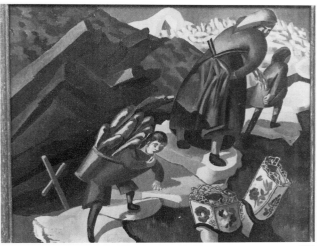

170

171 Cows at Cookham

1936
Oil on canvas
76.2 × 50.8 cm/30 × 20 ins
s. with initials and d. '36'
Lent by the Visitors of the Ashmolean Museum, Oxford

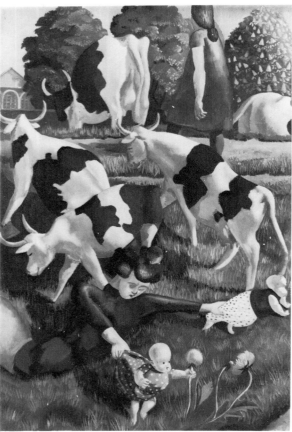

171

This delightful painting is based on one of a series of twenty-four illustrations to an *Almanac* published by Chatto & Windus in 1927, this one being for the month of May. The artist used the original tiny illustration, which is squared-up in meticulous detail, in the book (see display cabinet).

In transferring the scene to canvas Spencer made a number of small changes. He extended the composition downwards to include the woman and two children (probably Shirin and Unity), and added a building with arched windows to the left of the trees on the skyline. The artist seems to have been particularly fond of the cows which amble across the field and over the causeway, and they reappear in *Love on the Moor* 1937–55 (no. 267), calmly chewing the cud behind the fertility statue. Drawings of cows, probably from life, frequently occur in Spencer's notebooks.

Although the painting is charming and full of life, Spencer later felt that the subject was 'trivial', and the figure of the young girl across the causeway 'spoiled' the composition (notes made in 1937, Tate 733.3.1).

The original drawing for the *Almanac*, *The Month of May*, 1926, is included in the exhibition (no. 93).

EXHIBITIONS
Tooth, 1936 (12)
Leeds, 1947 (35)
Arts Council, *Second Anthology of British Painting*, 1925–50, 1951 (91)
Stanley Spencer Gallery, Cookham, 1958 (7)
Arts Council, 1976–7 (32) repr.

REFERENCES
E. Rothenstein, pl. 45
E. Newton, 1947, pl. 26
Robinson, 1979, pl. 36

172 The Boatbuilder's Yard, Cookham

1936
Oil on canvas
86.6 × 71.4 cm/34⅛ × 28⅛ ins
Lent by the City of Manchester Art Galleries

This unusually elaborate picture shows a view over a garden wall into Turk's Boatyard in Cookham. The boatyard appears in three other paintings by Spencer: *Swan Upping* 1915–19 (no. 33), *View from Cookham Bridge* 1936 (Private Collection, 66 × 86.4 cm/26 × 34 ins), and *Turk's Boatyard, Cookham* (Tate Gallery, 63.5 × 76.5 cm/25 × 30⅛ ins).

EXHIBITIONS
Royal Scottish Academy, 1939 (221)
Arts Council, Wales, *Some 20th Century English Paintings and Drawings*, 1950 (73)
Swansea, Glynn Vivian Art Gallery, *An Exhibition of Paintings from Manchester Art Gallery Permanent Collection*, 1952
Royal Scottish Academy, 1953 (179)
Tate Gallery, 1955 (41)
Barnsley, Cannon Hall, Cawthorne, *Four Modern Masters*, 1959 (30)
Arts Council, *Three Masters of Modern Painting*, 1961 (31)
Plymouth, 1963 (22)
Arts Council, 1976–7 (30)

REFERENCE
The Tate Gallery 1970–72, 1972, pp. 187–8

172

173 Self-Portrait with Patricia Preece

[repr. in colour on p. 154]
1936
Oil on canvas
61 × 91.2 cm/24 × 36 ins
Lent by the Fitzwilliam Museum, Cambridge

The picture is the first of the two 'double nudes' in which Spencer painted himself with Patricia Preece during the winter of 1936–7.

Unlike in the imaginative compositions which he was painting at the time (see no. 165), the artist did not introduce any elements of distortion into the picture. When working from the model (or landscape), Spencer painted exactly what he saw in front of him: 'There was no need to design or compose, all one had to do was put down what one saw', he wrote in 1937 (Gormley, p. 33). The artist likened himself to an ant which crawled over every detail of the body, thereby creating the sharp focus seen in this picture. The sensation is increased by the proximity of Spencer's head to Patricia's body. Because of the more spacious horizontal format the picture lacks the claustrophobic sexual tension of *The Leg of Mutton Nude* (no. 178), painted shortly afterwards.

In 1942 Spencer proposed that the portrait should be included in a room devoted to his nudes in the Church House (see no. 178).

EXHIBITIONS
Fitzwilliam Museum, Cambridge, 1949–50
Brighton, 1965 (206)
London, Hayward Gallery, *The Thirties*, 1979 (606)

REFERENCES
E. Rothenstein, 1945, p. 11, detail repr.
M. Collis, 1962, pp. 125, 245
Burlington Magazine, CVII, 1965, p. 595, repr.
L. Collis, 1972, pp. 62, 106, repr. p. 40
Robinson, 1979, p. 53, pl. 43 (in colour)
J. Rothenstein, 1979, repr. f. p. 17

174 Bellrope Meadow, Cookham

1936
Oil on canvas
90.2 × 130.8 cm/35½ × 51½ ins
Lent by Rochdale Art Gallery

A view from the riverbank across Cookham with the tower of Cookham Church standing above the trees on the left. The house on the right was called 'Cookham End'. It was demolished some years ago and an old peoples home 'Cookham House', built on the site.

Bellrope Meadow is also the setting for *By the River* 1935 (no. 151). Spencer frequently painted landscapes in association with his figure paintings. In 1937 for example *Cookham Moor* (no. 179) and *Love on Moor* 1937–54 were composed at the same time, indicating that the artist took considerable care over the accuracy of the landscape settings in his figure paintings. Spencer also had a vague plan in the thirties to include landscape views of various parts of Cookham in the Church House.

EXHIBITIONS
National Gallery, *British Painting since Whistler*, 1940
Arts Council, Welsh Committee, 1950
Barnsley, Cannon Hall, 1959
Tourcoing, France, *English Week*, 1960
Plymouth, 1963 (20)
Arts Council, 1976–7 (29)
London, Hayward Gallery, *The Thirties*, 1979

175 Gardens in the Pound, Cookham

1936
Oil on canvas
91.4 × 76.2 cm/36 × 30 ins
Lent by Leeds City Art Galleries

174

175

EXHIBITIONS
Leeds, 1947
Leeds, *Acquisitions of the Leeds Art Collections Fund, 1913–39*, 1949 (24)
Plymouth, 1963
Durham, *Landscape into Art*, 1974 (38)

REFERENCES
W. Gaunt, *English Painting of Today*, in *Studio*, 113, June 1937, repr. p. 309
E. Rothenstein, 1945, pl. 51
E. Rothenstein, 1962, repr. (in colour)
Leeds Art Calendar, no. 29, 155, p. 195
J. Rothenstein, *Modern English Painters, Lewis to Moore*, 1956, p. 180
M. Collis, 1962, p. 135
L. Collis, 1972, repr. f.p.25
Robinson, 1979, p. 53, pl. 48 (in colour)

176 Riveting

1936
Oil on canvas
61 × 91.4 cm/24 × 36 ins
Lent by a Private Collector

Spencer was often disparaging about landscapes like these, which took him away from the more important figure paintings. But there is no doubt that a great deal of skill and care went into the better paintings such as this one. It was painted before the onset of the financial pressures of the late thirties and early forties, which sometimes caused him to cut corners in an attempt to provide the easily saleable work, for which Dudley Tooth had a ready market.

The circular flower-beds and the red and black tiled paths recur in the top right corner of the centre panel of *The Resurrection with the Raising of Jairus's Daughter* 1947 (no. 241).

The painting is a fragment adapted from a little-known drawing which Spencer entered for a competition to paint a twenty-foot high panel over the entrance to the ballroom of the Cunard liner *Queen Mary*. The artist's name had been put forward by his agent Dudley Tooth (letter, Tooth to Spencer, 30 May 1935, Tooth archive), who had been impressed by Spencer's earlier industrial scenes from the Empire Marketing Board.

According to the artist, the commission and a fee of £750 had already been awarded to him by the selection committee when he visited the Cunard offices in London. Disturbed that the committee members did not know his work, Spencer agreed on condition that he would first provide a preliminary drawing for approval. If this was rejected he would receive a fee of £25 for his trouble. The theme of the painting was to be a nautical one, and the artist chose a shipbuilding scene from among the large batch of photographs sent to him by Cunard. He explained his choice in a letter to the owner of *Riveting*, 8 January 1948: 'I felt that out of the midst of this wealth and splendour [in the ballroom] should rise something so remote from the seas as to seem like a ghost of the past, namely the men building the ship'.

The study (nine sheets joined, 99.1 × 70 cm/39 × 24 ins,

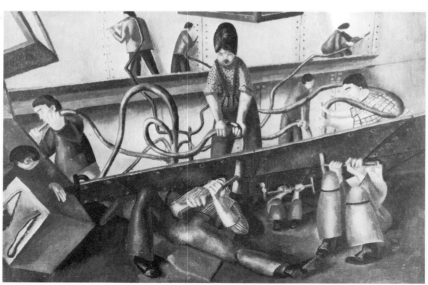

176

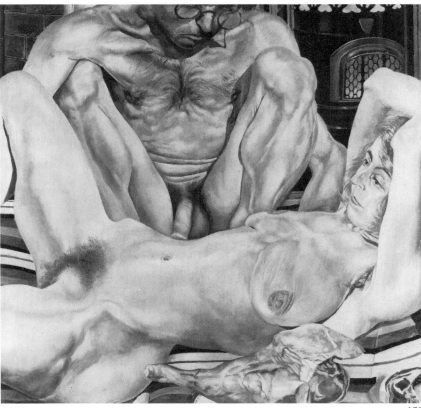

178

Private Collection) shows the outside of a ship's hull resting on a slipway. In the upper half men suspended in cradles paint the vessel's side. Below, over the ballroom doorway, in the scene which Spencer used for *Riveting*, a group of men rivet together steel plates.

When the drawing was shown to the committee it was rejected and, in order to salvage part of the composition, Spencer painted two small canvases one of which was *Riveting*. Spencer described the picture in his 1948 letter to the owner: 'I had very little knowledge of [shipbuilding] methods when I did your study. In it, you are looking at the side of the ship. You see the dark underneath of it, and what is meant to be riveters working there. . . . The scene . . . is like looking through a window into the ship.' Spencer recalled that the riveting process is not strictly accurate because he modified both men and machines to suit the composition.

The second oil study, *Shipbuilding* (Private Collection), was also derived from the drawing.

EXHIBITION
Tooth, 1936 (13)

177 Greenhouse and Garden

[repr. in colour on p. 155]
1937
Oil on canvas
76.2 × 50.8 cm/30 × 20 ins
Lent by the Ferens Art Gallery, City of Kingston-upon-Hull

The picture shows a view through the door of the greenhouse at 'Lindworth'. In 1937 he made over the title of the house to his

second wife Patricia Preece (later Lady Spencer), finally moving out a year later when the house was sold.

The detailed still life in the foreground of the picture is a recurring device in Spencer's landscapes (see also no. 233). There is another view of the 'Lindworth' greenhouse which the artist painted in 1935 (Private Collection).

EXHIBITIONS
Nottingham, 1946
Arts Council, 1947
Leeds, 1947 (44)
British Council, *British Art in Europe*, 1948–9 (51)
Graves Art Gallery, Sheffield, *The Eye Deceived*, 1954 (59)
Barnsley, Cannon Hall, Cawthorne, *Four Modern Masters*, 1959 (31)
Arts Council, *Three Masters of Modern British Painting*, 1961 (33)
Leeds University, 1963
Plymouth, 1963 (25)
Stanley Spencer Gallery, Cookham, 1967

178 The Leg of Mutton Nude

1937
Oil on canvas
91.5 × 93.5 cm/36 × 36⅞ ins
Lent by the Trustees of the Tate Gallery

The picture was painted at 'Lindworth', Cookham, and was completed in March 1937. According to Nicholas Tooth it was probably given its present title by Dudley Tooth when acting as Spencer's executor after his death in 1959 (information from the Tate Gallery catalogue). The artist's own provisional titles for the picture included *Double Nude and Stove*, and *Double Nude*, which was also used for the Fitzwilliam portrait (no. 173).

Because of the intimate nature of the nudes, Dudley Tooth regarded them as 'difficult sellers', and they were rarely, if ever, exhibited. This disappointed Spencer, who felt that the pictures played an important role in the context of his other imaginative figure paintings. In a notebook entry of 1947 (Tate 733.8.2) he wrote: 'I wish my shows could include the nudes (oil) that I have done. I think to have them interspersed in a show would convey the range of my work. They are quite different. I wish I had more of them . . . they have such an effect on the other works'.

Spencer also allocated a special room in the Church House to the nude paintings. In a drawing (Tate 733.3.49) made in July 1942 he showed how they were to be hung; *The Leg of Mutton Nude* was to be in the centre, flanked by the nudes of Patricia (no. 159) and Hilda (no. 215), with the Fitzwilliam double portrait on the far right. No. 158 was hung as a predella beneath the portrait of Hilda, and two other nudes (see no. 173) were to balance the group. The artist described his intentions in a note made on 17 April 1947: 'I wanted in the nude section to show the analogy between the church and the prescribed nature of worship, and human love' (Tate 733.8.2). Simon Wilson (Tate Gallery catalogue) has interpreted this statement to mean that Spencer intended the painting as a reference to the Communion Service; with the Host represented by a leg of mutton, the celebrant and communicant by the artist, and the base of the painting as the altar. But it is unlikely that Spencer was so specific in his reference to church ritual (elsewhere he called the mutton 'our dinner'), and the idea of the painting as an altarpiece was first conceived in 1942, long after it was painted. However the picture is certainly an expression of the artist's belief in the sanctity of human love, freed from the moral restrictions usually imposed upon it by Christianity. On a more personal level the painting symbolises the artist's unfulfilled desire for Patricia, whom he married two months later on 29 May 1937.

Spencer made a final reference to the painting in September 1955: 'I have now brought back home the big double nude. When I put it alongside any of my other work it shows how needed it is to give my work the variety that is so refreshing. This big double nude is rather a remarkable thing. There is in it male, female and animal flesh. The remarkable thing is that to me it is absorbing and restful to look at. There is none of my usual imagination in this thing: it is direct from nature and my imagination never works faced with objects or landscape . . .' (Tate 733.8.2).

EXHIBITION
Merradin Gallery, 1972 (ex catalogue)

REFERENCES
M. Collis, 1962, p. 125
Edward Lucie-Smith, *Eroticism in Western Art*, 1972, pl. 173
Simon Wilson and Robert Melville, *Erotic Art of the West*, 1973, pp. 30, 145, pl. 53 (in colour)
Andrew Forge, *Artforum*, April 1974, p. 66

179　Cookham Moor

1937
Oil on canvas
49.5 × 75.6 cm/19½ × 29¾ ins
Lent by the City of Manchester Art Galleries

Painted before 4 June 1937, the day Spencer left for St Ives, this is another picture of Cookham. The view shows the road leading over Cookham Moor with the War Memorial (see no. 267) and the village in the background. At the time the artist was also working on the compositions for *From up the Rise* 1954 (95.3 × 106.7 cm/37½ × 42 ins, Private Collection), which was set by the bridge in the foreground, and *Love on the Moor* (no. 267 completed 1954) which, as its name suggests, was based on the meadows on the right of the causeway.

EXHIBITIONS
Mansfield Art Gallery, 1948
London, Roland, Browse and Delbanco Gallery, *The English Scene–Important British Paintings from Three Centuries*, 1951 (18)
Tate Gallery, 1955 (44)
Brighouse Art Gallery, *Jubilee Exhibition 1907–57: British Painting*, 1957 (69)
Adelaide, *Art Gallery of South Australia, Stanley Spencer*, 1966 (12)
Arts Council, 1976–7 (31)

REFERENCES
E. Newton, 1947, pl. 21 (in colour)
The British Heritage, London, 1948, pl. IV
M. Collis, 1962, pp. 129–30, 133, 245, repr. f. p. 33
Cookham Festival Souvenir Programme, 1967, repr. cover
Robinson, 1979, p. 53, pl. 46

180　The Harbour, St Ives

1937
Oil on canvas
71.1 × 95.2 cm/28 × 37½ ins
Lent by Lord Iliffe

Spencer made a painting trip to St Ives in June and July 1937 in company with Patricia Preece (whom he had married on 24 May) and her companion Dorothy Hepworth. During the visit, which lasted six weeks, he painted a total of six canvases of St Ives and its environs: *Cottage, St Ives* (76.2 × 50 cm/30 × 20 ins); *Fishing Boats, St Ives* (50 × 61 cm/20 × 24 ins); *A Wet Morning, St Ives* (50 × 61 cm/20 × 24 ins); *From the Quay* (53 × 86.3 cm/21 × 34 ins); *Low Tide, St Ives* (71.1 × 95.2 cm/28 × 37½ ins), all in private collections.

EXHIBITION
Stanley Spencer Gallery, Cookham, 1965–6 (14)

179

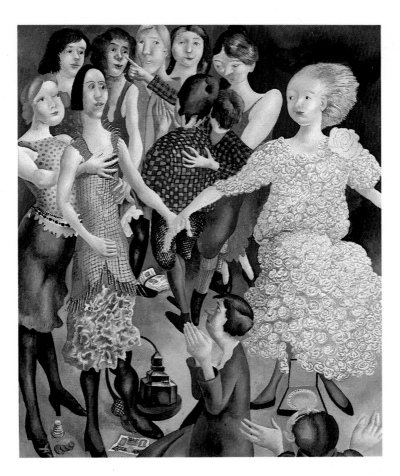

189 The Beatitudes of Love: Worship
1938

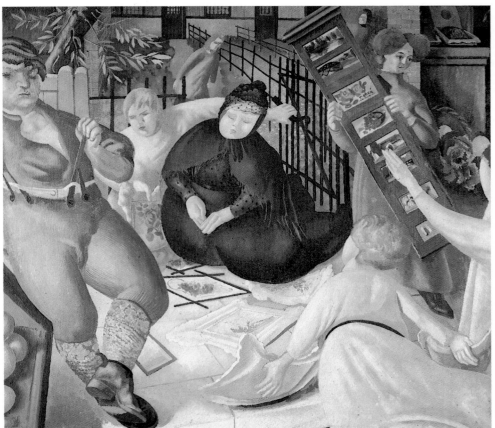

142 Sarah Tubb and the Heavenly Visitors
1933

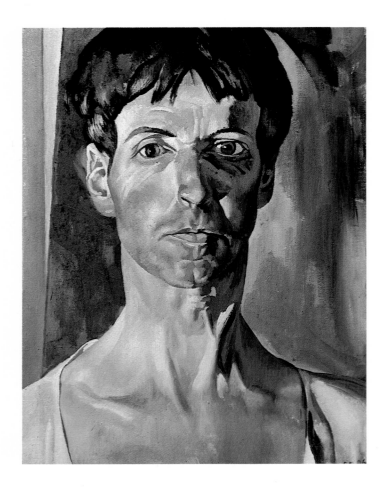

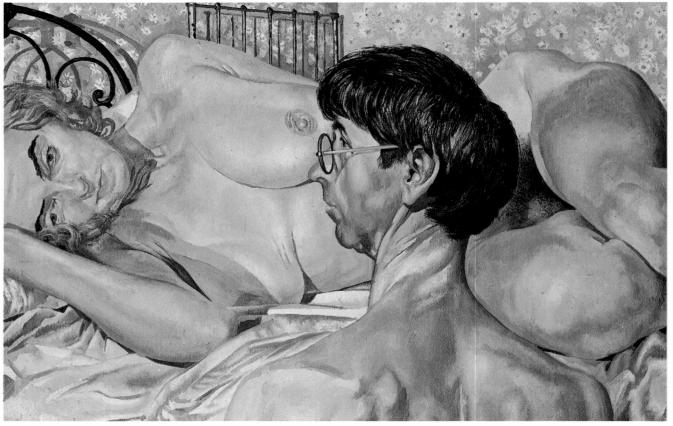

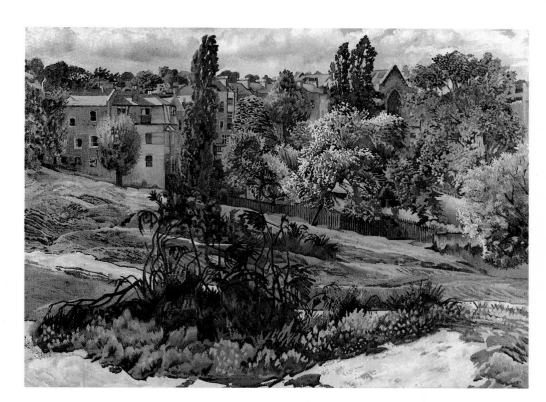

203 The Vale of Health, Hampstead
 1939

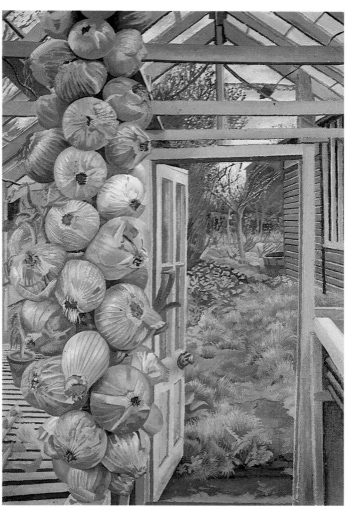

177 Greenhouse and Garden 1937

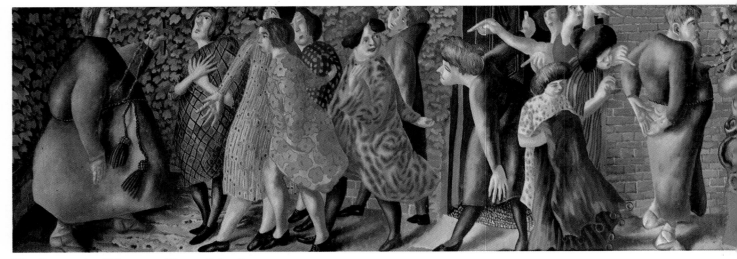

191 Promenade of Women or Women Going for
a Walk in Heaven 1938

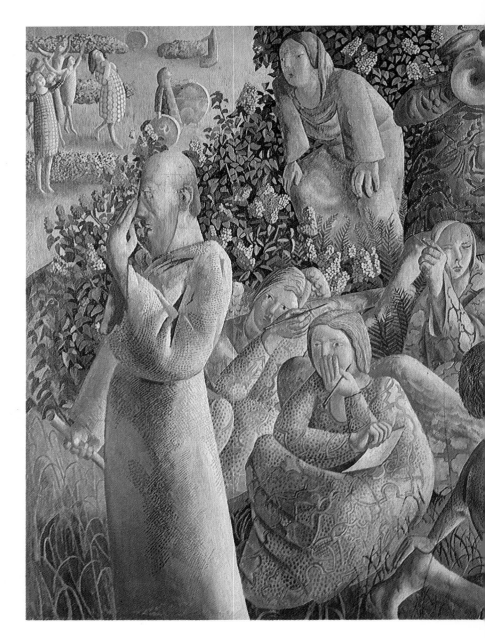

235 The Resurrection: The Hill of Zion 1946

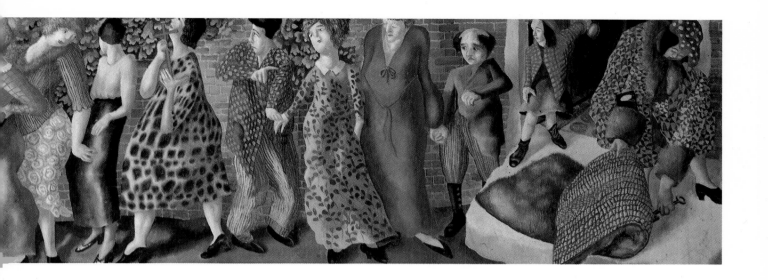

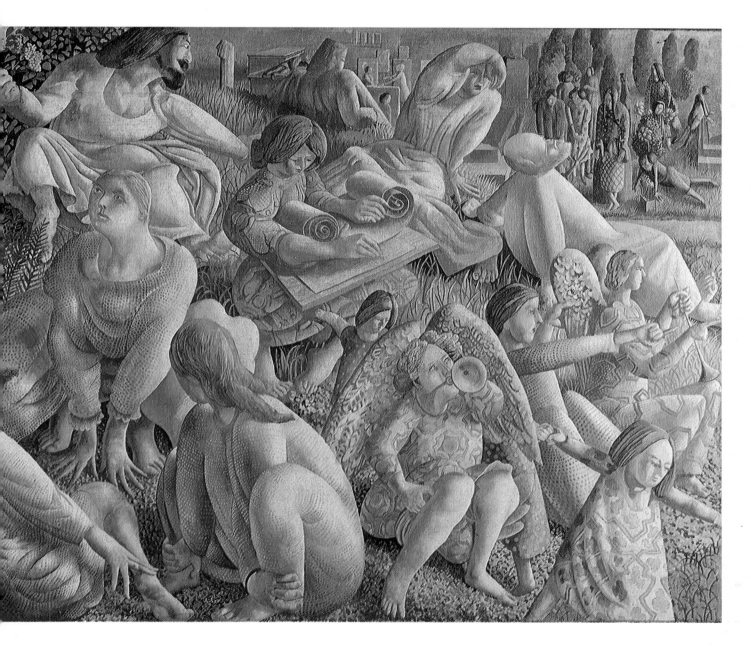

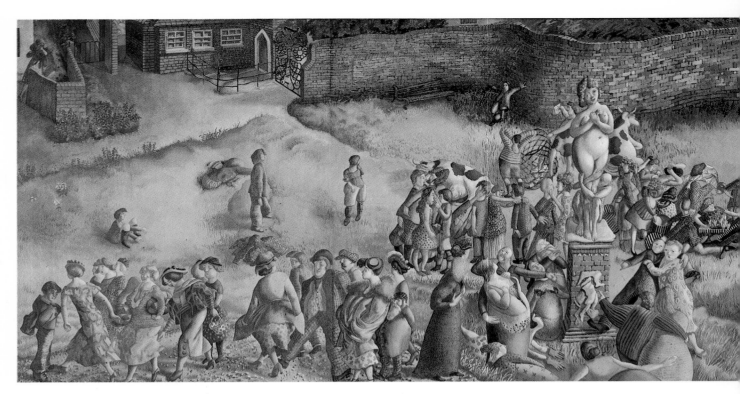

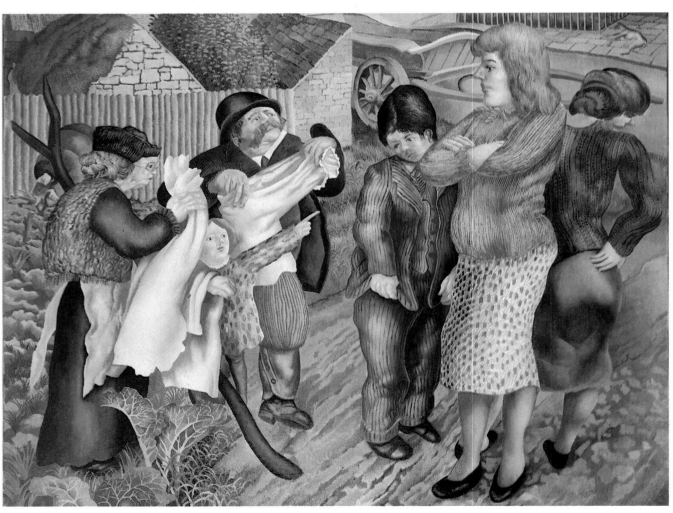

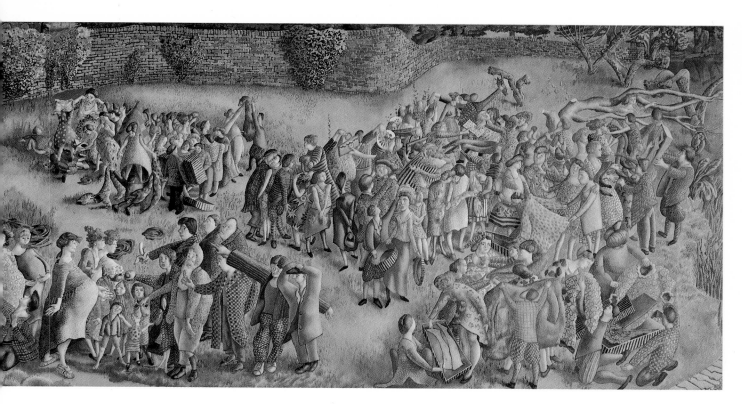

267 Love on the Moor 1937–55 (*above*)

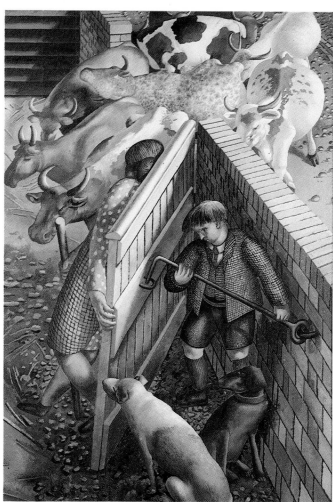

211 Village Life, Gloucestershire 1940 (*left*)

255 The Farm Gate 1950 (*right*)

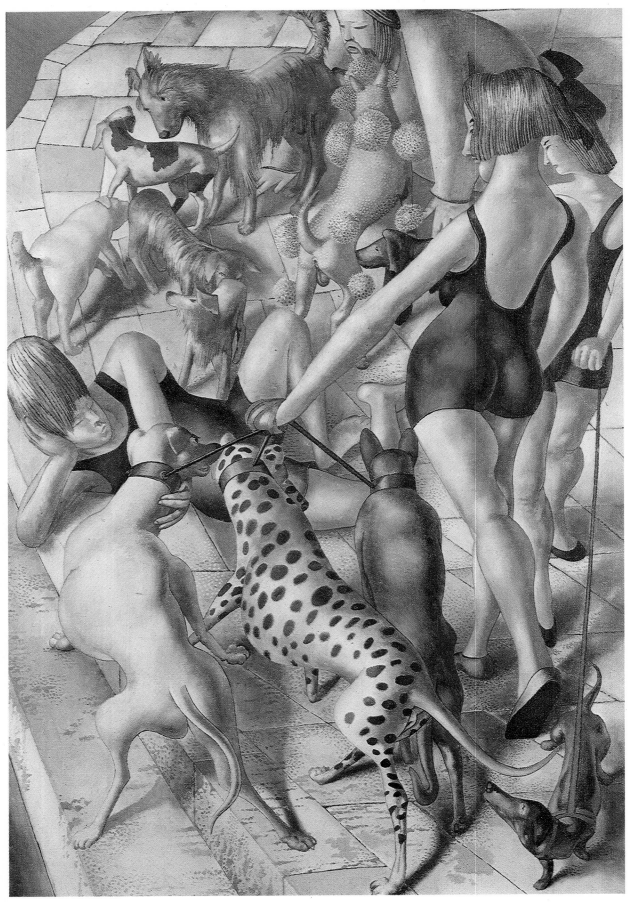

274 The Bathing Pool, Dogs 1957

180

181 Southwold

1937
Oil on canvas
81 × 50.8 cm/31⅞ × 20 ins
Lent by Aberdeen Art Gallery and Museums

According to Richard Carline, Spencer visited Southwold
several times while he was staying at the nearby village of
Wangford where he had first stayed in 1924 with his brother
Gilbert and Hilda Carline. Hilda had worked on a farm near the
village as a member of the Land Army in the war. The following
year Spencer and Hilda returned to Wangford to be married. On
this occasion they visited Southwold in company with Gilbert,
where they drew and painted Miss Silcox, headmistress of
Southwold Girls' School (see no. 87).

Subsequently, after the failure of his second marriage to
Patricia Preece, Spencer tried to persuade Hilda to return with
him to Wangford, scene of the happy early days in their
marriage. When she refused the artist went there on his own,
staying at their old lodgings with Mrs Lambert. On the day
after his arrival Spencer paid a short visit to Southwold, where
he began the present splendid view of the busy beach.

Although the composition was painted on site in accordance
with Spencer's usual landscape practice, it does contain certain
similarities to an illustration made for the Chatto & Windus
Almanac (see no. 94), in this case for the month of August.
Here a similar view of deckchairs and bathers is depicted
running down to the water's edge.

EXHIBITIONS
Tooth, *Contemporary British Painting*, 1937 (37)
Leeds, 1947 (52)
RSA, 1949 (238)

181

Arts Council, Scottish Committee, *20th Century British Paintings from Aberdeen
Art Gallery*, 1952, (41)
Tate Gallery, 1955 (45)
Plymouth, 1963 (23)

182 Hilda, Unity and Dolls

1937
Oil on canvas
76.2 × 50.8 cm/30 × 20 ins
Lent by Leeds City Art Galleries

Painted towards the end of August 1937 at the Carlines' house
in Pond Street, Hampstead, when Spencer was on a two-week
visit there. The picture shows a retreat from the more radical
handling of the human form seen in two other double-portraits,
nos. 173 and 178, painted in 1936–7.

The artist may later have considered including the picture in
the imagined Hilda Memorial Chapel of the early fifties, but

161

182

The scene is set in the fairground by the Vale Hotel in the Vale of Health. Here the artist had painted a similar subject, *The Roundabout* (no. 83), while he was living in a studio at the top of the hotel in 1923. As in *Southwold* (no. 181), painted a few weeks before, Spencer seems to have deliberately sought out a landscape which had pleasant associations for him, in this case the view from the studio window of the Vale Hotel.

EXHIBITIONS
National Museum of Wales, *Contemporary Art Exhibition*, 1938
Huddersfield Art Gallery, *Opening Exhibition*, 1939
Leeds, 1947 (43)
Keighley Museum, 1948
Stalybridge, *Annual Exhibition of Contemporary Art*, 1949
Arts Council, *British Painters of Today*, 1955 (27)
Barnsley, Cannon Hall, Cawthorne, *Four Modern Masters*, 1958–9 (29)
Cookham, Stanley Spencer Gallery, on loan 1977
Arts Council, *3 Masters of Modern Painting*, 1961
Plymouth, 1963 (23)
Arts Council, RA, Cityscape, 1977–8 (139)
Camden Arts Centre, *The Camden Scene*, 1979 (219)

REFERENCE
E. Rothenstein, 1945, pl. 64, as *The Slide, Hampstead Heath*

there is no evidence that this formed part of his plan when the picture was painted (see d'Offay Gallery catalogue, 1978, no. 15).

EXHIBITIONS
Leeds, 1947 (49) repr.
Tate Gallery, 1955 (43), pl. 5
Plymouth, 1963 (24)
Arts Council, 1976–7, (37), repr. p. 66 (in colour)
d'Offay Gallery, 1978 (15), repr.

REFERENCES
E. Rothenstein, 1945, pl. 62
Leeds Art Calendar, vol. 8, no. 29, 1955
M. Collis, 1962, pp. 135, 245
E. Rothenstein, 1962, pl. 10 (in colour)
L. Collis, 1972, repr. f. p. 25
Robinson, 1979, p. 61, pl. 53 (in colour)

183 Helter Skelter, Hampstead Heath

1937
Oil on canvas
91.5 × 58.5 cm/35¾ × 23¼ ins
Lent by Sheffield City Art Galleries

Shortly after his visit to Wangford (see no. 181), Spencer went to stay with the Carlines at their house in Pond Street, Hampstead, for two weeks in August. Here, between sessions painting *Hilda, Unity and Dolls* (no. 182), he worked on the present picture, which he tentatively named *The Slide, Hampstead*.

183

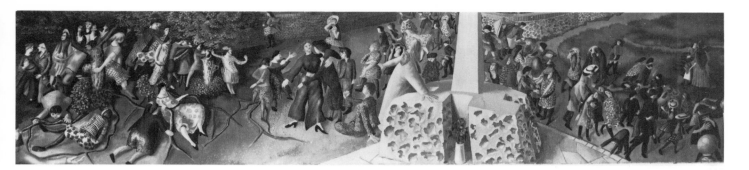

184 A Village in Heaven

1937
Oil on canvas
45.7 × 182.9 cm/18 × 72 ins
Lent by the City of Manchester Art Galleries

The painting belongs to the *Last Judgement* series which were intended to hang in the 'nave' of the projected Church House. Its theme is the redemption of the world by sexual love which has become free of all shameful associations. The scene is set on the edge of Cookham Moor by the War Memorial, where the village girls traditionally came to meet their lovers. Here one of the disciples who has redeemed the village stands by the Memorial and gives his blessing to the young lovers under the trees. These in turn gaze at each other in ecstatic anticipation of sexual union. The joy and innocence of their love-making is given additional emphasis by the presence of the schoolchildren.

Spencer's original title for the picture, *The Celebration of Love in Heaven*, is more explicit. The name was then briefly changed by Dudley Tooth to *A Village Fête*, probably to direct attention from its real meaning and to make it more saleable. The present title was chosen by the artist as a compromise.

This painting and others in the series, including *The Beatitudes of Love* (no. 188), show Spencer's interest in Indian art, specifically temple sculpture like that at Khajuraho (*c.* AD 1000), symbolising Krishna's love for the Gopis. Here, in the figures entwined in sexual union, Spencer found support for his own ideas about sexual freedom. As Gormley (p. 38) has pointed out, the fact that these figures decorated temples must have provided an important precedent for the Church House where the sacred and the profane are freely mixed. Spencer owned a number of loose colour plates of Indian temple sculpture, later found among his papers. According to Graham Murray, the artist was deeply impressed by photographs of Hindu temples taken by the scholar Alice Bonar which he saw in Glasgow *c.* 1945 (letter to the writer, 5 December 1979). These apparently influenced the *Port Glasgow Resurrection* series. Earlier he had called the sculpture at Borobadur 'some of the most magnificent carving in the world' (Gormley, p. 38). The narrative form of the pictures, unfolding from left to right, may also have been influenced by Indian sculpture, although the early influence of cartoons (found amongst his papers in 1959), and the frescoes of Giotto and other Italian masters (see no. 8), were probably of equal importance.

A study for *A Village in Heaven* (pencil, s. 1937, 27.3 × 37.5 cm/10¾ × 14¾ ins) was sold at Sotheby's on 1 May 1968 (48).

EXHIBITIONS
Sheffield, Graves Art Gallery and Derby Museum and Art Gallery, *Exhibition of Contemporary Art*, 1945 (12)
Leeds, 1947 (47)
Arts Council of Great Britain, *British Painting 1925–50, First Anthology* 1951 (92)
Barnsley, Cannon Hall, Cawthorne, *Four Modern Masters*, 1959 (28)
REFERENCES
E. Rothenstein, 1945, p. 19, pl. 65
M. Collis, 1962, pp. 140–1, 245

185 The Village Lovers

c. 1937
Oil on canvas
69.9 × 105.4 cm/35½ × 41½ ins
From the collection of the late W. A. Evill

The picture belongs to the Church House, *Adorations* series, in which Cookham is transformed at the Last Day into a village where love is no longer governed by the old moral constraints.

There, in front of the War Memorial at the village end of Cookham Moor, a group of elegantly dressed village girls are worshipped by a party of young men. Behind, a youth kneels before another girl who assumes the attitude of the crucifixion against the Memorial cross. The atmosphere is one of hardly repressed joy and sexual excitement.

Curiously, the artist makes no mention of the picture in his commentaries and painting lists, an unusual omission for a picture which plays an important part in the Church House series. Although the late owner, Wilfrid Evill, dated the picture 'about 1934' (Brighton Catalogue, 1965, no. 212), both style and subject matter indicate a later date of *c.* 1937, when Spencer painted two similar works, *Adoration of Girls* (no. 185a) and *Adoration of Old Men* (no. 186), both of which take place in the village near the War Memorial.

The Memorial appears again in *A Village in Heaven* (no. 184).

Despite the oddly distorted figures which dominate Spencer's imaginative paintings at this time, both his landscapes (see no. 192) and his portraits (see no. 182) show an increased emphasis on accurately detailed painting.

EXHIBITION
Brighton, 1965 (212)

185a Adoration of Girls 1937

See addenda, p. 230

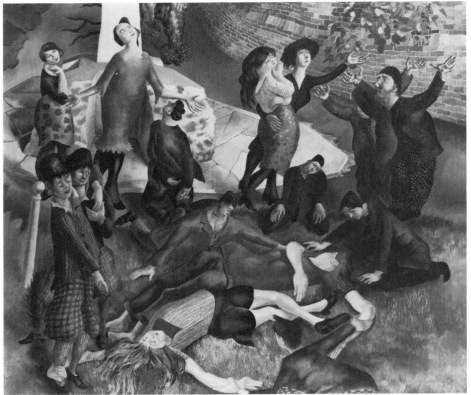

185

186 Adoration of Old Men

1937
Oil on canvas
92.7 × 111.8 cm/36½ × 44 ins
Lent by Leicestershire Museums and Art Galleries

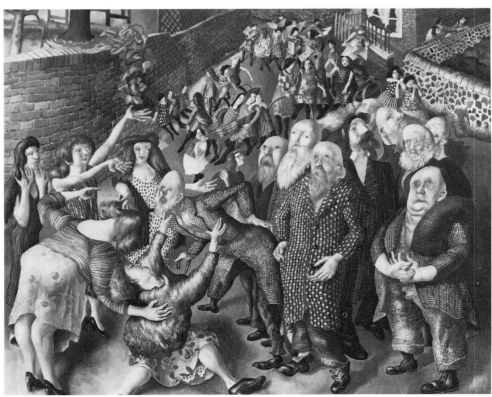

186

After completing *Adoration of Girls* (no. 185a) in autumn 1937, Spencer turned to a closely related drawing which he had made in 1935 and which was now brought to completion in *Adoration of Old Men*. Like the former picture it belongs to the *Last Judgement* series intended for the Church House, and represents Cookham on the Last Day, when the quick and the dead have been reunited in what has now become Heaven.

Here, in accordance with Spencer's belief in free and unrestrained relationships between the sexes (first expressed in *Love among the Nations* 1935, no. 155), five smartly dressed girls gather admiringly round a group of old men. In 1938 Spencer wrote: 'I only admire what is meaningful to me, this time I am the girls and I have imagined a girl who is supposed to be me and to have my feelings sexually. . . . The thing that is prompting their awe is the joy of the thought of going to bed with any of them. The disciple here is one of the girls who supports another woman who is rejoicing as the old man bends forward on to her supporting hands. She is almost fainting with the joy of the thought that she is to be alone with him.' (Tate 733.3.2). In the background young girls (who also appear in *A Village in Heaven*, no. 184), play with hoops and read illustrated papers in the street.

Spencer has left no explanation of this curious sexual transfer from man to woman, but it probably stemmed from a desire to experience (if only through his painting) the pleasures enjoyed by both sexes; in the same way that love between different nations, and numerous different partners, would become freely available after the Last Judgement. For the artist this was a furtherance of his deep childhood desire to see over a high wall into the mysterious garden beyond (see also *Zacharias and Elizabeth* 1914, no. 21), and in the painting the transition from childhood innocence to adulthood and experience (significantly a theme of Blake, whom he greatly admired) is symbolised by the young children, who are 'journeying and walking into sexual experience', which their elder sisters in the foreground are just acquiring.

EXHIBITIONS
Zwemmer Gallery, December 1937
Leeds, 1947 (46)

187 Sunflower and Dog Worship

1937
Oil on canvas
69.8 × 105.4 cm/27½ × 41½ ins
From the collection of the late W. A. Evill

Spencer's notion, expressed in *A Village in Heaven* (no. 184) and *Promenade of Women* (no. 191), of a Heaven composed of complete and all-embracing love, is further developed in a more bizarre fashion in *Sunflower and Dog Worship*. Here the artist exhibits his belief that sexuality can embrace all creation, including plants and animals. In a description of the painting written in 1937, he wrote: 'A husband and wife make love to the sunflowers in their own gardens. The husband holds the wife's bag so she can do it better. On the left top corner a girl and a woman are adoring a dog . . .' (Tate 733.3.1). Later Spencer told Wilfrid Evill that the picture was divided into two: inside the wall are those who have achieved grace by the acceptance of his doctrine, and outside are those who have yet to be converted. 'Look at that Aberdeen dog,' the artist remarked to Evill, 'I have made him look very unhappy' (Brighton, 1965, no. 211). The dogs may have been influenced by David Low's cartoon in *Political Parade*, a copy of which he was given in the early thirties (see also no. 274).

The painting is Spencer's most extreme expression of his belief in universal love, and is the forerunner of the 'married couples' series of *The Beatitudes of Love*. In these, however, his ideas are expressed in a more covert manner.

EXHIBITION
Brighton, 1965 (211), as *The Sunflower Worshippers*
REFERENCE
E. Rothenstein, 1945, pl. 59

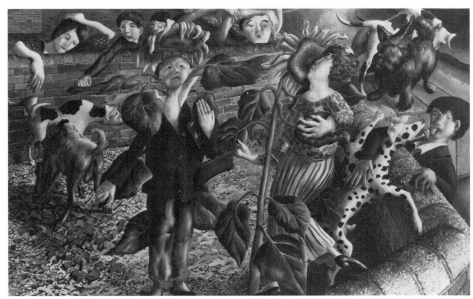

187

The Beatitudes of Love

The *Adorations* group of paintings (see no. 186) of 1937 had shown Spencer making a determined effort to unite sex and religion in his art. However, late in 1937 he moved briefly towards a more intensely sexually oriented group of eight pictures which he called *The Beatitudes of Love*. Beginning in 1937 with *Passion or Desire* (no. 188), he produced seven paintings in the series before he left Cookham to stay with the Rothensteins in October 1938. These paintings belong to the *Cana* series for the Church House and may be seen as a radical development of the earlier *Domestic Scenes* (nos. 161–7). They were intended for small cubicles off the side aisles of the Church House which were to contain street scenes such as the *Promenade of Women* (no. 191) and *A Village in Heaven* (no. 184). The cubicles were to be private spaces where 'the visitor could go and meditate on the sanctity and beauty of sex' (Gormley, p. 29).

These pictures were painted at a time when Spencer had recently separated from Patricia Preece (see no. 137), and was facing the disastrous consequences of his financial profligacy (see no. 189). He was also badly depressed and, as he was to do again at Adelaide Road in 1939, he retreated into the imaginary world of his paintings. These took on a reality which freed him from the immediate problems of everyday existence: 'You must remember that a picture is a real live thing', he confided to his diary in 1955 (Gormley, p. 29). To assist this impression Spencer invented names and occupations for the characters in the *Beatitudes* paintings. In *Romantic Meeting* or *Nearness* 1938 (104.1 × 50.1 cm/41 × 20 ins, National Gallery of New Zealand), the couple are a 'servant girl and husband' (Tate 733.3.3), and the pair in *Passion or Desire* (no. 188) are called 'Charley and Bertha' (*ibid.*). In some cases the picture has a lengthy story attached describing the couple's encounter, an indication of the importance which Spencer attached to the union of his painted and written work.

In the paintings all the couples are in a state of sexual excitement, and in their overwhelming love for each other they are, as Gormley has explained, 'perfect examples of marriage as a prayer to God – the threshhold both of redemption and mystical union with each other' (Gormley, p. 30). As such the couple becomes a single perfect unity: 'Each of the pictures shows', Spencer wrote, 'the twinned and unified soul of two persons. The composition turns the two into one person and becomes a single organism' (M. Collis, p. 141). The sexual encounters of the couples symbolise not only the means of achieving a harmonious life, but also life itself. As such the paintings are Spencer's personal statement of a philosophy for life which he had been developing since 1932.

The composition of the paintings is significantly different from the earlier 1937 works. Where the *Adorations* paintings and *Love on the Moor* 1937–55 (nos. 186 and 267) had been carefully associated with specific parts of Cookham, *The Beatitudes* are set against plain backgrounds. Instead the works are held together entirely by the inter-related forms of the 'couples'. As Gormley has remarked, 'the people and the emotion between them are sufficient' (p. 30). This is a new departure for Spencer, for whom the associations of place had played a crucial role in his painting from his earliest works. The idea was to continue in the 1939 *Christ in the Wilderness* series (nos. 194–201), in which the landscape provides an anonymous symbolic background to the central activities of Christ.

The Beatitudes of Love were Spencer's most radical excursion into the realm of sexual imagery. Faced with the difficulty of selling or exhibiting these pictures, he was forced to return to more recognisable religious subjects through which to express his ideas. While many of these later paintings are more readily comprehensible, they often lack the inventiveness and inner tension which is evident in Spencer's work of the thirties.

REFERENCES
M. Collis, 1962, pp. 141–9
L. Collis, 1972, pp. 72, 75, 105, 106, 108, 109
Robinson, 1979, pp. 55, 60, 61

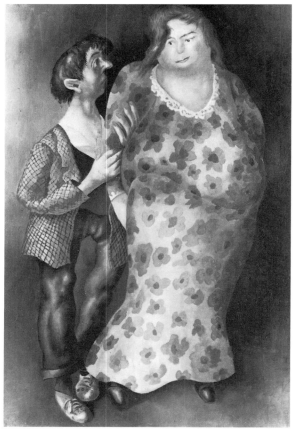

188

188 The Beatitudes of Love: Passion or Desire

1937
Oil on canvas
76.2 × 50.8 cm/30 × 20 ins
Lent by Lord Walston

This picture, the first of the *Beatitudes* series, was the only one to be completed in 1937. Spencer identified the couple as 'An Office Boy and His Wife', and continued, 'I love the way he holds her. He does not care how he holds her or where or what part of her so long as he has got hold of her. He would hold onto her bootlace with the same pleasure' (Tate 733.3.3, *c*. 1938). In keeping with the theme of spiritual integration between the couples the artist explained: 'He is giving himself to her so that part of his flesh become parts of her flesh every day' (Gormley, p. 30). The image of the small man dwarfed by the massively distorted woman has its origins in paintings such as *On the Landing* (no. 165) and *At the Chest of Drawers* (no. 166), belonging to the *Domestic Scenes* of 1935–6, in which the tiny figure is juxtaposed to the heavy forms of Hilda and Elsie.

Spencer's serious approach to these paintings was hampered by the curious imagery and the decidedly ugly and malformed characters which inhabit these paintings of a sensual paradise. This provoked misunderstanding even among old patrons like Sir Edward Marsh, who saw one of the *Beatitudes* paintings at Tooth's: 'It fogged his monocle,' the artist later recalled, 'He had to keep wiping it and having another go. ''Oh Stanley, are people really like that?'' I said: ''What's the matter with them? They are all right aren't they?'' ''Terrible, terrible, Stanley!'' Poor Eddie.' (M. Collis, p. 144). Reactions like this were a contributing factor to the new direction which Spencer's painting took in 1939.

EXHIBITIONS
Leicester Galleries, 1942 (38)
British Council, European tour, *Twelve Contemporary Painters*, 1948–9
Tate Gallery, 1955 (48)

REFERENCES
Studio, 147, 1954, p. 39
M. Collis, 1962, pp. 141, 144–5, 245
E. Rothenstein, 1962, pl. 10
L. Collis, 1972, pp. 107–8
Robinson, 1979, p. 55, pl. 44

189 The Beatitudes of Love: Worship

[repr. in colour on p. 153]
1938
Oil on canvas
91.4 × 73.7 cm/36 × 29 ins
From the collection of the late W. A. Evill

This painting, together with *Contemplation* (no. 190), differs from the other works in *The Beatitudes of Love* series in being slightly larger, and containing several figures instead of the usual pairs (see no. 188). The subject of the painting, the relationship of husband and wife, remains the same except that here the polygamous ideas which Spencer had expressed in the 1937 *Adorations* pictures (see no. 186) have been briefly revived.

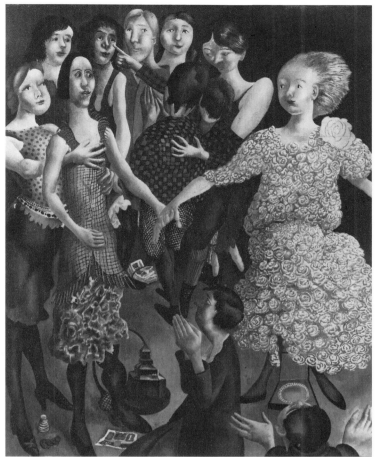
189

In the picture two small men kneel in positions of worship before a group of smartly dressed girls. On the ground before them are piled gifts of money, jewellery and a vast perfume bottle, presented like the offerings of the Wise Men at the birth of a new era of sexual and spiritual freedom. These offerings, together with the obsessive concentration on dress apparent in the picture, recall Spencer's relationship with Patricia Preece which began in 1932 and ended in separation shortly after their marriage in 1937. Fascinated by her evident glamour, and at the same time terrified of losing her, Spencer had bought her £1500 worth of clothing and jewellery, mostly at expensive Bond Street shops, during the course of 1935–6 (M. Collis p. 120). He also took great delight in seeing her smartly dressed, a pleasure which is reflected in his writings of the period and in the parade of elegantly dressed women who pass through his paintings of the thirties. The small size of the Spencer-like figures in this and other paintings of the *Beatitudes* series reflects both the artist's short stature and his appraisal of the nature of the relationship between the men and women in the paintings. The painting is the last in which Spencer's relationship with Patricia Preece plays a significant role.

EXHIBITIONS
Leicester Galleries, 1942 (37)
Brighton, 1965 (210)

REFERENCE
M. Collis, 1962, p. 141

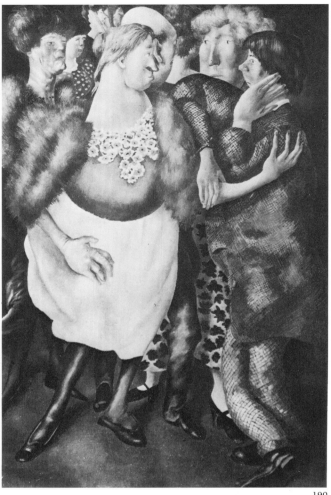

190

190 The Beatitudes of Love: Contemplation

1937
Oil on canvas
91.4 × 61 cm/36 × 24 ins
Lent by the Stanley Spencer Gallery, Cookham

In the picture 'a husband and wife and others . . . are engaged in contemplation of each other, as if expressed by their rapt gaze, as though they would never stop looking' (M. Collis, p. 141). The picture may be compared to *Worship* (no. 189), the only other painting in the series which includes figures other than the married couple.

The *Beatitudes* are the most extreme examples of distortion in Spencer's work. Distortion has been seen before, as early as *Apple Gatherers* (no. 15) of 1912, but the forms have never been so exaggerated and unreal. Elements like the hands, faces and feet in *Contemplation*, or the discrepancy in the size of the breasts in *Passion* or *Desire* (no. 188), mark a change in Spencer's pictures from more naturalistic works like the *Domestic Scenes* (no. 162). In part this arose from Spencer's use of his own hands and arms as models; and because he drew each section of the anatomy separately, without reference to the next part, as if 'seeing things for the first time . . .'

(Gormley, p. 32). Distortion increased when Spencer worked entirely from his imagination as he did in the *Beatitudes*. Composition was based upon 'feeling and desire' (Gormley, p. 33), which governed the form the figures were to take. Direct observation from the model would result only in a mechanical image, as it did in the landscapes, devoid of the inner vision which was central to Spencer's art. Hence his comment: 'I do myself love the "disagreeably abnormal" persons in these paintings in the same way as I love my home or whatever my feeling has fixed upon, so I love them from within outwards and whatever that outward appearance may be it is an exquisite reminder of what is loved within, no matter what that exterior appearance may be' (letter to Hilda from Glasgow, 1944, Tate 733).

EXHIBITIONS
Worthing, 1961 (15)
Arts Council, 1976–7 (36)

REFERENCES
M. Collis, 1962, pp. 141, 144–5
L. Collis, 1972, p. 108
Robinson, 1979, pp. 55, 60, pl. 45

191 Promenade of Women *or* Women Going for a Walk in Heaven

[repr. in colour on pp. 156–7]
1938
Oil on canvas
45.1 × 229.8 cm/17¾ × 90½ ins
Lent by the Maclean Gallery

The painting belongs to the *Adorations* group of pictures which formed an important part of the *Pentecost* and *Cana* series for the Church House, *Last Judgement* scheme. In 1938 the artist noted that the picture belonged to the 'same frieze' as *A Village in Heaven* (no. 184) (Tate 733.3.2). From this it is clear that the promenade takes place after the redemption of Cookham by the disciples. The village has now become part of Spencer's earthly Paradise.

In the painting men and women walk through the streets of the newly redeemed village, and go into 'ecstacy upon seeing the crucifixes' (*ibid.*) displayed by the disciples in the left and centre of the picture. The promenade is not aimless for they are also on their way to the marriage at Cana. In keeping with Spencer's conception of the calm everyday nature of the Last Day, a smartly dressed mother slips the door-key under the mat whilst her daughter pulls the door to.

Like the *Adoration of Girls* 1937 (no. 185a), the picture expresses Spencer's belief in the universal nature of free love, and his desire to live with more than one woman at a time: 'I have used each woman as a comment on the one coming next to her,' he wrote in 1938 (*ibid.*); 'They form a sentence, a statement of my feeling for women in general. Each woman is the instrument of my love-making to the other. . . . I had great joy in painting this . . . picture because painting each girl was like suddenly meeting them and talking to them and living with them.'

The picture was completed in January 1938, shortly after

Spencer had begun the *Beatitudes* series (nos. 188–90). According to a note made shortly afterwards (Tate 733.3.2), a second picture, *Promenade of Men*, was planned but never executed.

EXHIBITIONS
New York, World's Fair, 1939
Leeds, 1947 (55)

REFERENCES
E. Rothenstein, 1945, pp. 18, 24, pl. 66 (detail)
M. Collis, 1962, p. 140

192 Landscape in North Wales

1938
Oil on canvas
55.9 × 70.7 cm/22 × 27⅞ ins
Lent by the Fitzwilliam Museum, Cambridge

In August 1928 Spencer heard that Hilda and her mother were staying in North Wales, near Snowdon, at the house of a friend, Mrs Johnson. At this time he had not seen Hilda since painting her portrait (no. 182) at Hampstead a year before, and so he set out to join them, arriving in Wales some time before 7 September. By 14 October he was back in Cookham, bringing with him at least two landscapes which he had painted in Wales: *Landscape in North Wales*, and *Snowdon from Llanfrothen* (National Museum of Wales).

EXHIBITIONS
London, National Gallery, *British Painting Since Whistler*, 1940 (131)
Redfern Gallery: *Collection of Paintings formed by the late Maurice Ingram*, 1941 (40)
Arts Council, 1976–7 (38)

192

193 Magnolia

1938
Oil on canvas
54.6 × 63.5 cm/21½ × 25 ins
Lent by a Private Collector

Spencer painted this picture in the spring of 1938. On 5 April he wrote to tell Dudley Tooth that it was 'as good as anything I have done'. He was still working on it on 21 April, and the finished painting was immediately purchased by the present owner.

193

The Christ in the Wilderness Series 1939

In December 1938, after a visit to Malcolm MacDonald, Spencer moved into a room in 188 Adelaide Road, near Swiss Cottage, in London, not far from his friends the Rothensteins and Hilda Carline. It was here, in an atmosphere of peace and solitude which he had not experienced since before the war, that he composed and drew the *Christ in the Wilderness* series, and painted four of the final total of nine canvases which he derived from the designs.

By 1937 the crisis in Spencer's relationship with Patricia was echoed by a similar one in his art, in which the sexual element in his work seemed to be crowding out the powerful religious feeling which had guided his work up to the early 1930s. Now, living at Adelaide Road, he began a 'mental struggle' to regain the old unconscious ('no control') ease with which he had painted *Zacharias and Elizabeth* 1914 (no. 21) and the other early pictures.

The first result of this intense period of meditation, when he would retreat to bed to write in his notebooks, was a return to the Bible for inspiration. The years 1932–9 had, he felt, brought about 'a split in my feeling', which had 'drawn me too much one way [towards sexual subject matter].' The *Christ in the Wilderness* series was designed to redress the balance though, as Gormley has pointed out (Gormley, p. 50), they tend to emphasise the divergences between the sacred and profane rather than draw them

together. As Spencer commented: 'In these *Christ in the Wilderness* series hardly anything of the new stimuli that went into the making of the 1932–9 composition is present or used.'

Like most of the figure pictures which Spencer painted after 1932, the *Wilderness* series was intended to form a part of the Church House in Cookham. In reading one of the Gospels he had been attracted by the idea of Christ being led by the Spirit into the Wilderness, and tried to imagine what had happened to him there (written 2 November 1946). Remembering the chancel ceiling in Cookham church which is broken up into a chequer-board pattern, Spencer divided up a page in his notebook into forty squares, representing the forty days Christ spent in the Wilderness, and also considered, but rejected, a larger central panel depicting the Temptation. In the event of the Church House remaining unbuilt, he planned a small 'mantelpiece shrine' as an alternative, containing one picture which would be changed (like a calendar) on each day in Lent (Tate 733.3.62).

Spencer's original drawings for the scheme have survived (Tate 733.3.76) and they show that he first drew out the forty *Wilderness* scenes in a block, each picture being some $\frac{3}{4}$ in square. These were then taken and drawn up in greater detail in the same notebook before they were transferred to eighteen imperial sheets (now in a Private Collection), of which he felt that only seven were sufficiently satisfactory to make into paintings (this was later to rise to nine). The chosen drawings were then transferred, with only small changes to emphasise their expressiveness, on to the canvases; four of these were painted at Adelaide Road and the others, *Rising in the Morning*, *Crossing the Ravine*, and *The Eagles* were painted in 1940, 1942 and 1943, and *The Hen* in 1954. Another (untitled, Private Collection), remains incomplete.

The sources for the *Wilderness* pictures were the Gospels but, as Gormley points out, Spencer did not illustrate a specific subject, but used the biblical event only as the 'occasion' for the scenes which were often inspired by events which were closer to home – for instance *Crossing the Ravine* was drawn from a recollection of a ravine he had seen in Macedonia in 1917, and the sight of Shirin (his daughter) as a baby plucking wild flowers was the origin of *Consider the Lilies*. The religious element in these paintings is therefore made up of the relationship of simple events, devoid of the earlier sexual impulses, in which Spencer, virtually a recluse in his room in Adelaide Road, strongly identified himself with the equally isolated struggle of Christ. As he confided to his 1946 diary: 'The great adventure that Christ had all by himself with leaves, trees, mud and rabbits' was the equivalent of Spencer's experience in Adelaide Road, 'among two chairs, a bed, a fireplace and a table. . . . I was as it were in a wilderness.'

Stylistically, the *Wilderness* paintings follow Spencer's spiritual search for a pre-1932 innocence, back to the Giottesque style of paintings like the 1921 *Christ Overturning the Money Changers' Table* (no. 61), in their trend towards a simplicity and calm which had been absent in the paintings of 1932–7. At least in the earliest works in the series (*The Foxes*, *Consider the Lilies* and *The Scorpion*) he achieved a carefully balanced composition of large, simple, rounded forms and a centrally focused image quite different from the diffuse forms of pictures painted two years before (see no. 186). In *Foxes*, for example, the design is based on the two triangles formed by the body of Christ and the foxes in their holes, and *Rising in the Morning* is a circular design in which the forms rise like the petals and sepals of a flower, thereby combining the abstract formal quality of the composition with the inherent spiritual message which Spencer hoped to convey. In the later pictures, particularly *The Eagles* and *Crossing the Ravine*, some of the intensity of this image tends to break down into a horizontal or diagonal format, an effect which is exacerbated by the additional detail which again crowds in.

The *Christ in the Wilderness* series was an isolated event in Spencer's life, inspired by the unique situation in which he found himself at Adelaide Road. Several years later he summed up his feelings about that period, and described the revival which had taken place and which is expressed so eloquently by his paintings: 'I felt there was something wonderful in the life I was living my way into, penetrating into the unknown me. . . . I loved it all because it was God and me all the time.'

194 Christ in the Wilderness: The Foxes have Holes

1939
Oil on canvas
56 × 56 cm/22 × 22 ins
Lent by a Private Collector

The painting illustrates Matthew 7:20:

'And Jesus saith unto him, the foxes have holes
and the birds of the air have nests;
but the Son of man hath not where to lay his head.'

EXHIBITIONS
Leicester Galleries, 1942 (20)
Leeds, 1947 (56)
Arts Council, Festival Exhibition, *British Painting 1925–50*, 1st Anthology, 1951 (54)
Tate Gallery, 1955 (52)
Stanley Spencer Gallery, Cookham, 1963–4 (7)

REFERENCES
E. Newton, 1947, pl. 15 (in colour)
L. Collis, 1962, pp. 153–9, repr. facing p. 144
Robinson, 1979, p. 64

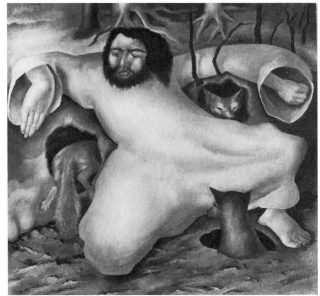

194

195 Christ in the Wilderness: He Departed into a Mountain to Pray

1939
Oil on canvas
56 × 56 cm/22 × 22 ins
Lent by a Private Collector

The painting illustrates Mark 6:46:

> 'And when he had sent them away,
> he departed into a mountain to pray.'

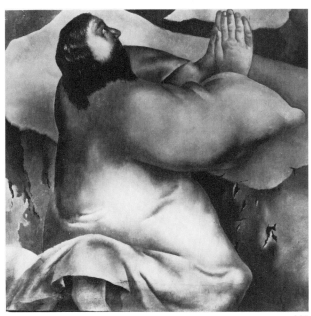

195

EXHIBITIONS
Leicester Galleries, 1942 (21)
Leeds, 1947 (57)
Tate Gallery, 1955 (53)
Stanley Spencer Gallery, Cookham, 1963–4 (8)

196 Christ in the Wilderness: The Scorpion

1939
Oil on canvas
56 × 56 cm/22 × 22 ins
Lent by a Private Collector

The painting is taken from Luke 10:19:

> 'Behold, I give unto you power to tread on serpents
> and scorpions, and over all the power of the enemy:
> and nothing shall by any means hurt you.'

This is one of the simplest and most deeply moving of the Wilderness paintings. In keeping with his distaste for violence Spencer has chosen to interpret the verse from St Luke by its last line '. . . and nothing shall by any means hurt you'. Instead of crushing the scorpion Christ holds it in his gently cupped hands, while the creature curves its tail in impotent fury.

In a 1946 notebook Spencer commented matter-of-factly: 'Although there are none about I feel this is Christ giving the once-over to the fleas and bugs and lice department'.

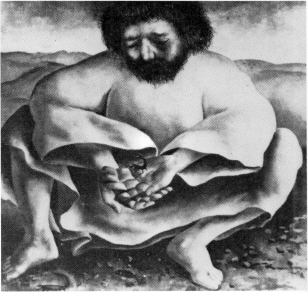

196

EXHIBITIONS
Leicester Galleries, 1942 (22)
Paris, Musée d'Art Moderne, UNESCO, Exposition d'Art Moderne, 1946 (54)
Leeds, 1947 (58)
Arts Council and Edinburgh University Art Society, Contemporary British Painting, 1949 (37)
Arts Council, Festival Exhibition, British Painting 1925–50, 1st Anthology, 1951 (54)
Tate Gallery, 1955 (54)
REFERENCES
E. Newton, 1947, pp. 11, 12, pl. 17 (in colour)
R. Ironside, Painting since 1939, Edinburgh 1947, pl. 11
L. Collis, 1962, pp. 153–9
Robinson, 1979, pl. 51

197　Christ in the Wilderness: Consider the Lilies

1939
Oil on canvas
56 × 56 cm/22 × 22 ins
Lent by a Private Collector

The painting illustrates Matthew 6:28–9:

> 'And why take ye thought of raiment? Consider the lilies of
> the field, how they grow; they toil not, neither do they spin:
> And yet I say unto you, that even Solomon in all his glory
> was not arrayed like one of these.'

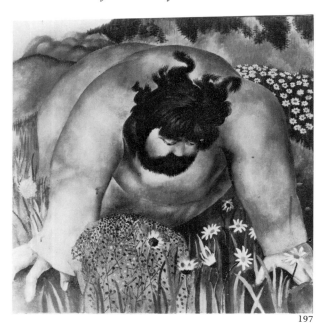

197

The complicated chain of thought set off by Spencer's reading
of the Bible is very evident in the short commentary which he
wrote in the 1950s: 'It was a longing to be in some way
associated with the flowers. One can say why not just consider
them? and pass on. We all admire them; No, the marsh
meadows full of them, leaves one with an aching longing. And
in my art that longing was among the first I sought to satisfy.
The detail on the left of the Cookham *Nativity* 1912 [no. 10]
celebrates my marriage to the Cookham wild flowers. . . .
Because we in a way re-create, we further creation, we can
somehow feel what it was. . . . And I remember Shirin [his
daughter] when she was a baby kneeling down on all fours
gazing into the long grass. From a sketch of this memory I did
Christ considering the Lilies' (Tate 733.3.62).

EXHIBITIONS
Leicester Galleries, 1942 (23)
Leeds, 1947 (59)
Tate Gallery, 1955 (55)
Stanley Spencer Gallery, Cookham, 1963–4 (10)

REFERENCE
Robinson, 1979, pl. 52

198　Christ in the Wilderness: Rising from Sleep in the Morning

1940
Oil on canvas
56 × 56 cm/22 × 22 ins
Lent by a Private Collector

The painting is taken from Luke 15:18:

> 'I will arise and go to my Father.'

Spencer explained this picture as an attempt 'to get some vital
relationship not between Christ and people, but between Christ
and all the accidentals of nature. He feels the shape of the sort of
ditch he is sitting in' (Tate 733.3.62, written in 1946). In order
to create this analogy of Christ's one-ness with his environment,
Spencer spread out his garment in such a way that it conforms
with the rough shape of the pit. This in turn combines to create
the petals and sepals of a massive 'flower' design. At this date
the artist was considering similar patterns in a series of early
studies for *Christ Preaching at Cookham Regatta* (see no. 213).

EXHIBITIONS
Leicester Galleries, 1942 (24)
Leeds, 1942 (60)
Tate Gallery, 1955 (56)
Stanley Spencer Gallery, Cookham, 1963–4 (11)

REFERENCE
Studio, 1943, vol. 126, p. 51, repr.

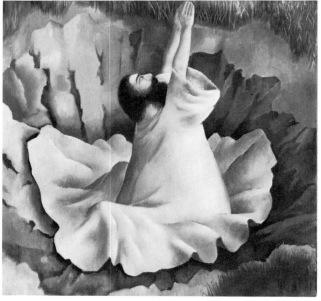

198

199　Christ in the Wilderness: Driven by the Spirit into the Wilderness

1942
Oil on canvas
56 × 56 cm/22 × 22 ins
Lent by a Private Collector

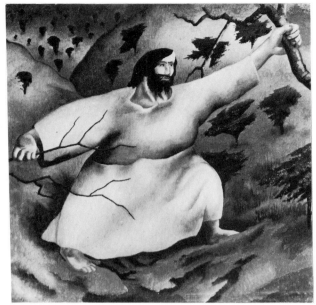

199

The picture illustrates Mark 1:12:

'*And immediately the Spirit driveth him into the wilderness.*'

EXHIBITIONS
Leicester Galleries, 1942 (25)
Leeds, 1947 (61)
Tate Gallery, 1955 (57)
Stanley Spencer Gallery, Cookham, 1963–4 (14)

200 Christ in the Wilderness: The Eagles

1943
Oil on canvas
56 × 56 cm/22 × 22 ins
Lent by a Private Collector

The picture illustrates Matthew 24:28:

'*For wheresoever the carcase is,
there will the eagles be gathered together.*'

In 1946 Spencer wrote of the drawings for *The Eagles* and *The Hen*: 'These last two have not quite the character of the other two groups. I may have done them later and not at 188 [Adelaide Road].' As the artist never dated his drawings it is impossible to ascertain if he was correct in concluding that the two drawings were of a later date, but both scenes do adopt a new horizontal composition with Christ shown reclining on his side. The change of mood which Spencer senses is particularly evident in the grisly *Eagles*, where the birds peck at the carcase of a dead animal, and Christ gazes over his shoulder. The pessimistic mood of the picture is given added emphasis in the broken branch in the background, echoing the outline of the figure.

Spencer painted the picture while staying at 'Quinney's', the house attached to 'Lindworth', with his cousin Bernard Smithers.

EXHIBITIONS
Leeds, 1947 (62), pl. 7
Tate Gallery, 1955 (58)
Stanley Spencer Gallery, Cookham, 1963–4 (15)

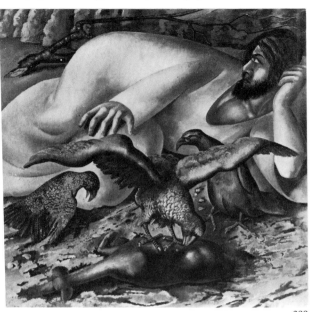

200

201 Christ in the Wilderness: The Hen

1954
Oil on canvas
56 × 56 cm/22 × 22 ins
Lent by a Private Collector

This painting is taken from Matthew 23:37:

'*. . . how often would I have gathered my children together,
even as a hen gathereth her chickens under her wings. . . .*'

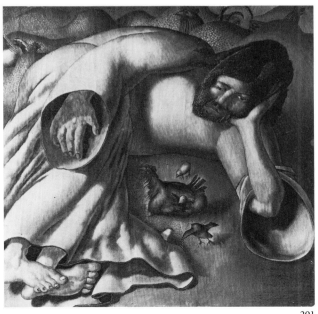

201

Spencer completed this picture sixteen years after the original drawings were made at Adelaide Road. During this time his painting style had changed very little, and apart from a harder, more detailed surface which is evident in the painting of Christ's hair and beard, there is nothing to distinguish the painting from those completed in the thirties and early forties. The curious device of the hand tucked inside the broad opening of the sleeve is a more exaggerated version of a similar idea which appears in *The Foxes* of 1939 (no. 194).

EXHIBITIONS
Tate Gallery, 1955 (59)
Stanley Spencer Gallery, Cookham, 1963–4 (16)

202 Self-Portrait

1939
Oil on canvas
39.6 × 55.2 cm/15⅝ × 21¾ ins
Lent by the Fitzwilliam Museum, Cambridge

In this painting Spencer adopted an unusually elaborate pose, with his brush raised and palette tilted towards the viewer, in what may be a reference to the traditional old master self-portrait. The intimate nature of the picture, with the figure crowded against the picture plane and a rumpled bed in the background, relate this composition to the 1936–7 *Self-Portrait with Patricia* (no. 173).

Gilbert Spencer has pointed out that the artist was holding the brush in his left hand. Spencer was not left-handed and his brother suggested that the contradiction was caused by the use of a single mirror (letter from Gilbert Spencer to Fitzwilliam Museum, June 1971).

EXHIBITIONS
Leicester Galleries, 1942 (16), repr. on cover
Stanley Spencer Gallery, Cookham, 1965
Cambridge, Kettle's Yard Gallery, *Opening Exhibition*, 1970 (7)
Arts Council, 1976–7 (39)

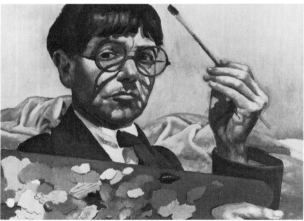

202

203 The Vale of Health, Hampstead

[repr. in colour on p. 155]
1939
Oil on canvas
60.9 × 81.3 cm/24 × 32 ins
Lent by Glasgow Art Gallery and Museum

Spencer painted the picture while staying with George and Daphne Charlton at 40 New End Square, Hampstead, in 1939. He was already familiar with the Vale of Health, having lived and worked there from 1923 to 1927, in the studios at the top of the Vale Hotel. Here, in a studio loaned to him by Henry Lamb, and later in another rented for him by the Behrends, he painted *The Resurrection, Cookham* (no. 89) and the first canvases for Burghclere. Between 1925 and 1927 the artist shared the studio with Hilda Carline, whom he married in January 1925.

Perhaps because of these associations Spencer took considerable care over this painting, and avoided the thinly-painted passages which had spoiled other landscapes of the late 1930s. The elevated viewpoint adopted in the painting may be compared with *Gardens in the Pound, Cookham* 1936 (no. 175).

EXHIBITION
Glasgow Institute, 1940–41 (497)

REFERENCE
Studio, 1940, 120, p. 103

204 The Woolshop

1939
Oil on canvas
91.5 × 61 cm/36 × 24 ins
Lent by a Private Collector

In July 1939 Spencer travelled with George and Daphne Charlton to the White Hart Inn, Leonard Stanley, Gloucestershire. Here he was given a large front room where, for the first time since he had lost his studio at 'Lindworth' in 1938, he was able to paint large-scale pictures. These were later to include the first of the *Shipbuilding* series. He also began the series of pencil studies in the 'Derwent' sketchbooks, later known as the *Scrapbook* drawings (see no. 207). Some of these were intended as studies for paintings destined for the Church House, including a number of scenes drawn in and about Leonard Stanley and Stonehouse. These show Spencer and Mrs Charlton on their rambles round the village. Spencer later intended these to form the basis of a 'chapel' dedicated to Mrs Charlton which was to join others for Hilda, Elsie the maid, and another woman, belonging to the Church House. Of the *Scrapbook* 'Daphne' compositions only four, including *The Woolshop*, were actually painted.

The picture recalls a visit which Spencer and Mrs Charlton made to a shop in nearby Stonehouse, an event which he later recalled in a notebook: 'Stonehouse had several of these small local shops such as I remembered years ago in Cookham. I think the Cookham ones must have imigrated there. The girl [Daphne] is matching some wool against her jumper. To the left one can see some sort of structure on which small rugs are hung. This stood at the entrance to the shop and we had to turn left or right to enter' (Tate 733.8.79, *c*. 1945).

Both the small male figures in the picture represent Spencer who reappears several times in the painting, as he does in *Love on the Moor* 1937–55 (no. 267).

The artist's growing love of abstract designs is evident in the cascading coils of wool and the 'op-art' skirt worn by Mrs

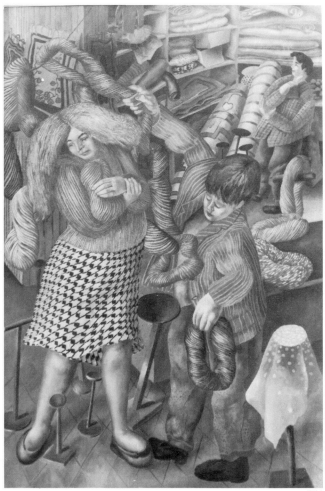

204

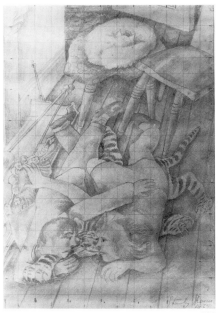

205

A study for the painting *Tiger Rug* 1940 (canvas, 91.4 × 60.9 cm/36 × 24 ins, Private Collection). In the picture Spencer and Daphne Charlton lie on a tiger rug before a fire; behind them a cat sleeps curled on a stool. Spencer probably made the drawing at the White Hart Inn, Leonard Stanley, Gloucestershire, where he stayed with the Charltons from 1939 to 1940.

The artist later noted: 'How wonderful would *Tiger Rug* be as a Resurrection picture. The rug would symbolise the man's and the woman's discarded shrouds. The paws would become sleeves and pyjama trousers, the tiger's head a stone carving of the woman's face. Their rapt staring at each other would be the rapt staring of two people awakening in paradise. How near is the meaning of Resurrection and of sexual union?' (quoted by M. Collis, p. 162). Spencer doubtless had in mind the newly resurrected couple kneeling in the foreground of *The Glasgow Resurrection* 1947–50 (no. 242) when he made this analogy. The drawing, however, was intended as part of a series celebrating the intimate domestic events of Spencer's relationship with Daphne (see also no. 212).

EXHIBITIONS
Leicester Galleries, 1942 (54)
Arts Council, 1976–7 (68)

Charlton. Spencer often copied similar clothing patterns from advertisements in *Picture Post*. These formal elaborations were to reach their height in the later *Shipbuilding* pictures, in particular *Riggers* (no. 222), where the ropes festooning the workshop are the successors to the coils of wool in *The Woolshop*.

The picture was derived with minor changes from the *Scrapbook* drawing (Leder, 8). An intermediate study was exhibited at the Leicester Galleries, 1942 (52), dated 1939.

EXHIBITIONS
Leeds, 1947, (64)
Worthing, 1961 (19)
Plymouth, 1963 (34)
Arts Council, 1976–77 (40)

REFERENCES
E. Newton, 1947, pl. 27 (in colour)
M. Collis, 1962, pp. 163, 246

205 Study for Tiger Rug

1939
Pencil on buff paper
40.1 × 27.3 cm/15⅞ × 10¾ ins
sdbr. 'Stanley Spencer 1939', inscrev. '3241/Study for Tiger Rug'
Lent by the Visitors of the Ashmolean Museum, Oxford

206 Cottage Garden, Leonard Stanley

1939
Oil on canvas
50.8 × 76.2 cm/20 × 30 ins
Lent by Sir Antony and Lady Hornby

This is one of at least five landscapes done by Spencer while staying with George and Daphne Charlton at the White Hart Inn, Leonard Stanley, Gloucestershire. The picture was completed by 6 October 1939, when he reported that he had three landscapes ready to be sent to London. These included

206

Old Tannery Mills (59 × 89.5 cm/23¼ × 35¼ ins, Birmingham City Art Gallery) and *Walled in Gardens*, which was Spencer's provisional title for the present picture. The artist had first begun to paint houses and gardens in 1926 when he painted *The Red House* (Private Collection) at Wangford, the village in which he had married Hilda Carline the previous year.

EXHIBITION
Leicester Galleries, 1924. The painting may be the picture referred to as *'Leonard Stanley'* (42)

207 Couple Drawing Each Other, Stan and Mary

Volume I, p. 31, 1939–43, Leder 27
Pencil on paper,
approx. 40.6 × 28 cm/16 × 11 ins
s. 'Stanley Spencer'
Lent by Thomas Gibson Fine Art Limited

This drawing and nos. 208, 209 and 210 belong to the *Scrapbook* series of pencil studies made in four 'Derwent' scrapbooks purchased at the stationers in Leonard Stanley in 1939. The main body of these drawings, published by Carolyn Leder as *Stanley Spencer, The Astor Collection*, Thomas Gibson Publishing Ltd., London 1976 (limited edition, 950 copies), belong to the Church House, *Last Day* scheme. Most are related to Spencer's growing interest in a series of four 'chapels' (later increased to five) dedicated to Hilda, Patricia Preece, Daphne Charlton, and Elsie. Each of these series of drawings illustrates events in their relationships which were symbolic to Spencer. The artist explained the motives behind the drawings in an essay for *The Saturday Book*, October 1946, called 'Domestic Scenes': 'In 1939 I began a new series of compositions. . . . The series came about as a result of my wish to become clear in some notion I had concerning the Last Day. My art . . . is a home-finder, for me a nest maker. It goes to prepare a place for me. In each of these drawings I approach heaven by what I find on earth. What is in my life and around me leads me to such hopefulness that I feel the happenings of the village are of heaven if not heaven itself. . . . When I see an ordinary circumstance I seem to see the whole of which it forms a part. . . . All ordinary acts such as sewing on a button are religious things and a part of perfection. . . . When I am composing these ordinary scenes I am seeing them in this redeemed and after resurrection and Last Day state'.

Spencer used the scrapbooks between 1939 and 1949, including, among the more intimate domestic studies, drawings for the *Port Glasgow Resurrection* series (see no. 244). The books provided a fruitful source of painting compositions until 1957 when Spencer painted *The Bathing Pool, Dogs* (no. 274, Leder 49).

The drawing shows the artist making a portrait of Mary (unidentified). Spencer and Hilda had drawn each other in a similar manner at Burghclere.

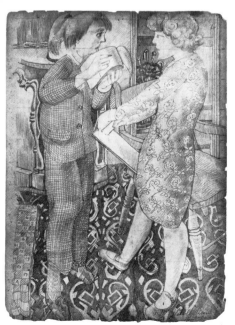

207

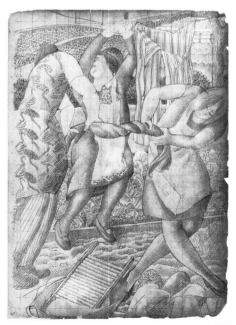

208

208 Wringing Clothes

Volume II, P. 35, 1943–44, Leder 63
approx. 40.6 × 28 cm/16 × 11 ins,
squared for transfer
s. 'Stanley Spencer', and insc. 'panel in servants hall
scheme, Chapel View'
Lent by Thomas Gibson Fine Art Limited

In this scene Hilda and the Swiss nurse Miss Herren wring clothes in the garden of 'Chapel View', Burghclere, while in the background Elsie the maid hangs a pair of pyjamas on the clothes-line.

The inscription indicates that the scene was originally intended for a panel in the Church House, *Marriage at Cana* series, but which was transformed in the late 1940s into the *Elsie Memorial*, an independent room in the House.

The drawing shows Spencer's interest in repetitive forms, with the two women, almost mirror images of each other, wringing out the washing, while the braced legs of the nurse repeat the twisted shape of the washing hung between them. Pattern, rarely absent from Spencer's work, is given a strange semi-independent life in the dress of the woman on the left.

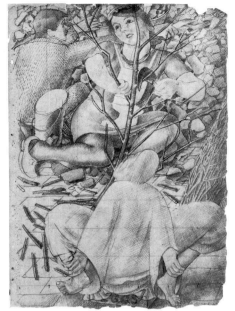

209

209 Chopping Wood in the Coal Cellar, Elsie

Volume II, January 1944–March 1945, Leder 51
approx. 40.6 × 28 cm/16 × 11 ins, squared for transfer
Lent by Thomas Gibson Fine Art Limited

This drawing, one of the finest of the *Scrapbook* series, shows Elsie the family maid chopping wood in the coal cellar. Beside her the artist himself collects coal. Squatting in front of them is a 'disciple' or 'holy-ghost' figure, whose function is to approve and sanctify the simple domestic scene. The drawing belongs to the 'Elsie Memorial' chapel in the Church House, and, according to a late plan of the room (Tate Gallery archives, 1950s), was to appear on the right-hand wall next to the 'altarpiece' on the end wall.

The idea for the drawing probably stems from memories of the twenties and thirties and is set either in 'Chapel View', Burghclere, or 'Lindworth', in Cookham, where Spencer lived from 1932 to 1938. Spencer made another fine coal-cellar drawing on a letter to Hilda in January 1942, where he explained: 'I feel I would like to continue this love letter to you darling in a picture, instead of writing, so here is me getting in the coal' (see display case). In the drawing Spencer's pose is similar to that of the disciple in the present picture, and this, together with the nearness in date, might suggest that the letter drawing (which was never posted) had brought back memories of past events. Another drawing, *Elsie Cutting Wood* (20.3 × 19 cm/8 × 7½ ins, Private Collection), dated by Tooths to *c.* 1928, was incorporated almost exactly into the picture for the figure of Elsie and the branch.

In another scrapbook drawing, *Breaking Firewood, Elsie*, (Leder, 52a), Elsie is shown with the gardener breaking branches from a tree.

210 Phyllis, Elsie's Sister, Lindworth, Cookham

Volume II, January 1943–March 1944, Leder 60 a
approx. 40.6 × 28 cm/16 × 11 ins,
squared for transfer
Lent by Thomas Gibson Fine Art Limited
insc. *recto* 'Phyllis is staying at Lindworth. In No. 6 I am taking the part of the adoring bearded me who is being adored collectively with Phyllis'. *verso*, a drawing of Hilda drying herself (Leder 60b), insc. 'The one on this page is the third of the you drying yourself. . . .'

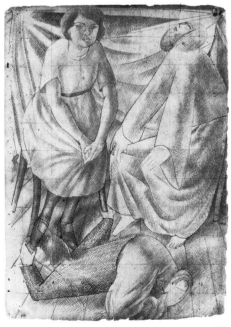

210

The drawing shows Phyllis, sister of Elsie the maid who frequently visited 'Lindworth', Spencer's home in Cookham, from 1932–38. On the floor at her feet appears Spencer himself in a pose of supplication. Seated at Phyllis's side is a 'disciple' figure who, as the inscription makes clear, is a kind of alter-ego for the artist, adding sanctity and approval to Spencer's actions. This strange figure had first been used in *The Meeting* 1933 (no. 141).

211 Village Life, Gloucestershire

[repr. in colour on p. 158]
1940
Oil on canvas
79.4 × 111.8 cm/34¼ × 44 ins
Lent by Cheltenham Art Gallery and Museum

The picture was painted in February 1940, while Spencer was staying with George and Daphne Charlton at Leonard Stanley in Gloucestershire. It belongs to the Church House, *Last Day*, series, begun after the completion of the Burghclere Chapel in 1932 (see p. 95). The exact placing of the picture within the scheme remains vague, but in a list made in the mid 1940s (Tate Gallery archives) it formed the central work in a 'room' in the Church House, called *Village Memorial*, made up of scenes commemorating Spencer's stay in Leonard Stanley with the Charltons. All of these, including *Village Life, Gloucestershire*, were to be painted from the *Scrapbook* drawings (see no. 207), which the artist had made as a record of his stay in the village in 1940. In 1948, however, this plan was changed and the painting, together with other (unpainted) scenes from the *Village Life* idea, was transferred to a new 'Chapel', called the *Daphne Memorial*, which was a more intimate celebration of his relationship with Daphne Charlton (Tate 733.2.430).

For the painting Spencer used two of the *Scrapbook* drawings, (Leder pp. 10, 13), which he reproduced with very few changes as the left and right halves of the canvas. This accounts for the very definite division of the composition into two parts.

In the picture Spencer and Daphne Charlton stand in the street watching an old man, a woman and a young girl folding up clothes which they have just taken from the clothes line. On the extreme right of the composition stands Hilda, a piece of poetic licence on Spencer's part, as she never visited Leonard Stanley. The painting has an added dimension, and is not just an idle scene of village gossip: on the *Scrapbook* drawing for the left-hand half (Leder, no. 10), Spencer wrote the following inscription: 'This no. 1 drawing of this series of . . . compositions was of an old couple witnessing the coming of God in the sky while they and a grand-child were in their garden taking in the clothes'. This explains the pointing arm of the small girl, and makes it clear that this picture too belongs to the *Last Day* idea of the Church House, in which those places which Spencer most loved were to be transformed into a kind of 'Heaven on earth'.

Of the other *Scrapbook* scenes of Leonard Stanley, Spencer was only able to paint one, *The Woolshop* (no. 204), painted in 1939, before he began to work on the Glasgow *Shipbuilding* pictures.

EXHIBITIONS
Cheltenham Festival, Cheltenham, 1964
Stanley Spencer Gallery, Cookham, loan, 1974

REFERENCE
C. Leder, *The Astor Collection*, p. 23 (see also pls. 10 and 13)

212 Daphne

1940
Oil on canvas
51 × 61 cm/20 × 24 ins
Lent by the Trustees of the Tate Gallery

212

The sitter is Daphne Charlton, an artist who had trained at the Slade School. She was married to another artist, George Charlton, who was a lecturer at the Slade. According to Spencer they met for the first time at a party given by the painter C. R. W. Nevinson, after which Spencer became a regular visitor to the Charltons' house at 40 New End Square, Hampstead. The portrait was begun when Spencer returned to London after staying with the Charltons at the White Hart Inn, Leonard Stanley, in Gloucestershire. Mrs Charlton sat to Spencer every day for two or three weeks in April 1940, wearing the hat which the artist bought for the occasion (information from the Tate Gallery catalogue, 1978, p. 664). Another portrait of the sitter, without a hat, was also painted in 1940 (Private Collection).

EXHIBITION
Tate Gallery, 1955 (61)

REFERENCES
E. Rothenstein, 1945, as frontispiece (in colour) and pl. 76 (detail)
M. Collis 1962, pp. 160–62, 246

213 Study for Christ Preaching at Cookham Regatta

1940
Pencil on paper, squared for transfer
32.5 × 40 cm/12¾ × 15¾ ins
Lent by Christopher Hill

An early drawing, later discarded, for *Christ Preaching at Cookham Regatta* (no. 279, unfinished 1959), and now in the Stanley Spencer Gallery, Cookham. In it Christ is shown surrounded by his disciples, preaching in the horse-ferry barge, which is viewed from the lawn of the Ferry Hotel. Three other disciples stand pensively in the foreground while visitors seated at the tables listen idly to the oration.

In the oil painting the ferry was moved from its mooring in the backwater to the river bank shown on the left in the drawing. The viewpoint was also changed, and the event is viewed from an elevated position on Cookham Bridge. Spencer preserved the scene on the lawn in a more elaborate composition, *Dinner on the Hotel Lawn* 1957 (no. 272).

The squared-up portion of the horse-ferry recurs in another drawing, *Christ Preaching* (10.2 × 10.2 cm/4 × 4 ins, Private Collection).

EXHIBITION
Piccadilly Gallery, 1978 (49)

214

213

214 Wisteria, Cookham

1942
Oil on canvas
63.5 × 76.2 cm/25 × 30 ins
Lent by Harris Museum and Art Gallery, Preston

Painted whilst Spencer was staying with his cousin, Bernard Smithers, at 'Quinneys', the house attached to 'Lindworth', which the artist had made over to Patricia Preece in 1937. Spencer recorded the picture's completion in a letter to Tooths in June 1942.

EXHIBITIONS
Leeds, 1947
Stalybridge, Lancs, 1957
Plymouth, 1963, (33)
Stanley Spencery Gallery, Cookham, 1979

215 Seated Nude

1942
Oil on canvas
76.2 × 50.8 cm/30 × 20 ins
Lent by Lord Walston

This is the only picture which Spencer painted of his first wife

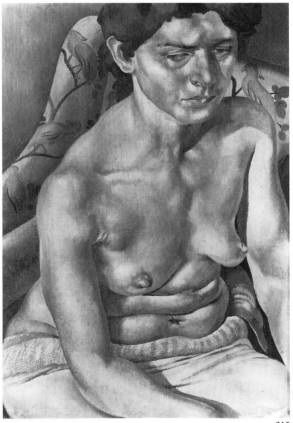

215

Hilda from the nude. It was painted from a drawing of
c. 1929–30, six years after their separation. In the late 1930s the
artist wrote of his wish to paint a series of nudes of Hilda
parallel to those which he had made of Patricia Preece between
1935 and 1937 (see nos. 158–159). They include the *Nude* (no.
159), which shows Patricia in a pose similar to that of Hilda in
the present picture.

The reserved, almost academic nature of the painting,
already noted by Duncan Robinson (1976–7, p. 38, no. 42), was
doubtless the result in part of Spencer working from a drawing
rather than directly from the model. This contrasts sharply with
the portraits of Patricia Preece, which convey the strong
atmosphere of sexual tension which existed at the time of
painting.

Richard Carline has suggested that the related drawing of
Hilda c. 1930 (pencil, 50.8 × 35.6 cm/20 × 14 ins), exhibited at
the d'Offay Gallery in 1978 (3), may have been the study
for this painting. However that drawing is of Hilda's head
and shoulders only, and shows her full-face at eye level.
The elevated, slightly oblique view of the painting suggests
that Spencer used another, more detailed, drawing, probably
one of the series which included *Hilda* and *Hilda with Hair
down* (no. 133) of 1929–31. The very precise academic nature of
these drawings would help to explain the similar characteristics
of the painting.

EXHIBITIONS
Leicester Galleries, 1942 (15)
Tate Gallery, 1955 (64)
Arts Council, 1976–7 (42)

180

5 Shipbuilding on the Clyde 1940–1946

On Christmas Day 1939 Dudley Tooth wrote to Sir Kenneth Clark, Chairman of the War Artists' Advisory Committee (WAAC), asking if Spencer could be found a job as an Official War Artist. Tooth was in the army and had little time to spare to assist Spencer who was '. . . terribly in debt all round' (Imperial War Museum archives). The war had caused a slump in the sales of his economic staple, the landscapes, and he was in danger of becoming destitute. Clark's reply, while not immediately helpful, offered some hope of future employment. The WAAC was a body set up under the Ministry of Information and was composed of an assortment of artists, art historians and civil servants. Its main purpose was to organise artists to record various aspects of the war for historical purposes.

On 25 January 1940 Spencer was interviewed by Mr Dickey for the WAAC; he offered to paint a large *Crucifixion* containing imaginative scenes from the overrunning of Poland, obviously on the lines of Burghclere. This was rejected because the Ministry wished to accept only eye-witness records. However on 19 March they proposed that Spencer should paint views of a shipyard and airfield, on the basis of experience with the Cunard *Queen Mary* project (see no. 176). The artist agreed to the shipyard suggestion, and in May he visited Lithgow's shipyards at Port Glasgow, staying for several weeks and making numerous detailed studies of the shipbuilding activities. The yards and the atmosphere of Port Glasgow delighted him, and he found there the close-knit community atmosphere which had been the central 'homely' element of his love for Cookham. Even in the shipyards the individual tasks of the men pleased him in the same way as the 'fetching and carrying' at Beaufort Hospital, which was one of the central themes of Burghclere. As he told Dickey in 1940: 'Many of the places and corners of Lithgow's factory moved me in much the same way as I was by the rooms of my childhood.'

Spencer's visit to Glasgow gave him a plan for a complete series of pictures celebrating the activities of the yard. This consisted of the existing series of pictures as its main component, together with a double predella beneath and further pictures to hang on opposite walls: the latter including scenes of men at home and entering the factory. Spencer's original intention for the series was based on a complete room or 'environment' in which to house the paintings.

A scaled-down version of this plan, together with the drawings, was submitted to the WAAC in 1941, and on 23 May Spencer was asked to paint a series of five paintings following his proposed scheme. The first of these, *Burners* (no. 216), was completed by 26 August. The committee was delighted and Spencer was encouraged to proceed with a further three canvases for which they hoped to find additional funds later. At first work proceeded rapidly and by the end of 1941 four sections were complete. By 1943, however, Spencer's interest began to wane as he turned his interest to another scheme: the celebration of Port Glasgow in a series of *Resurrection* pictures, a project which was closer to his heart than the work for the WAAC. The later canvases in the *Shipbuilding* series inevitably reflect this declining enthusiasm, and there is an increasing reliance on the abstract formal qualities to be found in shipyard objects. The early near-religious intensity of *Burners* (no. 216) had lost its focus by the time *Plumbers* (no. 223) and *Riggers* (no. 222) came to be painted, and in 1945 it required firm prompting from the WAAC to get Spencer to complete the problematical, and much reduced, painting of *Furnaces* (no. 224). Despite these shortcomings, the *Shipbuilding* paintings fully realise the promise found in the earlier semi-industrial scenes of the *Empire Marketing Board* series (nos. 124–8). It was one of the few series which Spencer managed to bring near to its originally conceived form.

216 Shipbuilding on the Clyde: Burners

[repr. in colour between pp. 200 and 201]
1940
Oil on canvas, triptych,
centre section 106.7 × 153.4 cm/42 × 60 ins
sides each 50.8 × 203.2 cm/20 × 80 ins
Lent by the Trustees of the Imperial War Museum

Burners was the first of the Port Glasgow *Shipbuilding* polyptychs to be completed. On Spencer's return from his trip to Glasgow in May 1940 he submitted some of the numerous drawings which he had made there to the War Artists' Advisory Committee (WAAC), chaired by Sir Kenneth Clark. These probably included two large drawings, *Caulking* (no. 226), and *Welders* (no. 231), and it was to these two ideas that Spencer directed his attention when, on 23 May, Dickey

informed him that the Committee had suggested he should work on a polyptych made up of paintings derived from the Port Glasgow drawings (Imperial War Museum archives). This was confirmed on 6 June when the Committee made a firm commitment for a total of five paintings, for which Spencer was to be paid £300.

At this time Spencer was living at the White Hart Inn at Leonard Stanley, with George and Daphne Charlton; and it was here, in the large front room, that he painted all three sections of *Burners* during the summer months of 1940. Progress on the picture was extremely rapid and he was able to report to Dickey on 29 July that he had 'drawn out' the left-hand wing of the triptych, as well as painting the small scene of *Caulking* (no. 217). Further progress was charted by Spencer in a useful series of detailed diary entries (Tate 733.3.23) for August 1940. Painting began with the left-hand panel on Friday, 2 August, and he then proceeded, working left to right across the composition, until on 9 August he stretched the canvas (which had probably been pinned to the wall) and began to paint the fifth and final man at the extreme right of the scene. By the following day the composition was finished, and he proceeded directly to the central panel, taking two days to draw in the design before painting began again. This time Spencer began at the top left corner, painting in the sheets of steel plate before filling out the figures set on top of them, and then worked downwards to finish in the bottom right on 22 August. The third and final panel was begun the same day and he proceeded in a similar manner to the first section, working from left to right, and returning every so often to fill in spaces which had been left blank. For example, on 27 August he 'finished the fourth figure and painted caps on three figures and arms and boots', and on 30 August he was 'painting [the] last figure', on the right (Tate 733.3.23). This method of working often resulted in giving the unfinished picture the appearance of a large partially completed jigsaw puzzle, as Spencer did not begin with an underpainting but completed each section before moving on to the next.

On 31 August, exactly a month after Spencer began work, the final panel was completed, and after allowing time for the canvas to dry, the artist sent the panels to London, where they were exhibited at the War Artists' Exhibition at the National Gallery in October 1940. The WAAC, to whom the pictures had initially been sent, wrote to Spencer on 15 October to say that they were 'delighted with your first three canvases in the *Shipbuilding* series. . .' (Imperial War Museum archives), and asked him to paint a further three. Pleased by the Committee's reaction Spencer set to work at once on *Welders* (no. 218).

Despite the tremendous speed with which Spencer painted *Burners*, the picture remains one of the most successful of the series. One of the reasons for this is undoubtedly the uncluttered design of the scenes, which may be compared with the diminished figures and cramped details of later pictures like *The Template* (no. 220), and *Riggers* (no. 222). Secondly there is a strong central focus to the design which is missing in the later works. In the central panel Spencer used a petal or 'star'-shaped format of the kind which he also considered in early drawings (1940s) for *Christ Preaching at Cookham Regatta* (no. 213).

Within this design each man is picked out against the metal plate on which he is working, a solution which was also applied to the side wings, where the flare of torches adds local lighting, which is so arranged as to transfer attention on to the next activity.

EXHIBITIONS
National Gallery, on completion, and on tour during the war
Glasgow Art Gallery, *War Artists Exhibition*, 1945
Stanley Spencer Gallery, Cookham (n.d.)
Glasgow, 1975 (1)
Arts Council, 1976–7 (41)
Science Museum, London, *Stanley Spencer in the Shipyard*, 1979
Crawford Art Centre, St Andrews, 1979

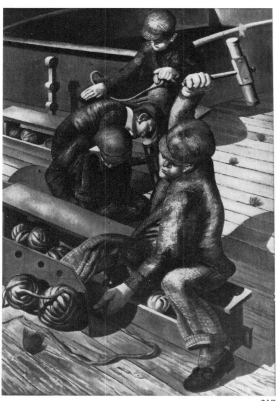

217

217 Caulking

1940
Oil on canvas
91.4 × 61 cm/36 × 24 ins
Lent by Mrs A. Lewinter-Frankl

This small painting, previously unnoticed in Spencer studies, belongs to the early stages of the artist's work for the WAAC.

In his letter of acceptance (see p. 181) Spencer mentioned two large drawings, *Men Welding* and *Caulking* (probably no. 226), on which he was beginning work at once, explaining: 'I really think I have mastered *one* of the ideas anyway, that is the *Caulking* scene. You saw a study for a portion of the scene and since then . . . amazing . . . developments have taken place in it. In the midst of the tapping, drilling and hammering there is a moment when the men take their mallets in both hands and lam on to the iron pegs or wedges with all their force. One of

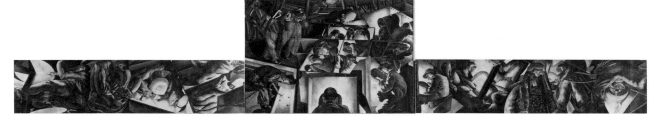

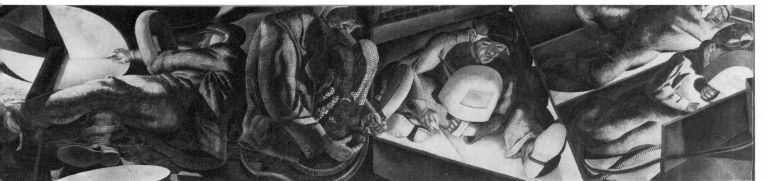

218

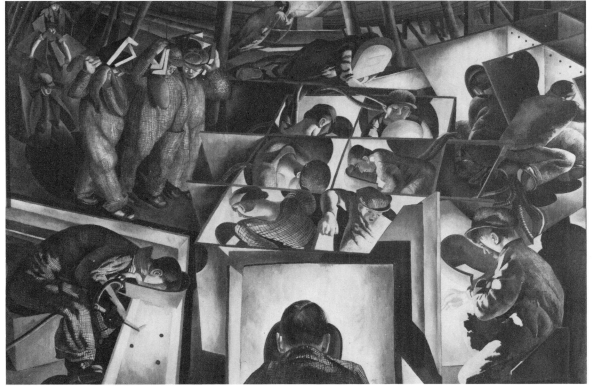

218a

218b

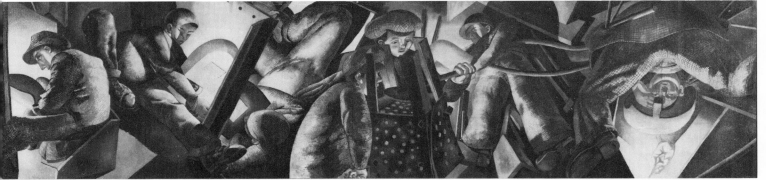

218c

these climaxes is occurring somewhere near the center [*sic*] of this idea and some ships davits with pyramids of rope descending from them form the background' (Imperial War Museum archives, 1940).

This letter is evidence that at first *Caulking* was intended to be one of the fine big paintings commissioned by the WAAC. At this stage, however, there was a hiatus in the work while Spencer searched for lodgings large enough to enable him to work on the big canvases. In a letter to Dickey, July 1940, he reported: '. . . In order that the time should not be completely wasted in addition to continuing to work out this scheme I have drawn on to a long strip of canvas. . . . I have also done a separate oil painting on canvas, 2 ft × 36 ins, of one of the groups of caulkers' (Imperial War Museum archives). This was the present painting, taken from the right-hand section of the original drawing described above (no. 226).

Although Spencer did not give up hope of painting what he called 'the big caulking and decker' picture, he turned to other works in the series: He gave his reason for not proceeding in a letter to Dickey of 26 August 1941: '*Caulking*. . . . I did this detail of it because I saw that as the scene occurs on the top deck of one of these cargo ships it would not be possible to bring it into the theme I have described. It would have to be a thing on its own' (Imperial War Museum archives). The picture was offered to the WAAC, who did not accept it. It was later sold to a Private Collector.

EXHIBITION
Leicester Galleries, 1942 (19)

218 Shipbuilding on the Clyde: Welders

1941
Oil on canvas
50.7 × 580.7 cm/20 × 228¼ ins (106.7 cm high in centre)
Lent by the Trustees of the Imperial War Museum

The picture was painted between 5 November 1940 and 11 February 1941. In it Spencer adopted a similar composition to *Burners* (no. 216), with each man separated from the other by the abstract shapes of the steel plates and the pool of light made by his welder's torch. At the top of the central panel can be seen the carved hull of a ship resting on the slipway. In a letter to Dickey at the Ministry of Information written on 23 October 1941 (Imperial War Museum archives), Spencer reported difficulties with the right-hand panel, which he was having to alter. In its completed form this section lacks the clarity of the left-hand scene, with the artist resorting to a series of sharply foreshortened forms in order to squeeze in the welders and riveters in the centre of the picture. Spencer probably used himself as a model for the squatting figure near the centre of the left-hand panel.

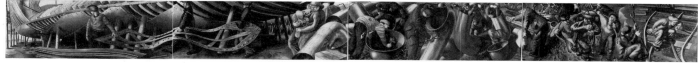

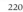

220

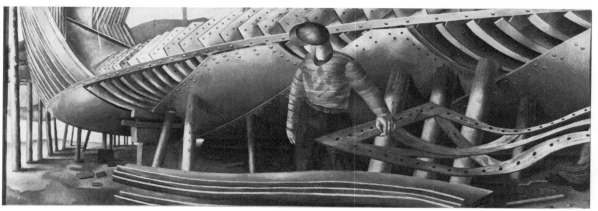

220a

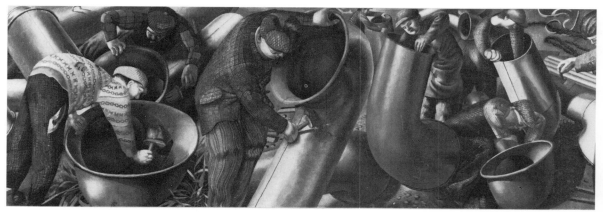

220c

219 Shipbuilding on the Clyde: Riveters

[repr. in colour between pp. 200 and 201]
1941
Oil on canvas
76.2 × 579.2 cm/30 × 228 ins
Lent by the Trustees of the Imperial War Museum

After the approval of *Welders* (no. 218), the second painting in the series, the WAAC agreed to commission a third painting from Spencer for a fee of £300. This was *Riveters*, which the artist began at the end of June 1941, following another visit to Port Glasgow. At this time Spencer was staying in Epsom with Mrs Harter, Sydney Carline's mother-in-law, who was looking after his two daughters. From here he reported to Dickey on 18 August that the picture would be finished in about eight days. Later, on 9 September, the panel was delivered to the WAAC, who agreed to pay the artist the reduced sum of £200, probably because the picture did not have the enlarged central section of *Burners* (no. 216) or *Welders* (no. 218).

The picture shows a scene in the shipyards, with men engaged in riveting together sections of ships' masts, derricks, and crows' nests. On the right three bowler-hatted supervisors check blueprints for a ship. In front of them three men tug on ropes attached to an unseen trolley. Spencer originally intended this scene to be a continuation of another picture, *Haulers*, which was never painted. The same group was also incorporated, turned 90° to face out from the canvas, in the right-hand section of *The Template* (no. 220).

As in *Burners* (no. 216), Spencer based the composition on the abstract shapes of shipyard materials, creating a centre of focus

through the three mast-ends or bases and placing the other masts in the outer sections of the composition parallel to the picture plane, thus causing a triptych-like effect.

There are detailed working drawings for most of the activities in the painting, including the portable furnaces for heating rivets and the workmen lying prone inside the mast at the right of the central section (see no. 225).

EXHIBITIONS
RA, *War Artists' Advisory Committee Exhibition of National War Pictures*, 1945 (328)
Whitechapel Art Gallery, *Looking Forward*, 1952 (96)

REFERENCES
War Pictures by British Artists, First selection, March 1942 (MOI)
Studio, 126, 1943, p. 52
E. Newton, 1947, pl. 29 (centre panel, in colour) *ibid*, 147, 1954, pp. 36–7
Robinson, 1979, pp. 66–7, pl. 57

220 Shipbuilding on the Clyde: The Template

1942
Oil on canvas
50.7 × 579 cm/20 × 228 ins
Lent by the Trustees of the Imperial War Museum

The picture was painted between February and May 1942 at 'Quinney's', Spencer's lodgings in Cookham. It was the first and only section of the five projected predella scenes to be completed, and was originally intended to hang under *Burners* (no. 216), at the extreme left of the series. After the WAAC was wound up in March 1946, Spencer suggested that the panel

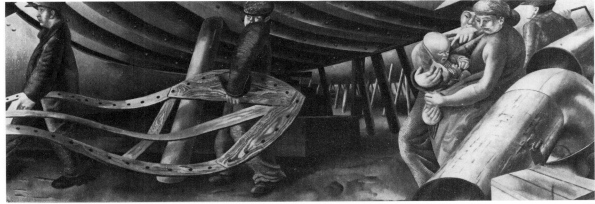

220b

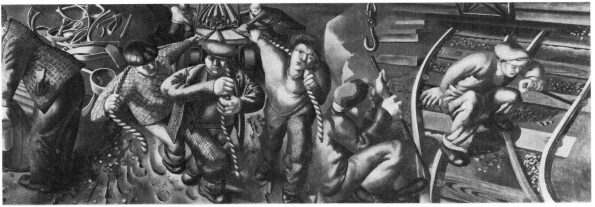

220d

should be hung in the centre, under and overlapping *Furnaces* (no. 224) in order to preserve the symmetry of the scheme.

In the painting three men carry a large wooden template beneath the partially completed hull of a ship; to their right others apply red lead paint to ship's ventilators. The woman, who appears carrying a baby in the middle of the composition, was painted from drawings which Spencer made in the Star Hotel, Port Glasgow, in April 1941. The drawings were used again in the *Port Glasgow Resurrection* series.

221 Shipbuilding on the Clyde: Bending the Keel Plate

1943
Oil on canvas
76 × 575 cm/30 × 228 ins
Lent by the Trustees of the Imperial War Museum

The picture was painted in the first half of 1943, not 1941, the usual date assigned to the work. In June 1943 Spencer informed Owen at the Ministry of Information that the painting was almost complete; he went on 'I have had difficulties and great doubts in doing this painting and until about four months ago

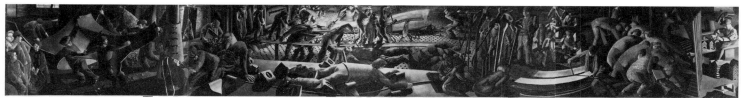

221

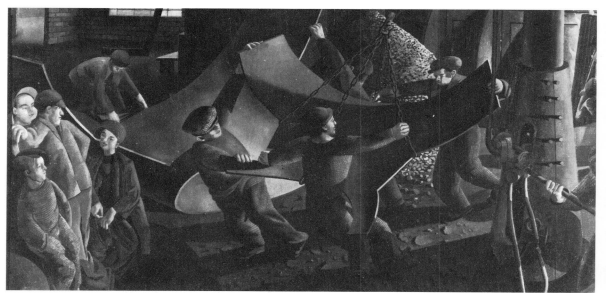

221a

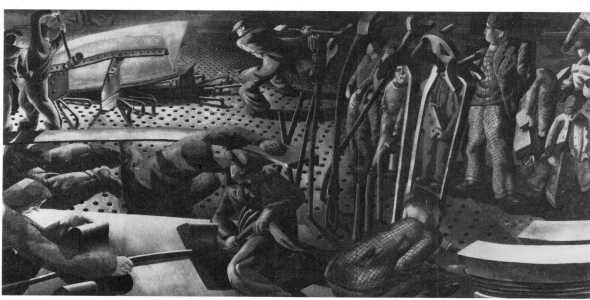

221c

when gradually I was able to continue it I had had several periods of losing interest in this panel and wondering if I should not begin another canvas. . . . In it [the picture] one looks across an intervening space in which men are respectfully preparing a plate for the machine burner, and bolting a lighter section of frame to a heavier section, to where the shoe plate in its cradle is being beaten into shape' (Imperial War Museum archives). The artist's original title for the picture was *The Shoe Plate*.

222 Shipbuilding on the Clyde: Riggers

1944
Oil on canvas
50.7 × 493.5 cm/20 × 194¼ ins
Lent by the Trustees of the Imperial War Museum

The picture shows the riggers' loft in Lithgow's shipyard in Port Glasgow. Spencer was impressed by the 'homely'

atmosphere of the loft because it contrasted sharply with the noise and bustle outside on the slipways. The dark interior also reminded him of the interior of a church, or his home. The dual nature of Spencer's vision, an eye for exacting detail and a deep sense of the all-pervading nature of religion are apparent in an account of his visit to the loft in 1941: 'Everything I see is manifestly religious and sexual. If I am in a loft where wire hawsers are being spliced and rolled up, everything as far as I can see intermarried with each other. . . . It is not that coils of rope suggest haloes, it is just that all those items, men, hawsers, strings, as in all forms have a hallowing effect of their own . . . it is a part of their nature. When I went into the room where big pieces of stiff material were being sewn. . . . At the top end was a woman standing with her back to me. She was working at her table, and at her left side was a great crumpled tarpaulin. . . . She did not look up and I was as disinclined to disturb the atmosphere as I would a religious service, even more so, as in the religious service it is prescribed that you should not do so, whereas here there seemed something in the very work itself that made me feel for the respect and peace' (Tate 733.3.34).

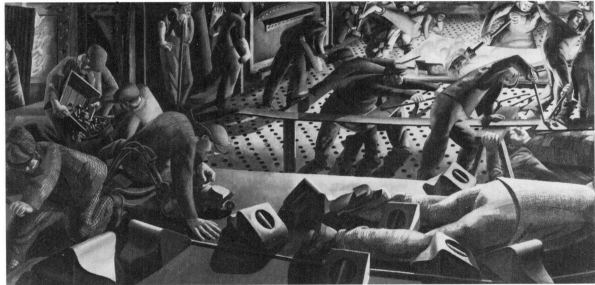

221b

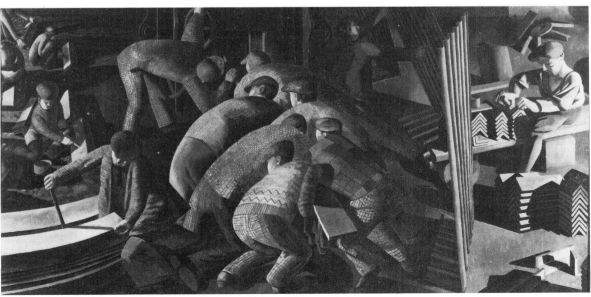

221d

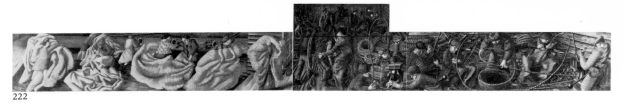

222

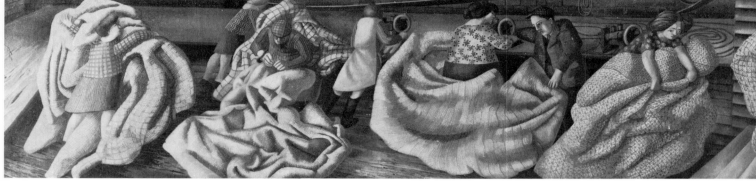

222a

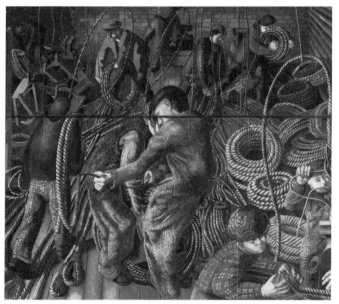

222b

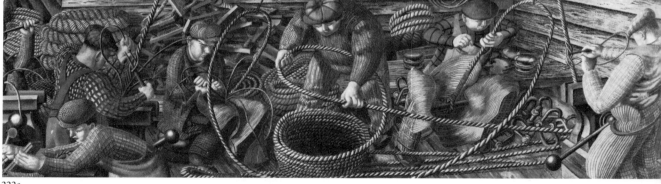

222c

This dark crowded space provided a deliberate contrast to the more spacious scenes like *Bending the Keel Plate* and *The Template*: 'In doing a painting I like to have in the same painting a space that is in part . . . confined and cramped even, and in other places plenty of room because *one* emotion I feel

will demand a variety of conditions to work in.'

The design was drawn on the canvas by 7 March 1942, and the painting was finally completed on 22 January 1944. It was accepted by the WAAC on 3 August 1944, when the artist was paid a fee of 250 guineas.

223 Shipbuilding on the Clyde: Plumbers

1944–45
Oil on canvas
50.7 × 492.9 cm/20 × 194 ins
upper panel 30.3 × 88.7 cm/12 × 35 ins
Lent by the Trustees of the Imperial War Museum

Spencer received the letter of agreement for *Plumbers* in a memorandum from the Ministry of Information written on 3 August 1944, in which they mistakenly referred to the picture as the 'centrepiece' of the predella (Imperial War Museum archives). Later that year the painting was almost finished, and on 30 March 1945 the WAAC declared themselves 'delighted' with the finished work. A study for the painting is included in the exhibition (no. 229).

223

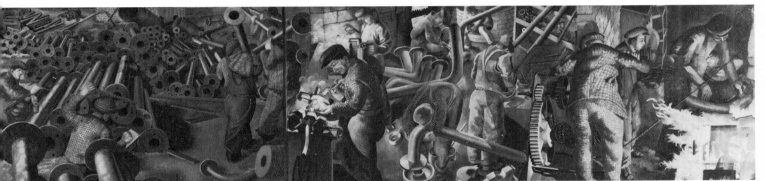

223a

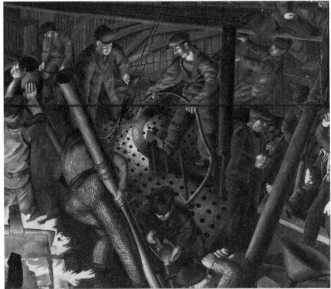

223b

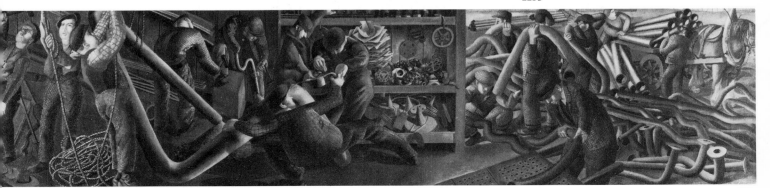

223c

224 Shipbuilding on the Clyde: Furnaces

1946
Oil on canvas
158 × 114 cm/61½ × 44¾ ins
Lent by the Trustees of the Imperial War Museum

The last of the *Shipbuilding* series, this painting was completed between January and March 1946, from an old study made in 1940 (no. 228). Since early 1944 Spencer's interest in the shipyard scenes had waned as he began to concentrate on the early *Port Glasgow Resurrection* paintings (no. 235). On 28 February 1946, however, Muirhead Bone informed him that the

WAAC was winding up, and suggested that the artist should paint 'a moderate size central panel', to complete the series (Imperial War Museum archives). Spencer's original plan had called for a large rectangular painting to provide a central focus to the shipbuilding scenes. But in January 1946, pressed for time, the artist resorted to expediency, telling Richard Smart at Tooths: 'I am getting on with the central shipbuilding picture. I am so arranging it that if the Ministry of Information time is up (1st March) and I have not finished the whole 6 × 8 foot by then, I shall have finished the central part of this canvas which is about 6 × 5 ft, and if they *must* have it I can separate it' (Tooth archive). As the dimensions of the present picture are only 5 × 3¾ ft there is little doubt that Spencer had to resort to

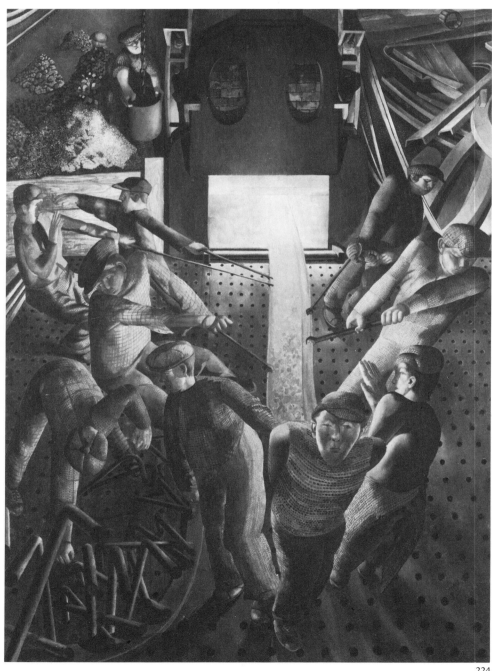

224

190

these drastic measures to meet the deadline. Later, in November 1946, he regretted his action: 'I wish I had done a better and bigger central panel', he wrote to the W A A C (Imperial War Museum archives).

A study for *Furnaces* is included in the exhibition (no. 228).

EXHIBITIONS AS A SERIES
Glasgow Art Gallery, *War Artists Exhibition*, 1945
Science Museum, *Stanley Spencer in the Shipyard*, 1979
St Andrews, Crawford Centre for the Arts, 1979

225 Study for Shipbuilding on the Clyde: Riveters

1941
Pencil on paper
54 × 218.5 cm/21¼ × 86 ins
Lent by the Trustees of the Imperial War Museum

A working drawing for *Riveters* 1942 (no. 219). Spencer used similar large-scale drawings for each of the *Shipbuilding* series, scaling up the design from the original studies before transferring them to canvas. The drawing shows the central section of *Riveters*, which, with some alterations, was used for the oil painting.

Spencer explained his concept for the composition of the *Shipbuilding* pictures in a letter to Dickey at the Ministry of Information in October 1940: 'I like the theme to be continuous and not absolutely cut off item by item as the continuous character helps to preserve the impressions one gets in the shipyard itself, as in wandering about among the varied happenings. . . . These transitional parts . . . are very important and serve as an interesting nebulous matter in which here and there these different activities form themselves' (Imperial War Museum archives).

226 Study for Shipbuilding on the Clyde: Caulkers with Carpenter in Centre

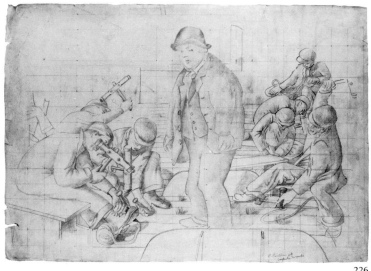

226

1940
Pencil on paper
52.8 × 73 cm/20¾ × 28¾ ins
inscbr. '8. Caulkers with Carpenter in centre'
Lent by the Trustees of the Imperial War Museum

This is probably the study mentioned by Spencer in a letter to Dickey at the Ministry of Information of May 1940 (Imperial War Museum archives). The artist intended to use the drawing as the basis for a painting in the *Shipbuilding on the Clyde* series, which he was planning to paint in 1941 after *Welders* (no. 218) was completed. However he later abandoned the idea because the scene, which takes place on a ship's deck, did not fit in with the other paintings of activities below on the slipway, or in the shipyard workshops. Spencer may also have had difficulties with the pyramid-shaped groups of workmen on the left and right, who would not have fitted into the long narrow format adopted for the other paintings in the series. He did however produce a small oil study, *Caulking* 1940 (no. 217), based on the right-hand section of the drawing. The scheme for the full-size painting was abandoned some time after February 1941.

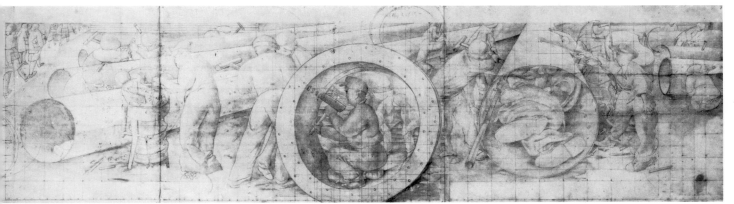

225

227 Study for Shipbuilding on the Clyde: Men at Furnace

c. 1940–1
Pencil on paper
37 × 26.8 cm/14½ × 10½ ins, squared for transfer
inscbr. '57 Men at Furnace. Imperial'
Lent by the Trustees of the Imperial War Museum

This is another of the drawings made by Spencer in Port Glasgow for the *Shipbuilding on the Clyde* series. Despite its similarity of subject the drawing is not a study for the central *Furnaces* 1946 (no. 224) canvas, as the working drawing for this was completed in 1940. Instead it was probably intended as a design for a detail in one of three other *Furnace* pictures which remained unpainted. These appear in a diagram made while Spencer was staying in Epsom in 1941 (Tate 733.3.34), showing a cycle of forty-three pictures depicting activities in the shipyards and the workers' homes. They were to be arranged round a large room with two of the projected *Furnace* pictures hanging opposite the existing *Furnaces* (no. 224), and the third on a side wall. Although no complete studies for these projected pictures have survived, the carefully finished state of the drawing indicates that Spencer was optimistic that the picture would be completed. After the W A A C was wound up in 1946, the artist wrote to Mr Oxford-Coxall at the Ministry of Information informing him that 'I still hope to go on . . . on my own and for my own interest' with the *Shipbuilding* paintings (Imperial War Museum archives). By now however his time was fully taken up by the *Port Glasgow Resurrection* series (nos. 235–42), and he did not carry out any more of the ambitious shipyard scheme.

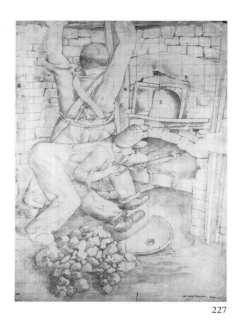

227

228 Study for Shipbuilding on the Clyde: Furnaces

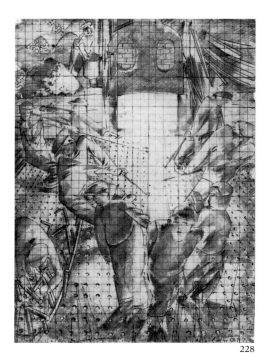

228

1940–1
Pencil on paper
83.8 × 34.8 cm/33 × 13⅝ ins, squared for transfer
sbr. 'Stanley Spencer'
Lent by the Trustees of the Imperial War Museum

The drawing is a study for *Furnaces* 1945 (no. 224), the central painting in the *Shipbuilding on the Clyde* series. It is probably the 'early first attempt' which Spencer told the Ministry of Information he was using for the painting in a letter of 1944 (Imperial War Museum archives).

A few slight changes were made in transferring the design to canvas: the central figure was slightly enlarged, and the bending man at the lower left was moved closer to the centre of the composition.

229 Study for Shipbuilding on the Clyde: Plumbers

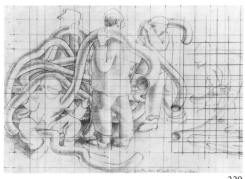

229

1940
Pencil on paper
24.7 × 34.9 cm/9¾ × 13¾ ins, squared for transfer
inscbr. '60. Plumbers rt. cent. fig: among pipes?'
Lent by the Trustees of the Imperial War Museum.

A working drawing for the inner part of the extreme right-hand section of *Plumbers* (no. 223) in the *Shipbuilding on the Clyde* series. The sketch is a good example of the artist's fascination with the abstract qualities of the materials which he found in the shipyard.

230 Study for Shipbuilding on the Clyde: Miss Susan Maire

c. 1940
Pencil on paper
49.5 × 40 cm/19½ × 15¾ ins
insc. 'Miss Susan Maire', and sbr. 'Stanley Spencer'
Lent by the Trustees of the Imperial War Museum

Spencer probably made the drawing as a study for *Welders* (no. 218) in the *Shipbuilding on the Clyde* series 1940–46. Drawings like this one were made on the spot in the shipyards and stored for future inclusion in the paintings. This study remained unused although the figure on the extreme right of the left-hand panel of *Welders* adopts a similar pose. Few of Spencer's shipyard portraits have survived as he frequently gave them away to the sitters.

Women were permitted to work in the shipyards for the duration of the war in order to make up the shortage in available manpower.

230

231

231 Study for Shipbuilding on the Clyde: Welders

1940
Pencil on paper
37.7 × 49 cm/14¾ × 19¼ ins
inscbl. '18. Self for Welders'
Lent by the Trustees of the Imperial War Museum

A self-portrait of the artist, this study was used for the second figure in the middle of the left hand panel of *Shipbuilding on the Clyde: Welders* 1941 (no. 218). In the painting Spencer is shown holding a protective face mask as he squats down to observe the welder at work. In a detail omitted in the drawing a pair of paint brushes protrude from his jacket pocket.

This is the only deliberate self-portrait in the *Shipbuilding* series but it is likely that Spencer used himself as a model for other figures and parts of figures in the paintings. This was occasioned by his frequent absences from Port Glasgow which prevented him from making the necessary studies for the pictures from life. Spencer explained these problems to Dickey at the Ministry of Information in a letter dated 4 March 1942: 'I wish I could have made more particular studies of the men. . . . What I seriously need is to make a careful series of drawings rather like I did once in Switzerland [see no. 144] of women and men . . . in their native clothes. . . . It is that subtle variation in their clothes [which is] expressive of their varied character that is so truly full of charm, beauty, and interest. But whenever I have been up there they have all been too busy' (Imperial War Museum archives). Spencer had exacerbated the problem by giving away many of the shipyard portrait studies to his subjects.

232 Port Glasgow from Clune Brae

1944
Oil on canvas
76.2 × 50.8 cm/30 × 20 ins
Lent by a Private Collector

The painting is one of eight landscapes which Spencer painted on his visits to Port Glasgow 1940–45, where he was working on the *Shipbuilding* and *Glasgow Resurrection* series.

The picture shows a view looking down on to the red brick tenements and beyond over the smoke shrouded roofs of Port Glasgow to the cranes of the shipyards, and the hills on the far bank of the Clyde.

Spencer referred to the picture in a letter to his agent, Dudley Tooth, on 27 October 1944: 'It is filled with trees, chestnut, holly, yew, and big bushes and shrubs, and a distant view sitting up among the branches. It was a test for time, I had to go hard at it as the leaves were falling. It took me just two weeks.' The length of time which Spencer took to paint a landscape (an average of four to six weeks) compared unfavourably with the four or five days which was all that was required for a similarly-sized figure painting. This was compounded by the heavy demand for his landscapes, causing him to complain to Tooth in 1942: 'About the doing of landscapes, when I do them I find they absorb every bit of my energy and concentration, and when I attempt to switch from that to my ship picture [for the Ministry of Information], one or the other work suffers.'

EXHIBITION
The Piccadilly Gallery, 1978 (14), illustrated

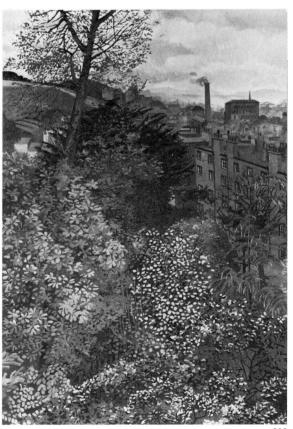

232

233 Orchids, Lilies and Palms

1945
Oil on canvas
76.2 × 50.8 cm/30 × 20 ins
Lent by Barclays Bank Limited

The picture was painted in Port Glasgow during April and May 1945. Spencer reported its progress in a letter to Dudley Tooth dated 7 May 1945: 'As I was feeling I should do a painting of flowers and I was just by some fine old Botanic Gardens, and as one can depend on the weather in a greenhouse, I began a painting of orchids, lilies and palms etc. This is getting to the end now.' (Tooth archive). No. 250 was also painted in Port Glasgow.

234 The Psychiatrist

1945
Oil on canvas
74.9 × 49.5 cm/29½ × 19½ ins
Lent by Birmingham City Art Gallery

The subject of the painting is Mrs Charlotte Murray, to whom Spencer was introduced shortly after meeting her husband, Graham Murray, at the Port Glasgow High School in the winter of 1943–44. The artist, who was living in Port Glasgow while painting the *Shipbuilding* pictures for the War Artists' Advisory Committee, soon became friendly with the Murrays and their

233

friends, among whom was a Jungian psychoanalyst and brilliant amateur cello player, Dr Karl Abenheimer. Apart from the support and friendship which this group provided, they also enjoyed playing music, and Spencer frequently participated in these events, either playing the piano or conducting. Graham Murray has since recalled that Spencer had 'the inner ear of a born musician'. Apart from these social and musical events, Spencer was able to use the Murrays' flat at No. 7 Crown Circus, Port Glasgow, for some of his painting, working there on several of the *Shipbuilding* and *Port Glasgow Resurrection* pictures, in a room set aside for him as a studio. Graham Murray recalls that he would work on several pictures at one time, usually spending 'two or three hours on one painting – have a nap – then turn the work with its face to the wall, and return to continue another picture'. It was through the Murrays that Spencer met Mr William Bennet, who bought one of the *Resurrection* scenes (see no. 239), painted in this way at the Crown Circus flat.

The portrait of Mrs Murray was not, according to Graham Murray, painted from life, but was based upon drawing studies which Spencer made of her head and hands. The rest of the picture was completed by stuffing towels and cushions into a fine dressing gown of Mr Murray's of which Spencer was particularly fond; while another cushion was painted in behind the sitter's head. This rather strange evolution is probably the cause of the unusual composition of the portrait in which it is difficult to tell the sitter's exact position, and where one hand disappears off the bottom of the canvas. Despite this, Spencer did not lose any of the intensity of the sitter's gaze, which is emphasised by the strange, almost ritualistic patterns on the dark cushion behind her head.

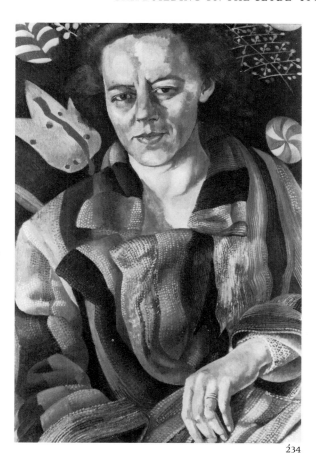

234

EXHIBITIONS
Leicester Galleries, *Artists of Fame and Promise, Part I*, 1945 (106)
British Council, South Africa, *Contemporary British Paintings and Drawings*, 1947 (107)
Tate Gallery, 1955 (66)

6 The Port Glasgow Resurrection Series 1945–1950

The particular sense of joy and belonging which Spencer experienced while living among the shipyard workers in Port Glasgow during the forties persuaded him of the need to celebrate his feelings for the place, as he had already done for Macedonia and Cookham. At first this took the form of projected scenes in the *Shipbuilding* series, showing the workers at home or streaming through the yard gates. But he was looking for something more personal. As he later recorded: 'there is an undefined not-yet-come-to-earth-Port-Glasgow epitomising something I hope to find and arrive at. . . . I keep wondering what form it can have and . . . what could realise all that meaning that keeps peeping at me from all and anything happening here' (Wilenski, 1951, p. 2). One evening, unable to sleep, he went for a walk down by the gasworks and discovered what he felt to be the spiritual core of the town. Characteristically it was a cemetery (see no. 250). The upturned saucer-shape of the hill upon which the graveyard stood reminded Spencer of a quotation from John Donne in which he likened 'the resurrection of the dead [to] a king of climbing of the hill of Sion [*sic*]' (Tate 733.8.61, written August 1948). He also felt that it looked like 'what the Arabian Nights call the mountain of the bereft', although in this case it was to 'become the hill of the blessed' (*ibid.*).

This gave Spencer the idea for a vast stepped canvas fifty feet across, showing Christ seated in judgement on the Hill of Zion, surrounded by a sky filled with angels. Below, in the main body of the picture, the resurrected rise from a series of graves arranged in a fan shape round the foot of the hill. In the fields behind others make their way towards the hill to be judged (drawing in Tate Gallery archives, 733.8.57).

The plan proved too ambitious and, fearing that the project might fail, Spencer adopted the compromise first used in the Church House scheme, splitting the composition up into a number of independent pictures. The central idea, much changed, became *The Resurrection, Port Glasgow* (no. 242), with the *Hill of Zion* (no. 235) and *Angels of the Apocalypse* (no. 251) showing the hill and sky above. For a time Spencer hoped that these might be hung one above the other in an approximation of the original design, but the scale was inconsistent and the pictures were sold separately.

The remaining pictures in the series were not part of the original scheme, but dealt with other aspects of the Resurrection, which Spencer had first touched on as early as 1926, in *The Resurrection, Cookham* 1924–6 (no. 89). With the exception of *The Resurrection with the Raising of Jairus's Daughter* (no. 241), planned in 1939 as a celebration of Spencer's stay in Leonard Stanley, 1939–40, they were all based on the Port Glasgow cemetery. The majority of these paintings were first drawn out in the 'Derwent' scrapbooks (see no. 207), and were transferred with few changes to the canvas. Again Spencer had hoped to paint them on a scale more closely approaching *The Resurrection, Port Glasgow* (no. 242), but chose instead a more practical size, probably on the urging of Dudley Tooth.

The Port Glasgow paintings were Spencer's last treatment of the Resurrection theme.

235 The Resurrection: The Hill of Zion

[repr. in colour on pp. 156–7]
1946
Oil on canvas
94 × 190.5 cm/37 × 75 ins
Lent by the Harris Museum and Art Gallery, Preston

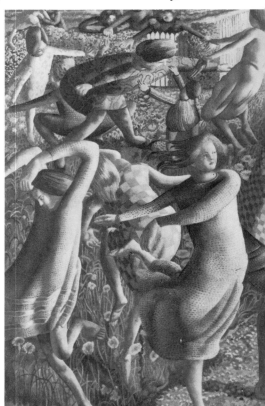

196

When Spencer abandoned his plan to paint a single large picture of *The Resurrection* he tried to retain at least part of the original scheme by dividing it up into three pictures of a more manageable size. *The Resurrection, Port Glasgow* (no. 242), much modified, became the main section, with the *Hill of Zion*, the cemetery hill which rose above this scene; and *Angels of the Apocalypse* (no. 251), which was to show the angel-filled sky above. For a time the artist retained the notion that these works could be hung one above the other in a semblance of the original scheme, but the disparity in scale, particularly after *The Resurrection, Port Glasgow* was extended by several feet, made this impracticable.

The painting was inspired by the shape of the hill on which the Port Glasgow Cemetery was located (see no. 250). Writing in 1951, Spencer recalled that it was 'an oval-saucer-upside-down-shaped hill hedged in by high red brick tenements looking down on it; a sort of green mound in a nest of red with here and there the Clyde and distant hills showing between gaps in the blocks of tenements' (Wilenski, 1951, p. 6). It was on this hill that Spencer chose to site the scene of the Last Judgement, 'where Christ, seated in the top centre, directs the prophets, angels and disciples at the Resurrection. Among the lilac there is a standing prophet scanning the country and by him a trumpeting angel; a recording angel with a scroll is above a second trumpeting angel on the other side; one of the disciples sits and hugs his ankles. Beyond the left slope of the hill some girls lead a chain of children climbing from the plain, and beyond on the right side there are resurrected men and women' (Wilenski, 1951, p. 6). Referring to these figures on 8 January 1949, Spencer drew attention to their symbolic nature. They were 'shapes expressing the Resurrection . . . they are not the shape of a human being simply, any more than the shape of a human being is the shape of the clay he was made from' (Tate 733.8.30).

The painting was completed on 22 August 1946 (Tate 733.8.60), although some additions were made to the left-hand side of the canvas the following year. Spencer also planned to add two smaller wings (76.2 × 50.8 cm/30 × 20 ins) on either side of the main canvas: 'on the left two other prophets scanning the countryside and noting that all is taking place as it should be. On the right [myself] drying the eyes of a mourner.' Neither of these were painted.

While the composition for *The Hill of Zion* was entirely conceived in Port Glasgow, the designs for some of the figures were adapted from ten pre-existing sketches. These were figure studies made in a notebook (now lost), which were intended for a 'Pentecost, Upper Room' scene drawn in the early 1930s. Spencer used himself as a model for the drawings, where he appeared 'in a seated or squatting position'. Three of these figures were used in *The Hill of Zion*, probably for the three 'disciples' in the centre foregound of the painting (Tate 733.3.87, February 1949).

EXHIBITIONS
RA, summer 1950 (565)
Arts Council, London and Manchester, *British Painting 1925–50*, 1951 (95)
Tate Gallery, 1955 (73)
Plymouth, 1963 (36)
Cardiff, Llandaff Castle, *Stanley Spencer, Religious Paintings*, 1965, Bangor, Haverfordwest, Swansea (repr.)

REFERENCES
RA *Illustrated*, 1950, p. 27
Wilenski, 1951, p. 6, pl. 1 (in colour)

236 The Resurrection: Rejoicing

1947
Oil on canvas, triptych
each panel 76.2 × 50.8 cm/30 × 20 ins
Lent by The Beaverbrook Art Gallery, Fredericton, New Brunswick; Gift of the Second Beaverbrook Foundation

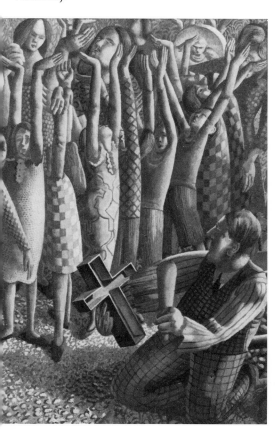
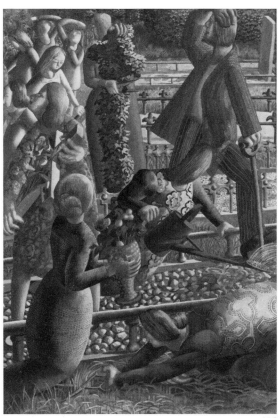

236

Like the *Resurrection: Reunion* (no. 240), this painting shows the joyful resurrection of the quick and the dead. In this picture, however, Spencer tried to create a scene in which the people tending the graves on the right, and those leaning over the hedge at the extreme top left, see the Resurrection as 'a kind of vision', which takes place on the gravel path and the flower-filled grass of the central and left hand panels.

The central scene shows a group of children accompanied by three women, who raise their arms heavenwards in ecstasy, watched from the foreground by a man brushing out a cross-shaped 'flower trough'. In the right-hand panel the man and women tending the graves look up from their activities to see the 'vision', while two others, one cutting the grass with a pair of scissors, the other using a watering can, carry on their work oblivious of what is happening. In a rare reference to an actual event, Spencer recalled that the woman with the scissors was someone who had once looked after him, who used to say: ' "I've just been down to the churchyard and given me mother a clip round", and she did it just with scissors' (Wilenski, p. 14).

The 'vision' of the Resurrection continues in the left-hand panel where young girls skip joyfully through the grass. One of the dancers presents a baby to its 'living mother', while onlookers gaze over the cemetery hedge.

EXHIBITIONS
RA, summer 1950 (564)
British Council, London, and Vancouver Art Gallery, *21 Modern British Painters*, 1951 (33) and on tour to the Western USA

237 The Resurrection: Waking Up

1945
Oil on canvas, triptych
centre 76.2 × 50.8 cm/30 × 20 ins
side panels each 50.8 × 76.2 cm/20 × 30 ins
Lent by the Nevill Gallery, Canterbury and Bath

In this painting Spencer chose to show the early stages of the Resurrection, at the moment when the dead are just coming to life, stretching and yawning on their graves as though the event was an everyday occurrence. In 1950 he wrote: 'Here in the central panel there are two mourners on a cast-iron seat . . . and all around them are the resurrecting waking up. I wanted to stress the idea of the seat being somewhere in the cemetery specially made for the living and now used at the resurrection by these visitors, just as they have used it time and again when they came to sit there and think peacefully and hopefully about those lying near them. They are not disturbed by the resurrection but, because of the joy they feel at the peace of it, remain where they are. The man who holds the wreaths in his lap now points to people resurrecting in the left panel, and the woman with arm linked in the man's sends her child off to greet people resurrecting in the right panel. Above this couple are seen resurrecting people lying on the top of graves in praying attitudes and below them in the foreground an old grave-digger . . . gathers up leaves with two wooden boards' (Wilenski, p. 15).

In the left and right-hand panels women and children sit up or lie in among the convolvulus, primroses and daisies. Several babies, who need no care now that the Resurrection has taken place, crawl wherever they wish.

An early pencil composition (see no. 244) for the right-hand panel included two 'kitchen alarum clocks', which were not used in the final painting. These were probably intended to add to the 'homely' atmosphere of the Resurrection, in which the dead were to be roused at the Last Trump by the familiar sound of an alarm call.

EXHIBITIONS
RA, summer 1950 (566)
ICA, *Ten Decades*, 1951 (250)
Tate Gallery, 1955 (69)

REFERENCES
Wilenski, 1950, p. 16, pl. 7 (in colour)
Britain Today, July 1950, pp. 36, 37

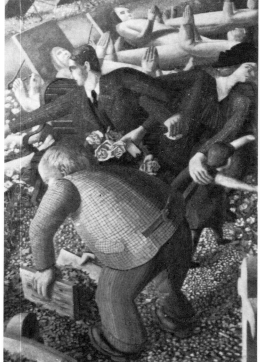

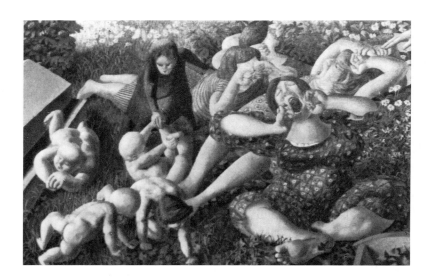

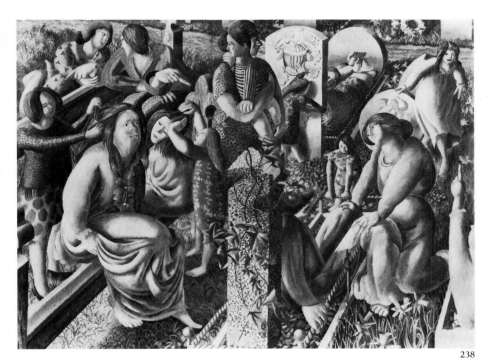

238

238 The Resurrection: Tidying

1945
Oil on canvas
76.2 × 101.6 cm/30 × 40 ins
Lent by Birmingham City Art Gallery

In 1951 Spencer described the picture in his usual detailed manner: 'A pink granite head-stone is here the central element dividing the two worlds, right and left. Above it is a sort of nursemaid woman holding a child in a striped jersey in her arms; behind this group a child in a flowered frock reaches round the head-stone of another grave to take the left hand of her mother lying on this grave; in her right hand the mother holds a handkerchief which she has just waved to attract the child.

'In the foreground of the right half of the picture a girl greets her bearded father who leans back against the pink granite stone; and a child leans on the rail and looks down. Further to

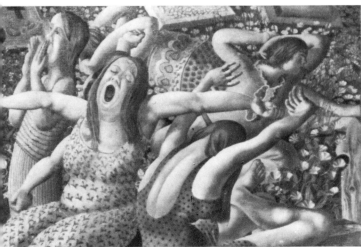

237

the right a young woman recognises her husband (who beckons her with a raised hand) and comes forward to meet him. This husband, of which only this raised left arm is seen here, is part of another group outside the picture.

'On the other side of the pink pillar head-stone two women sit opposite ways on a wooden stile grave while their children comb their hair. Behind, a man and woman talk to each other across a similar style grave' (Wilenski, 1951, p. 18).

The title of the picture, *Tidying*, refers to the two young girls who comb their newly arisen mothers' hair in preparation for returning to their homes, as they do in *The Resurrection with the Raising of Jairus's Daughter* (no. 241). The beautiful intertwining of the figures with the gravestones, and grass and flowers, was a constant feature of Spencer's earliest representation of the event, *The Resurrection of the Good and the Bad*, in 1913. The tapestry-like quality of some of the *Resurrection* series is particularly evident in this scene.

In his commentary to the work for Wilenski (1951) Spencer also made some general points about the *Resurrection* pictures: 'In several of these paintings I have wanted to suggest an idea of different kinds of "looking" – the steadfast look of the parents in the big picture (no. 242), for example; and here I wanted to give the difference between the daughter on the right who looks with affection and devotion at her father, and the kind of peering round the headstone of the child and mother, and the conversational look of the man and woman at the top on the left who are just talking sympathetically; and in the centre I wanted to make the contrast between the nurse-maid woman looking into the right-hand world and aware of all she sees, and the look of the child she carries, who is turned to the left and looks at what he sees with wonder.' The division of the picture into a left and right hand 'world' also occurs in *The Resurrection, Port Glasgow* (no. 242), in which the two halves are symbolised by the man and woman who meet in the centre of the picture. There, the idea is clearly intended as a

reconciliation, at the Resurrection, of the opposing 'male-female' poles.

In *Tidying* Spencer seems to be trying for the same effect, with the Janus-headed pair of the nurse-maid and boy placed strategically in the centre of the composition, which is further divided by the large pink granite tombstone in the foreground.

EXHIBITIONS
Tooth, 1950 (3), repr. on cover of catalogue
Tate Gallery, 1955 (70)

REFERENCES
Wilenski, 1951, pp. 4, 18, 24, repr. p. 54
Illustrations, 1952, repr. p. 42
Studio, vol. 147, Feb. 1954

239 The Resurrection: Reunion of Families

1945
Oil on canvas
76.2 × 101.6 cm/30 × 71¼ ins
Lent by City of Dundee District Council Museums and Art
Galleries Department

This is another of the scenes of the Resurrection which Spencer imagined taking place in Port Glasgow cemetery. The theme of the *Reunion of Families* is closely related to another painting in the series, *Reunion* (no. 240), in which visitors to the cemetery meet their newly risen friends and relatives.

In the picture the living have come to the cemetery on the Last Day to welcome their resurrecting parents and children. On the left a mother leans calmly back over her tombstone to be greeted by her child who is presented by a relative, while behind her a bearded old man embraces his daughter. To the right another mother helps her daughter climb from a grave, and beside them a child stretches and yawns sleepily. In the

background a group of newly resurrected men carry home in domed glass cases the wax flowers which were used to decorate their graves. Beside them walk three women carrying babies tightly wrapped in shawls. Spencer had been intrigued by the sight of Glasgow women carrying their babies in the traditional manner, on an earlier visit to Port Glasgow. In April 1941 he described to Dudley Tooth (Tooth archives) how a maid at the Star Hotel where he was staying had demonstrated the method of wrapping, using a cushion as a substitute for the baby. He had made a quick sketch of the scene, which he used here.

The picture was originally purchased from the artist by Mr W. M. Bennet, a member of Spencer's circle of friends in Port Glasgow. It was not included in Wilenski's book on the *Resurrection* series (Faber and Faber, 1951).

EXHIBITIONS
Tooth, 1950 (1)
Tate Gallery, 1955 (68)

REFERENCE
Britain Today, July 1950, pp. 36, 37

240 The Resurrection: Reunion

[detail of right-hand panel repr. on front cover]

1945
Oil on canvas, triptych
left and middle panels 75.6 × 50.8 cm/29¾ × 20 ins
right panel 76.2 × 50.1 cm/30 × 19¾ ins
Lent by Aberdeen Art Gallery and Museum

In his commentary on the picture written for R. H. Wilenski's book on the *Glasgow Resurrection* series (Faber and Faber, 1951), Spencer wrote: 'In the large resurrection picture [no. 242] . . ., there are some still living people (the mourners) as well as the risen dead. In *Reunion* this is carried further and I have tried to suggest the circumstance of the resurrection through the quick

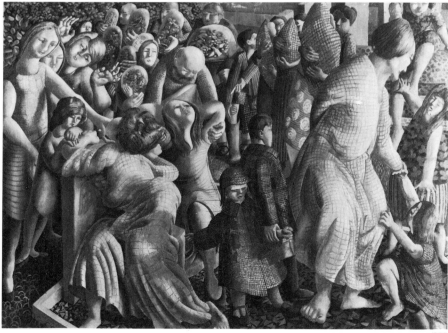

239

216 Shipbuilding on the Clyde: Burners 1940 (*top*)

219 Shipbuilding on the Clyde: Riveters 1941 (*bottom*)

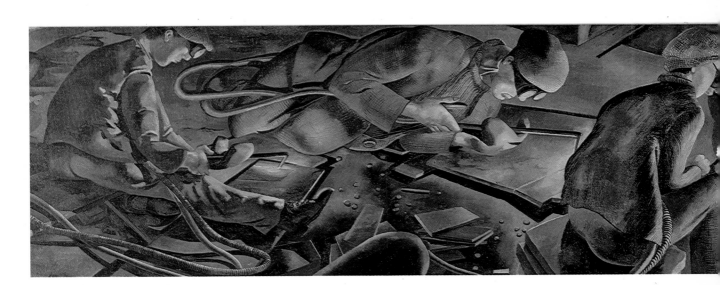

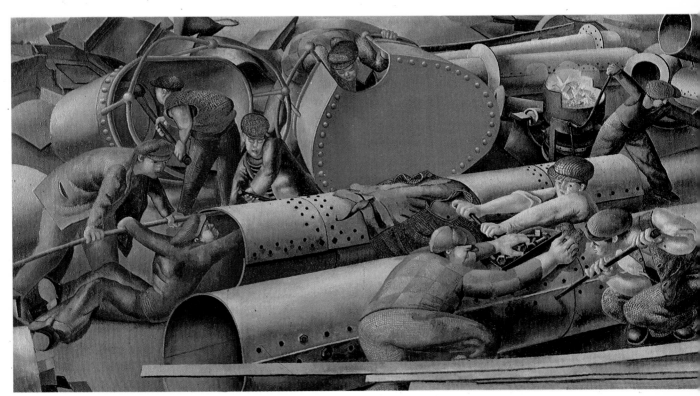

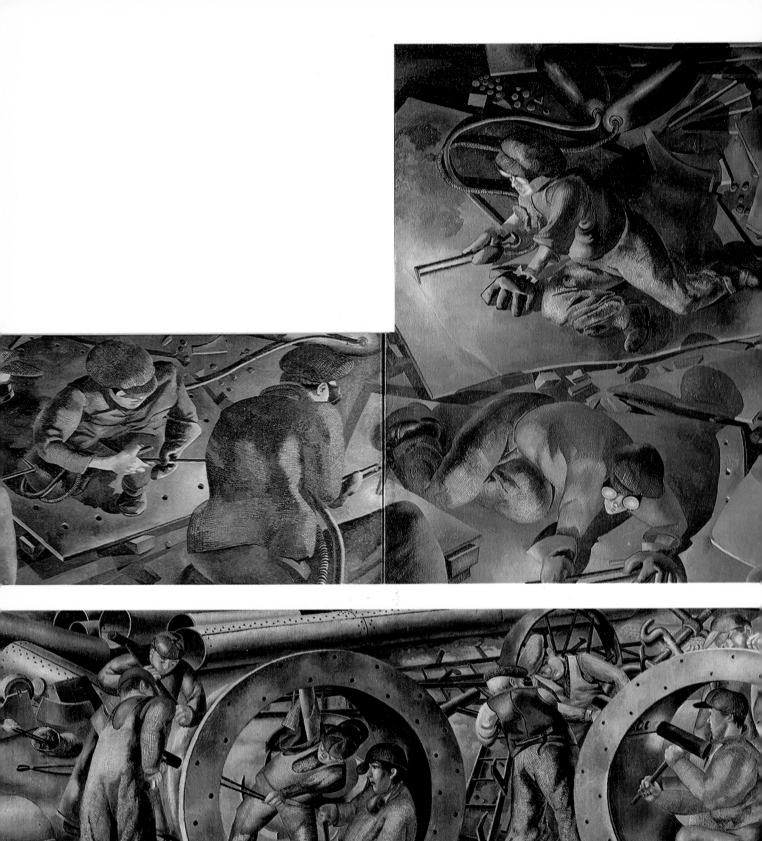

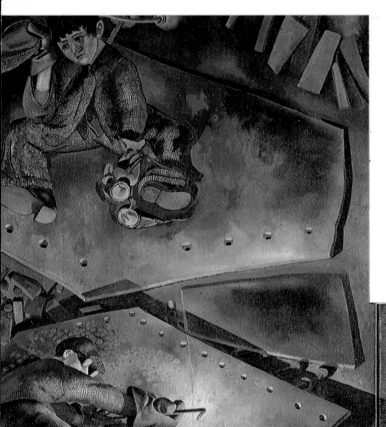

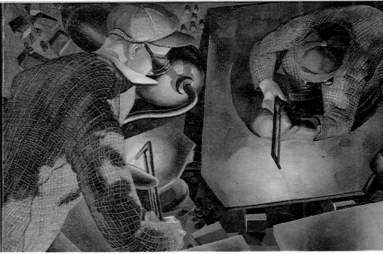

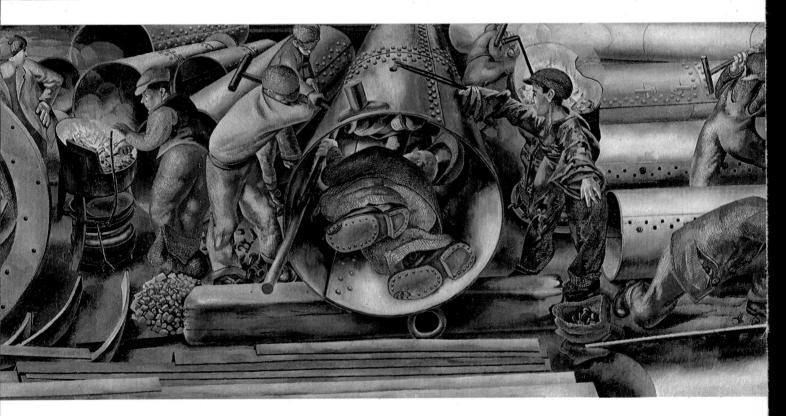

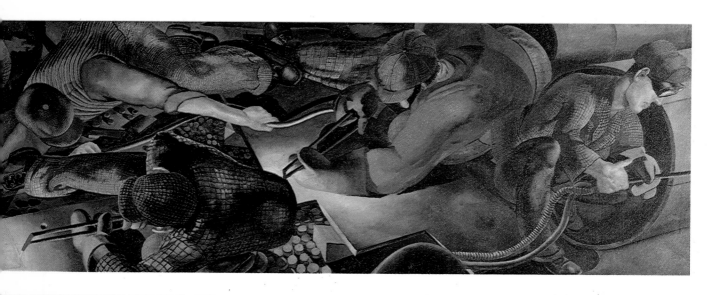

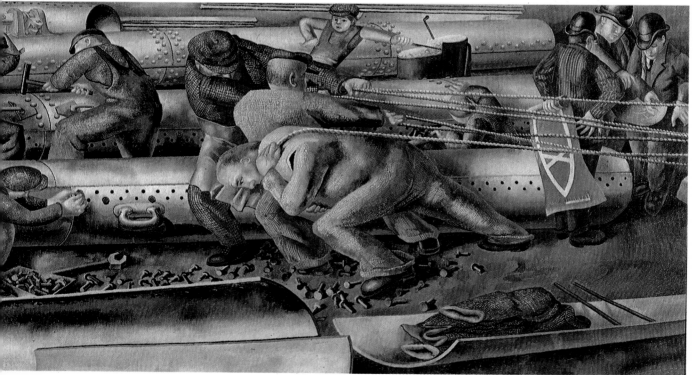

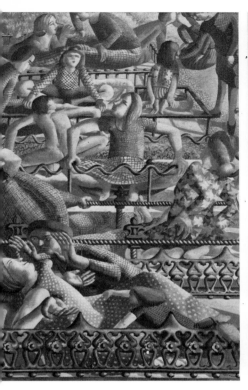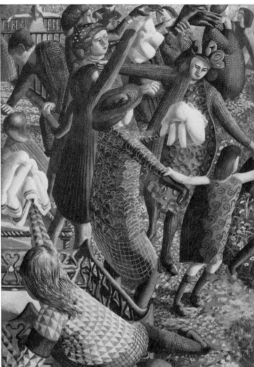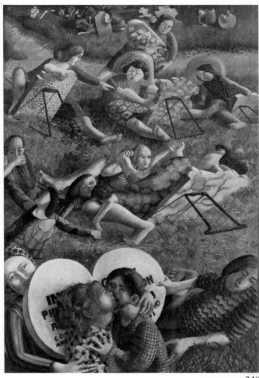

240

and the dead, between the visitors to a cemetery and the dead now rising from it. These visitors are in the central panel, and the resurrected are in the panels right and left.'

In this panel the visitors, 'wearing semi-mourning clothes', walk up the gravel path or lean over the graves, and wave handkerchiefs and gloves to their newly-resurrected friends. To the right are heart-shaped tombstones and others supported by iron stands, which Spencer had seen in the Port Glasgow cemetery (see no. 250). Here, in the foreground, a couple embrace before two adoring women; and beyond, others, newly arisen, lean on their headstones and talk, while a mother plays with her two children, who emerge from their grave to clamber over her.

Other Resurrection scenes take place in the left-hand panel, where this time the dead emerge from graves surrounded by elaborate cast-iron railings. Here in the foreground a husband greets his wife while a child clambers on to her knees. Beyond a husband and wife gaze about them and a group of children 'squat and hold on to the railing as they might of their own garden [fence] or crib.' Beyond, '. . . a wife uses her husband's outstretched leg as a fence for looking into the beyond'. Near them a 'still living mother' greets her newly resurrected child.

Spencer explained the atmosphere he wished to create in Wilenski's book (p. 22): 'Here I had the feeling that each grave forms a part of the person's home just as their front gardens do, so that a row of graves and a row of cottage gardens have much the same meaning for me. Also although the people are adult or any age, I think of them in cribs or prams or mangers. ''Grown-ups in prams'' would perhaps express what I was after – the sense of security and peace that a babe has as it gazes over the rim of its pram out into the world around it.' Spencer used this idea literally in *The Resurrection with the Raising of Jairus's*

Daughter (no. 241), where the resurrected emerge from under the paving stones in front of their houses. Studies for the left and right hand panels are included in the exhibition (nos. 248, 249).

EXHIBITIONS
RA, summer 1950 (567)
British Council, Canada and USA, *21 Modern British Painters*, 1951 (32)
Tate Gallery, 1955 (71)
Arts Council Welsh Committee, *Stanley Spencer – Religious Paintings*, 1965 (23), pl. 23
Cookham Festival of the Arts, May 1975
Arts Council, 1976–7 (43)

REFERENCES
Wilenski, 1951, pp. 12, 22, pls. 5 and 10 (detail in colour)
Scottish Art Review, vol. v, no. 3, p. 24
Studio, vol. 147, p. 34
Aberdeen Art Gallery, *Annual Report*, 1952
Robinson, 1979, p. 69, pl. 58

241 The Resurrection with the Raising of Jairus's Daughter

1947
Oil on canvas, triptych
centre section 76.8 × 88.3 cm/30¼ × 34¾ ins
sides each 76.8 × 51.4 cm/30¼ × 20¼ ins
Lent by Southampton Art Gallery

As Spencer later commented, this triptych differs from the other *Glasgow Resurrection* pictures, having been conceived in part as early as 1940 when the artist was staying in Leonard Stanley, Gloucestershire. There he had developed a desire to do a Resurrection '. . . in some suburban place or small town such as Stonehouse, and with this wish strongly felt, I saw a photograph in a house where I was lodging of a church standing

at a junction of two streets. . . . This actually gave me the first material for this street resurrection picture' (Wilenski 1951, p. 20). Inspired by these ideas, Spencer drew the two side panels of the triptych before returning to Port Glasgow where he composed the central scene, the whole design not being finally completed until April 1947.

The central panel illustrates the miracle of Jairus's daughter (Mark 5:22–43) who can be seen through the window of the house standing between the two streets. Here, in the homely atmosphere of the brightly lit room, Spencer has chosen the moment at which Christ, with one hand pointing heavenward, brings Jairus's daughter back to life. Around the bed and leaning comfortably on the mantlepiece, believers watch the miracle. The unbelievers, seated on the bed, turn their backs in open scepticism. In accordance with his usual leniency towards wrongdoers, Spencer does not follow the Bible in having them driven from the room, although the working drawing shows that originally several of them were to have been placed outside on the ground beneath the window.

Spencer chose to link this New Testament Resurrection scene with the more general events of the Resurrection and Last Judgement as they are predicted in the Book of Revelation, which he shows taking place in the wings of the triptych.

In the left-hand panel people resurrect in the streets of Leonard Stanley, emerging in an extraordinary and truly Spencerian manner from beneath the paving stones. Here, watched by a row of curious children who lean against the ivy-clad wall, they stand about or greet their friends joyfully. Others return home to their families who have decorated their doorway with 'the usual "Welcome Home" signs and flags and bunting they put up for the soldiers returning from the war' (Wilenski, 1951, p. 20). At the top of the scene is the lower part of Leonard Stanley church, which had inspired the idea of a Resurrection in 1940.

In the right-hand scene newly resurrected people spill out of a churchyard at the top of the picture and hurry down the street to be greeted at the garden gates by their families. Some bring with them the 'wreaths and framed photographs' which had been placed on top of their graves, and which they now return to their relations. In the lower right foreground Spencer

himself, dressed in a strange metallic coat, and his first wife Hilda, in a flowered pink and white blouse, are united again at the Resurrection and watch the scenes of rejoicing from behind the garden fence.

In the triptych Spencer contrasted the quiet, intimate scene of the bedroom, which is concealed from all but the viewer's eyes, with the scenes of communal rejoicing outside. Despite the momentous nature of the event, the villagers take it in their stride, and even the appearance of their relatives from beneath the pavement gives rise to only mild curiosity on the part of the children.

EXHIBITIONS
Tooth, 1950 (15)
Bournemouth Arts Club, *Contemporary British Painting*, 1952 (54)
London, Arts Council Gallery, *Paintings from Southern and Midland Art Galleries*, 1953 (31), pl. 3 (centre panel)
Exeter Art Gallery, *Contemporary Paintings from Southampton Art Gallery*, 1955 (24)
Tate Gallery, 1955 (72)
Worthing, 1961 (30)
Cannon Hall, Cawthorne, Barnsley, *Four Modern Masters*, 1959 (34)
Arts Council, Welsh Committee, *Stanley Spencer, Religious Paintings*, 1965 (26)
Adelaide, National Gallery of South Australia, *Adelaide Festival of Arts, Special Exhibition*, 1966 (17)
Arts Council, 1976–7 (44)

REFERENCES
Wilenski, 1951, p. 20, pl. 9
Britain Today, July 1950, pp. 36–7
M. Collis, 1962, p. 197
E. Rothenstein, 1962, pl. 12 (detail, in colour) and black and white
Robinson, 1979, pp. 71–2, repr. in colour

242 The Resurrection, Port Glasgow

1947–50
Oil on canvas
215 × 665 cm/84½ × 262 ins
Lent by the Trustees of the Tate Gallery

This work, painted between 1947 and 1950, was, with *The Hill of Zion* (no. 235), the only picture in the *Resurrection* series to be made to the original scale intended by the artist. In it Spencer sought to provide the people of Port Glasgow and the shipyards with the same kind of joyful Resurrection which he had earlier

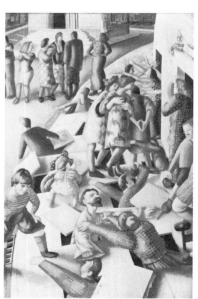
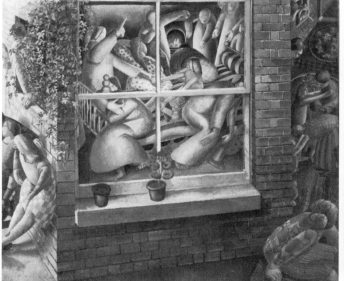
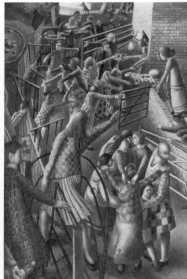

made for his friends and fellow Cookhamites in *The Resurrection, Cookham* 1926.

Originally the picture was only two-thirds the size of the present work. Early in 1949 Spencer decided to include a scrapbook drawing scene (not included in the Leder catalogue) of the 'table tomb', which he painted in at the left-hand end of the nearly completed canvas. This moved the centre of vision to the left and unbalanced the composition. It also left the old man in the foreground cut in half by the edge of the canvas, and 'without a world' (as the artist put it) 'of his own'. To solve these difficulties Spencer added a further nine feet of canvas to the left of the existing picture. This placed the tomb in the centre of the composition, and equally divided the two 'worlds' of the old couple (Spencer and Hilda), kneeling in the foreground. The remainder of February 1949 was spent in composing the scenes in the new section. The picture was finally completed early in 1950 (notes made by Spencer 1949–50, Tate 733.3.61).

In his description of the painting (Wilenski, 1951, pp. 8, 10), Spencer divided the picture into three sections: in the centre a group of men, women, and children look at the carvings 'and references to themselves' on the lid of the table tomb. In front the old couple, or 'grandparents', have crawled from their respective graves to meet in the middle of the composition. They come from the two worlds of the left and right halves of the picture. These were not, as the artist explained, rigid divisions into male and female spheres, but he '. . . did want to suggest something of the growing together from the two worlds of a long married couple, the togetherness and yet separateness, and also something of the mystery of the Resurrection, the meeting of the two worlds, this world and the resurrected-life world. . . .' (Wilenski, 1951, p. 8).

Spencer imagined the opening of the table tomb taking place in the left and right hand sections of the painting. On the right a group of the resurrected stand with their hands raised in ecstasy. In the foreground a 'wingless angel' wipes the tears from an old man's face. Behind, watched by a grave-digger, a young girl is helped out of a grave by clambering over a man's back. Spencer was particularly pleased with this section of the composition, which he likened to the stalk and petals of a flower.

In the left-hand scene, a girl climbs out of the tomb to meet her sailor husband. The shells on the ground beside him were apparently common grave ornaments in the Port Glasgow cemetery. Below them three 'mourners' recline comfortably on the grass as they watch the newly-resurrected raising the granite lids of their tombs. In the top left of the picture a group of men and women stand reading the inscriptions on the tombstone made in the shape of a book. This had been adapted from an earlier self-portrait drawing which Spencer had made in the shipyards (*c.* 1940), in which he is seen turning over the leaves of his large sketch-pad for a group of shipyard workers (notes made by Spencer, February 1949, Tate Gallery archives). In *The Resurrection* he imagined the stone book coming to life, so that the pages could once again be turned over and read.

A comparison with the 1926 picture, *The Resurrection, Cookham* (no. 89), gives a clear impression of the changes which Spencer's painting style had undergone in the intervening period. The composition has become more densely packed, with details crowded into every available space. The figures have become larger and more distorted by their exaggerated expressive movement. Spencer's growing obsession with pattern, both in the gestures and in the clothes of the resurrected, gives the painting an agitated artificial air which contrasts sharply with the calm naturalistic atmosphere of the Cookham picture. The paint surface, too, has become thinner and flatter. Colour, which plays an important if subdued role in the 1926 painting, is reduced to the function of complementing the drawing. The light falling from the right is paler and harsher than the warm glow which pervades the Cookham painting.

EXHIBITIONS
RA, summer 1950 (557)
Tate Gallery, 1955 (74)

REFERENCES
Britain Today, July 1950, pp. 37–8
Wilenski, 1951, pp. 6–10, 204, pls 2–4 and cover (details), all in colour
Studio, CXLVII, 1954, p. 37
J. Rothenstein, *Modern English Painters; Lewis to Moore*, 1956
M. Collis, 1962, pp. 193–9, 211–12, 215, 224, 247
Robinson, 1979, p. 69, pl. 69

243 Study for The Resurrection: Port Glasgow

1949
Pencil on paper
37.5 × 96.5 cm/14¾ × 38 ins
Lent by a Private Collector

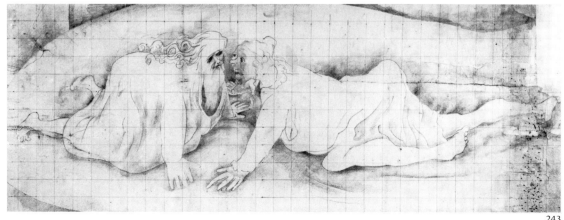

243

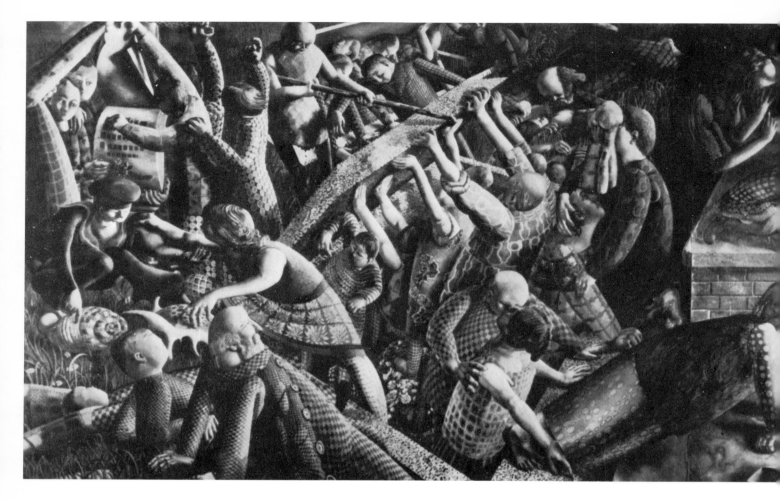

A study for the man and woman who meet in the centre foreground of *The Resurrection: Port Glasgow* (no. 242). The artist identified the pair as himself and Hilda Carline. The drawing was probably made in February 1949 when Spencer added an extra seven feet of canvas to the left hand end of the painting. This meant that the old man, previously cut in half by the edge of the canvas, was now seen in his entirety. The artist later explained that the couple, who have just emerged from their respective graves, symbolise the 'his' and 'her', left and right halves of the canvas.

244 Study for The Resurrection: Waking Up

1944
Pencil on paper
40.4 × 26.7 cm/16 × 10½ ins
Lent by the Trustees of the Tate Gallery

This study and nos. 245–9 belong to a series of working drawings made by Spencer in 1944–5 for paintings in the *Port Glasgow Resurrection* series (p. 196).

Spencer described the drawing in 1951 (Wilenski, p. 16): 'In the pencil composition of the right-hand panel I had two kitchen alarum clocks rolling in the grass. Although there is no

likelihood of such things being in a graveyard, I think it was a mistake not to have kept them in the painting' (see no. 237).

245 Study for The Resurrection: Rejoicing

1944
Pencil on paper
40.4 × 26.7 cm/16 × 10½ ins
Lent by the Trustees of the Tate Gallery

A study for the right-hand panel of *The Resurrection: Rejoicing* (no. 236), showing the 'mourners' watching the Resurrection taking place on the far side of the cemetery. In transferring the composition to canvas the artist omitted the angel's wing at the upper left of the drawing.

246 Study for The Resurrection: Tidying

1944
Pencil on paper
43.2 × 26.6 cm/17 × 10½ ins
s. 'Stanley Spencer Oct 1st 44'
Lent by the Trustees of the Tate Gallery

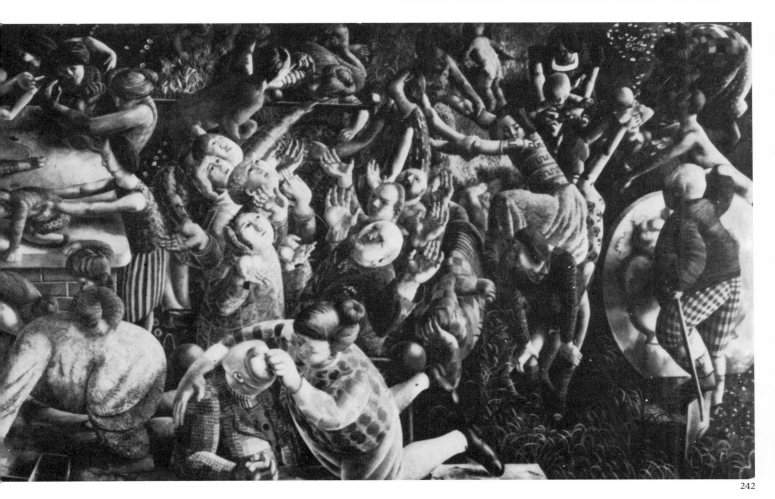

242

A working drawing for the right-hand part of *The Resurrection: Tidying* (no. 238), showing a mother and child greeting a newly resurrected man who leans against the granite headstone of his grave.

247 Resurrecting Mothers

1944
Pencil on paper
40.4 × 26.7 cm/16 × 10½ ins
s. 'Stanley Spencer Sept–Oct 1944'
Lent by the Trustees of the Tate Gallery

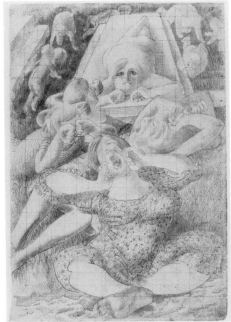

244

245

246

247

A working drawing for a detail of the painting *The Resurrection: Tidying* 1945 (no. 238).

EXHIBITION
Arts Council, 1954 (45)

A study for the right-hand panel of *The Resurrection: Reunion* (no. 240), showing the Resurrection taking place in the cemetery at Port Glasgow.

249

249 Study for The Resurrection: Reunion

1945
Pencil on paper
40.4 × 26.7 cm/16 × 10½ ins
s. 'Stanley Spencer 1945'
Lent by the Trustees of the Tate Gallery

A working drawing for the left-hand panel of *The Resurrection: Reunion* (no. 240). In the study families are reunited at the Resurrection.

248

248 Study for The Resurrection: Reunion

1944
Pencil on paper
40.4 × 26.7 cm/16 × 10½ ins
Lent by the Trustees of the Tate Gallery

250

250 Port Glasgow Cemetery

1947
Oil on canvas
50 × 76.2 cm/20 × 30 ins
Lent by the British Council

The painting is a view of the cemetery at Port Glasgow which Spencer discovered while he was working on the *Shipbuilding* pictures (see nos. 216–24) as official war artist of the nearby Lithgows shipyards during the Second World War. The event is recorded in a famous passage written in his notebook shortly afterwards: 'One evening in Port Glasgow when unable to write due to a jazz band playing in the drawing-room just below me, I walked up along the road past the gas works to where I saw a cemetery on a gently rising slope. . . . I seemed then to see that it rose in the midst of a great plain and that all in the plain were resurrecting and moving towards it. . . . I knew then that the resurrection would be directed from that hill.' This walk inspired the *Port Glasgow Resurrection* series, 1945–50 (nos. 235–42), whose central picture, *The Hill of Zion* (no. 235), was set on the summit of the hill which fills the larger part of this landscape. Here Spencer envisioned a scene of Christ and his disciples and angels observing the Resurrection of the people buried in the surrounding graves, from which they emerge to celebrate their reawakening. The other paintings in the series (with the exception of *The Raising of Jairus's Daughter* (no. 241), which is based on a street in Leonard Stanley) were set among the neatly kept graves and parallel gravel paths which run round the slope of the cemetery, 'hill of Zion', and down on to the more level ground of the 'plain'.

Beyond the cemetery and over the rooftops of Port Glasgow can be seen the river Clyde and the gently rolling hills on the far bank. Spencer had already painted these views on previous visits to the Port during breaks from his work on the shipyard canvases. These four pictures were: *Port Glasgow* 1944 (no. 232), *The Garden, Port Glasgow* 1944, *The Clyde from Port Glasgow*

1945 and *Clydeside* 1945, all in Private Collections. *Port Glasgow Cemetery* was the last landscape which Spencer painted in Scotland, probably while he was staying with his friend Graham Murray at 7, Crown Circus, where some of the *Resurrection* pictures were painted between 1945 and 1950.

EXHIBITION
Stanley Spencer Gallery, Cookham 1979

251 Angels of the Apocalypse

1949
Oil on canvas
70 × 88.9 cm/24 × 35 ins
Lent by Dr the Hon. C. H. T. Chubb

The picture, inspired by 'photographs of French cathedral tapestries', was originally intended to form part of the *Port Glasgow Resurrection* series of paintings, where it was to hang above *The Resurrection: The Hill of Zion* 1946 (no. 235). The angels with their vials of wrath were to go over the hill upon which Christ, the prophets, and the angels were seated to give judgement.

In April 1949, however, Spencer had a change of heart. Writing to Dudley Tooth he explained that he did not like the idea of the angels as bringers of retribution (Revelation 16), but preferred their errand to be of a gentler nature; 'I wanted some measure of mercy and so hoped it could be thought that some less potent poison was being poured on the wrongdoers', he wrote (Tooth archives). This difficulty was compounded by a difference in mood between the two paintings: 'I do not know why I lost heart over it being at the top of the Hill of Zion. I think I thought . . . it cast a shadow over the sunlit hillside . . . and while the intent of both paintings is a kind of severity . . . in the angels flying it is the kind that goes with sadness, a something not of the same order of happiness that I expressed in the Hill of Zion.'

251

Because of these doubts Spencer decided to transform the picture into a new subject only tenuously related to the *Resurrection* theme. Instead of the Apocalypse the picture was to become 'one of the few compositions I have done of the Creation, this being angels assisting God in fertilising the earth with distributory [*sic*] seeds.' This did not mean that the idea of the Apocalypse was entirely abandoned, as Spencer explained: 'I think the composing of these angels was done with the thought of them being Apocalyptic ones but not on such awful punishing errands. . . . I cannot face the punishment as revealed in the book of Revelation . . . there is something inexplicable in angels carrying out eternal punishments. . . . A reminder of past wrongs and a call to repentance was as much as I could bear in the matter of the quality of punishment, if there was to be any at all.'

Although the artist clearly tried to reconcile these conflicting feelings, the picture was never hung above *The Hill of Zion*, and was sold separately.

As completed the painting forms only the central part of a longer compositional drawing, now lost. It is likely that the artist intended this composition to form the sky over the entire length of *The Hill of Zion* rather than only the central part as it does in its existing form.

EXHIBITIONS
Tooth, *Today and Yesterday*, 1949 (6)
Tooth, 1950 (2), repr.
Tate Gallery, 1955 (75)
Cookham Church and Vicarage, 1958
Arts Council, 1976–7 (46)

REFERENCE
Herbert Read, *Contemporary British Art*, Harmondsworth, 1947, pl. 42

6 Years of Recognition 1945–1959

At the end of the war in 1945 Spencer found himself in a considerably better situation than his state of near isolation six years earlier in 1939. The *Shipbuilding* series, completed in 1946 with *Furnaces* (no. 224), had gained him a great deal of favourable critical support and publicity. He was also well on the way to completing the important *Port Glasgow Resurrection* paintings, which promised to be less controversial, and therefore more saleable, than the figure paintings of the late thirties. Finally his economic situation had improved with the help of Dudley Tooth. Although he was never to become wealthy from his painting, Spencer could relax somewhat after the continuous crises of the pre-war years.

The years 1945–50 were spent finishing the *Resurrection* series, and in particular *The Resurrection: Port Glasgow* 1950 (no. 242), which he clearly saw as an attempt to recreate the outstanding quality of the 1926 *The Resurrection, Cookham* (no. 89); this hope was in part realised when the painting was bought by the Chantrey Bequest for the Tate Gallery in 1950. In the same year Spencer was drawn back into the art establishment when he rejoined the Royal Academy and was elected R A. His Diploma work was *The Farm Gate* 1950 (no. 255), exhibited there in 1951. In the summer exhibition in 1950 he entered five of the *Port Glasgow Resurrection* paintings and made a highly successful come-back. Spencer continued to exhibit regularly at the Academy until his death, reaching a peak in 1956 when no less than seven works were exhibited. Many of these pictures were portraits, a reflection of his growing popularity, but also an indication that he was frequently distracted from his more important figure paintings.

The year 1950 also saw the death of Hilda, an event which Spencer marked with a painting, *Love Letters* 1950 (no. 256), which recalled their past voluminous correspondence and looked forward to its one-sided continuation until Spencer's own death in 1959. Hilda's death also caused Spencer to resume his interest in the Church House, which he now modified to contain small 'chapels' dedicated to Hilda, Daphne Charlton, Patricia Preece, Elsie, and one other. Some of the pictures for these already existed in paintings, or in drawings belonging to the 'Derwent' scrapbooks (see no. 207). Spencer drew heavily on the latter for subjects such as *Hilda Welcomed* 1953 (no.

262), and *Hilda and I at Burghclere* 1955 (no. 270), for the Hilda 'chapel'. He also began work on a vast canvas tentatively named *Hilda on Hampstead Heath*, or *Hampstead Heath, Litter* (unfinished, Private Collection), showing Hilda and the artist seated on a park bench surrounded by love letters, which are read by young women. This was to have been the 'altarpiece' for the chapel. Spencer also completed *Love on the Moor* 1955 (no. 267), begun in 1937, in which Hilda again figures prominently. The remaining 'chapels' in the Church House were neglected through lack of time, or were assigned pictures completed in the thirties, as in the case of Patricia Preece.

In the late forties Spencer also returned to his plans for *Christ Preaching at Cookham Regatta* (unfinished, no. 279), and the *Regatta* series which were intended for the 'river aisle' of the Church House. Several of these were completed, but the paintings lack the concentration and intensity of the 1930s works. During the same period Spencer also added two further scenes to the *Cana* series: *A Servant in the Kitchen Announcing the Miracle* 1953 (no. 260) and *Bride and Bridegroom* 1953 (no. 261). The *Odney Baptism* 1952 (no. 259) and *Bathing Pool, Dogs* 1957 (no. 274) also marked an attempt to paint more of the Church House, *Baptism of Christ* cycle.

Finally, in 1956, Spencer received his last major commission: to paint two pictures for Aldenham School. Of these *The Crucifixion* (no. 276), although much criticised at the time, remains one of the most successful of his post-war paintings.

During the last years of his life Spencer's work was increasingly interrupted by the cancer from which he eventually died, and the two major works of these years, *Hampstead Heath, Litter* (Private Collection) and *Christ Preaching at Cookham Regatta* (no. 279), remained unfinished at his death.

252 The Temptation of St Anthony

1945
Oil on canvas
121.9 × 91.4 cm/48 × 36 ins
Lent by the Hamet Gallery

The picture was painted for a competition run by an American

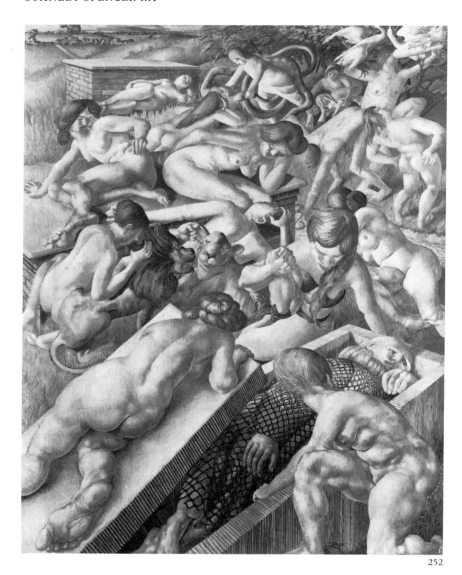

252

film company, Loew-Lewin Inc., for their motion picture production of Maupassant's *Bel Ami*, in which the winning painting was to appear. Other entrants included Leonora Carrington, Ivan Albright, Salvador Dali, Paul Delvaux, Dorothea Tanning, Abraham Ratner, and Max Ernst, and the works were to be juried by Alfred H. Barr Jr, Marcel Duchamp and Sidney Janis. Spencer's own name was probably suggested to the company by his agent Dudley Tooth, who was always alert for possible commissions for his artists. In the event Max Ernst was declared the winner and received an award of $2500, but in accordance with the terms of the competition Spencer was given a consolation fee of $500 and retained the painting.

In his treatment of the St Anthony legend, Spencer adopted an original approach which links the picture with other figure paintings concerned with religious and sexual freedom which he had painted in the thirties (see no. 184). In a letter to Dudley Tooth, dated January 1946, he commented: 'The story is the naming of creation, its animals etc., by Adam, and in doing so bringing together their respective kinds. . . . This ordering and dispensing of things, so fitting and so amiable, is what moves St Anthony and gives him a feeling of a need for completeness by

mergence in such harmony' (Tooth archive). The animal pairs, which appear in the top half of the painting, were adapted with slight changes from three *Scrapbook* compositions (see no. 207, Leder pp. 88–90) composed during 1943–4. They had been intended for a section of the Church House devoted to the naming of animals at the creation.

In the foreground of the painting St Anthony lies in a half open sarcophagus surrounded by naked women, several of whom bear a resemblance to Hilda Carline and Patricia Preece. Spencer explained to Tooth that St Anthony is tempted to enjoy the women before he has properly comprehended the nature of his desire. Unlike the saint of St Athanasius's legend however, he does not reject this desire out of hand; 'it is not a turning away from what he sees,' Spencer wrote, 'but a waiting for a time when he finds his own spiritual niche in the harmony' (Tooth archive). The women, as part of God's creation, may only be enjoyed when that harmony is achieved. The artist's highly personal theology rejected the idea that desire was evil and improper, but rather sought to exalt it as an important element of his faith.

The peculiar merging of the St Anthony legend with the

naming of the animals may have resulted from the short two month deadline set for the competition. Spencer had to work with unaccustomed haste, and he therefore tried to blend together a number of existing sketches rather than starting from scratch. Writing to Mary Behrend in February 1959 he recalled, '. . . I just emptied all my Slade life drawings into it' (Tate 733.1.120, draft letter). None of these drawings are identifiable, but the nude women in the foreground strike poses frequently employed in Slade School life classes (see no. 79). The *Scrapbook* drawings were incorporated for the same reason.

REFERENCE
The Life of Saint Anthony; newly translated and annotated by R. T. Meyer (Ancient Christian Writers), Westminster, Md. 1950

253 Portrait of Shirin Spencer

> 1947
> Pencil on paper
> 48.9 × 38.1 cm/19¼ × 15 ins
> inscbr. in pencil 'Stanley Spencer'
> Lent by Southampton Art Gallery

Shirin, aged 21, was living with her mother and Richard Carline in Pond Street, Hampstead, when Spencer made this drawing on one of his frequent visits there.

EXHIBITIONS
Worthing, 1961 (29)
RA, *Bicentenary Exhibition*, 1963–9 (645)
Arts Council, 1975–6 (90)

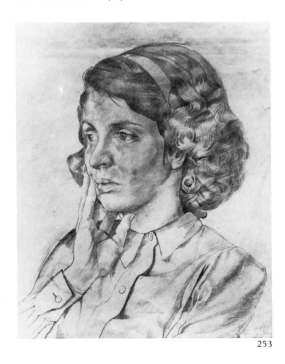

253

254 Cookham from Englefield

> 1948
> Oil on canvas
> 76.2 × 50.8 cm/30 × 20 ins
> Lent by Mr and Mrs R. W. H. Elsden

254

This is the first of five paintings commissioned by Gerard Shiel of his house and its grounds. It is dated 1948 in the artist's 1959 painting list, where it is described as *Cedar and Cookham from Englefield*. Mr Shiel took a lease on Englefield, Cookham, in 1939, and settled there permanently after the war. After meeting Spencer he began to collect his work, specialising in the landscapes. A Founder Member, Trustee, and sometime Chairman of the Trustees of the Stanley Spencer Gallery, Cookham, he died in 1975.

The other commissioned landscapes were: *Englefield Garden, looking towards Hedsor* 1950, *Englefield House, Cookham* 1951 (no. 257), *Wistaria at Englefield* 1954 (no. 266) and *Lilac and Clematis at Englefield* 1955 (all canvas, 76.2 × 50.8 cm/30 × 20 ins).

EXHIBITIONS
Tooth, 1950 (6)
Cookham Church and Vicarage, 1958 (15)
Plymouth, 1963 (37)
Stanley Spencer Gallery, Cookham, 1971, 74, 77
Cookham, Odney Club, Cookham Festival, *The Gerard Shiel Collection of Stanley Spencer Paintings* (1)
Arts Council, 1976–7 (45)

255 The Farm Gate

> [repr. in colour on p. 159]
> 1950
> Oil on canvas
> 89 × 57.1 cm/35 × 22½ ins
> Lent by the Royal Academy of Arts

The picture was presented to the Royal Academy by the artist as his Diploma Painting in 1950.

In the painting Spencer and his first wife Hilda open the gate of Ovey's farm in Cookham, which is opposite 'Fernlea', the artist's childhood home, to which he returned to live just before his death in 1959.

A drawing in the Astor Scrapbook series (vol. 4, p. 7), *The Farm Gate*, a detailed preparatory study squared for transfer, is dated 16 June 1946.

EXHIBITIONS
RA, summer 1951 (479)
RA, *A Selection of Diploma Works*, 1954
Tate Gallery, 1955 (76), pl. 8
Worthing, 1961 (32)
Plymouth, 1963 (39)
Bournemouth, 1965 (59)
RA, winter 1968 (470)
Arts Council, 1976–7 (48), pl. 48

256 Love Letters

1950
Oil on canvas
86.4 × 116.8 cm/34 × 46 ins
Lent by the Thyssen-Bornemisza Collection

The painting was intended to form part of the *Hilda Memorial* in the Church House scheme, where it was to hang as a kind of altarpiece on the end wall of the room. The correspondence between Spencer and Hilda began during the late twenties when the couple lived together at Chapel View, Burghclere. The letters were never posted; the Spencers read them aloud to each other. They maintained the correspondence after their divorce in 1937. Even after Hilda died in 1950 Spencer continued to write to her. In letters which were often over one hundred pages in length, he continued to inform her of his activities, and to describe his paintings.

In a letter of 1954 the artist discussed *Hampstead Heath, Litter* (never completed) in which love letters featured prominently. He recalled Burghclere where 'two- and three-hundred page' love letters were written at the kitchen table. Their letters frequently included drawings; the present painting is based on a sketch of Hilda which appears in a letter of 1930 (Carline, 1978, pl. 22). 'Love making' is the central theme of the letters written after Hilda's death, and is reflected in Spencer's paintings of scenes from their life together (see nos. 278 and 166). Both letters and paintings provided for Spencer an extension of the relationship rather than mere recollections of past experiences.

In the painting Hilda transfers letters from her bosom to Spencer's pocket, while he holds an opened letter to his face in a kind of ecstasy. Hilda died in 1950, the year in which *Love Letters* was painted. It is probable therefore that Spencer intended to commemorate their correspondence and to look forward to the spiritual communication which he was to maintain with her by means of letters and paintings. In 1954 he wrote: 'And then I thought how nice if I could wander forth out into certain places I know and write to you from there.' Some of these places had already been painted in the *Domestic Scenes* 1935–6 (nos. 162–7). Others were planned in the *Scrapbook* drawings of the forties. In 1950, with *Love Letters*, Spencer began to concentrate on the subject of his life with Hilda. Other paintings in the series include: *Hilda and I at Burghclere* 1955; *Hilda with Bluebells* 1955 (no. 268); the unfinished *Me and Hilda, Downshire Hill* (no. 278), and *Hampstead Heath, Litter* (Private Collection). In this last painting the love letters recur as the central theme. Hilda is shown at a council seat, with Spencer beside her. She reads letters which he writes to her.

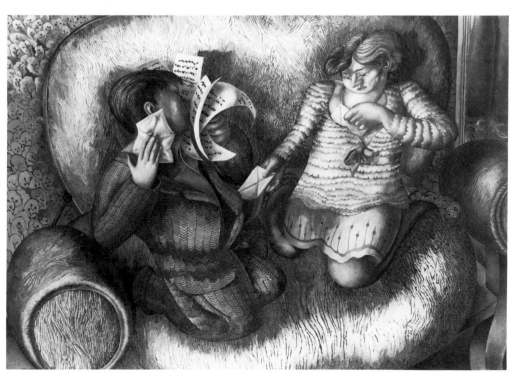

256

EXHIBITIONS
Tooth, 1950 (10)
Pittsburgh, Carnegie Institute, *International Exhibition of Paintings*, 1950 (187),
pl. 41
Tate Gallery, 1955 (77)
Tooth, 1960, repr.
Stanley Spencer Gallery, Cookham, 1967
Arts Council, 1976–7 (47), pl. 69

REFERENCES
M. Collis, 1962, pp. 214, 247, repr. f. p. 192
Robinson, 1979, p. 74, pl. 63 (in colour)

257

257 Englefield House, Cookham

1951
Oil on canvas
76.2 × 50.8 cm/30 × 20 ins
Lent by Mr and Mrs R. W. H. Elsden

The third of five paintings commissioned by Gerard Shiel of his house and garden. Spencer's diary records that he painted Englefield House in the afternoons and evenings in July and August 1951.

EXHIBITIONS
RA, summer 1952
Cookham Church and Vicarage, 1958 (17)
Worthing, 1961 (35)
Plymouth, 1963 (41)
Stanley Spencer Gallery, Cookham, 1972 and subsequently *The Gerard Shiel Collection*, Cookham Festival, 1975 (4)

258 Shillington's House, Whitehouse

1951
Oil on canvas
62.2 × 74.9 cm/24½ × 29½ ins
Lent by Lord Walston

After the Second World War Spencer made a number of journeys to see his elder brother, Harold Spencer, who lived at Whitehouse in Northern Ireland. On these visits he took the opportunity to paint new landscape subjects, as well as making several portraits of his niece, Daphne Spencer, including the fine *Daphne by the Window, Northern Ireland* 1952 (National Art Gallery, Wellington, New Zealand). According to Daphne Robinson (*née* Spencer) the title given to the picture by Dudley Tooth in 1951, *Shillington's House, Merville Garden Village*, is incorrect, the picture being painted in Whitehouse.

On a further visit to Northern Ireland in 1952 Spencer painted three more views of Whitehouse: *The Monkey Puzzle, Whitehouse, Northern Ireland* (50.8 × 70 cm/20 × 24 ins, Private Collection); *The Foreshore at Whitehouse* (30.5 × 40.6 cm/12 × 16 ins, Private Collection) and *Garden at Whitehouse, Northern Ireland* (50.8 × 76.2 cm/20 × 30 ins, Private Collection).

EXHIBITION
Stanley Spencer Gallery, Cookham, 1967–8, as *Shillington's House, Merville Garden Village*

258

259 The Baptism

1952
Oil on canvas
76 × 127 cm/30 × 50 ins
Lent by a Private Collector

Based on a drawing of 1945–6 (now in the Tate Gallery archives), this painting was intended as the central 'altarpiece'

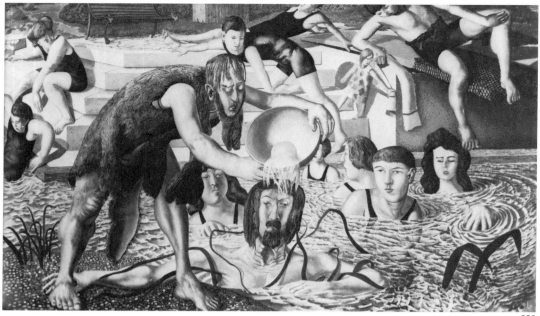

for a series of related scenes depicting events surrounding the Baptism of Christ, which in turn formed part of the ambitious Church House scheme. Within this *The Baptism* was to be a link with the life cycle of *Cana* (see no. 261), with the people who have just witnessed the events of the Baptism returning home (in the *Domestic Scenes*, for the marriage feast shown in *The Marriage at Cana: Bride and Bridegroom* 1953 (no. 261).

Spencer chose as a setting for *The Baptism* the bathing pool at the Odney Club in Cookham, where he had gone swimming as a youth, and which held a deep religious significance for him. In the foreground of the picture, Christ, half submerged among the reeds, is baptised by John the Baptist who leans forward from the single bank to pour the baptismal water solemnly over his head. The event is witnessed by the Odney bathers, who watch idly from vantage points on the steps, or stand up to their necks in the shallow waters of the bathing pool. Despite the momentous nature of the event, there is an atmosphere of matter-of-fact calm, which is emphasised by the small girl playing with a towel, and the man on the left who has not even seen what is happening and gingerly lowers himself into the water.

Spencer's fascination with repetitious pattern is particularly evident in this picture, where the jellyfish-like stream of water from the baptismal bowl finds an echo in the disembodied hand emerging from the water on the right. Another curious device, the reeds which wrap themselves like snakes round the figure of Christ, create an electric tension round him which helps to separate his form from those of the onlookers.

There are three other paintings in the *Baptism* series: *Sunbathers at Odney* 1955 (76.2 × 50.8 cm/30 × 20 ins, Stanley Spencer Gallery); *Girls Returning from a Bathe* 1935 (76.2 × 50.8 cm/30 × 20 ins, Private Collection) and *The Bathing Pool, Dogs* 1957 (no. 274). Spencer had first drawn the Odney Pool in 1921, in a sepia sketch, *Bathing in Odney Pool, Cookham* (whereabouts unknown, Wilenski 1924, pl. 23). He also painted a landscape of the scene, *Magnolia at Odney Club* (Private Collection).

REFERENCE
E. Rothenstein, 1962, p. 1, repr.

260 The Marriage at Cana: A Servant in the Kitchen Announcing the Miracle

1952–3
Oil on canvas
91.9 × 152.8 cm/37¾ × 60⅛ ins
Lent by the Beaverbrook Art Gallery, Fredericton, New Brunswick
Gift of Second Beaverbrook Foundation

The picture belongs to the central wedding-feast section of the *Marriage at Cana* series, and was begun in October 1952. On 4 July 1959, shortly before his death, Spencer explained the painting in a letter to Lord Beaverbrook: 'I was so pleased when some while ago . . . you acquired for your gallery the two paintings you mention. I like the ''Cana'' one: the idea that on so festive an occasion as a wedding the servants have some guests of their own – seen coming in the kitchen door and wiping their shoes, and the parlour maid coming from the dining-room and announcing the miracle to the kitchen maid (in a Windsor chair on the left), and seeing if the clothes on the horse are properly aired feeling them with the upper surface of her wrist as I remember they did. I am in the kitchen in which I imagined this part of the Cana marriage to have occurred, namely the kitchen of my old home ['Fernlea'] in which I and all the enormous family were born' (Beaverbrook Art Gallery files).

In a letter dated 10 October 1952 Spencer informed Elizabeth [Rothenstein?]: 'I have only just begun to paint it, but the little done (of kitchen wallpaper) has a homely look about it (*op. cit.*). A sepia drawing, *Servant announcing the Miracle* (91.4 × 15.24 cm/36 × 60 ins, Private Collection), is a study for the painting.

EXHIBITIONS
London, Royal Academy, *185th Annual Exhibition*, 1953 (145)
University of New Brunswick, Bonar Law–Bennet Library, Fredericton, Canada, *Exhibition of the Beaverbrook Collection of Paintings and Prints and some Portraits from the Collection of Sir James Dunn, Bart*, 1954 (8)

REFERENCE
E. Rothenstein, 1962 (n.p.)

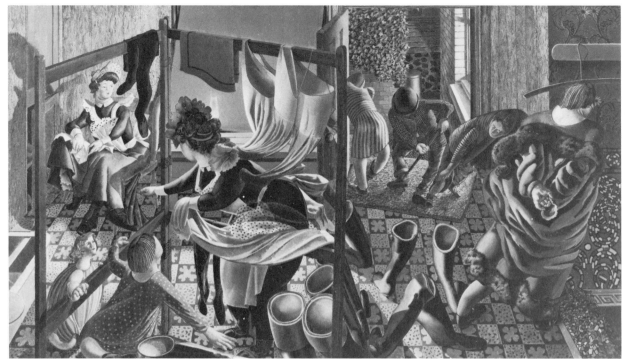

260

261 The Marriage at Cana: Bride and Bridegroom

1953
Oil on canvas
66 × 50.1 cm/26 × 20 ins
Lent by the Glynn Vivian Art Gallery and Museum, Swansea

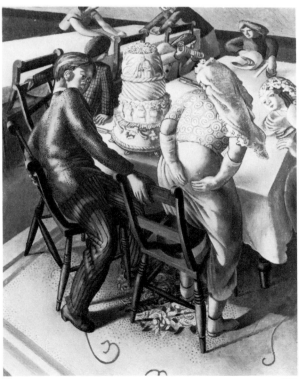

261

The subject of this painting belongs to the Church House scheme, first conceived in the thirties, in which the *Marriage at Cana* was a major theme. Within this series the central event is the feast itself which symbolises the blessing of the state of marriage by God. As Anthony Gormley has explained in an unpublished Cambridge thesis: 'The guests take part in a cycle of life through marriage. Their journey from their homes to the feast itself represents life from the age of majority to marriage. The return journey symbolises the passing on of life possibly through marriage – the children that result from the union of man and wife. Thus Cana becomes a symbol of life through marriage. . . .' Spencer's *Domestic Scenes* show the guests preparing for the feast or returning home, and *The Beatitudes of Love* (no. 188) are concerned with the more intimate details of married life.

The couple in the composition are represented by Stanley and Hilda Spencer, who also appear as the principal characters in the *Domestic Scenes* (nos. 161–7). In many ways the Cana pictures are also celebrations of Spencer's married life with Hilda, where they represent a relationship which eluded the artist in real life: '. . . my desire to paint pictures is caused by my being unable or incapable of fulfilling my desires in life itself,' he wrote (Arts Council Catalogue, 1976–7, p. 22).

The painting is also a reference back to the artist's marriage, and forward to a second marriage with Hilda, which he began to consider shortly after their divorce. When Hilda died, Spencer continued to think in terms of a spiritual union, which was symbolised by the Hilda Memorial chapel in the Church House.

Spencer began work on the central theme of the Cana wedding feast in 1935, when he painted *Bridesmaids at Cana* (no. 154). Another picture, *Marriage at Cana: A Servant in the*

Kitchen announcing the Miracle (no. 260), was painted in 1953. The composition of *Bride and Bridegroom* remains in an autolithograph: *The Wedding Cake* 1953 (55.6 × 43.8 cm/21⅞ × 17¼ ins, edition of 75), executed by the artist under the guidance of Henry Trevick RBA.

EXHIBITIONS
Arts Council, 1961 (38)
Plymouth, 1963 (43)
Arts Council, 1976–7 (49)

REFERENCES
L. Collis, 1972, p. 218, repr. facing p. 20
Robinson, p. 74, pl. 64

262 Hilda Welcomed

1953
Oil on canvas
140.9 × 95.2 cm/55½ × 37½ ins
Lent by the Art Gallery of South Australia, Adelaide

This painting is derived from one of the Astor *Scrapbook* drawings (vol. 2, p. 47), made between January 1943 and March 1944, and was intended for the Hilda Memorial chapel in the Church House, which was to contain paintings celebrating Spencer's relationship with his first wife Hilda Carline. Despite the importance which he attached to the project, only two other *Scrapbook* scenes from the chapel were painted: *Hilda and I at Burghclere* 1955 (no. 270); and *Me and Hilda on Downshire Hill*, unfinished (no. 278).

As in the other Church House pictures, the scene takes place on the Last Day, when the newly resurrected dead return home to be welcomed joyfully by their families. Here, Hilda (who died in 1950) is greeted in the hallway by Spencer, their daughters, Shirin and Unity, and two other women. The picture also celebrates the spiritual union (or 'marriage') between the artist and Hilda, which he kept up in a stream of unposted letters written to her after her death (see no. 256).

The rich variety of patterns found in this picture, both in the

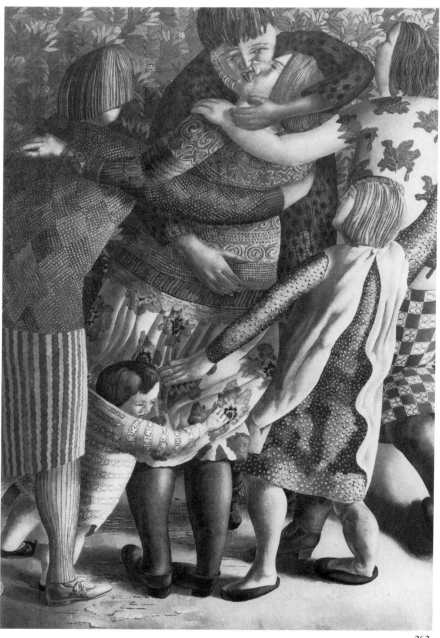

clothes and wallpaper, were an element which had entered Spencer's work in the early thirties. At that time the paint surface was still richly worked, but the artist's growing disinterest in the act of painting (which he referred to disparagingly as 'knitting') became particularly marked in the late forties, and in this picture the resulting rather dry, hard-edged forms and thin paint surface are typical of his late painting style.

Another *Scrapbook* drawing (vol. 2, p. 30) shows a similar scene of Hilda being welcomed, this time by the artist and six children. Behind them is a large hat and umbrella stand.

EXHIBITION
RA, summer 1954

REFERENCES
Selected works from the Art Gallery of South Australia, Adelaide, Art Gallery Board, 1972, p. 40
Royal Academy Illustrated, 1954, repr. p. 31

The picture, completed in December 1953, shows a party of barmaids seated round a table set on the lush grass by the river. Although they are supposed to be listening to Christ preaching nearby, only two, seated on the far side of the table, seem to be paying any attention; the rest carry on with more diverting activities. As the artist commented elsewhere (no. 272), he had forgotten to provide the tables with food.

The expressive gestures of the girls' arms, which Spencer had first used in the *Glasgow Resurrection* paintings, appear here in cross like shapes silhouetted against the white tablecloth.

EXHIBITION
RA, summer 1955 (50)

REFERENCE
Royal Academy Illustrated, 1955, illus p. 30

263 Christ Preaching at Cookham Regatta: Girls Listening

1953
Oil on canvas
137 × 152 cm/54 × 60 ins
Lent by a Private Collector

264 Christ Preaching at Cookham Regatta: Listening from Punts

1953
Oil on canvas
96.5 × 149.8 cm/38 × 57 ins
Lent by Bronwen, Viscountess Astor

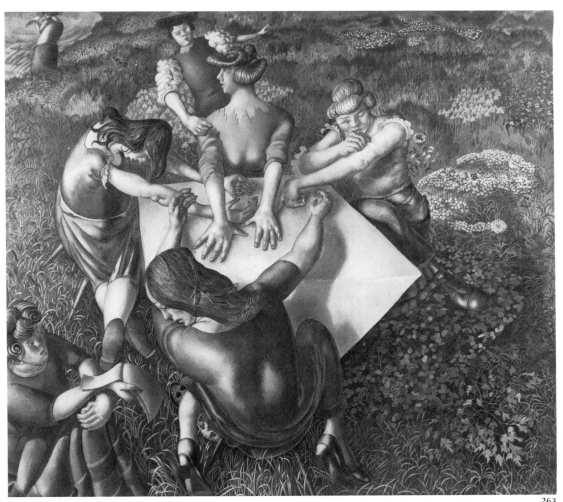

263

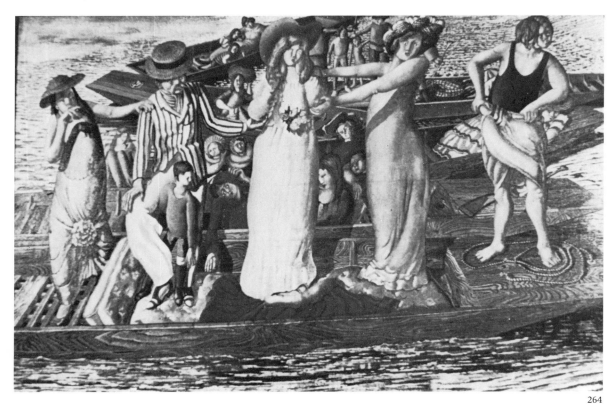

264

The picture was the third in the *Cookham Regatta* series to be painted. The artist imagined the scene viewed from above, as if looking down from Cookham Bridge. As children he and his brother Gilbert had stood on the bridge with their elder sister Annie to listen to their brother Will and others singing popular songs from the nearby horse-ferry barge, after the boat races were over (G. Spencer, 1961, p. 86). In this scene, however, the punters are gathered to listen to the more important message of Christ, who speaks from the same vantage point used by the singers (see no. 279).

EXHIBITIONS
Tooth, *Today and Yesterday*, 1955 (23)
RA, summer 1955 (95)
Tate Gallery, 1955 (82)

REFERENCES
Studio, 147, 1954, pp. 36–7
Royal Academy Illustrated, 1955, repr. p. 17
Modern Artist, vol. 1, no. 2, 1955, pp. 2–6
Studio, 150, 155, p. 52, repr. (reversed)
Robinson, 1979, pl. 70

265 Ming Tombs, Peking

1954
Oil on canvas
41.9 × 54 cm/16½ × 21¼ ins
From the collection of the late W. A. Evill

Spencer went to China in 1954 as part of a cultural mission. While staying in Peking he visited the tombs of the Ming Emperors situated on the outskirts of the city. Here he painted two canvases, the present work and *The Ministers, Ming Tombs, Peking* (Private Collection, Canada). Spencer rarely travelled

and painted outside Britain and apart from his war service in Macedonia had only been to Yugoslavia in 1922 and Switzerland in 1933 and 1936. Normally he disliked long journeys, but he agreed to the trip out of a respect for Chinese religion and art. Writing to Dudley Tooth in 1957 he commented: 'That Ming Tomb painting will never happen with me again. It is charged with the feeling of that place and I was a bit disturbed while doing it, at being such thousands of miles away. It might have been another planet' (Tooth archive).

Spencer also made at least one landscape drawing, *The Western Lake, Hangchow* 1954, and a number of quick sketches in a notebook on his flight to China, including aerial views of the landscape, the wing of the aircraft, and scenes on the ground in Moscow (where he was deeply moved by the two Kremlin churches of the Annunciation and Assumption) and Mongolia. By the time he reached home he had lost one and a half stone in weight and was weak. The long and arduous trip had proved exhausting and he did not leave England again.

265

REFERENCE
M. Collis, 1962, pp. 228–30

266 Wistaria at Englefield

1954
Oil on canvas
76.2 × 50.8 cm/30 × 20 ins
Lent by Mr and Mrs R. W. H. Elsden

Another of the pictures commissioned by Gerard Shiel of his house and its grounds. It took five weeks to paint.

EXHIBITIONS
Tate Gallery, 1955 (83), as *Chestnut and Wistaria at Englefield*
Cookham Church and Vicarage, 1958 (18)
Worthing, 1961 (36)
Cookham, Odney Club, *The Gerard Shiel Collection of Stanley Spencer Paintings*, 1975 (4)

266

267 Love on the Moor

[repr. in colour on pp. 158–9]
1937–55
Oil on canvas
79.1 × 310.2 cm/31⅛ × 122⅛ ins
Lent by the Fitzwilliam Museum, Cambridge

The painting celebrates the apotheosis of Hilda, who appears in the centre of the canvas as a statue of Venus on Cookham Moor. It brings together a number of Spencer's most cherished themes in the familiar setting of the Moor; here the artist appears first as a boy, squatting on the grass at the left, 'like the top notch of a teapot lid', where he 'used to sit behind the overcoats on the moor, so that I could kick the ball back when it came through' (written in 1954, Tate 733.10.94). He reappears as a man entwined about the legs of the statue in an attitude of abased worship. Around him, presided over by the deity, groups of figures engage in an orgy of joyful love-making. The celebrants give each other gifts of clothes and other objects, and smell flowers, all familiar objects which had special significance for the artist (see no. 189). Behind the statue is a wire litter-basket filled with love-letters (see no. 256), a reference to the lengthy correspondence between Spencer and Hilda which continued even after her death. The same basket reappears in *Hampstead Heath, Litter* (unfinished, Private Collection), begun shortly after the completion of *Love on the Moor* in 1955.

The date usually ascribed to the painting is not strictly accurate. In a notebook entry of 2 February 1942 (Tate Gallery archives) the artist mentioned a 'two hundred figure composition drawn on a ten foot canvas that I did in 1937. . .'. This had been left in a greenhouse at 'Lindworth', together with several other large canvases, when the artist moved out in August 1938. They remained untouched until he returned to Cookham to live at 'Cliveden View', in 1945. Spencer finally began to paint the picture in 1949, and, on completion in 1955, referred to it again as having 'been drawn on canvas in 1936 about' (Tate Gallery archives).

The artist had another reason for abandoning the picture at the drawing stage. In 1954 he recalled: 'Many years ago when I showed them to Dudley Tooth . . . he said they would be difficult to sell. So, as they would take a long time to paint I delayed doing so.' Then the *Daily Express* incident occurred in 1950 [when Sir Alfred Munnings, RA, accused Spencer of being a pornographic painter]. This persuaded the artist 'that since I so love these two works why not paint them and not show them publicly' (Tate Gallery archives). This seems to have been what happened, and shortly afterwards the picture passed into the hands of Wilfrid Evill, a collector who bought several of Spencer's more controversial figure paintings.

When the artist returned to the picture in 1949, he began by painting a small separate canvas (76.2 × 63.5 cm/30 × 25 ins), which now forms the left-hand end of the present work. This was photographed at Tooths in 1949, and a note on the back of the archive photograph is inscribed: 'Love without Barriers (1949), section of a projected painting'. Spencer may have considered selling this relatively innocuous scene separately. Later, when the remainder of the painting was completed, in January 1955, the two sections were reunited. The vertical join may be seen running down the picture from a point two inches in from the end of the brick wall in the top of the composition. In 1945 Spencer had added a five-foot section in a similar manner to the left-hand end of *The Resurrection: Port Glasgow*.

EXHIBITIONS
Brighton, 1965 (204)
Arts Council, 1976–7 (50)

REFERENCES
M. Collis, 1962, pp. 213–14, 220, 247, repr. p. 176 (centre detail)
Burlington Magazine, CVII, 1965, pp. 107, 158–9, repr. p. 137 (detail to right)
Robinson, 1979, pp. 74, 75, pl. 67 (in colour)

268 Hilda with Bluebells

1955
Oil on canvas
50.1 × 70 cm/20 × 24 ins
From the collection of the late W. A. Evill

In this evocative spring scene on Hampstead Heath, Spencer painted his first wife Hilda gazing at a clump of bluebells while the artist reclines comfortably on the grassy bank behind.

Hilda died in November 1950, and the painting belongs to the series of scenes depicting their marriage which the artist painted for the imagined *Hilda Memorial* in the Church House during the fifties. The size and shape of the painting suggest that it was intended to hang on the lower register (or predella), on one of the side walls of the chapel.

EXHIBITION
Brighton, 1965 (197), exhibited as *In the Woods – Hilda Picking Bluebells*

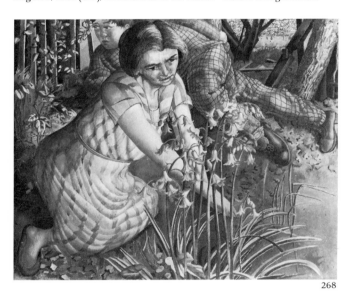

268

269 Christ Preaching at Cookham Regatta: Conversation between Punts

1955
Oil on canvas
106.7 × 91.5 cm/43 × 36 ins
Lent by a Private Collector

In his memoirs of Stanley Spencer, his brother Gilbert described a similar scene of punts on the river which they had witnessed as boys before the First World War: 'The Regatta always emphasised class distinctions; there were those on the river and those on the bank. Those on the river collected themselves in groups, according to rank, and floated about together, holding on to one another's boats and punts, looking rather like gay little floating islands' (G. Spencer, 1961, p. 85). Unlike the figures in *Listening from Punts* (no. 264), the people seem to be unaware of the presence of Christ, preaching not far away in front of the Ferry Hotel.

In the painting Spencer adopted elements of his early designs (see no. 213) for the central *Christ Preaching at Cookham Regatta* picture (no. 279), using a vertical format and placing the main emphasis on the two figures in the foreground, which replace the preaching Christ. The holiday-makers in the background are similarly derived from the boat-loads of worshippers who frame Christ in the drawing.

There are three other scenes of punts on the river in the *Regatta* series: *Listening from Punts* 1954 (121.9 × 91.4 cm/48 × 36 ins, Private Collection), no. 264; *Punts Meeting* 1953 (77.4 × 127 cm/30½ × 50 ins, Private Collection) and *Punts by the River* 1958 (99.7 × 152.4 cm/39¼ × 60 ins, Private Collection).

EXHIBITION
RA, summer 1956 (186)

REFERENCE
G. Spencer, 1961, pp. 84–7

270 Hilda and I at Burghclere

1955
Oil on canvas
76.2 × 50.8 cm/30 × 20 ins
Lent by a Private Collector

In this scene Spencer recalls his stay at 'Chapel View', Burghclere. The artist appears on the right of the canvas carrying the baby's bath. His daughter Unity (born 1930) lies in Hilda's lap, while the elder daughter Shirin (born 1925) plays with the cat. Though Spencer was later to complain that these

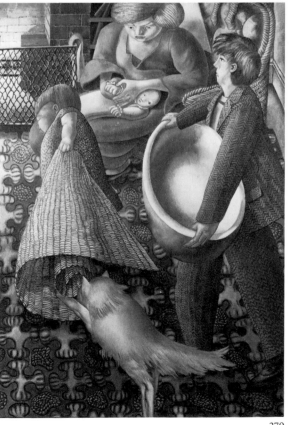

270

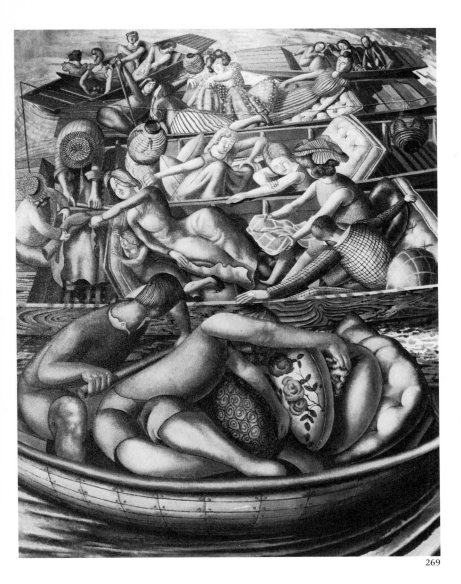

269

family duties interrupted his painting, the scene here is one of deep domestic bliss.

The idea for the painting originated in a small drawing (10.2 × 6.9 cm/4 × 2¾ ins, exhibited d'Offay Gallery, 1978–9) which formed part of the *Domestic Scenes* series of *c.* 1935. Its composition may be compared with *Going to Bed* (no. 162). In the 1940s the artist transferred the scene to the larger drawing which is now in the Astor *Scrapbook* drawing series (vol. I). This Astor study is squared for transfer and was presumably used by Spencer when he painted the present picture.

The painting was intended to hang on one of the side walls of the projected *Hilda Memorial* chapel in Spencer's Church House.

EXHIBITIONS
RA, summer 1955 (602)
d'Offay Gallery, 1978 (33), repr. on the cover (in colour)

REFERENCES
E. Rothenstein, 1962, repr.
Robinson, 1979, p. 31, pl. 22

271 The Dustbin, Cookham

1956
Oil on canvas
76.2 × 50.8 cm/30 × 20 ins
Lent by the Royal Academy of Arts

Spencer based the unusual painting upon one of the twenty-four designs which he had made for the Chatto & Windus *Almanac* of 1927. At the time of publication he was given two copies of the *Almanac* which he subsequently used as diaries (see display case). It was to these illustrations that he returned from time to time, adapting, with varying degrees of modification, no less than seven of the plates into substantial paintings. Of these, *The Dustbin*, which was copied almost exactly from the design for *September*, was the last, being painted some twenty-nine years after the original drawings were made. In fact Spencer did not make use of the pen drawings themselves, but worked from the minute illustrations in the Almanac itself, which were carefully squared up for transfer. He recorded the progress of the picture in his diary, reporting on 25 January that the design was being drawn in on

221

the canvas, and on 6 February that he had begun the painting, which was finally completed on 12 March of that year, in time to be shown at the Royal Academy Summer Exhibition.

Dustbins and rubbish had played a significant part in Spencer's imagination since his childhood, and it is probable that this painting is a recollection of his early experiences. In a letter written to his sister Florence Image on 12 October 1918, from the war front in Macedonia, Spencer explained that his thoughts 'just seem like a row of dustbins, but one can find interesting and very nice things in dustbins and incinerators . . . but I was thinking of a time when in poking about for cart wheels and haddocks eyes I disturbed a whole bevy of unopened tins of bully beef in good condition, the incinerator gave me a feed every night for a fortnight. But I honestly think that looking for treasure on dust heaps where there is not too unpleasant a smell is a distinctly entertaining and elevating pastime. I used to love scurrying about on Farmer Hatchy's rubbish heap [at Ovey's Farm opposite 'Fernlea']. There I would find beads, pieces of broken china with all sorts of painted flowers on them, old books with engravings. I was almost sure to find something that really satisfied my highest thoughts' (Tate 756.45). For Spencer these cast-off details of everyday life clearly represented the same 'homely' characteristics of people's personal lives as did the way in which they dressed, or the simple, even trivial, objects with which they surrounded themselves, as in *Sarah Tubb and the Heavenly Visitors* (no. 142). In the rubbish dump too there was an air of expectancy and discovery which he also looked for in his paintings. Rubbish also plays a central role in *The Dustman* or *Lovers* 1935 (no. 150).

271

EXHIBITIONS
RA, summer 1956 (56)
Arts Council, 1961, (40)
Stanley Spencer Gallery, Cookham, 1962 (21), and subsequently
Arts Council, 1976–7 (51)

REFERENCE
Royal Academy Illustrated, 1956, p. 14, repr.

272 Christ Preaching at Cookham Regatta: Dinner on the Hotel Lawn

1956–7
Oil on canvas
95 × 136 cm/37⅜ × 53½ ins
Lent by the Trustees of the Tate Gallery

This is the fourth of the Cookham Regatta series begun in 1952, and was painted during 1956–7. The scene takes place on the lawn of the Ferry Hotel by the side of the Thames. Here the visitors prepare to eat their dinner, listening to Christ preaching from the horse-ferry barge moored further up-river, just out of sight on the left (see no. 279). Spencer later commented in a letter to the compiler of the Tate Gallery Catalogue (1963, p. 672) that the long tables, whose shapes bear a passing resemblance to punts, occur only in this painting, whereas those in others of the series are square. 'In all of them I seem to have forgotten about the food, square or long table. And I was annoyed to notice that I had made the servants putting the knives on the wrong side: and they are doing it so nicely.' The gaily dressed crowds which attended the regatta in Edwardian times gave Spencer an ideal opportunity to paint the elaborate and colourful clothes for which he had developed a taste in the 1930s.

In an early drawing scheme (no. 213) for *Christ Preaching at Cookham Regatta*, the horse-ferry barge was to have been moored in the creek in the background of the present painting and a group of disciples was shown mingling with the diners. Spencer retained the general viewpoint of the drawing in *Dinner on the Hotel Lawn*.

A landscape, *Ferry Hotel Lawn* (71.1 × 94 cm/28 × 37 ins, Dundee Art Gallery), was painted in 1936.

EXHIBITIONS
Tooth, *Today and Yesterday*, 1957 (3)
RA, summer 1957 (131)

REFERENCES
Royal Academy Illustrated, 1957, p. 37, repr.
M. Collis, 1962, pp. 218, 226, 247

273 Rock Roses, Old Lodge, Taplow

1957
Oil on canvas
70 × 40.1 cm/24 × 20 ins
Lent by J. E. Martineau

This was painted in response to a long-standing request from Mr and Mrs J. E. Martineau for a landscape or still life picture. Spencer worked on the painting in the Martineau's garden at

272

Old Lodge, Taplow, between 4 p.m. and 6 p.m. each day from May to July 1957. According to Mrs Martineau he began by painting the rock roses in the foreground on the blank canvas, and completed it by adding the shadows on the brickwork in the bottom right of the picture. As the season progressed newly opened flowers were added to the composition.

EXHIBITIONS
Cookham, *Stanley Spencer Exhibition*, 1958
Stanley Spencer Gallery, Cookham, 1979

273

274 The Bathing Pool, Dogs

[repr. in colour on p. 160]
1957
Oil on canvas
91.4 × 61 cm/36 × 24 ins
From the collection of the late W. A. Evill

The picture shows Phyllis and Delphis standing on the steps of the bathing pool at the Odney Club, Cookham. It is derived from a drawing, *Dogs and Lead, Phyllis and Delphis*, in the *Scrapbook* series (Leder, 49), drawn in 1943–4, and inscribed on the *verso*: 'Street scene, Cookham. Bathers on the common. Part of the Odney Baptism scene'. Phyllis and Delphis, who were friends of the artist, appear in another drawing in the series, *Dogs and Girls, Phyllis and Delphis* (Leder, p. 47). The inscription on the drawing shows that Spencer intended the painting to form part of the Odney Baptism series, in which the Cookham bathers watch the baptism of Christ (see no. 259) from across the pool. The numerous dogs had appeared before in *Sunflower and Dog Worship* 1937 (no. 187). In the background a 'disciple' gives his blessing to the event.

The style of the picture is typical of Spencer's late works painted after *c.* 1950, in its pale colours and thin, flat paint surface, which barely covers the underdrawing. This was at least partly due to the large volume of work in which the artist was involved at the time, including *The Crucifixion* and *In Church* (nos. 276 and 277) for Aldenham School, as well as studies for the *Regatta* series and a self-portrait (not identified).

EXHIBITION
Brighton, 1965 (213)

REFERENCE
C. Leder, 1976, p. 25

223

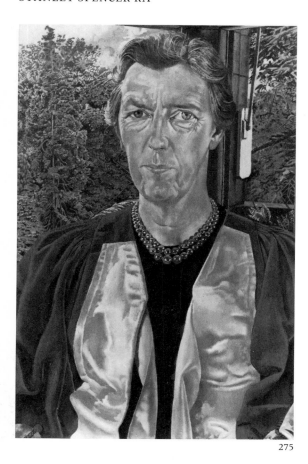

275

275 Portrait of Dame Mary Cartwright, FRS, ScD

1958
Oil on canvas
76 × 49.5 cm/30 × 19½ ins
Lent by Girton College, Cambridge

Mary Lucy Cartwright was born in 1900. She was admitted to St Hugh's College, Oxford, in 1919, and became a Fellow of Girton College, Cambridge, from 1934 to 1939. A University Lecturer in Mathematics, 1935–9, and Reader in the Theory of Functions, 1959–68, she was Mistress of Girton from 1949 to 1968 and was made DBE in 1969.

The portrait was commissioned by the College with the approval of the sitter. Dame Mary's sister had been a student at the Ruskin School, Oxford, where Gilbert Spencer taught, and was a friend of his wife Ursula (*née* Bradshaw). The painting of Dame Mary was done in her room at Girton, with the background taken from a slightly different viewpoint in the same room, looking through the window into the College garden. Spencer stayed in the College whilst painting the picture, with interruptions, from 7–11 July and 28 July–1 August 1958. On 3 August, writing to thank the mistress, he reported: 'Yesterday I was on my pitch in the Church yard at 7–10 and it was very cold'. The painting in question was *Clematis, Cookham Churchyard* (oil, 91.5 × 70 cm/36 × 24 ins, Private Collection), the last landscape painted before the artist's death in 1959. On 6 November Spencer wrote to thank Dame

Mary for photographs she had taken of him at work on the portrait. The letter, now in Girton library, contains a small drawing of a *Visitation*, and confides: 'I am having a muddling time . . . fiddling about with composition drawings that won't come right'. These were probably for *Christ Preaching at Cookham Regatta* (no. 279, unfinished).

EXHIBITIONS
London, Goldsmiths' Hall, *Treasures of Cambridge*, 1959 (42)
Arts Council, 1976–7 (*hors catalogue*)
Cambridge, Fitzwilliam Museum, *Cambridge Portraits: from Lely to Hockney*, 1978 (35)

276 The Crucifixion

1958
Oil on canvas
216 × 216 cm/85 × 85 ins
Lent by the Letchmore Trust

The picture was commissioned by Mr J.E. Martineau in 1958 for the new chapel extension at Aldenham School. The setting for the picture is Cookham High Street, where the artist was attracted by the perspective formed by the roofs of the houses receding towards the east end of the village. In this 'basin-shaped' view he imagined the cross wedged across the street 'like a crashed airliner' (letter to *The Times*, 12 June 1958). The pile of earth in the foreground with the figure of the fainting virgin lying on top was inspired by pipe-laying operations in the High Street which Spencer saw while composing the picture.

When the completed picture was exhibited at Cookham Vicarage and Church in June 1958 it was criticised for weaknesses in composition and the unpleasant relish displayed by Christ's tormentors. In a letter of defence written to *The Times* on 12 June 1958, Spencer gave an interesting account of the inception of the picture and the problems which he had experienced with the design: 'The difficulty I had in doing it was caused through having "seen" and drawn just the top part where you see Christ and the two men being fixed to the cross-poles. This in-the-sky part I liked, but wished the rest of the scene – namely at the foot of the cross – could have been with it. I knew what kind of sky it would be, but I felt some significance would come if I could establish its whereabouts: where in the sky it occurred. I like the no-where of sky, as I like the no-where of mid-ocean. But the shape of this top section of the Crucifixion was such a "shape". The cross upon which Christ is being nailed is a T-shaped one, so that, although seen from behind, you see the head and profile. The malefactors are on the right and left, and facing inwards, so that you see them nailing. The three cross-bars make a frame, like a broken up coffin in shape, or like a magnet.

'In drawing this top scene I was thinking of the words: "the thieves also, which were crucified with him, cast the same in his teeth", and it was their words that made me want the on the ground scene because from there the people called up to Christ, and in the Bible passage you have a vivid sense of being down below the cross-bars and again being on the same level with them.' Spencer later shocked the boys of Aldenham School by

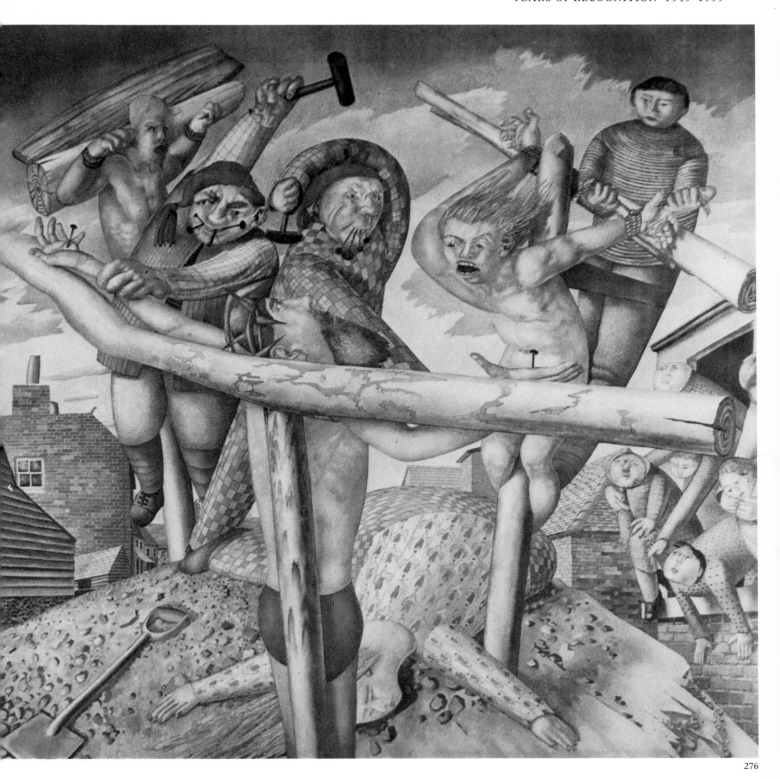

276

telling them: 'I have given the men who are nailing Christ on the Cross – (and making sure that they make a good job of it) – Brewers caps, because it is your Governors, and you, who are still nailing Christ to the Cross' (J. Rothenstein, 1979, p. 131).

Spencer began making studies for the picture on 25 February 1957, but it was not until 3 November that a satisfactory working drawing was finally completed. The painting was finished in time to be exhibited at Cookham

Church in June 1958. Three cartoons for the painting (each 50.1 × 76.2 cm/20 × 30 ins) are in the possession of the Letchmore Trust.

EXHIBITIONS
Cookham Vicarage and Church, 1958
Stanley Spencer Gallery, Cookham, 1971

REFERENCE
E. Rothenstein, 1962

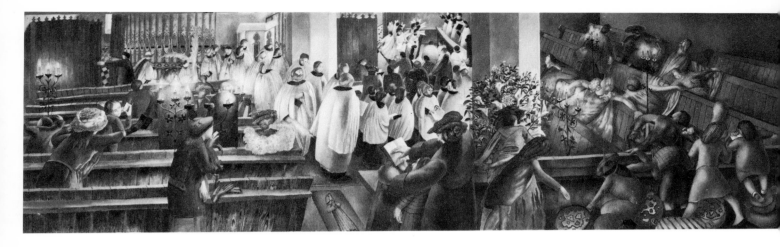

277 In Church

1958
Oil on canvas
61 × 216 cm/24 × 85 ins
Lent by the Letchmore Trust

The second of two paintings commissioned to mark the
extension of the chapel at Aldenham School in 1957. It was
intended to hang as a predella to *The Crucifixion* (no. 276), but
when completed proved incompatible with it and was placed
elsewhere in the chapel. The picture represents the interior of
Cookham Church as the artist remembered it from his
childhood.

Spencer made use of a number of early drawings for the
picture, including a series called *In Church*, made in the mid
twenties. Most of these are now lost, but one, *A Heavenly Choir*
1925 (pencil and wash, 25.4 × 24.1 cm/10 × 9½ ins, Private
Collection), is the source for the procession. An illustration from
the Chatto & Windus *Almanac* (see no. 90) for the month of
June was used, reversed, for the figures in pews between the
candle-holders in the centre right of the picture. This too was
derived from a drawing *People in Pews in Church* (pencil and
wash, 17.8 × 25.4 cm/7 × 10 ins, Private Collection) which
belonged to the *In Church* series. Before commencing the picture
Spencer had painted a smaller canvas also called *In Church* 1956
(91.5 × 70 cm/36 × 24 ins, St Edmund Hall, Oxford), which
shows the artist standing up to let a girl into the pew. A cartoon
for the painting (50.1 × 76.2 cm/20 × 30 ins) also belongs to
the Letchmore Trust.

The picture was begun on 3 February 1957, when the artist
began to draw the design on to the canvas, and was almost
complete by 14 December. Spencer worked on the picture
concurrently with *The Crucifixion* and several other important
late works including *Christ Preaching at Cookham Regatta* (no.
279) and *The Bathing Pool, Dogs* 1957 (no. 274).

EXHIBITIONS
Cookham Church, 1962
Plymouth, 1963
Stanley Spencer Gallery, Cookham, 1966, 1971

278 Me and Hilda, Downshire Hill

unfinished
Oil and pencil on canvas, unfinished
141 × 96.5 cm/55½ × 38 ins
Lent by a Private Collector

Designed for the Hilda Memorial chapel in the Church House
scheme, this canvas is closely derived from one of the Astor
Scrapbook drawings (Leder, p. 74). The painting was hanging on
the artist's wall in 'Fernlea', Cookham, at the time of his death.

The couple are shown near the front gate of no. 47 Downshire
Hill, the home of the Carline family for many years. Behind
them is the church of St John, Downshire Hill; on the left can
be seen Downshire Hill and on the right Keats Grove (d'Offay
Gallery catalogue, 1978, no. 31).

Spencer made several similar drawings in the *Scrapbook*
series commemorating walks which he and Hilda had taken in
Hampstead. These are: *Me and Hilda, Pilgrim's Lane* (Leder 75);
Me and Hilda, East Heath Road (Leder 78) and *Me and Hilda
near the Priors* (Leder, p. 79). These drawings were studies for
paintings (never completed) belonging to the Hilda Memorial,
whose climax was to be the vast *Hampstead Heath, Litter*
(unfinished), showing the artist and Hilda seated on a park
bench on the Heath. This was to hang on the end wall of the
room, performing the function of an altarpiece. A related
painting, *Hilda and I at Pond St.*, 1954, is in a Private Collection.

EXHIBITION
d'Offay Gallery, 1978 (31)

279 Christ Preaching at Cookham Regatta

unfinished
Oil on canvas
205.7 × 535.9 cm/81½ × 211 ins
Lent by The Viscount Astor

Spencer was at work on the painting until a few weeks before
his death in 1959. The picture was intended to form the central
'altarpiece' section of the so-called 'river aisle' in the Church

278

House. This was to celebrate another part of the village, in this case the river, and was based on Spencer's memories of the annual Regatta at Cookham in Edwardian days. The scene is the Ferry Hotel by Cookham Bridge.

In the painting Spencer imagined the Regatta transformed into the Last Day on which Christ and his disciples visit the newly redeemed village. He is shown, seated in a wicker chair, preaching to the ecstatic villagers from the horse-ferry barge, moored to the river bank in the centre of the picture. The scene is based on memories of the concert put on by the artist's brother, Will, and others, who sang popular songs from the barge at the end of the Regatta. Those who owned boats would crowd about the barge. Others, including the artist, his brother Gilbert and sister Annie, would listen from Cookham Bridge or the river bank (G. Spencer, 1961, pp. 84–9). In a letter to Hilda dated 8 April 1953, Spencer recalled that the family could not afford a punt, so that to do so seemed to him like 'an

unattainable Eden' (Tate 733.1.1685). In the foreground, carrying assorted oars and mops, is Mr Turk, the owner of Turk's Boatyard, the site of *Swan Upping* 1915–19 (no. 33).

The first studies for the picture were made in the late twenties when Spencer made a drawing, now lost, showing Christ preaching from the horse-ferry drawn up to the riverbank at the Ferry Hotel. Christ is shown standing in the boat with his arms spread. Punts are arranged round the ferry in a 'star' shape, which echoes Christ's pose. Further work on the picture was delayed by the *Shipbuilding* and *Port Glasgow Resurrection* series, but recommenced in 1949. In 1953 the artist made a series of 60 chalk outline drawings (each 50.1 × 76.2 cm/20 × 30 ins, various Private Collections), which form the basis of the present composition. Work on the canvas began shortly afterwards and continued intermittently until the artist's death. Two scenes in the unpainted upper left of the canvas were also painted as independent pictures in the

Regatta series *Listening from Punts* 1953 (no. 264) and *Punts on the River* 1950 (150.5 × 152.4 cm/59¼ × 60 ins, Private Collection).

The painting clearly shows Spencer's working methods. Beginning at the top and working down and outwards, the artist first filled in the background detail before starting on the figures. The underdrawing seen on the left was traced on to the canvas from the six preparatory studies.

EXHIBITIONS
Tooth, 1955
Tate, 1955 (82)
Stanley Spencer Exhibition, Cookham, 1958 (44)
RA, summer 1960, as *The Viscount Astor's 'Christ Preaching at Cookham Regatta'*
Stanley Spencer Gallery, Cookham, on loan since 1962

REFERENCES
Tate Gallery, 1955 exhibition, Introduction
J. Rothenstein, *Modern English Painters, Lewis to Moore*, 1956
M. Collis, 1962, pp. 185, 218, 219, 226
M. Collis, *The Journey Up, Reminiscences, 1945–1968*, Faber and Faber, 1970, pp. 146, 173, repr. p. 144
J. Rothenstein, *Time's Thievish Progress*, Cassell, 1970 pp. 62, 72
L. Collis, 1972, pp. 110, 148, 159
G. Spencer, 1961, pp. 185–6
G. Spencer, 1974, pp. 166–7, 182, 205, 208, repr. pl. 1b
C. Leder, 1976, p. 29, no. 134
J. Rothenstein, *Stanley Spencer*, Paul Elek, 1979, pp. 107, 117, 121, 125–7, 132–33.
Robinson, 1979, pp. 77, 80, repr. pl. 68

280 Self-Portrait

1959
Oil on canvas
50.8 × 40.6 cm/20 × 16 ins
Lent by a Private Collector

Spencer painted this moving self-portrait at a friend's house in Yorkshire in 1959. He first made a red conté drawing of himself which is substantially the same as the oil painting (48.3 × 36.8 cm/19 × 14½ ins, Private Collection), using the bedroom looking-glass. Then, again using conté, he drew the outline in on the canvas, beginning in his usual manner with the eyes and working outwards. At the time Spencer painted the picture he was seriously ill; he died shortly afterwards on 14 December

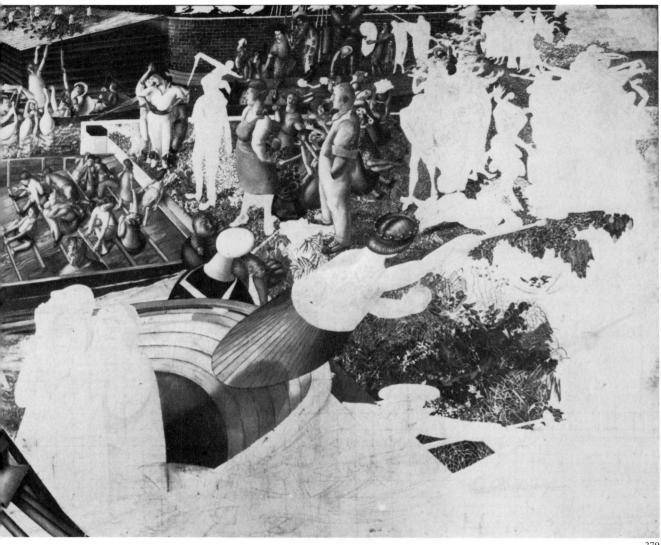

279

1959 at the Canadian War Memorial Hospital, Cliveden. The picture was the last but one painted by Spencer, the final one being a portrait of *Mrs Michael Westropp* 1959 (70 × 55.9 cm/ 24 × 22 ins, Private Collection).

The artist began making self-portraits in 1913 (see no. 17), and he continued to practise the genre from time to time for the rest of his career. With the exception of the youthful idealism of the 1914 *Self-Portrait* (no. 23), and the slightly pretentious *Self-Portrait* (no. 158) of 1939, all these pictures show an unremitting honesty and directness in their treatment of the subject. As in his intimate portraits of his friends, Spencer painted himself in close-up without the benefit of background detail to soften the impact of the study.

EXHIBITIONS
Tooth, *Critics Choice*, 1959
RA, summer 1960 (70)
RA, *British Painting 1952–77*, 1977 (335)

REFERENCES
M. Collis, 1962, repr. facing p. 225
J. Rothenstein, 1979, repr. facing p. 129, and on the dust-jacket
(detail, in colour)

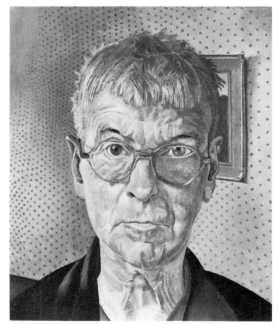

280

Addenda

12a Joachim among the Shepherds

1913
Oil on canvas
51 × 38 cm/20 × 15 ins
Lent by the National Art Gallery of New Zealand

12a

One of the first works painted after leaving the Slade. The artist's painting lists (Tate 733.3.12, *c.* 1940; 733.3.88, 1959) date the picture to 1913, not 1912 as stated in the catalogue of the Tate Gallery retrospective of 1955 (p. 10, no. 4). Joachim, on the right, is seen arriving among the shepherds in the fields near Cookham. The man on the other side of the hawthorn hedge is Jack Hatch, a cousin who lived opposite at Ovey's farm. When Hatch was a child the maid, Emily, would stand him on a cart horse and he would stretch his arms out to the sun. There was something gentle in his nature which made him seem to Spencer to be the very substance of the Cookham landscape.

Painted shortly after *Apple Gatherers* (no. 15), the picture shows a renewed interest in the works of Giotto, particularly in the stiff poses, broadly painted forms and simple direct gestures of the figures. The influence of Gauguin, clearly evident in the earlier painting, is no longer readily discernible, and can therefore be seen as a passing phase in Spencer's artistic development.

Nos. 11, 12 and 24 are studies or related works.

EXHIBITIONS
Goupil Gallery, 1927 (56)
Leicester Galleries, *Artists of Fame and of Promise*, Parts I and II, 1943 (63)
Tate Gallery, 1955 (4)
Wellington, National Art Gallery, *Picture of the Month*, December, 1965

REFERENCES
M. Collis, 1962, pp. 26–27
Carline, p. 28

185a Adoration of Girls

1937
Oil on canvas
92 × 135.9 cm/36¼ × 53½ ins
Lent by a Private Collector

The painting, a companion-piece to *Adoration of Old Men* 1937 (no. 186), is a further expression of Spencer's belief in free love. During 1937, the year of his divorce from Hilda and remarriage to Patricia Preece, he had conceived the idea of a polygamous relationship with both women, a theme which he developed in *Seeing* 1937 (destroyed), the third of the *Beatitudes of Love* series. After the failure of this plan and the subsequent collapse of his marriage to Patricia, Spencer's ideas became more generalised and idealistic, and 'guest characters' were introduced to supplement the more intimate autobiographical references of the earlier *Domestic Scenes* paintings. The resulting series, in which the two *Adorations* form a central part, became a communal celebration of free love in a 'heaven' devoid of moral restraint. In his notes on the painting, made late in 1937,

the artist explained: 'The picture is still the Day of Judgement and the two parties are judging and adoring each other, but it's the girls' turn to stand in a group as one would to be photographed, only here it is for the purpose of being worshipped. They collectively own a sacred image called "girls", and just as snakes are worshipped as they climb about the branches placed in an aquarium on an altar in a Buddhist Temple, so I make this group of girls a sacred thing and place it on an altar of grass . . . The disciple is the old man down on the left who is helping the young man to make love . . . (by) grasping the woman's arm he becomes aware of the mystery (of sexual love)' (Tate 733.3.2). The man is created in the likeness of Spencer himself, who reappears in a similar supplicating pose in *Love on the Moor* (1937–55). Elsewhere the artist wrote, '. . . it is a painting I had longed to do . . . I love each girl in the picture and painted them with passion' (Tate 733.3.2, no. 37).

Spencer worked on the picture, then called *Girls being Adored by Men*, in the autumn of 1937 after completing a summer session of landscape painting. When he had finished he immediately began *Adoration of Old Men*, in which the situation is reversed and it is the men's turn to be worshipped by the young women.

EXHIBITIONS
Zwemmer Galleries, December–January, 1938–9 (1)
Leeds, 1947 (42)
Cookham, Stanley Spencer Gallery, summer 1976 (46), and subsequently

185a

Chronology

1891 Born 30 June at Cookham on Thames, Berkshire, the eighth surviving child of William Spencer, organist and piano teacher. Educated at a morning school run by his sisters. First painting lessons from artist and designer Dorothy Bailey.

1907 Entered Maidenhead Technical Institute.

1908–12 Studied at the Slade School under Tonks, where his contemporaries included Christopher Nevinson, William Roberts, Mark Gertler, David Bomberg, Paul Nash and Edward Wadsworth.
During this period he lived and painted at home. Awarded a scholarship, 1910; the Melville Nettleship Prize and the Composition Prize, 1912.

1912 Exhibited *John Donne Arriving in Heaven* and two drawings in Roger Fry's Second Post-Impressionist Exhibition at the Grafton Galleries.

1915–18 Enlisted at the Royal Army Medical Corps and was stationed at Beaufort War Hospital, Bristol, July 1915. Posted to Macedonia in August 1916 and served with the 68th, 66th and 143rd Field Ambulances until August 1917, when he volunteered and joined the 7th Battalion, the Royal Berkshires. Commissioned to paint an official war picture on his return to England in December 1918.

1919 Lived and worked in Cookham. Member of the New English Art Club until 1927.

1920–1 Went to live with Sir Henry and Lady Slesser at Bourne End, near Cookham.
Stayed at Durweston, Dorset, with Henry Lamb during the summer of 1920.

1921–2 Lived with the Muirhead Bones at Steep, near Petersfield, Hampshire, and then at lodgings in Petersfield.

1922 Visited Yugoslavia with the Carlines during the summer. Moved to Hampstead in December.

1923–4 Enrolled at the Slade School for the spring term, 1923. Then joined Henry Lamb at Poole, Dorset. Worked on a series of designs for the mural decoration of a chapel based on his experiences during the war. They were seen by Mr and Mrs J. L. Behrend, who decided to build a chapel at Burghclere, Berkshire. Returned to Hampstead, October 1923, where he used Henry Lamb's studio on the top floor of the Vale Hotel in the Vale of Health.

1925 Married Anne Hilda Carline at Wangford, near Southwold. A daughter, Shirin, born.

1926–7 Completed *The Resurrection, Cookham* in 1926 and exhibited it in his first one-man show at the Goupil Gallery, February–March 1927. It was purchased by the Duveen Paintings fund for presentation to the Tate Gallery. Moved to Burghclere to decorate the Sandham Memorial Chapel.

1930 A second daughter, Unity, born.

1932 Completed the Memorial Chapel and moved from Burghclere to Lindworth, Cookham. Elected ARA and exhibited five paintings and five drawings at the Venice Biennale. In October Dudley Tooth became his sole agent.

1933 Invited to Saas Fee, Switzerland, by Edward Beddington-Behrens to paint landscapes.
Sarah Tubb exhibited at the Carnegie Institute, Pittsburgh (honourable mention).

1935 Resigned from the Royal Academy after the rejection of *St Francis and the Birds* and *The Dustman (or The Lovers)* by the hanging committee.

1936 Visited Zermatt, Switzerland, for a second time with Beddington-Behrens. One-man show, Arthur Tooth and Sons Ltd.

1937 Divorced by Hilda. Married Patricia Preece, 29 May. Spent a month in St Ives and also visited, and painted at, Southwold.

1938 Twenty-two paintings shown at the Venice Biennale. Stayed with the Rothensteins and Malcolm MacDonald until December, when he moved to a room at 188 Adelaide Road, London. Began the *Christ in the Wilderness* series.

1939 Exhibited at J. Leger and Son in March–April. 30 July, moved to the White Hart Inn, Leonard Stanley, Gloucestershire, with George and Daphne Charlton.

1940 Commissioned to paint pictures of shipyards by the War Artists' Advisory Committee. Made the first of a series of visits to Lithgow's Yard, Port Glasgow.

1941 Stayed with Mrs Harter, Sydney Carline's mother-in-law, at Epsom.

1942–4 Returned to Cookham, 7 January, as the tenant of his cousin, Bernard Smithers, with whom he stayed until May 1944. Continued to visit Port Glasgow where he stayed at the Glencairn boarding-house. Continued to work on *Shipbuilding on the Clyde*. Began *The Resurrection, Port Glasgow* series on which he worked until 1950.

1945 September, returned to Cookham, to Cliveden View.

1947 Retrospective exhibition, Temple Newsam, Leeds. The chapel at Burghclere was presented to the National Trust by Mr and Mrs J. L. Behrend.

1950 Created CBE. Rejoined the Royal Academy and elected RA. Hilda Spencer died in November.

1954 Visited China as a member of a cultural delegation.

1955 November–December retrospective exhibition at the Tate Gallery.

1958 Knighted, Hon D. Litt, Southampton and Associate of the Royal College of Art.

1959 14 December, died at the Canadian War Memorial Hospital, Cliveden.

Bibliography

Published writings by Stanley Spencer

'A Letter', *The Game*, vol. III, No. 1, Corpus Christi 1919, pp. 1–8.

'Footnote on Sarah Tubb', *Carnegie Magazine*, vol. 7, November 1933, p. 184.

Paul Nash, Stanley Spencer, David Low, et al.: 'Sermons by Artists', GOLDEN COCKEREL PRESS, 1934, pp. 47–53.

A note on 'Burners', 'Welders' and 'Riveters', catalogue of an exhibition of war subjects circulated by the Ministry of Information for showing in schools. First Selection, March 1942.

'Lone Journey', *Pavement* No. 1, May 1946, pp. 3–4.

'Domestic Scenes', *The Saturday Book*, sixth year, HUTCHINSON, 1946, pp. 249–256, illus.

'Stanley Spencer Resurrection Pictures' (1945–1950), FABER AND FABER, 1951, 24 pp, illus. Notes by the artist and an introduction by R. H. Wilenski.

Books on Stanley Spencer

R. H. W. (Wilenski): *Stanley Spencer*, ERNEST BENN, 1924, 30 pp. illus.

Elizabeth Rothenstein: *Stanley Spencer*, PHAIDON PRESS, Oxford and London, 1945, 25 pp. illus.

Eric Newton: *Stanley Spencer*, PENGUIN BOOKS, Harmondsworth, 1947, 15 pp. illus.

See also *Stanley Spencer: Resurrection Pictures (1945–50)*, above.

Gilbert Spencer: *Stanley Spencer*, VICTOR GOLLANCZ LTD., 1961, 192 pp. illus. by the author.

Elizabeth Rothenstein: *Stanley Spencer*, BEAVERBROOK NEWSPAPERS, 1962, illus.

Maurice Collis: *Stanley Spencer*, HARVILL PRESS, 1962, 255 pp. illus.

C. Hayes: *Scrapbook drawings of Stanley Spencer*, LION AND UNICORN PRESS, Royal College of Art, 1964, limited edition (400 copies), 16 pp. illus.

George Behrend: *Stanley Spencer at Burghclere*, MACDONALD AND CO LTD., 1965, 63 pp. illus.

Elizabeth Rothenstein: *Stanley Spencer*, PURNELL AND SONS LTD., 1967, 6 pp. illus.

John Bratby: *Stanley Spencer's Early Self-Portrait*, CASSELL AND CO. LTD., 1969, 32 pp. illus.

Louis Collis: *A Private View of Stanley Spencer*, HEINEMANN, 1972, 166 pp. illus.

Richard Carline: *Stanley Spencer at War*, FABER AND FABER, 1978, 231 pp. illus.

Duncan Robinson: *Stanley Spencer: Visions from a Berkshire Village*, PHAIDON PRESS, Oxford, 1979, 80 pp. illus.

Sir John Rothenstein, ed: *Stanley Spencer The Man: Correspondence and Reminiscences*, PAUL ELEK, London, 1979, 156 pp. illus.

References in Books

G. L. K. (Kennedy): *Henry Lamb*, ERNEST BENN, 1924.

John Rothenstein: *British Artists and the War*, PETER DAVIES, 1931.

Charles Johnson: *English Painting from the Seventeenth Century to the Present Day*, BELL, 1932, pp. 327–33, illus.

Sir William Rothenstein: *Men and Memories*, vol. II, FABER AND FABER, 1932.

Robert Speaight: *William Rothenstein, The Portrait of an Artist in His Time*, EYRE AND SPOTTISWOODE, 1962.

R. H. Wilenski: *English Painting*, FABER AND FABER, 1933, pp. 280–5, illus., appendix on the Burghclere Memorial Chapel.

Frank Rutter: *Art in My Time*, RICH AND COWAN, 1933, pp. 174–7, 201–4.

C. R. W. Nevinson: *Paint and Prejudice*, METHUEN, 1937.

Mary Chamot: *Modern Painting in England*, COUNTRY LIFE, 1937, pp. 71–5, 123, illus.

Joseph Hone: *The Life of Henry Tonks*, HEINEMANN, 1939.

Paul Nash: *Outline*, FABER AND FABER, 1949.

C. C. Abbott and A. Bertram: *Poet and Painter. Being the Correspondence between Gordon Bottomley and Paul Nash, 1910–1946*, Oxford, 1955.

J. T. Soby: *Contemporary Painters*, MUSEUM OF MODERN ART, New York, 1948, pp. 122–9, illus.

Herbert Read: *Contemporary British Art*, PENGUIN BOOKS, Harmondsworth, 1951, pp. 122–9, illus.

Sir John Rothenstein: *British Art Since 1900*, PHAIDON PRESS, Oxford and London, 1962, illus.

William Gaunt: *A Concise History of English Painting*, THAMES AND HUDSON, 1964, pp. 210–3, 228, illus.

Sir John Rothenstein: *Summers Lease*, autobiography I, 1901–38, HAMISH HAMILTON, 1965.

Sir John Rothenstein: *Brave Day Hideous Night*, autobiography II, 1939–65, HAMISH HAMILTON, 1966.

Sir John Rothenstein: *Time's Thievish Progress*, autobiography III, CASSELL, 1970, chapter on Stanley Spencer, pp. 50–74.

Noel Carrington, ed: *Mark Gertler, Selected Letters*, RUPERT HART-DAVIS LTD., 1965.

G. H. Hamilton: *Painting and Sculpture in Europe, 1880–1940*, PELICAN HISTORY OF ART, Harmondsworth, 1967, pp. 473, 512–14 (paperback edition) illus.

Andrew Forge: *The Slade*, 1960–1.

Maurice Collis, *The Journey Up, Reminiscences, 1934–68*, FABER AND FABER, 1970.

John Woddeson: *Mark Gertler*, SIDGWICK AND JACKSON, 1972.

Gilbert Spencer: *Memoirs of a Painter*, CHATTO & WINDUS, 1974.

Nicolette Devas, *Two Flamboyant Fathers*, COLLINS, 1966, reprinted 1978.

Articles and Criticism

P.G. Konody: *The NEAC*, THE OBSERVER, 4 January 1920.

A. Hind: *Some Remarks on recent English painting*, January 1925, p. 13, illus.

William Gaunt: 'Stanley Spencer', *Drawing and Design*, vol. II, March 1927, pp. 59–60, illus.

John Rothenstein: 'Stanley Spencer', *Apollo*, V, April 1927, pp. 162–6, illus.

Roger Fry: *Nation and Athenaeum*, 12 March 1927. Review of the Goupil Gallery exhibition.

Anon: *The Guardian*, 3 March 1927. Review of the Goupil Gallery exhibition.

Richard Carline: 'New Mural Paintings by Stanley Spencer', *Studio*, vol. 96, November 1928, pp. 316–23, illus.

D. S. MacColl: 'Super and Sub Realism, Mr Stanley Spencer and the Academy', *Nineteenth Century and After*, June 1935.

John Rothenstein: 'Stanley Spencer', *Picture Post*, 8 April 1939, illus.

Jan Gordon: 'Stanley Spencer', *Studio*, vol. 134, 1943, pp. 50–3, illus.

Bernard Denvir: 'Sir Edward Marsh', *Studio*, vol. 134, 1947, p. 133.

Anon: 'The Resurrection of Stanley Spencer', *News Review*, 27 April 1950, pp. 8–9, illus.

Elizabeth Rothenstein: 'Portrait of the Artist No. 34. Stanley Spencer', *Art News and Review*, 20 May 1950, p. 1, illus.

M. Collis: 'A Cookham Visionary', *Art News and Review*, 3 June 1950.

David Sylvester: 'Two Painters: Stanley Spencer and Lucian Freud', *Britain Today*, No. 171, July 1950, pp. 36–9.

Mary Sorrell: 'A Day with Stanley Spencer', *Queen*, 1 July 1953, illus.

Mary Sorrell: 'The Loved World of Stanley Spencer', *Studio*, vol. 147, February 1954, pp. 33–9, illus.

M.G.C. (Compton): 'Stanley Spencer', *Leeds Art Calendar*, vol. 8, No. 29, Spring 1955, pp. 23–6, illus.

Alan Clutton-Brock: 'Stanley Spencer', *Modern Art*, vol. 1, No. 2, June 1955, pp. 2–6, illus.

Alec Sturrock: 'Artists at the Seaside', *Scottish Art Review*, 1955, illus.

National Art Gallery of S. Australia Bulletin, vol. 18, No. 11, serial 65, July 1956.

Carel Weight: 'The Resurrection, Cookham', *The Listener*, 16 February 1961.

Aimee B. Brown: 'Stanley Spencer's "The Builders" ', *Yale University Art Gallery Bulletin*, vol. xxix, No. 2, December 1963, pp. 22–3.

Anon: 'Pictures by Stanley Spencer in the Fitzwilliam Museum, Cambridge. *The Burlington Magazine*, November, 1965.

Walter Shewring: '*Stanley Spencer to Desmond Chute: extracts from letters of 1916–1926*', *Apollo*, June 1966.

Art Gallery of New South Wales, Australia: 'Christ in Cookham 1952', *Picturebook*, 1972.

Richard Carline: 'Recollections of Stanley Spencer', *Stanley Spencer*, Arts Council catalogue, 1976, pp. 11–13.

Carolyn Leder: 'Influences on the early work of Stanley Spencer', *loc. cit.*, pp. 14–17.

Duncan Robinson: 'The Oratory of All Souls, Burghclere', *loc. cit.*, pp. 18–20.

Anthony Gormley: 'The Sacred and the Profane in the Art of Stanley Spencer', *loc. cit.*, pp. 21–3.

Robin Johnson, 'Stanley Spencer: Shipbuilding on the Clyde, 1940–46', *loc. cit.*, pp. 24–5.

D.P.G. Waley: 'Two Stanley Spencer Letters from Salonika', pp. 167–8, *The British Library Journal*, vol. 3, No. 2, Autumn 1977.

Marina Vaizey: 'An everyday story of artistic folk', *The Sunday Times*, 5 October 1978.

Caroline Tisdall: 'From Cookham to Clydeside', *The Guardian*, 10 March 1979.

The Guardian, 'A Life of Wedlock', 28 April 1979.

Lou Klepac: 'Perth's Great Spencer', The Art Gallery of Western Australia, *Bulletin 1979*.

Exhibition Record

1912	*Second Post-Impressionist Exhibition*, London, Grafton Galleries (Rearrangement, January 1913).
1912	*48th Exhibition of Modern Pictures*, London, New English Art Club.
1913	*Contemporary Art Society*, London, Goupil Gallery.
1914	*Twentieth-century Art*, London, Whitechapel Art Gallery.
1915	New English Art Club, London.
1919–20	*The Imperial War Museum, The Nation's War Paintings*, London, Royal Academy of Arts.
1919–27	Member of New English Art Club, and represented in their exhibitions.
1923	*Contemporary Art Society*, London, Grosvenor House.
1924	*British Empire Exhibition*, Wembley.
1927	*The Resurrection, and other works by Stanley Spencer*, London, Goupil Gallery, First One-Man Exhibition.
1929	*Contemporary British Art*, Whitechapel Art Gallery.
1932	Tooth. Messrs. Arthur Tooth and Sons, who were Spencer's sole agent from 1932.
1932	Venice Biennale.
1933	*59th Autumn Exhibition*, Walker Art Gallery, Liverpool.
1936	*Recent Paintings by Stanley Spencer*, London, Arthur Tooth and Sons Ltd.
1938	Venice Biennale.
1939	*Stanley Spencer*, London, Leger Gallery.
1942	*Stanley Spencer: paintings and drawings*, London, Leicester Galleries.
1946	*British Contemporary Painters*, Fine Arts Academy, Buffalo, NY.
1946	International exhibition, organised by UNESCO, in the Musée d'Art Moderne, Paris.
1947	*Paintings and Drawings by Stanley Spencer*, retrospective exhibition, Temple Newsam, Leeds.
1948	*Contemporary Painting in Britain* (British Council Exhibition), Palais des Beaux-Arts, Brussels.
1950	*Stanley Spencer: recent landscape, portraits and flower paintings*, London, Arthur Tooth and Sons Ltd.
1950	*Some 20th Century English Paintings and Drawings*, Arts Council.
1952	A selection of pictures from the collection of Wilfrid A. Evill, London, Leicester Galleries.
1953	*Paintings and Drawings from the Sir Edward Marsh Collection*, Arts Council.
1953	*The collection of the late Sir Edward Marsh, a selection of works bequeathed to the Contemporary Art Society*, London, Leicester Galleries.
1954/5	*Drawings by Stanley Spencer*, Arts Council. Introduction by David Sylvester.
1955	*Stanley Spencer, a retrospective exhibition*, London, Tate Gallery, introduction by the artist.
1955	*Contemporary Paintings from Southampton Art Gallery*, Exeter Art Gallery.
1956	*Pictures from Garsington: the collection of Lady Ottoline Morrell*, London, Leicester Galleries.
1958	*Stanley Spencer Exhibition*, Cookham Church and Vicarage.
1959	Cannon Hall, Cawthorne, Barnsley, *Four Modern Masters*.
1960	*The Viscount Astor's 'Christ Preaching at Cookham Regatta'*, London, Royal Academy of Arts.
1961	*Three Masters of Modern British Painting (Ivon Hitchens, Stanley Spencer, Graham Sutherland)*, Arts Council, Second Series, touring exhibition.
1961	*Sir Stanley Spencer, RA*, Worthing Art Gallery.
1962	*The J. L. Behrend collection*, London, Leicester Galleries.
1962	(*and subsequently*), Cookham on Thames, King's Hall, *Stanley Spencer Gallery*, opened 7 April 1962, with an exhibition of works from the permanent collection augmented by loans.
1963	*Sir Stanley Spencer CBE, RA*, Plymouth, City Museum and Art Gallery. Introduction by Richard Carline.
1964	*Paintings, Drawings, Watercolours and Sculptures by six artists, including Stanley Spencer*, London, Arthur Tooth and Sons Ltd.
1965	*The Wilfrid Evill Collection*, Brighton Art Gallery.
1965	Cardiff, Llandaff Castle, *Stanley Spencer, Religious Paintings*, Bangor, Haverfordwest, Swansea.
1966	*British Painting and Sculpture: 1900–1950*, London, Arthur Tooth and Sons Ltd.
1967	*British Painting 1900–1950*, London, Arthur Tooth and Sons Ltd.
1968–9	*Royal Academy of Arts Bicentenary Exhibition. 1768–1968*, London, Royal Academy of Arts.
1969	*Exhibition of Important Unfinished Works by the late Sir Stanley Spencer*, The Odney Club, Cookham.
1970	*A Decade 1920–30*, Arts Council.
1970	*Drawings of Importance of the 19th and 20th Century*, London, Roland, Browse and Delbanco Ltd.
1971	*The Slade, 1871–1971*, Royal Academy of Arts, London.
1971	*British Paintings, 1900–1971*, London, Arthur Tooth and Sons Ltd.
1971	*Stanley in Macedonia*, Cookham Festival.
1972	*British Paintings, 1900–1971*, London, Arthur Tooth and Sons Ltd.
1972	*A Decade 1940–49*, Arts Council.
1972	*Base Details – British Artists of the First World War*, Nottingham University Art Gallery.

1972	*Stanley Spencer*, Merradin Gallery.
1972	*Drawings of Children by Sir Stanley Spencer* R A, Stanley Spencer Gallery, Cookham.
1973	*Hampstead One c. 1915–c. 1925*, London, Gallery Edward Harvane.
1973	*The Spencers and Carlines in Hampstead in the 1920s*, Cookham Festival.
1973	*A Selection of Drawings by Sir Stanley Spencer* R A *from the Astor Collection*, Stanley Spencer Gallery, Cookham.
1974	*Hampstead Two c. 1928–c. 1938*, London, Gallery Edward Harvane.
1974	*Henry Lamb and his friends*, London, Gallery Edward Harvane.
1974	*English Painting, 1900–40*, London, New Grafton Gallery.
1975	*The Gerard Shiel Collection of Stanley Spencer Paintings*, Cookham Festival.
1975	*English Painting and Drawing 1900–1940*, London, New Grafton Gallery.
1975	*Stanley Spencer, War Artist on Clydeside*, Scottish Arts Council, Third Eye Centre, Glasgow. Introduction by Joan Hughson.
1976	*An Honest Patron (Sir Edward Marsh)*, Bluecoat Gallery, Liverpool.
1976–77	*Sir Stanley Spencer*, Arts Council touring exhibition, Brighton Art Gallery 1976, Glasgow Art Gallery and Museum 1976, Leeds City Art Gallery 1976, Fitzwilliam Museum, Cambridge 1977.
1977	*Sir Stanley Spencer*, West Surrey College of Art, Farnham.
1977	*Stanley Spencer and his family – paintings and studies*, Cookham Festival.
1977	*British Painting 1952–77*, Royal Academy of Arts.
1977–8	*The Bible in British Art*, Victoria and Albert Museum, London.
1978	*Sir Stanley Spencer* R A, *A Collection of Paintings and Drawings*, Piccadilly Gallery, London.
1978	*Stanley and Hilda Spencer*, Anthony d'Offay Gallery, London. Introduction by Richard Carline.
1979	*12 X England*, Museum for Religious Art, Ostend, Belgium.
1979	'Stanley Spencer in the Shipyard', joint exhibition mounted by the Imperial War Museum and The Science Museum, London.
1979	St Andrews, Crawford Art Centre.
1979–80	*The Thirties*, Hayward Gallery, London.
1980	*Pictures for an Exhibition*, Whitechapel Art Gallery, London.

Acknowledgments

The Committees for the exhibition would like
to thank the following individuals, in addition
to the lenders, who contributed in many
different ways to the organisation of the
exhibition and the preparation of the
catalogue.

Lynne Bell
Mrs B. Branson
Christabel Briggs
Daphne Charlton
Keith Clements
Clare Colvin
Mrs C. Cumming
Joseph Darracott
R. W. H. Elsden
Anthony d'Offay
Sarah Fox-Pitt
Alec Gardner-Medwin
Thomas Gibson
Janet Green
Robin Johnson
James Kirkman
Lady Pansy Lamb
Carolyn Leder
Marjorie Metz
Philip Metz
Graham Murray
Daphne Robinson
Duncan Robinson
Geoffrey Robinson
David Rowan
Eric Rowan
Shirin Spencer
Unity Spencer
Nicholas Tooth
The Rev Canon R. M. L. Westropp
Margaret Williams

The authors would also like particularly to
thank the artist's daughters, Shirin and Unity
Spencer, for their permission to use
documentary material from the Tate Gallery
archive; they also thank the staff of the Tate
Gallery for their patient collaboration.

Index of Lenders

Also owners who prefer to remain anonymous.

The Friends of the Royal Academy

Patron: HRH The Duke of Edinburgh, KG, KT

Friends

£12.50 annually or
£10 annually for Museum Staff and Teachers or
£7 annually for Pensioners and Young Friends (16–25 years).

Gain free and immediate admission to all
Royal Academy Exhibitions with a guest or
husband/wife and children under 16.

Obtain catalogues at a reduced price.

Enjoy the privacy of the Friends' Room in Burlington House.

Receive private view invitations to various exhibitions
including the Summer Exhibition.

Have access to the library and historical archives.

Benefit from other special arrangements, such as
lectures and tours.

Artist Subscribers

£22.50 annually.

Receive all the privileges shown above.

Receive free submission forms for the Summer Exhibition.

Obtain art materials at a reduced price.

Obtain constructive help where the experience of the Royal
Academy could be of assistance.

Sponsors

£500 (corporate)
£100 (individual) annually

Receive all the privileges offered to Friends.

Enjoy the particular privileges of reserving the
Royal Academy's private rooms when appropriate and
similarly of arranging evening viewings of certain exhibitions.

Receive acknowledgment through the inclusion of the
Sponsor's name on official documents.

Benefactors

£1,000 or more

An involvement with the Royal Academy
which will be honoured in every way.

Further information is available from The Secretary,
The Friends of the Royal Academy.

Benefactors and Sponsors

BENEFACTORS
Mrs Hilda Benham
Mrs Keith Bromley
The John S. Cohen Foundation
The Colby Trust
The Lady Gibson
Jack Goldhill, Esq.
Mrs Mary Graves
Sir Antony Hornby
Irene and Hyman Kreitman
The Landmark Trust
Roland Lay, Esq.
The Trustees of the Leach Fourteenth Trust
Hugh Leggatt, Esq.
Sir Jack Lyons, CBE
The Manor Charitable Trustees
Lieutenant-Colonel L. S. Michael, OBE
The Lord Moyne
Mrs Sylvia Mulcahy
G. R. Nicholas, Esq.
Lieutenant-Colonel Vincent Paravicini
Mrs Vincent Paravicini
Phillips Fine Art Auctioneers
Mrs Denise Rapp
Mrs A. Reed
Mrs Basil Samuel
Eric Sharp, Esq., CBE
The Revd Prebendary E. F. Shotter
Keith Showering, Esq.
Dr Francis Singer
Lady Daphne Straight
Mrs Pamela Synge
Harry Teacher, Esq.
Henry Vyner Charitable Trust
Charles Wollaston, Esq.

CORPORATE SPONSORS
Ovearup Partnership
Barclays Bank International Limited
The British Petroleum Company Limited
Christie Manson and Woods Limited
Consolidated Safeguards Limited
Courage Limited
Courtaulds Limited
Debenhams Limited
The Delta Metal Company Limited
Ford of Europe Incorporated
The Worshipful Company of Goldsmiths
The Granada Group
Arthur Guinness Son and Company Limited
Guinness Peat Group
House of Fraser Limited
Alexander Howden Underwriting Limited
IBM United Kingdom Limited
Imperial Chemical Industries Limited
Lex Service Group Limited
Marks and Spencer Limited
Mars Limited
The Worshipful Company of Mercers
Midland Bank Limited
The Nestlé Charitable Trust
Ocean Transport and Trading Limited
(P.H. Holt Trust)
Philips Electronic and Associated
Industries Limited
Playboy Clubs International

The Rio Tinto-Zinc Corporation Limited
Rowe and Pitman
The Royal Bank of Scotland Limited
J. Henry Schroder Wagg and Company
Limited
Seascope Limited
Shell UK Limited
Thames Television Limited
J. Walter Thompson Company Limited
Ultramar Company Limited
United Biscuits (UK) Limited
Waddington Galleries Limited
Watney Mann and Truman Brewers
Limited

INDIVIDUAL SPONSORS
Mrs John W. Anderson II
Mrs Ann Appelbe
The Rt. Hon. Lord Astor of Hever
The Rt. Hon. Lady Astor of Hever
Miss Margaret Louise Band
A. Chester Beatty, Esq.
Peter Bowring, Esq.
Mrs Susan Bradman
Lady Brinton
Jeremy Brown, Esq.
Derek Carver, Esq.
Simon Cawkwell, Esq.
W.J. Chapman, Esq.
Alec Clifton-Taylor, Esq.
Henry M. Cohen, Esq.
Mrs Elizabeth Corob
Raphael Djanogly, Esq., JP
Brian E. Eldridge, Esq.
Mrs Erica Eske
Friedrich W. Eske, Esq.
Mrs Myrtle Franklin
Victor Gauntlett, Esq.
Peter George Goulandris, Esq.
J. Home Dickson, Esq.
Mrs Penelope Heseltine
Joel Honigberg, Esq.
Geoffrey J.E. Howard, Esq.
Mrs Patricia D. Howard
Mrs M. Igel
J.P. Jacobs, Esq.
Mrs Christopher James
Alan Jeavons, Esq.
S.D. Kahan, Esq.
David J. Kingston, Esq.
Beverly Le Blanc
Graham Leggatt-Chidgey, Esq.
H.V. Litchfield, Esq.
Owen Luder, Esq.
A. Lyall Lush, Esq.
Jeremy Maas, Esq.
Ciarán MacGonigal, Esq.
Peter McMean, Esq.
José Martin, Esq.
Princess Helena Moutafian
David A. Newton, Esq.
S.H. Picker, Esq.
John Poland, Esq.
Dr Malcolm Quantrill
Cyril Ray, Esq.
Mrs Margaret Reeves

The Stanley Spencer Gallery
Cookham on Thames,
Berkshire

The Stanley Spencer Gallery is unique. It is the only memorial gallery in Britain devoted exclusively to an artist in the village where he was born and spent most of his working life.

To Spencer Cookham was the scene of heavenly visitations. Located in the heart of the village he immortalised, the gallery contains a permanent collection of his work along with letters, documents and objects associated with the artist. It also displays important works on long term loan, such as *Christ Preaching at Cookham Regatta*, and mounts twice-yearly winter and summer exhibitions. More than three hundred works have been shown since the gallery opened in 1962.

Close at hand are his birthplace 'Fernlea' and the parish church in which hangs his painting of *The Last Supper* 1920. The church and churchyard are immediately recognisable as the setting for *The Resurrection, Cookham* 1924–6, and many places in the village are similarly identifiable.

OPENING TIMES

Winter Months
November to Easter: Saturdays, Sundays and Bank Holidays 11 a.m.–5 p.m.
This winter also open Fridays until 5 December 1980 at the same times.

Summer Months
Easter to October: weekdays 10.30 a.m.–6 p.m.
Saturdays, Sundays and Bank Holidays 10.30 a.m.–6.30 p.m.

Admission Charges
Adults 35p. Students and Pensioners 25p. Children 10p.
Arrangements for organised parties through the Secretary, telephone Bourne End (06285) 24580.

Cookham is within easy access of the M4.
Bus and train services are also available.